THE GUENNOL COLLECTION

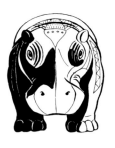

THE

GUENNOL

COLLECTION

VOLUME I

Edited by

IDA ELY RUBIN

THE METROPOLITAN MUSEUM OF ART

COPYRIGHT © THE METROPOLITAN MUSEUM OF ART, 1975

FIRST PRINTING, 1975, 1000 COPIES

LIBRARY OF CONGRESS CATALOGING IN PUBLICATION DATA

Main entry under title:
THE GUENNOL COLLECTION.

 Held at the Metropolitan Museum of Art in 1969.
 Bibliography: p.
 *1. Art—Exhibitions. 2. Martin, Alastair
Bradley—Art collections. 3. Martin, Edith—Art
collections. I. Rubin, Ida Ely. II. New York
(City). Metropolitan Museum of Art.*

N5220.M39G83 707'.4'01471 75-33291
ISBN 0-87099-144-2

PRINTED IN THE UNITED STATES OF AMERICA

BY THE JOHN B. WATKINS COMPANY

NEW YORK CITY

TO

THE FAKERS

AND COUNTERFEITERS

WITHOUT WHOM

COLLECTING WOULD BE

CONSIDERABLY LESS

CHALLENGING

ACKNOWLEDGMENTS

IN 1969 The Metropolitan Museum of Art held an exhibition of The Guennol Collection. It was hoped that this catalogue would have been published in time for the exhibition, but it was not, and the catalogue was laid aside for several years. The essays, with minor corrections, stand as they were then, and bibliographical references end with the year 1969. Objects no longer in our collection or in those of our children have been deleted.

Although a true reflection of our own personal taste, The Guennol Collection owes much to the generous assistance we received from many people. Particular recognition is due the contributors to this catalogue, not only for their work on it, but for the considerate help they so freely gave in the formation of the Collection itself. Our warmest gratitude is due to the late James J. Rorimer and to John D. Cooney, Charles K. Wilkinson, Christine Alexander, Dietrich von Bothmer, Harry Bober, Jane Durgin, Yvonne Hackenbroch, George J. Lee, the late Samuel K. Lothrop, Gordon F. Ekholm, Frederick R. Pleasants, and Ida E. Rubin.

We profited especially from James Rorimer's extensive

knowledge of the craft of collecting, its pitfalls and opportunities. John D. Cooney's sage counsel on ancient objects and contemporary dealers, as well as his technical evaluations of many pieces, was of inestimable value.

Ranging over varied fields in our search for the Guennol objects, we often relied on acknowledged experts for guidance. (In the United States discriminating *amateurs* turn to scholars quite as readily as to their reference libraries.) And we found these specialists had excellent objective opinions on many subjects unrelated to their particular studies. Unfortunately, it is impossible to name all the specialists whose knowledge and encouragement meant so much to us, but in addition to those listed above, we are greatly indebted to Junius B. Bird, Maurice S. Dimand, William H. Forsyth, Lloyd Goodrich, Henry Gruenthal, Sheldon Keck, John G. Phillips, Elizabeth T. Riefstahl, Hanns Swarzenski, and the late Georg Swarzenski.

To the late Walter C. Baker, Robert W. Bliss, and Thornton Wilson, and to Ernest Erickson—all owners of exceptional art collections—we are grateful for suggestions and advice on individual pieces. Their great contribution, however, was the example they set in establishing such high standards of quality in their own collecting.

We are happy to acknowledge our appreciation to the trustees and directors of the Museum of Fine Arts, Boston, the Brooklyn Museum, and the American Museum of Natural History for the invaluable assistance of their trained staffs and for the technical facilities made available to us whenever requested. We thank The Metropolitan Museum of Art for mounting the 1969 exhibition and Thomas Hoving and Philippe de Montebello for undertaking the publication of this book. Our debt to libraries, vital to serious collecting, is great. In addition to the libraries of all these museums, we frequently made use of the Frick Art Refer-

ence Library, the Morgan Library, and the New York Public Library, where the staffs provided prompt and intelligent assistance.

Anthony Giambalvo, formerly of the Brooklyn Museum, is to be remembered for his careful examining, cleaning, and mounting of various pieces in the Collection.

The catalogue has been enhanced by drawings contributed by Charles Addams, William Baake, André Durenceau, Anthony Groves-Raines, Lindsley F. Hall, Fred Scherer, and Charles K. Wilkinson. The reproductions, so important in an art book, are largely the result of the professional skills of Charles Uht, who photographed many of the objects. The form and layout of this volume represent the excellent work of John B. Watkins, ably assisted by Frances M. Cornish. The publication of this catalogue would not have been possible but for the detailed and understanding work of Bradford D. Kelleher and Anne M. Preuss of The Metropolitan Museum of Art.

It is customary at this point to offer an apologia for personal pleasure, to label one's collecting "for the welfare of society." Rather than repeat this inaccurate cliché, we prefer to close by thanking again all those whose wisdom and generosity helped us bring you The Guennol Collection.

EDITH and ALASTAIR MARTIN
October 31, 1975

FOREWORD

COLLECTIONS may be as individual as their owners—as revealing as an autobiography. The Guennol Collection began in 1947 when the Alastair Bradley Martins became enamoured of a few objects unlike any they had previously assembled.

The Martins have not concentrated on any specialized field of collecting nor are they followers of fashionable trends. They find excitement in assimilating man's artistic achievements through an examination of the arts of bygone civilizations and they have sharpened their wits in an effort to appreciate the creative work of our own time. That so outstanding a collection has been assembled within only a short time gives both of them great personal satisfaction. The rare, beautiful, extraordinary items that form this collection—unique in the annals of collecting—are the result of the Martins' perspicacity and perseverance. They love the game of collecting. Their selectivity, without the usual prejudices and limitations of most collectors, has resulted in the acquisition of about one hundred objects of such quality that they are proudly exhibited as long term

loans in The Metropolitan Museum of Art and the Brooklyn Museum.

This catalogue, the result of lay and professional enthusiasm, has been in preparation concurrently with the growth of the Guennol Collection. It will stand as a landmark of the ingenuity of its sponsors in an era when collecting is fraught with difficulties and challenges.

JAMES J. RORIMER
Director
The Metropolitan Museum of Art

1966

CONTENTS

PARDON A HUNTER

THE true collector, like the artist, is an impassioned creator. Frustration and delight, anguish and ecstasy, await those who search for the ideal, whether it be in one work of art or the composite creation of an art collection. The ideal may never be achieved, for "the Castle of the Grail lies in the Land of Longing."

In this catalogue you will read about the many works of art acquired by us over the last thirty or more years. Our collection is highly personal and traces its name to Wales. Guennol is Welsh for "marten," and it was in Wales that we spent part of our honeymoon. Over the years we made every effort to assemble the best possible objects, whether ancient or relatively modern, whether from Peru, Babylonia, China, or the shores of Gitchee Gumee, and whether of major historical significance or mere whimwhams. Although the Collection is worldwide in scope, it has a truly American slant, it is an American Strawberry. We sought to honor the ideal and the universal, and the Collection is no servant to our contemporary culture.

Specialist collectors have accomplished a great deal, but

fishing in many waters rather than in a single pond is not only more intriguing, it may also improve the skill of the angler.

Our home contains evidences of earlier and less sophisticated efforts in collecting: shells, stamps, rare stones, angling books, and butterflies. In the words of Coventry Patmore's poem "The Toys":

> *A box of counters and a red-vein'd stone,*
> *A piece of glass abraded by the beach,*
> *And six or seven shells,*
> *A bottle with bluebells,*
> *And two French copper coins, ranged with careful art.*

Some cultures are not represented because we were unable to obtain fine examples. Among regretted omissions are examples of paleolithic bone carving, Scythian gold and silver, Irish illumination, an Egyptian Twelfth Dynasty head, a Burgundian metal object, Italian Renaissance jewelry, a page from a Pre-Columbian codex, and an animal sculpture by the American Indians of Key Marco. Some cultures did not attract us. Thus there are no examples of Luristan, Ordos, Mohammedan, Roman, Etruscan, Early Christian, or Byzantine art. Modern art, with few exceptions, has no interest for us. It is a world without laws and is too old-fashioned for our taste.

Then too, there were fine objects we could have and should have acquired, such as The Cloisters' Book of Hours of Jeanne d'Evreux by Pucelle, the Bliss jade Teotihuacan mask (now at Dumbarton Oaks), Mrs. C. S. Payson's Van Gogh painting Irises, and the Irish house-shaped Emly Shrine now at the Museum of Fine Arts, Boston. Of these examples, the failure to purchase the Pucelle was, we think, our worst mistake.

Many objects we craved changed hands during the time

we were collecting; masterworks we could not purchase but which we nevertheless enjoy and admire—objects such as the English Romanesque ivory cross now at The Cloisters, the majestic wood Maya carving in the New York Museum of Primitive Art, and the Metropolitan Museum's wonderful bearded bronze head from northwestern Iran.

Some years ago the Trustees of the British Museum published an illustrated report listing their major accessions for the period 1938–1966. Their booty included such well-known objects as the Lycurgus Cup, a Late Roman glass vessel with a mythological scene of the death of Lycurgus; the Benedictional of St. Ethelwold, Bishop of Winchester a thousand years ago; the Mildenhall, Snettisham, and Sutton Hoo treasures—to say nothing of the Portland Vase and the "Chatsworth Head." If these treasures are beyond the dreams of all of us, there were in the listing many objects just right for our Collection: the Dunstable jewel, the French (or English) fifteenth century gold and enamel figure of a swan, a fine Sasanian fifth century silver dish showing a king battling three lions, a Benin ivory double-bell, a black porphyritic figure of a frog, Egyptian of about 4000 B.C., and others no less significant! With such objects entering the maw of enlightened institutions, what chances and opportunities are left the amateur collector?

He will have to search far and wide. The auction house is ancient in its allure and hazards. There it is wise to behold the bidder, not the bid. Instead one can buy directly from other collectors. Although the entire group of Mound Builder objects in our Collection is the result of writing to thirty Midwestern collectors and hitting on one, this approach is fraught with peril. If you want something belonging to a fellow collector, never let him know. Remember too, things often look better when in another man's collection.

Agents and experts can be tremendously helpful. In fact, whereas many famous collectors, such as the late D. G. van Beuningen, recommended avoiding expert advice, we urge using experts as touchstones in collecting. But never allow one person to screen objects unless you lack confidence in your own discernment, for then you will be forming his collection, not yours. Many collections reflect the eye not of the purchaser but of some friend. In collecting, the greater the effort made, the more one mirrors one's own personality. Nothing should be more disappointing to the collector than to find someone, expert or novice, who likes all his collection.

No one is more important to the collector than the art dealer, whose business, as Booth Tarkington's Mr. Rumbin said, "is to place happiness in permanent collections at the nicest profit he can." Prices paid by dealers, and where they buy their objects, are highly classified secrets of the trade. Joseph Brummer, New York dealer in ancient art, was a particularly astute businessman, with a remarkable eye for the authentic. We were fortunate indeed to obtain the objects listed below at any price, but Joseph was more fortunate. This was in part due to his willingness to strike out into new fields where more timid dealers feared to go. Each object in Brummer's stock was carefully given a number preceded by the letter "N" for a New York purchase, and "P" for a Paris purchase. Brummer also kept a photographic record of each piece, catalogued according to its culture. Following is a listing of Brummer objects in the Collection, along with prices he paid, as described on his index cards or bills:

Achaemenian Ox in Gray Stone N 318/b, January 1919, from Messayeh, $200.00

Statuette in Wood representing an Angel P 5239, August 1928, from Moretti, $1,019.72

Solid gold Collar, ending with an Ibex P 6097, June 1929, from Maurice Nahman, $2,509.00

Virgin and Child, in Wood P 6248, July 1929, from A. Lambert, $3,920.00

Needlework Roundel with Man on horseback and 3 other personages P 6470, August 1929, from Salvadori, $65.00

Hippopotamus in blue glazed ware with black designs P 6378, October 1929, from Joseph Altounian, $800.00

Body of a Woman, clad in a lion's skin, in limestone or meerschaum N 2937 May 1931, from E. S. David, $500.00

Babylonian bronze and gold Ram N 3136, October 1933, from E. S. David, $600.00

Glass fragment depicting Christ with two Apostles P 11043, September 1934, from G. Bideaux (with another fragment), $608.55

Early Persian silver Dish, from Mazanderan P 12000, June 1935, from Spink & Son, $1,109.00

Aquamanile in Limoges Enamel N 3595, November 1935, from French & Co., $400.00

Strip of 13th century English Embroidery P 12169/B, May 1936, from Raimondo Ruiz, $1,667.00

Rouge box in Ivory. Egyptian from New Empire P 13065, August 1936, from Maurice Nahman, $195.00

Egyptian black marble Rhino N 4014, December 1936, from Raphael Stora, $250.00

Flat bronze Ornament forming a Bird P 15042, July 1938, from Arthur Sambon, $750.00

Head of a Hippopotamus in Alabaster, Egyptian N 4618, August 1940, from International Studio of Art, Sale August 12, Lot #570 Article #7, $800.00

Bronze Lamp in Shape of Bull N 6661, August 1946, from Tuba Lalezari through Manoochehrian, $4,000.00

Gothic Silk and Gold Needlepainted Panel landscape with kneeling Figures in Foreground J. B. 13, November 1946, from Arthur Sachs, $3,500.00

The wise collector is friendly, if possible, with all dealers but not overly dependent on any, for in most cases a good client is a bad collector. Those who buy from only one dealer are actually buying from several sources—the objects being fed through the dealer of their choice. Collectors must be prepared to search far afield; and the true collector, like Conan Doyle's master detective in *The Hound of the Baskervilles*, must tramp lonely moors for clues, making his solitary way, ever alert for Grimpen Mires and other dread and unknown hazards.

The collector had better fraternize neither with dealers nor with museum curators; he must be a *Waldgänger*. A

number of our pieces were recommended by museum curators, but one cannot rely on this help, as curators have first to consider their own museums. Actually it is difficult for a curator to become a true collector, for, immersed in one field, he rarely interests himself in the relationships between diverse areas. Though one is told it is impossible to compare quality in objects of different cultures and periods, it is precisely this that a serious collector must do. If there is a message in our Collection it is that diverse objects may be compared. Here is Classical and Primitive, but as Kipling might have written, there is no Classical and no Primitive when a real collector is about. Many people viewing the Collection discern a characteristic Guennol quality, but perhaps the Collection is most remarkable not for the objects themselves but for its demonstration of the success that an amateur can achieve in bringing together objects even from areas in which he has little knowledge.

Comparisons between private and public collections are unfair to the latter; the Collection should properly be compared with similar private collections where complete freedom of selection was possible. However, today the true collector acknowledges that there are art objects which are too important to be desirable in a private collection. Some authorities criticize collectors for having ancient art objects. But even national museums do not always protect their exhibits from vandalism and looting. In 1639 a young girl discovered one of the two famous fifth century Danish Golden Horns of Gallehus. About a hundred years later the second solid gold horn was found in the same Danish field. These horns were dutifully deposited in the Royal Gallery of Art at Copenhagen. Then in 1802 they were stolen and immediately melted down. Our Frasnes torcs, a Belgian national treasure of somewhat the same historical interest, have at least been preserved, even though in private hands.

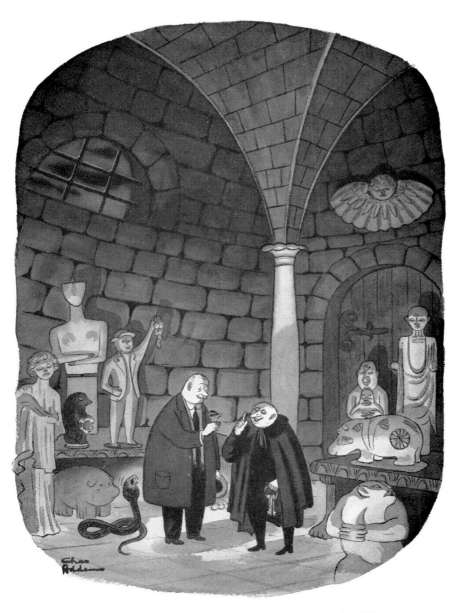

"NOW THIS ONE IS SUPPOSED TO HAVE
A CURSE ON IT."

Actually, as the Guennol Collection grew, most objects have been shown in New York museums on long-term loan —a rare example of a private collection being formed publicly.

Malraux has stated that private ownership of works of art is almost finished. We do not share his pessimism! Good opportunities still exist for collecting in many fields. Travel is easier, our knowledge is greater, the number of art dealers is larger, and collectors abound. Of course, certain things are scarce, but time and circumstances provide ways of freeing rare objects.

A private collector is a composite of many men—detective, strategist, gambler. If he is lucky, he will be the eventual possessor of a slice of eternity. But a collection does not preserve the collector. And only for a fragment of time is the collection his:

> *Collecting has sorrow:*
> *To buy is to borrow.*

Edna St. Vincent Millay has written that collectors are "like thieves that scratch the jewels from a tomb." But in spite of this, often perhaps because of it, collecting is enthralling. It should not, of course, get the best of one.* The omnivorous amasser resembles Kenneth Grahame's desperate and zoophagous Toad of Toad Hall, driving his hobby at full throttle, living his hour, possessed, out of control. A sense of humor is essential in collecting, as it is in all serious endeavors.

In forming the Collection the excitement of the hunt was a principal attraction, for all during the process of searching, studying, comparing, and selecting, there was that slim hope

* One is reminded of the British collector of Egyptian art who developed such a mania for his avocation that he added a codicil to his will directing that he be mummified and interred, along with a favorite scarabaeus, in the vicinity of the right forepaw of the Great Sphinx at Gizeh.

of harpooning the elusive white whale, the priceless treasure that justifies endless effort and sacrifice. This chance, however remote, lent zest and even a kind of frenzy to the chase. The legends and histories associated with many of the objects were other attractions of considerable appeal. The Collection often bridged the gap between the worlds of fantasy and reality. The following tale of the Black Idol (Olmec Black Stone Statuette) is an example. This story is narrated by a prior owner, now deceased.

The historia of the Black Idol starts in the year 1918. At that time I was engaged in subsoil leasing and perfection of land titles in the Huastecan district of Mexico for El Aguila Oil Company. In the course of my work I received instructions to locate a certain Rosa Azuara and obtain her hereditary rights to a parcel of land.

Accordingly, I made tracks with a mozo, two desert canaries, and some twenty thousand pesos in gold coin. Late one evening, after three days of punching the breeze, we reached the pueblo where the Azuara family lived. I hurried to Rosa's jacal. She denied having any hereditary rights to the oil tracts and, despite my honest evaluation of the property, was steadfast in refusing a deal. Her spouse wasn't there: he was following a native custom of star-pitching in his vanilla patch, a muzzle-loader by his side, to protect the vanilla beans. I tackled him the next morning, but he was equally stubborn. Although I was anxious to accomplish my mission and leave that bandit-infested country, I cooled my heels for a full week before they accepted ten thousand pesos for the rights.

Much of this dreary time of waiting was spent with Rosa's son, a leatherworker. One morning I happened to see the idol: he was using it as a punch block for riveting. He said a compadre had found it in a stream near the ruins of Tuzapan, not far distant, and had given it to his father. As I had previously made a modest gift to the lad—my fountain pen—he begged me

THE ROMANCE OF THE BLACK IDOL

to accept the carving as a token of his good will. At supper that evening I mentioned this kind gesture to his father. Surprisingly, the oldster bristled, forcing me to return the idol to avoid further frothiness. Later, after the codger had lumbered off to his vanilla patch, his family told me the old gaffer was superstitious about giving up the idol because the finder had shaken hands with Saint Peter almost immediately after parting with it.

I almost forgot the incident but, while repairing to my base after a touching farewell, I came across the sculpture in my saddlebag, no doubt cached there by Rosa's son. The story was climaxed for me some weeks later with the deplorable news that two days after my departure a group of bean-eaters riding the owlhoot trail had arrived with plenty of hardware at the abode of my amigos, apparently having been creditably informed that a gringo had paid them a handsome sum of money. The son escaped, but Rosa and her husband, being mulish and refusing to deliver the swag, were 'dobe walled into Kingdom Come. This double coincidence whelped the legend that the idol mustn't change ownership. Incidentally, when the Azuara land was drilled for oil it produced a series of dusters.

The melancholy tale isn't ended. For a spell the idol was mounted on the radiator cap of my Packard, and while I was visiting British Columbia the automobile was stolen. Learning it had run off the steep Malahat Drive, north of Victoria, I went out with a wrecking car and found my Packard, wheels up, about two hundred feet down the ravine, and a very bloody mess inside. I kept the wrecking crew busy seeking the black idol which had become detached with the cap and was resting under a nearby shrub, the bright nickel of the cap leading to the recovery.

Although a Tarascan dog is a Tarascan dog whether it cost two dollars or two thousand dollars, relative prices provide a rather sure index of current fashion. We are still "enjoying" a boom in the art market with prices at or near

an all-time high. Regarding the high prices of art objects, certain museums are particularly culpable. Just because an institution obtains private donations for a specific object is no excuse for it to overpay. Any overblown purchase pushes the whole art market up, to the detriment of all museums and collectors. Should a large museum or a rich collector desire a fashionable painting, a rare piece of eighteenth century porcelain, or a Cycladic figure, the sky's the limit with the smaller fish always trying to ape their betters by buying similar truck. Almost every Tom, Dick, and Harry wants a Picasso, a Mondrian, a Luristan bronze, an African mask, a Peruvian textile, a sculpture by Brancusi. The respective quality of these things makes only the slightest difference to the proud possessors. Few remember that the enemy of a true collector is popular opinion. The paradox of collecting is that a successful collection is never a success. Homage to the maverick!

Calouste Gulbenkian was in a class by himself as a private collector, and no one had the eye or the funds to compete with him. His miraculous collection, now housed in Lisbon, is an inspiration and a delight. We especially admire his obsidian Egyptian Amenemhat III head, which I foolishly tried to extract from him, and his magnificent Rothschild jasper ewer.

The Collection's beautiful Renaissance enamel hunting horn was shown to us by a dealer as an example of something on consignment at a ridiculously high price. In fact, its price was inordinately reasonable. On another occasion, during a trip to Mexico, we were at a small town enjoying the varied sights when we came to a shop with a patio. There out in the open and nailed to the wall we saw the six Guennol monkey paintings, and the price asked for them was only a few pesos! How far from that auction gallery in New York where a connoisseur was overheard saying:

"Yes, dear, I'll buy it for you—even if it goes cheap." Another collector is so impressed with the auction price attained by the "two-point-three" Rembrandt, Homer Contemplating the Bust of Aristotle, that he gives the scout salute whenever he sees the picture in the Metropolitan Museum, a *beau geste* perhaps lost on the museum attendants. We overpaid for the Egyptian fayence hippopotamus, the Hacilar figure, and some other pieces. These extravagances are perhaps offset by happier purchases: the Japanese book of textiles, the Olmec jade pectoral, many of the Joseph Brummer wares, and several other Near Eastern objects. Certainly, the cost of an object is a poor index of its value, especially if the object is currently in demand. Anyway, once something is bought, the price is forgiven, forgotten. Though even great works of art are seldom actually priceless, it is very difficult to give them monetary values; for example, it would be hard to set a price on a picture by the great Dutch master Vermeer, as there are only six or seven in private hands that may one day enter the market.

In every great work of art there is something special, something that proves again that man himself is special. And as the artist soars in creation the collector must also soar to appreciate the creation.

Our friend Jeannette Chapell has given expression to this feeling in one of her poems:

> *Air does not free the birds,*
> *it is their element,*
> *commands them:*
> *Nor water liberate the fish*
> *that briefly arc . . . and plummet.*
> *But man,*
> *slipping earthly shackles,*
> *trembles*
> *as they loosen.*

Forming a collection, like the creation of the works of art in it, is bound by no rules of time. We remember our biggest one-day haul, and all from one source, in June 1948, when we purchased some wonderful objects: the Near Eastern bronze bull lamp, the blue fayence hippo, and the Gothic angel—along with many other objects since given to museums or sold. But if on some days things are realized swiftly, often there are long periods of looking, of endeavoring to add to the collection, with no success. We averaged about seven Guennol purchases a year. Collecting is a passion that grows, runs its course, and wanes. The best decisions are made when this passion is at its greatest. As Blake pointed out, "The road of excess leads to the palace of wisdom."

The story of the acquisition of our most important item, the enamel Mosan reliquary triptych, is atypical, but it exemplifies the many fortuitous elements in this specialized activity. Periodically we used to see a distinguished out-of-town curator when he visited New York. One evening we met at the St. Regis for cocktails, and over a long drink this very helpful gentleman mentioned a quite extraordinary enamel he had seen that afternoon. The next morning we visited the gallery where the masterpiece was supposed to be. Shown a few minor things, and not the piece expected, we eventually left in disgust, fearful it had been sold or was on reserve. The next step was to explain to the management —through an emissary—that we knew about the enamel and might we please see it. As a result we were shown the Mosan triptych and were given a two-day option on it. Although the price was at the far limit of our available resources, we acted quickly: a phone call was made to a trusted adviser to ascertain the reasons why the enamel had not yet been sold; libraries and museums were visited. At home, reflection joined with research as we looked over

books, pamphlets, and sales catalogues, and discussed the relative values of the triptych and the finest pieces already in our collection. Next day we purchased it. The thrill and pride of possession are a worthy climax when the collector adds one more part to a larger work of art. There remain the intimate delights of living with the object, of examining it with ultraviolet and other scientific revelators, of sharing one's triumph.

Oftentimes a strange sequence of events precedes a purchase, as in the acquisition of the Olmec jade figure with "baby," the Collection's morning star, and perhaps the most widely known Guennol piece, since hideous facsimiles are sold throughout Mexico. In the mid-winter of 1947, just before his death, we paid a visit to Joseph Brummer at his fabulous establishment at 110 East 58th Street in New York City and were shown the Olmec jade figure, nestled resplendently in its mauve velvet-lined cardboard box. It was not offered to us at this time, but about a year later a friendly curator was shown the same wonderful jade, and he told us the owner, a French dealer, was returning with it to France unless it was sold within the week. We did not miss the opportunity to acquire it. It was later confirmed to us that Brummer had had it on consignment from the French dealer and had actually quoted him the same price we had paid—a price which the dealer had rejected as too low.

On the other hand, the gold bracelet from Ziwiyeh and the Ifé head were on the New York market for some time. The protoliterate magnesite leonine figure was purchased quite simply one day, along with three other assorted objects. It was well known to everyone in the field.

A firmly established collector is more likely to be shown art objects of top quality, but every collector buys a fake now and then. The best collectors weed most of them out; nevertheless, even a fake has interest in a collection. Cer-

tainly Van Meegeren's "Vermeers" prove the fallibility of experts, not the validity of forgeries. Some collectors protect their mistakes from outside criticism and act like silkies setting on china eggs; they are as fond of each new acquisition, regardless of merit, as is a wart hog sow of her piglet. Olmec jades, Persian gold, and especially Cycladic marbles are particularly troublesome; official documents authenticating their antiquity are often to be taken *cum grano salis*.

Choosing favorites from the Collection is an interesting but difficult task. The leonine figure we consider the Guennol talisman. According to a note in Joseph Brummer's handwriting in his card files, this was his "best" piece. Despite man's knowledge of antiquity, this albino monster remains as mysterious as Edwin Drood. But a mysterious object is almost always a splendid object: *Omne ignotum pro magnifico.* Our personal favorite is the Olmec jade hand. The reader might single out the Mixtec bone reliquary; the Egyptian grasshopper from the cursed tomb of Tut; the sensitive, mysterious Ifé head; or, since "the eternal feminine draws us upward," the Hacilar figure might be a favorite. Everyone should find something that he especially enjoys, and, of course, as the Collection is incomplete, each viewer has the pleasure of completing it in his imagination. We continue to add to the Collection: a sapphire and diamond pin once owned by Catherine the Great; a lapis seal from Grand Duchess Olga Alexandrovna's collection; a jasper bowl with mounts by Thêlot; a Mogul archer's ring; a cast-iron vase by H. Guimard; papier-maché Victorian and Art Nouveau furniture; treasures from the Dresden Green Vaults; pictures by America's great naïve impressionist Justin McCarthy; an elephant from the Danish Order of the Elephant herd, containing the cypher of King Frederick IV (1699–1730); letters of Rasputin; a Scottish dirk; grossularite beads from the Helena Rubinstein auc-

tion; a Gnostic gem; a portion of Queen Victoria's silver service; a Bugatti "cobra" chair; a Zuñi gila monster; a King Ludwig III box; a 1775 Swiss cowbell; early tiles from Portugal; a Wittelsbach bracelet; Navaho conchas; a relic from Elizabeth of Austria; a Fabergé lapis box; a Maya wood box with date glyphs that correspond to A.D. 679, according to Dr. Michael Coe; an Olmec jaguar baby; additional Maya and Olmec jades; and Olmec and Maya beads. Other jade finds make our Pre-Columbian section the strongest group in the Collection.

Pleasurable as it is to purchase a work of art or receive it as a gift, it is incomparably more difficult—and immensely more satisfying—to create it. So it is with the forming of a private art collection. If museums often appear as warehouses, then it is perhaps only in the fine private collections that individual works of art take on, as Jacques Mauny wrote, "their full significance . . . every item closely related to the others by the passionate taste of the collector."

The true collector, having done his best, is little influenced by the opinions of mere mortals, especially the Jubjub birds of art criticism. For him everything is down Lewis Carroll's rabbit hole. Time and taxes are friendly, immortality is achieved, at least till "the stars of heaven fall unto the earth and till death and hell are cast into the lake of fire."

A.B.M.

EGYPTIAN OBJECTS

John D. Cooney

EGYPTIAN ART

EGYPTIAN art had but two functions, the service of man and the maintenance of the gods. It could even be argued that the two were but one, for the maintenance of the gods, which involved architecture, sculpture, and the crafts, was a practical human consideration, since its purpose was to ensure the continued existence of that divinely appointed order that had made Egypt a great nation and "the land of the gods." This emphasis on the importance and dignity of man, the absence of that fear of heaven so characteristic of Mesopotamia and later of Christianity, combined to make Egyptian art, if not completely humanistic, at least the most human of the arts of early antiquity, the first and greatest to place man in a world made for his enjoyment.

If ever their contemporaries speculated on such matters, the Egyptian's attitude must have been criticized as arrogant, and such certainly it would seem to men living in a harsh environment. But in the benign and unbelievably beautiful landscape of Egypt, so delightful a setting for life, the Egyptians inevitably believed themselves favored by the

gods. Their art is the tangible expression of that assurance.

In representing man as lord of the world and heir of heaven, for only the great were portrayed, the Egyptian sculptor composed his subject with a dignity verging on the divine. The result has seemed to casual viewers far removed from human experience, as certainly were all the religious representations and, magnificent as are the best Egyptian sculptures, few would now care to live with them.

But the sculptures of man were official art, objects made for a very serious purpose. There was a less austere, profane art in Egypt, which indicated a frank enjoyment of the world, some of it revealing an exceptionally keen observation of nature, a side of Egyptian art well illustrated in this collection. Wonderful details of landscape and scenes from peasant life, possibly reflections of Egyptian domestic art now largely lost to us, are found intermixed with serious tomb and temple decorations, graphic reminders that the Egyptians did not take themselves too seriously.

It is difficult to grasp the quality of many of these details, lost in the mass of vast compositions, only because the Egyptian artist rarely managed to subordinate detail to mass in wall decorations, a problem he never completely solved. But in their smaller objects—the marble bowl of this collection is a typical example—with but a limited area to be decorated, the Egyptian artist composed details of the landscape with a simplicity, delicacy, and accuracy that were again mastered only by the Japanese at a much later date. These small objects are doubtless minor art, but they are more indicative of the real nature of the Egyptians than are the monumental creations for which Egypt has so long been famed.

ARCHAIC NODDING FALCON

THIS archaic Egyptian statue of a falcon* in black and white granite was bought from a London dealer who had acquired it from the collection of Sir Jacob Epstein, the sculptor, who died in 1959. It had been shown in the exhibition of his collection arranged by the Arts Council of Great Britain in 1960 and is mentioned, with another falcon, in the catalogue.[1] The larger of the two is the Guennol falcon, for the measurement fits it. I could not trace the smaller bird. There is no photograph of either in the catalogue.

The earliest representations of the falcon god Horus date from about the beginning of the First Dynasty, whose kings had taken him as their patron. Archaic Egyptian statues are extremely rare. Aside from the second falcon of the Epstein collection, I know of only one other bird that has been attributed to this period (Oxford, Ashmolean Museum no. 1894. 105a). It was found by Petrie under the Twelfth Dynasty pavement in the Min Temple of Koptos and was described by him as a product of the "New Race," i.e. Predynastic.[2] He attributed the statue to the Seventh to Ninth Dynasties, which was his mistaken date for the civilization he had first excavated at Naqada.[3] The tail of the bird is broken off. The head is erect so that the neck forms an angle with the rest of the body. Half of the head is missing; this is not a break, since the surface is carefully smoothed and a ridge is worked out just above the eyes, to which the upper part of the head must have been fitted. Why this was done, whether the top of the head was of some other material than the limestone of the rest of the figure or whether it was a repair to the head,

* This essay is an abstract of an article published anonymously in *The Brooklyn Museum Annual*, IX (1967–1968), pp. 69–87. Thanks are due to the author, to the Brooklyn Museum, and to Bernard V. Bothmer, Curator of Ancient Art, for permission to print this abstract.

cannot now be ascertained. Nor is it possible to say to which species the bird belongs.[4] It sits on its small legs, which must have been fastened to some sort of base. Since the statue is now cemented to a modern base, the nature of its original pedestal cannot be determined. The figure as it exists now is about 60 cm. long and about 50 cm. high. It is rather narrow for its height and length; the sides are straight with no details. Only in front are there shallow ridges that indicate the wings. The eyes are very lightly carved; however, not only is the opening of the beak shown, but also, toward the front, a denticulation of the edges is indicated. A break at the lower beak, right in front, gives the impression that there had been a triangular groove, but I do not know how much of this is original. This attention to detail is in strong contrast to the treatment of the rest of the bird, with its plain vertical sides and barely indicated feet. Neither the circumstances of its discovery nor the style of the figure allow us to date it with confidence to the beginning of the Archaic Period.

The Guennol falcon too is represented with a minimum of detail, but the whole statue is treated consistently, with no part more detailed than the others. Yet there is no doubt that it represents a falcon, for the sculptor has understood the characteristics of the bird and brought them out in the way the surface is modeled, one part flowing into the next without hard transitions. The bird is in the squatting position with talons folded forward characteristic of the small archaic falcons of the time of Narmer-Aha excavated at Naqada,[5] and of the royal cartouches of the beginning of the First Dynasty. The slate palettes in the shape of a falcon which also belong to this period show the bird in the same attitude.[6]

The head of the Guennol falcon sits deep between the wings and forms a continuous line with the body. Its width

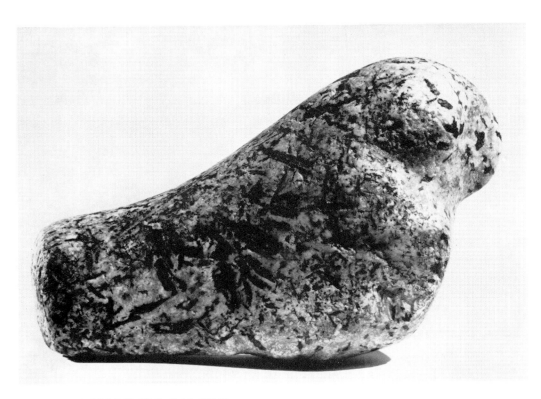

ARCHAIC NODDING FALCON

favors an identification as *falco* rather than as *accipiter*. The neck is not indicated. Although the eyes are faintly hinted at, the only detail of the head shown is the long and very strong beak. This prominent beak is a feature the Guennol falcon has in common with the falcon in relief that spreads its protecting wings over the pavilion in which King Narmer sits on the smaller mace head of Hierakonpolis in Oxford.[7] The beak merges into the division between the wings, which form shallow curves; this lifts the front of the bird slightly so that it did not touch the surface of whatever pedestal it may once have had. The left shoulder is stronger than the right, as is the entire left side. The heavy tail is cut off at a right angle and forms one curve with the body. This feature also is in keeping with the style of other early First Dynasty falcons.

A shallow furrow on the bottom of the statue indicates the division between the legs, as on other archaic statues of animals. The talons, folded forward, show four claws—a simplification of the three forward claws and one rear claw a *Falco peregrinus* has in reality. The front part of the bird is somewhat higher than the back, and the main weight of the figure is toward the front. The result is that even a very light touch under the tail makes the falcon nod. This is no accident; it required the careful working out of the underside of the bird so that it does not wobble but just gives one dignified nod.

The nodding falcon helps to solve the problem of the technical aspect of Egyptian oracles, namely how did the god reply and make his decision known to the petitioner who approached him. This question has been dealt with by J. Černý, who followed up each case in which an oracle given by a god is recorded either on stone or on papyrus.[8] The sign by which the god makes his decision known is described by the Egyptian verb *hn* or, in its older form, *hnn*. The

8

Egyptian dictionary, the *Berlin Wörterbuch*, translates it with "neigen, beugen," meaning to incline or to nod. It seems to Černý so unlikely that the statue of a god could be made to nod that he thinks some other meaning must be given to the verb *hn* and suggests that the god gave an affirmative answer by moving forward, which he deduces from an example he quotes in which the god gives a negative answer by moving backward. This could only be done when the god was carried in procession outside his sanctuary because, Černý claims, the chapel in which the god was kept was not accessible to the *misera plebs*.

In the case of the Guennol falcon, there is no need to give an otherwise unknown meaning to the "nodding" of the god, for that is exactly what the statue does. It must have been the sacred image of the god Horus that gave oracles. It seems to me more likely that this was done in the chapel of his sanctuary rather than when he was carried in procession. We know very little of what sanctuaries of this early period looked like. They were certainly much simpler than those of the Middle and New Kingdoms with which Černý is concerned. On the boats that appear on Predynastic decorated pottery, the chapels are made of reeds or a similar light material, and so are some depicted on early dynastic labels. The chapel shown on the small mace head of Hierakonpolis[9] gives a view of the interior. On one side stands a bird, perhaps an ibis, and on the other is a stand with a vase in it. Between the two is a wooden post, fitted at the top to take a crossbeam of the roof. Whether there was a wall separating the two halves, or whether bird and vase shared the same room, is impossible to say. The god stands on something that is partly destroyed but may have been his shrine. Although he is visible on top of the shrine, he must be understood to be inside it, a well-known device of Egyptian two-dimensional representation. It seems unlikely to me that

there was a partition between the god and the vase on its stand.

If a god gave oracles, there must have been a possibility of seeing him, either from a distance, perhaps through a door, or when he was outside his shrine and carried in procession. From the pictures on the decorated pottery, one can deduce that the gods were taken out in boats on the Nile in their reed chapels, which were provided with hooks at the top to lift them up onto the vessel. By the time of Narmer-Aha, the sanctuaries must have been more substantial than these primitive constructions, which is shown not only by the relief of the small Narmer mace head, but also by the ceremony on the large Hierakonpolis mace head (Oxford, Ashmolean Museum no. E 3632) that in all probability represents the king performing the foundation rites of a temple.[10] It would certainly have been easier to make the falcon nod if it were inside the sanctuary, perhaps outside its shrine for the occasion, than when it was carried in procession around the sanctuary court. Since the interior of the chapel was dark, a man crouching behind the pedestal on which the bird stood could not have been seen by the petitioner standing some distance away. A light tap with the finger or with a stick under its tail would make the falcon nod. The Guennol falcon is, as far as I could ascertain, not only the earliest example of a Horus falcon that was made to give oracles, but the earliest oracle-giving statue of any god. Indeed, it provides the first proof that there were oracle-giving gods at so remote a time.

Later, more sophisticated contraptions were used to make the falcon god nod. The famous falcon with the golden head found in a carefully prepared brick-lined pit under the middle chapel of the Twelfth Dynasty temple at Hierakonpolis had a hollow cylindrical rod under its flat base which ran through the center of the red pottery stand on which the bird was

10

placed.[11] The end of the rod was inserted into a rough pottery vase. Quibell gives a reconstruction of the whole apparatus, but it is difficult to imagine that he is correct. There must have been a way to get at the rod to make the falcon nod. The wooden body of the bird was completely decayed when found, and the rod and vase must also have been broken to judge from the reconstruction.

Another falcon with some provision to manipulate it is now in the collection of the Oriental Institute, Chicago.[12] It is a bought specimen and is dated there to the New Kingdom. It is larger than the two discussed above and of a dark stone. This falcon has a shaft running obliquely through the head to the underside of the base. A smaller shaft has been drilled through the beak upward into the head, where it joins the major shaft—surely the most elaborate mechanical provision ever made within a solid piece of ancient Egyptian sculpture in the round. The label states that a string could be inserted into the statue to make the bird nod. I do not know how this could be done, but it shows that the falcon gods did give oracles, whatever may have been the methods by which they were made to respond.

The Guennol falcon tells us more about its original importance. It was the cult statue that could be made to give oracles, precisely the way the (much later) oracle papyri say, namely by nodding. There is no need to try to explain the term *hn* other than by its common meaning. The Guennol falcon also shows that the giving of oracles by nodding goes back right to the beginning of the dynasties, one more proof of the enormous importance throughout the generations of Egypt's formative period.

ARCHAIC NODDING FALCON

Height 6.4″ Length 9″

Beginning of Dynasty I, *c.* 3200 B. C.

EX COLL.: Sir Jacob Epstein, London.

BIBLIOGRAPHY: *The Brooklyn Museum Annual*, VI, 1964–1965, p. 18, ill. (the falcon is incorrectly shown resting on talons and tail before it was recognized that it balances on its legs); *The Brooklyn Museum Annual*, IX, 1967–1968, pp. 69–87, 19 ills.

EXHIBITED: Arts Council of Great Britain, London, *The Epstein Collection of Tribal and Exotic Sculpture*, May 1960, no. 299; Brooklyn Museum since 1965.

NOTES

1. *The Epstein Collection of Tribal and Exotic Sculpture*, no. 299: "two figures of falcons as sacred emblems. Granite. Length 7 in., 9 in. Late Predynastic or Early Dynastic Period (about 3000 B. C.)."

2. W. M. F. Petrie, *Koptos*, London, 1896, p. 7.

3. W. M. F. Petrie and J. E. Quibell, *Naqada and Ballas, 1895*, London, 1896.

4. It should be noted, however, that *Falco peregrinus* has a toothed beak; see the denticulation referred to below.

5. Petrie and Quibell, nos. 14, 15, 18, 20, pl. LX.

6. W. M. F. Petrie, *Tarkhan II*, London, 1914, no. 10d, pl. XXII; no. 873, pl. XXXII; p. 12.

7. Oxford, Ashmolean Museum no. E 3631: E. J. Baumgärtel, *The Cultures of Prehistoric Egypt*, London, 1960, II, pl. IX, no. 1.

8. J. Cerny, "Egyptian Oracles," in *A Saite Oracle Papyrus from Thebes in The Brooklyn Museum (Papyrus Brooklyn 47.218.3)*, ed. and trans. R. A. Parker, Providence, 1962, pp. 43 ff.

9. Oxford, Ashmolean Museum no. E 3631: J. E. Quibell, *Hierakonpolis*, London, 1900, I, pl. XXVI.B.

10. E. J. Baumgärtel, "Scorpion and Rosette and the Fragment of the Large Hierakonpolis Mace Head," in *Zeitschrift für ägyptische Sprache und Altertumskunde*, 93, *Festschrift Rudolf Anthes zum 70. Geburtstag*, I, Berlin, 1966, pp. 9–13.

11. Cairo no. CG 52701: Quibell, p. 11, pls. XLII, XLIII; J. E. Quibell and F.W. Green, *Hierakonpolis*, London, 1902, II, p. 27, pl. XLVII; E. Vernier, *Bijoux et orfèvreries*, Catalogue général des antiquités égyptiennes du Musée du Caire, Cairo, 1925, pp. 233–235, pl. LXI, believes that this falcon dates from the Middle Kingdom.

12. Chicago, Oriental Institute acc. no. 10504. Serpentine. Height, with base, 59.6 cm.; width across chest 23.4 cm.; width of base 21.5 cm.; depth of base 55.2 cm. The top of the head is broken. A shaft, 63.3 cm. in length, runs obliquely through the head, where its diameter is 3.6 cm., to the underside of the base, where the opening is 3.3 cm. in diameter. A smaller shaft, 1.2 cm. in diameter, has been drilled through the beak upward into the head, where it joins the major shaft. The statue was acquired from Maurice Nahman in Cairo in 1919. I am indebted to Joan W. Gartland, Registrar of the Oriental Institute Museum, for her thorough investigation of the statue.

TWO
HIPPOPOTAMUS
SCULPTURES

O<small>F</small> all Egyptian animal sculptures, sacred or profane, those of the hippopotamus have appealed most to the modern world. Egyptian art fixed for all time the classic representation of this animal, an ideal that permits variations but hardly improvement. The hippopotamus appears at the very beginning of Egyptian art and continues to be represented in almost every period down to the collapse of Egyptian civilization, but the most famous examples are those of the Middle Kingdom, made of fayence and covered with blue glaze. The Collection has a splendid example of this type and another, more remarkable, fragment of an alabaster sculpture of the same animal.

The fayence sculpture is composed as a standing figure with the head frontal and slightly lowered, both head and body being skillfully modeled to stress the enormous bulk of the great beast. The representation is completely naturalistic save for the traditional blue glaze, here deep blue and excellently preserved. Somehow, and it is difficult to decide why, the Egyptians endowed these sculptures with an appeal far greater than that of any living hippo, a monstrous beast with a body disproportionate to his short legs.

That these Middle Kingdom hippopotamus statuettes had some magical purpose has long been known but the exact nature of their function is uncertain. The traditional view that they were magical figures to serve as quarry in the next world is only a plausible assumption. It has also been suggested that they are representations of a deity. But

it seems unlikely that, as a god or as the sacred animal of a god, the representations would have been composed so naturalistically and informally, for the Middle Kingdom range includes sleeping, walking, and roaring types. Representations of sacred animals were as dignified and conventionalized as the statues of the gods themselves. The most recent and likely explanation is that statuettes were placed in the tomb to give the deceased magical power over the animal represented, for the Egyptians expected to face the dangers, as well as the pleasures, of this life in the future world.

Whatever their real significance, these fayence statuettes glowing in blue glaze were a fashion of the Middle Kingdom never revived in later times. Fayence long continued to be one of Egypt's chief crafts, and sculptures of the spectacular beast of the Nile were produced in later periods, but for some reason the most typically Egyptian medium was never again used to render the most famous of Egyptian mammals.

The other hippopotamus in the Collection is one of the finest sculptures of the animal surviving from ancient Egypt, a sculpture which no photograph can ever adequately reproduce. The artist carved the head in a manner basically naturalistic, but so accentuated and distorted certain details that the result is a mixture of naturalism and stylization. The great mushroom form of the jaw is a baroque version of the slightly bulbous form of this detail in the living animal, and it is matched in scale and richness by the deep channels representing stylized folds of flesh which sweep up to the back of the head. The other details of the head are naturalistic with the mouth indicated by a simple incised line.

When the sculpture was complete it must have been at least two feet in length, perhaps considerably longer, and so about the largest hippopotamus sculpture known from an-

14

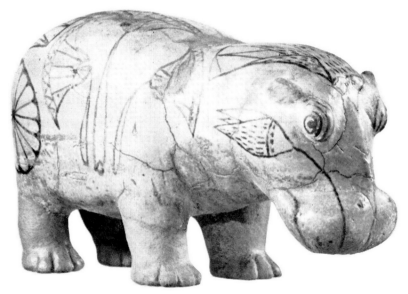

FAYENCE HIPPOPOTAMUS

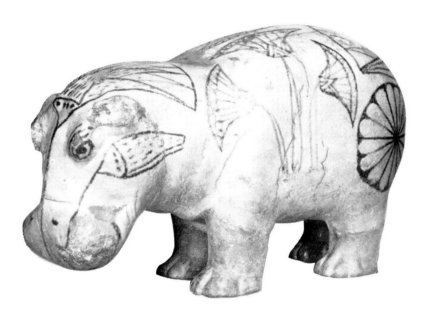

FAYENCE HIPPOPOTAMUS

cient Egypt. That the head is from a complete figure is clear not only from the break but also from the small portion of an incised line preserved at the top of the head. This line is part of a roughly oval area which extended along the back of the beast. It is a rare detail, the significance of which is not entirely clear, but it has been explained as representing the water line of the animal, just as in fayence figures the plant decorations suggest the habitat of this beast.

In an earlier publication of this sculpture I suggested, and then discounted, the possibility that this head was a fragment of a temple statue. I was then unaware that the hippopotamus was worshiped in Egypt, but it is now evident that it was worshiped and had a place in temple ritual, at least from the time of the New Kingdom. The alabaster head is of a scale only consistent with a temple sculpture, making it certain that a sacred animal is represented. The identity of the deity is far from obvious but it is possibly Set. Another alabaster statue of a hippopotamus, headless and smaller than the Guennol example, was discovered at Karnak, but it also is uninscribed and of uncertain date.

While little concrete evidence is available for dating the Guennol hippopotamus it is unlikely that it is much earlier or later than the Twenty-sixth Dynasty. The decorative treatment of the jaws and the stylized modeling certainly suggest Saïte influence, but the absence of comparable sculptures of this date makes a more definite statement impossible. It is certain however, there was a hippopotamus included in the amuletic equipment of Queen Takhout when she was buried at Tell Atrib in the Twenty-sixth Dynasty. This amulet is a miniature version of a known Middle Kingdom type whose informal pose persuaded me to state above that it was doubtful if such representations had a religious significance. Whether the inconsistency is mine or the Egyptians' cannot be decided until we possess a more de-

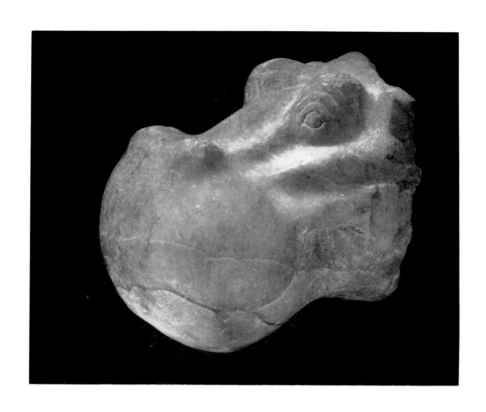

ALABASTER HIPPOPOTAMUS

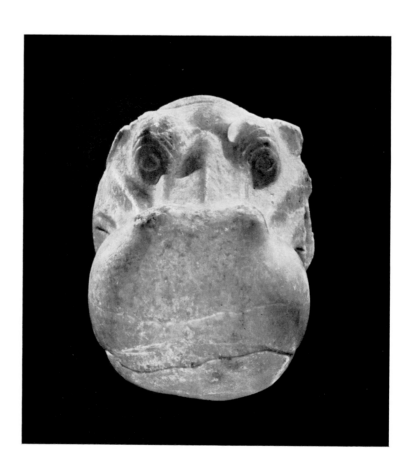

tailed knowledge of the place of the hippopotamus in Egyptian religion. That that knowledge is not already ours, at least for the late period, is due in great part to the change in burial customs at the close of the Eighteenth Dynasty. The following era, seemingly from a mixture of religious and economic reasons, gradually abandoned the ancient practice of equipping the tomb with objects from life. With the advent of this austerity our knowledge of the details of life and art in Egypt declines.

FAYENCE HIPPOPOTAMUS

Height (as restored) 4.3″ Length 6.6″

Middle Kingdom, probably Dynasty XII, *c.* 2000–1785 B. C.

Ex Coll.: Joseph Brummer, New York.

Bibliography: L. Keimer, in *Revue de l'Egypte ancienne*, II, 1929, no. 8, p. 218, figs. 1, 2, pl. xii, has published a detailed study of the decorations found on Egyptian hippopotamus sculptures; C. Aldred, *Middle Kingdom Art in Ancient Egypt: 2300–1590 B. C.*, London, 1950, pl. 55; *The Brooklyn Museum Bulletin*, XII, 1, 1950, p. 8, figs. 3, 4; L. B. Adams, F. Adams, and W. Brown, *Story of Nations*, New York, 1960, ill. p. 29; S. Glubok, *The Art of Ancient Egypt*, New York, 1962, ill. p. 32 and back cover of jacket; J. Hawkes, ed., *The World of the Past*, New York, 1963, I, pl. xvi; *The Illustrated London News*, February 8, 1964, p. 193, ill.; J. Hawkes, *Pharaohs of Egypt*, New York [1965], p. 30, ill.; *The International Art Series*, 21, *Orient, Egypt*, Tokyo, 1965, pl. 95.

Exhibited: Brooklyn Museum since 1948.

ALABASTER HIPPOPOTAMUS

Height (at back) 5.5″ Depth (back to jaw) 6″

Width (at front of jaw) 4.8″

Dynasty XXVI (?), 663–525 B. C.

Provenance: Probably from Thebes.

Ex Coll.: W. Frankland Hood (purchased between 1851 and 1861, probably at Thebes); Frankland Hood Sale, Sotheby, London, November 11, 1924, no. 12; William Randolph Hearst; Joseph Brummer, New York.

Bibliography: *The Brooklyn Museum Bulletin*, XII, 1, 1950, pp. 10 ff., fig. 7.

Exhibited: Fogg Art Museum, Cambridge, Massachusetts, *Ancient Art in American Private Collections*, December 1954–February 1955, no. 19, pl. vii; Brooklyn Museum since 1948.

19

BLUE MARBLE BOWL

IN a period famed for the classical design and perfect work-
manship of its minor objects, the small and beautiful
group of blue marble (anhydrite) vessels is prominent. The
restraint and formality of their decorations, intensified by
the somber color of the stone, typify the spirit of Middle
Kingdom art. Indeed, a comparison of the bowl in the Col-
lection with the ivory grasshopper of the late Eighteenth
Dynasty will reveal in miniature the profound difference be-
tween the arts of the Middle and New Kingdom.

The blue marble bowl is one of a small group of vases,
all of the same material, found at Esna in the tomb of Dedu
during Garstang's excavations of 1906. Its form is conven-
tional, a shallow bowl resting on a low circular foot and hav-
ing an incurving rim. The exterior of the bowl is decorated
by high reliefs of two geese in flight, their wings outspread;
the feet, however, are not indicated as in flight but are
drawn up under the body. Each goose has its head turned
to one side in a manner suggesting, rather than forming, a
handle. The eyes are in the form of circular hollows, but
there is no indication that they were ever inlaid. The fine
workmanship is hardly apparent in the illustrations, for the
circular composition, a rarity in Egyptian design, excludes
a comprehensive view from any one angle. Nor can the
illustrations give more than a suggestion of the beauty of
the translucent stone, a light gray-blue on the exterior but
so finely polished on the interior that a deeper blue is re-
flected. The complete absence of any trace of wear on the
interior of the bowl indicates that it was made only as tomb
equipment.

The use of blue marble was an innovation of the Twelfth
Dynasty when this stone was extensively employed for

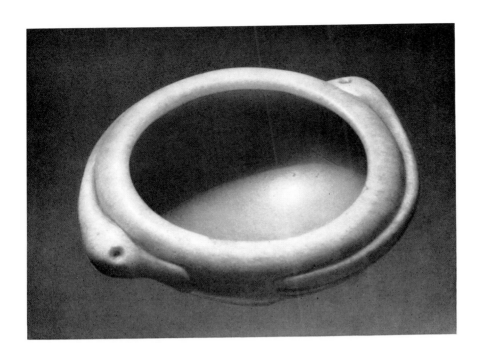

BLUE MARBLE BOWL

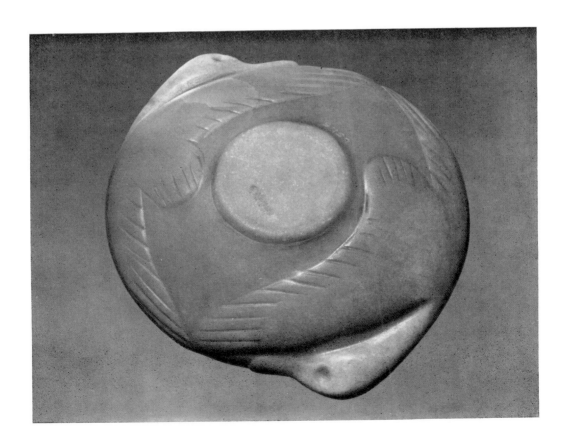

small toilet vases, particularly kohl jars, occasionally for slightly larger vases, and only very rarely for statuettes. The toilet vessels decorated in raised relief, although represented by only a small group of surviving specimens, are the most famous and characteristic work in this material.

The source of blue marble, really anhydrite, is unknown, but it has been assumed from the relatively large number of vessels made of this stone found in and near Abydos that it was probably quarried in that area. The location of the source, in any case, must have been in Upper Egypt, for practically all excavated specimens have been found in cemeteries between Abydos and Esna. Occasionally the stone, or more probably an object fashioned from it, was exported, at least one fine but undecorated vase of blue marble having been found by Reisner at the distant colony of Kerma. Apparently the stone was available to the Egyptians only in relatively small pieces for no large objects made of it are known.

The majority of the decorated blue marble vessels have been assigned to the Twelfth Dynasty or, less specifically, to the Middle Kingdom, and there is little doubt that most of the finest pieces are of this period. However, at least one decorated specimen is known to date from the Seventeenth Dynasty, and doubtless it is not an isolated example. Small, undecorated vessels in this stone, mainly kohl jars, linger on in burials of the early Eighteenth Dynasty, at least into the reign of Tuthmosis III; after that time blue marble disappears from Egyptian art. Probably the supply, an isolated deposit in Upper Egypt, had been worked out. Curiously, the majority of the vessels, both plain and decorated, while suggesting luxury to us, have been found only in relatively modest burials.

Objects in blue marble have no single characteristic in common. While most of the decorated examples are of fine

quality, mediocre examples exist, and many of the small, unornamented vases are of noticeably poor workmanship. Their shapes and decoration, the latter consisting largely of birds, animals, and reptiles, repeat those of other stone and ivory containers of the Middle and New Kingdoms. Blue marble was a fine and rare stone, but it lacked any special properties which would favor the development of an individual style.

The date of the Guennol bowl was set by Garstang between the Twelfth and Thirteenth Dynasties, or in the late Middle Kingdom. There are two very close parallels to this bowl, but their decorations show apes. One of these, in Cairo, from Garstang's excavations at El Arabah, is also of the late Middle Kingdom; the other, excavated by Petrie at Qurneh in 1909 and now in Edinburgh, was found in an undisturbed burial of the Seventeenth Dynasty—apparently the latest known example of its type.

BLUE MARBLE BOWL

Height 1.5″ Diameter (maximum) 4.5″ Diameter (of opening) 2.9″
Dynasty XII–XIII, *c.* 2000–1700 B. C.

PROVENANCE: Tomb 153, Esna.

Ex COLL.: MacGregor, sold at Sotheby, London, July 3, 1922, no. 1017.

BIBLIOGRAPHY: J. Garstang, *El Arabáh*, London, 1901, pp. 7 ff., pl. IX, and W. M. F. Petrie, *Qurneh*, London, 1909, p. 7, pl. XXV, have published two similar bowls; J. Garstang, in *Annales du service des antiquités de l'Egypte*, VIII, 1907, pp. 142 ff., reports on excavation.

EXHIBITED: Burlington Fine Arts Club, London, *Ancient Egyptian Art*, 1922, no. 34, p. 89, pl. XXXIII; Brooklyn Museum since 1951.

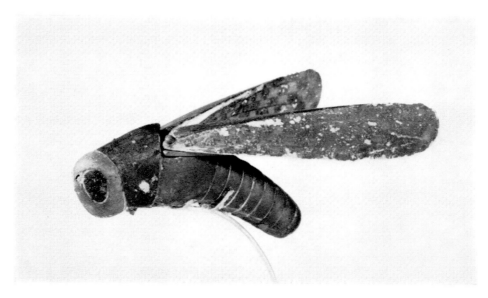

IVORY GRASSHOPPER

IVORY GRASSHOPPER

LATE in the Eighteenth Dynasty, during the reign of Amenhotep III, Egypt developed her civilization to a degree of magnificence and luxury that aroused the envious admiration of her neighbors. The country had known periods of greater internal strength and, long before, had created her profoundest works of art, but never before had wealth been so great or the daily life of the aristocracy so delicately luxurious. It was a period, experienced to some degree by every great nation, when inherited wealth and power allowed the brief but unfettered enjoyment of luxury and art.

This was the age when even toilet objects, such as containers for cosmetics and perfumes, were developed into elaborate and imaginative, if miniature, works of art, surpassing in their complexity and elegance anything previously known. The painted ivory grasshopper in this collection is an example of the skill lavished by royal craftsmen on a mere toilet object. Even in its present state, which is far from complete, the grasshopper consists of five pieces, the body and the two upper wings carved in ivory, the underwings in wood. These flat underwings swing together to form a cover for a small oval cavity which was carved in the locust's body to receive a few drops of perfume or kohl. This insignificant cavity is the sole functional portion of the entire object, all the remainder of the complex unit being a fantasy to delight the eye. But it was on this great unfunctional area that the craftsman applied his skill.

The theoretical use of this wonderful carving as a cosmetic box may be ignored; it is simpler to regard it as an Egyptian sculptor's rendering of a locust in motion, perhaps even in flight. The sculptor, to a surprising degree, has

rendered the insect in a naturalistic style, with all anatomical details carefully indicated even to the insertion of turquoise-blue glass antennae of which only the roots now remain. In the selection of colors (for this object, like almost all Egyptian ivories, was painted) the artist made no attempt to follow nature but painted the head orange-red with black eyes, the section directly behind the head being black and the body red-brown. The checkerboard pattern of the upper wings is a conventionalization of the irregular mottling of a locust's wings. On the underside of the body are six holes to receive the legs; under the black area behind the head are the remains of the wooden peg which originally supported the grasshopper. That this peg required a base is evident, but its appearance can only be conjectured.

The curvature of the insect's body suggests that it is represented at the moment of alighting on a plant which it is about to devour, making it probable that the base was either of floral form or at least bore some floral decorations. Only one other carving of similar form is known, a larger and simpler toilet box of wood in the Cairo Collection.

We have no certain knowledge of the way in which these elaborate toilet objects were used, if ever they were used, or of their possible significance in Egyptian ritual. The majority of the finest specimens now known are undocumented, but those which have histories were, with rare exceptions, found in tombs. Nor do we have a single ancient representation showing them in use. The majority of them are so fragile and so rarely show any evidence of wear that it is fair to assume they were made only for funerary purposes, possibly based on pieces used in life. There is at least a probability that they were made for some religious or magical purpose as yet not apparent to us. Amulets of locust form, though decidedly uncommon, are known in Egyptian art, one having been found in the Tytus excavations at the

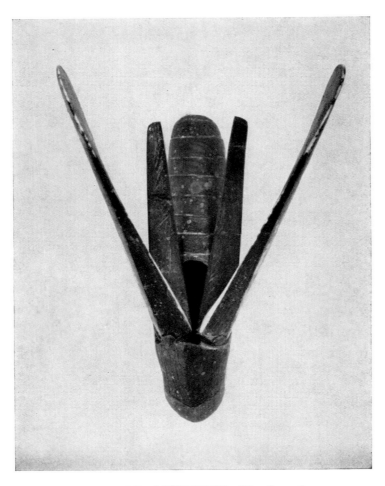

IVORY GRASSHOPPER—*View from above*

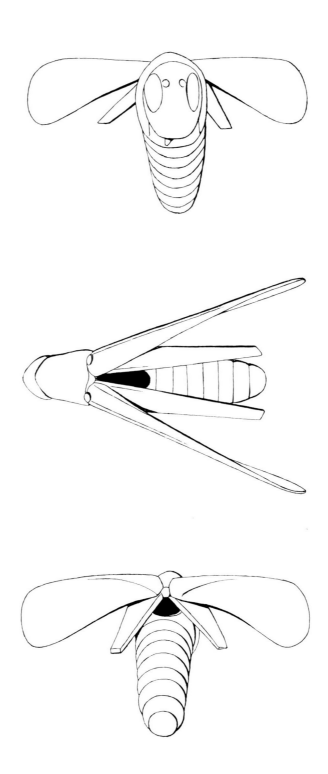

IVORY GRASSHOPPER—*Drawings of three views*

palace of Amenhotep III at Thebes, but their significance is not clear. A royal symbolism for this insect is also implied in the Pyramid Texts, where the king is likened to a grasshopper, but the meaning of the passage is far from clear.

The Guennol grasshopper appears to have been found in Western Thebes in a tomb of the late Eighteenth Dynasty, a period which is close to the end of the vogue for such luxurious creations. A few fine examples, mostly in hippopotamus ivory, can be traced to the reign of Ramesses II of the Nineteenth Dynasty, after which fine and imaginative toilet objects disappear from Egyptian art. It cannot be claimed that any of these objects are great art. Obviously, they lack depth of feeling, but they cannot fail to charm or to arouse admiration for Egyptian craftsmanship and skill in design. It is indeed remarkable that a nation famed for its colossal creations was also unrivaled in the creation of masterpieces in miniature.

IVORY GRASSHOPPER

Length (head to wing tips) 3.6″ Length (head to end of body) 2.6″

Late Dynasty XVIII, *c.* 1350–1340 B. C.

PROVENANCE: Probably from Western Thebes.

EX COLL.: Howard Carter, London; Joseph Brummer, New York.

BIBLIOGRAPHY: L. Keimer, in *Annales du service des antiquités de l'Egypte*, XXXII, 1932, p. 139, pl. VIII, has published a comparable specimen in Cairo, dating it in the late Old Kingdom. In private correspondence Keimer later assigned the example in Cairo to the late Eighteenth Dynasty; *The Brooklyn Museum Bulletin*, X, 1, 1948, pp. 1 ff., figs. 1–4, ill. on cover; C. Aldred, *New Kingdom Art in Ancient Egypt during the Eighteenth Dynasty: 1590 to 1315 B. C.*, London, 1951, no. 97; C. Singer, E. J. Holmyard, and A. R. Hall, eds., *A History of Technology*, Oxford, 1954, I, p. 670, fig. 462; W. Stevenson Smith, *The Art and Architecture of Ancient Egypt*, Baltimore, 1958, p. 214, pl. 153A; L. B. Adams, F. Adams, and W. Brown, *Story of Nations*, New York, 1960, ill. p. 29.

EXHIBITED: Brooklyn Museum since 1948.

PROBLEM PIECES

John D. Cooney

"A Frog of Uncertain Ancestry"
by Andrée Cooney

MAN OR GOD?

AROUND 1952 two almost identical metal statuettes of standing men, about seven inches high, appeared in the Baghdad antiquities trade. The only fact then available concerning them was the unsupported statement that they were from Tello, a site that has yielded many famous bronzes. The statuettes soon passed into other hands and were sent to Paris for removal of the heavy corrosion which completely obscured their modeling.

When the restoration was completed, the sculptures were revealed as works of such fine quality that they quickly found purchasers. One of them entered the Collection, and soon afterward its companion piece was purchased by the Albright-Knox Art Gallery of Buffalo. During the long period since their entrance into these collections the two sculptures have been extensively discussed and studied by numerous scholars, at first with widely varying opinions but within the last few years with an increasing consensus.

There has been general agreement that these pieces are outstanding works of art, probably originating in the Middle East. But at first there was little agreement on their approximate date, these estimates ranging from *c.* 1200 B. C. to the early third millennium.

Various origins were suggested. These ranged from Syria, Anatolia, the Caucasus, to Mesopotamia. Some even argued that they were forgeries. The first publication centered on the Buffalo sculpture in an article by the late Edgar C. Schenck, which gave a clear presentation of the iconographical problems involved in identifying these sculptures. He settled on a date of about 2800–2400 B. C.

An important factor in assigning so early a date was the

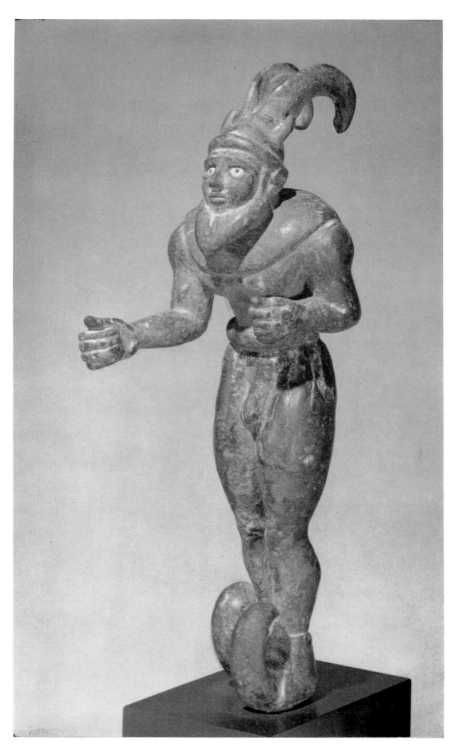

MAN OR GOD?

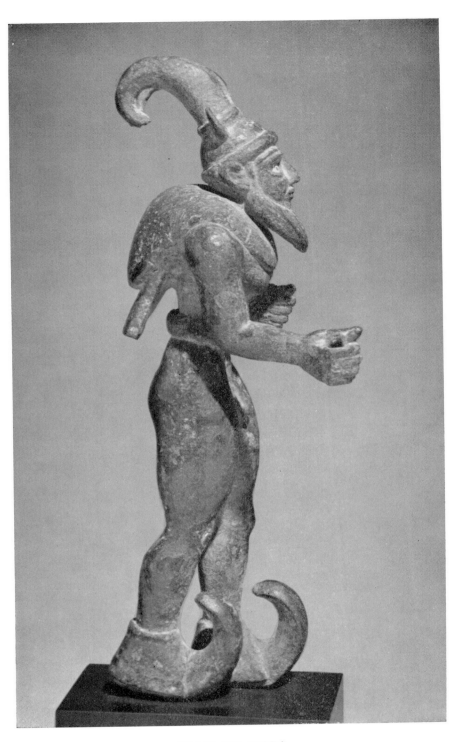

MAN OR GOD?

discovery that the Buffalo sculpture, and presumably there-fore the Guennol example, is of copper, a medium that yielded to bronze at an early date. This is sound but not en-tirely conclusive evidence of early date, since sporadic sur-vivals of copper are found until a quite late date.

An incomplete and undocumented bronze (?) statuette in a Russian collection, showing some points in common with the Guennol statuette, has been studied by John Haskins. The Russian example, believed to be from the Caucasus, is of about the same size as the Guennol piece but is headless and armless. However, both figures wear curious boots with turned-up tips and have similar modeling of the legs, thighs, and hips, details that clearly indicate a common origin. The Russian scholar E. O. Prushevskaya, who published this sculpture, was impressed by its similarity to North Syrian examples and suggested a date of c. 1200 B. C., but even in a translated synopsis of the article her uncertainty is obvious.

The best documented and most convincing analysis of these enigmatic representations appeared in an article by R. D. Barnett of the British Museum, published in 1966. The very title of the article, "A Masked Man or an Ibex Deity?," aptly epitomizes one problem of these sculptures. With a wealth of comparable representations drawn from seals and other objects, Dr. Barnett narrows the subject to a man masked as an ibex for any one of several reasons or to an anthropomorphic deity with an ibex head very much in the Egyptian manner. In the article it is pointed out that a male deity with ibex head and associated with serpents and also with other animals plays an important role at the end of the fourth millennium B. C. at Tepe Giyan in Iran and also at Tepe Gawra in northern Mesopotamia. That this date is probably correct is strengthened by the opinion (delivered orally) of M. Henri Seyrig, who examined the Guennol stat-uette in 1965. He stated that in his opinion it probably dated

from the Djemdet Nsar Period, end of the fourth millennium B. C.

Whether these attributions are decisive is doubtless a matter of opinion, but it is unlikely that they are far from the mark. To the writer the sophistication of these sculptures would suggest a later date, one nearer the date reached in Schenck's publication, and he also believes strongly in a Mesopotamian origin. Meanwhile the Guennol statuette is considerably less enigmatic than it was in 1953.

MAN OR GOD?

Height 6.8"

Middle Eastern (?), *c.* 2800 B. C. (?)

PROVENANCE: Said to be from Tello.

BIBLIOGRAPHY: E. O. Prushevskaya, "Near Eastern Statuettes II," *Isvestiya*, V–VI, 1930, has published a similar Russian sculpture; E. C. Schenck, "Two Near Eastern Figurines," *Gallery Notes*, Albright Art Gallery, XVII, 1, January 1953, pp. 2–13, ill.; *Time*, February 28, 1955, p. 59, ill.; J. F. Haskins, "Shamanistic Figurines from the Caucasus," *Marsyas*, VII, 1957, pp. 40–52, ill.; M. B. Davidson, ed., *Horizon Book of Lost Worlds*, New York, 1962, p. 313; R. D. Barnett, "Homme masqué ou Dieu Ibex?" *Syria*, 3–4, 1966, pp. 259–276.

EXHIBITED: Fogg Art Museum, Cambridge, Massachusetts, *Ancient Art in American Private Collections*, December 1954–February 1955, no. 72, pl. XXII; Jewish Museum, New York, *Thou Shalt Have No Other Gods Before Me*, May–September 1964, no. 7, ill.; Brooklyn Museum since 1951.

BRONZE FINIAL

No historian of ancient art will ever find himself in the position of Alexander the Great who complained at a remarkably early age (or so it is said) that his work was finished. For no historian, indeed no series of historians, will ever completely recover the lost history of art in antiquity. Some cultures flourished so briefly or obscurely that their record is forever lost. Some are represented only by scattered objects, the products of illicit excavations, which are without documentation concerning period or place of origin. Publication of such orphan pieces is rare, since it involves an official admission of ignorance, but if they are ever to be identified they should be recorded: the world of learning is large and somewhere in it there may be a scholar who can trace their parentage.

A problem piece in the Collection is a curious bronze object, just under ten inches in height, which has never been identified or dated with any degree of certainty. Its very function is unknown. It may be described as a finial, but that is a term only slightly less vague than "object," giving the illusion, rather than the substance, of knowledge. Its strange, sickle-like shape has suggested to some the highly conventionalized likeness of a bird; others see in it an animal; still others, an abstract ornament. The style is apparently most unreliable as a guide to dating, for competent scholars have seen in the piece the marks of widely divergent periods, assigning it respectively to early Islamic times, the first millennium and the third millennium B. C.

As for provenance, Northwest Persia and the Caucasus have been advanced as probable places of origin. Both areas are comparatively little known; both have yielded other problem pieces, many of which vaguely suggest a relation-

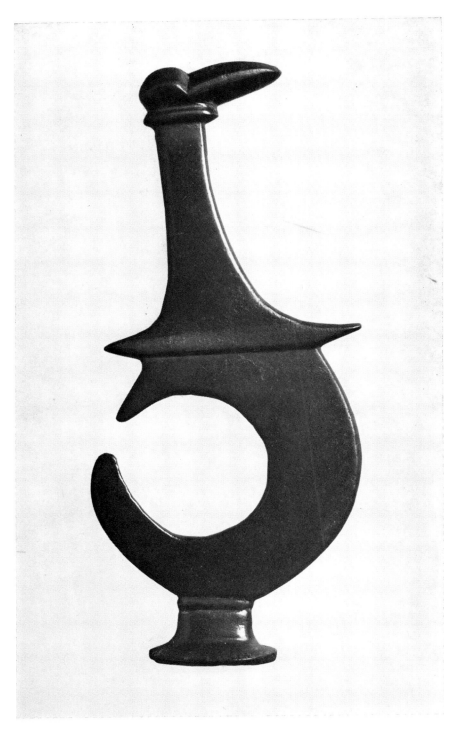

BRONZE FINIAL

ship with the great cultural centers of the Near East. But the art history of the ancient Near East is exceptionally complex, for various cultures that were completely separate, even antagonistic, politically were influenced by each other's art, indeed by the art of vanquished enemies. The constant and long-continued intermingling of cultures is as yet very imperfectly understood for the great centers, and almost nothing is known of its course in the provinces, where the Guennol piece is supposed to have originated. Until excavated parallels appear this curious thing must therefore continue to be many things to many men—a not unsuitable function for a work of art.

BRONZE FINIAL
Height 9.8″
Azerbaijan or Caucasus, V century b. c. (?)

Ex Coll.: Arthur Sambon, Paris; Joseph Brummer, New York.

Exhibited: Iranian Institute, New York, *Persian Art*, 1940, p. 328, Case 45, no. a; Fogg Art Museum, Cambridge, Massachusetts, *Ancient Art in American Private Collections*, December 1954–February 1955, no. 95, pl. xxvii; Metropolitan Museum of Art since 1948.

RHINOCEROS SCULPTURE

No one has ever identified the black basalt rhinoceros in the Collection, though for many years it was assumed to be Egyptian. Little is known of its history. It appeared in the hands of a well-known London picture dealer, but it is uncertain where he obtained it. When the sculpture passed into the collection of Joseph Brummer he also accepted it as Egyptian work of the Roman period. On first glance the black stone and the frontality of the pose do suggest Egyptian work, an origin which I did not question when I first saw this sculpture many years ago. The medium, a close-grained black stone, probably basalt, is found in so many countries that it is of no aid in determining the place of origin. The style of details in the body is equally indecisive, though, on the whole, it does not suggest Egyptian work. But the conclusive argument against an Egyptian attribution is that the Guennol rhinoceros is the Indian species, the *Rhinoceros unicornis*, an animal unknown in Africa and never shown in Egyptian art.

The rhinoceros was infrequently represented by the Egyptians, and the few examples we know always depict one of the African genera, either the white or the black rhinoceros, both of them having two horns and a skin lacking the pronounced folds of the Indian rhinoceros. In prehistoric times the African rhinoceros probably existed in Egypt, but it must have withdrawn southward at an early date, for, unlike the hippopotamus, the rhinoceros did not figure in Egyptian folklore, mythology, or religion, a lack that can be explained only by the absence of this fearsome beast. When the rhinoceros does appear in dynastic art it is only as an exotic animal from the lands to the south, usually as a record of an expedition. One temple relief from Abu

Gurab, two minor representations from Beni Hasan, one or two inlays from Kerma, and another temple relief of the New Kingdom from Armant are the best-known representations of this beast in Egyptian art. Indeed the animal appears so seldom in Egyptian art or inscriptions that the New Kingdom word for rhinoceros was unknown until the recent discovery at Armant of a stele of Tuthmosis III in which this king records his kill of a rhinoceros on an expedition to Nubia.

After its extinction in prehistoric times the rhinoceros was never again seen in Egypt until its importation as a curiosity under the Ptolemies, who anticipated the Roman passion for displays of curious animals. So far as we know, those imported to Alexandria in the Ptolemaic Period were of the African genera, and there is no evidence that the Indian rhinoceros was known in Egypt even at this late date.

While the Indian rhinoceros was certainly unknown in dynastic Egypt and probably unknown in Ptolemaic Egypt, it has been much disputed whether it ever was known in Rome under the Empire, or, if so, at what time it was introduced. For information on this historical fact I am indebted to the late Louis Keimer of Cairo who generously placed at my disposal his vast knowledge of ancient fauna. For many years a relief of an Indian rhinoceros, said to be from Pompeii and now in the Naples Museum, was quoted as certain proof that the Indian rhinoceros was known to the Romans. But this evidence became worthless when it was proved that the Naples representation was copied from the famous engraving of the animal made by Dürer in 1517. A considerable controversy has developed, mainly because Dürer never saw the rhinoceros he so forcefully drew but worked from the sketch of a Portuguese artist. It has been argued that Dürer was influenced by a lost drawing of an Indian

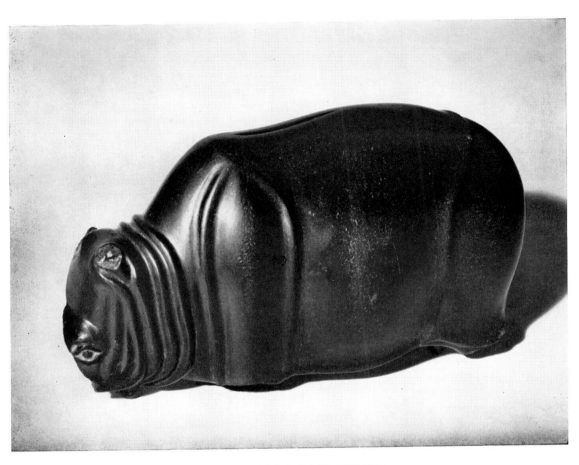

RHINOCEROS SCULPTURE

rhinoceros, presumably of classical origin, which was likewise used by the sculptor of the Naples relief. I can see no trace of classical influence in the Naples rhinoceros, and, in any case, the argument is too tenuous to establish the relief as evidence of the Indian rhinoceros in Rome.

The available literary evidence, though not conclusive, is stronger and suggests that this beast was indeed imported to Rome. While references to rhinoceroses are fairly numerous in Roman literature they are rarely sufficiently detailed to permit certain identification of the species. But the geographer Strabo, in a passage relating to a rhinoceros, seems certainly to be describing the Indian species, for he mentions the single horn and "the two raised ridges like the coils of snakes from the spine to the belly, one at the shoulders, one at the loins," details which are exclusively characteristic of the Indian rhinoceros. Unfortunately, Strabo does not state whether he is describing a beast he saw in Rome or elsewhere in his extensive travels. Possibly it was the same rhinoceros that Suetonius mentions as imported by Augustus and exhibited in 11 B. C. along with a tiger, then a novelty to the Roman people. In any case it is clear that Strabo did see an Indian rhinoceros, and as his travels were entirely within the Roman Empire he must have seen it in that area, a fact of considerable importance in any attempt to identify the Guennol sculpture.[1]

That this sculpture is ancient and of Western rather than Eastern origin seems certain, but the absence of convincing stylistic evidence or of comparable examples, for the sculpture is indeed unique, limits investigation to historical or literary evidence, seldom a completely satisfactory basis. From the accuracy of the representation—a correct, though somewhat stylized, rendering of the Indian rhinoceros—it is clear that the sculptor had a first-hand knowledge of this animal. The evidence points to an origin within the Roman

Empire, probably during the first or second century, but where to locate the sculpture in the Empire is at present an almost insoluble problem. It bears some resemblance to Egyptianizing work produced in Italy during the first two centuries of the Empire, but it is more probably the creation of one of the Eastern provinces. It is even possible that future evidence will justify the original Egyptian attribution.

Until additional sculptures of the Indian rhinoceros are found, the Guennol sculpture must rest on its merits—which are considerable—both as a work of art and as the sole representation of the Indian rhinoceros surviving from antiquity.

RHINOCEROS SCULPTURE

Length 10.3″

Roman (?), I–II century A. D.

Ex Coll.: Bernard d'Hendecourt (?), Paris; Joseph Brummer, sold at Parke-Bernet Galleries, New York, April 20, 1949, no. 33, ill.

Bibliography: G. Jennison, *Animals for Show and Pleasure in Ancient Rome*, Manchester, England, 1937, pp. 54 ff., discusses the introduction of the Indian rhinoceros to Europe; W. F. Gowers, *Antiquity*, XXIV, 94, 1950, pp. 61–71, presents the history of the rhinoceros in classical antiquity, with references to important ancient authors; *Ibid.*, XXV, 99, 1951, p. 155, makes an important correction; B. Pace, *I mosaici di Piazza Armerina*, Rome, 1955, figs. 22, 24; E. L. B. Terrace, *Journal of the American Research Center in Egypt*, V, 1966, p. 61, no. B II 1, pl. XXV, figs. 29–31.

Exhibited: Brooklyn Museum, New York, *Pagan and Christian Egypt from the First to the Tenth Century A. D.*, January–March 1941; Brooklyn Museum since 1951.

NOTE

1. The long controversy on whether the Romans did or did not know the Indian rhinoceros appears to have been settled by a recent discovery at Piazza Armerina in Sicily. There, in one of the many splendid third century mosaics uncovered in the imperial villa, is what seems unmistakably to be a representation of an Indian rhinoceros. The scene is reproduced in *The Illustrated London News*, November 26, 1955, fig. 3, opposite p. 912.

A FROG OF
UNCERTAIN ANCESTRY

ALL too frequently archaeological exploration in the Far East has been a haphazard affair and a deterrent to exact knowledge. The vastness of area, the wide range of time spanned, extensive colonization and trade have added further to the confusion, and it is not unusual that objects of exceptional quality appear without provenance or an indication of date. A unique vessel in the form of a frog, now part of the Collection, is an excellent illustration of such a situation.

This curious and powerful object, which brings to mind a *metate* from Costa Rica or Panama more immediately than anything Far Eastern, was first offered for sale in Bangkok with the legend that it had recently been excavated in the southwest of Siam. There can be little doubt that the piece, fashioned from a hard grey-green limestone, is of Indonesian origin, but from which land is uncertain.

The head of the frog is powerfully and realistically portrayed with careful attention to detail; the legs, terminating in three-clawed feet which rest on individual pedestals, are less naturalistic in treatment but contribute much to the sense of monumentality contained in this small sculpture. The modeling has been achieved by an abrasive technique, attesting to the intractability of the limestone.

The bowl, which has acquired a high polish as the result of use, is too shallow to have been employed as a container, and the object seems too heavy to have been used for pouring. One is drawn to the tentative conclusion that it served as a ritual mortar, probably, judging from the prominence and the anatomical inconsistency of the genitals, for use in a fertility rite.

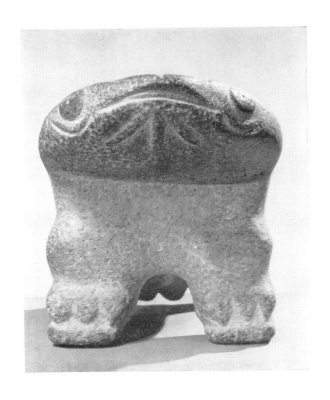

SIAMESE (?) STONE FROG

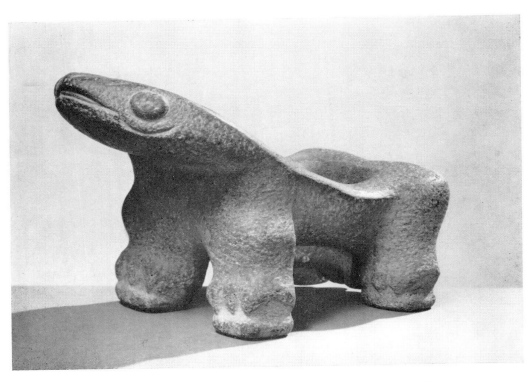

Neither in form nor in feeling does the Guennol frog seem to bear a relation to the Buddhist or Hindu art of Southeast Asia. Whether pre-dating the period of Indian influence or originating in a culture isolated from it is a question which must at present remain unanswered. One may hope that with time the problem of its pedigree will be solved, but meanwhile this vessel is one that stands on its own authority.

A FROG OF UNCERTAIN ANCESTRY

Height 8.4″ Length 14.3″

Siamese (?), First millennium A. D.

PROVENANCE: Said to have been excavated in the southwest of Siam.

EXHIBITED: Brooklyn Museum since 1960.

ANCIENT
NEAR EASTERN OBJECTS

The Ancient Near Eastern Art Section was written by Charles K. Wilkinson, with the exception of the essay "Neolithic Female Idol" by Machteld J. Mellink and the essay "Bahram Gur Silver Plate" by Prudence O. Harper.

ANCIENT NEAR EASTERN ART

I~N~ the Collection there are several objects that come from the ancient Near East, all of which illustrate in varying degrees the skill of Mesopotamian and Persian craftsmen. A comparative study of them will give some indication of resemblances and differences characteristic of the art of various areas in the ancient Near East over many centuries. The period during which they were made ranges from the third millennium B. C. to almost the beginning of the Christian era.

It might be thought when we look at these various antiquities that they would speak fairly for themselves. Unfortunately they do not. We hear them in our language and not in theirs. We cannot be sure what men of their day admired or what they despised, we cannot always know why a thing was fashioned or for what purpose it was used, we cannot even be certain which elements were purely decorative and which practical. Myth, religion, decoration, and use all played their part in what was made then as they do today. But no matter what we know and what we do not know, here in the Collection there are not only archaeological survivals, but some living works of art.

51

NEOLITHIC FEMALE IDOL

CREATED over seven thousand years ago, this reclining figure was probably found in the area of Hacilar, near Burdur in southwest Turkey. An early representative of the village farming communities which were established in the Near East with the diffusion of the techniques of food production, Hacilar has produced in Level VI a remarkable series of clay figurines of types related to this statuette, some of unbaked clay, some finished in red polished terracotta, others in stone. The date of this level, called Late Neolithic by its excavator James Mellaart, has been determined at about 5600 B.C. by the carbon 14 method.

This figurine was made with simple tools, probably without the use of metal. The incisions on the dense-surfaced limestone (?) were made with sharp (obsidian?) blades. The surface—yellowish white with light brown streaks— was polished and covered with red paint, many traces of which are visible in the grooves, and recalls the red polished terracotta figurines. There is slight roughness and incrustation on parts of the surface due to weathering.

It is clear that the stone-and-clay figurines from Hacilar are of religious importance. It is impossible to tell whether one or several individual goddesses were represented in these small works of art. The idols may still belong to an inarticulate stage of religious response to the forces of nature and procreation. They were certainly made to be of magic value to the villagers who kept them around their dwellings. In the continuous tradition of the making of such female figurines from Palaeolithic into the Bronze Age, we can be less sure of the specific religious concepts than of the artistic evolution involved.

This figure belongs to a series of prehistoric female idols

53

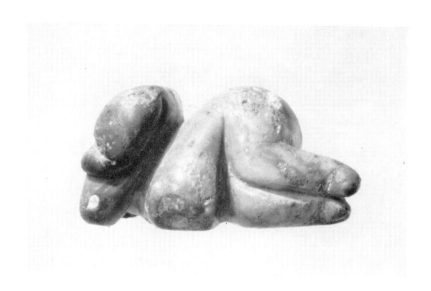

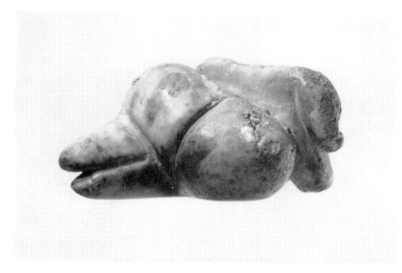

NEOLITHIC FEMALE IDOL—*Three views*

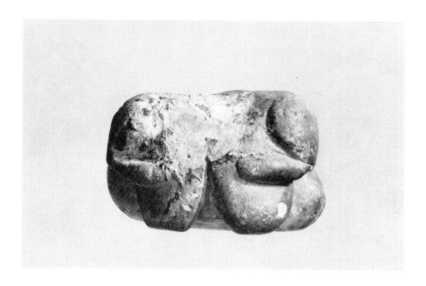

which starts in the Upper Palaeolithic period with the Venus of Willendorf and her counterparts, and ends in the Early Bronze Age with the highly stylized marble idols of the Early Cycladic group. The Hacilar figurine marks a crucial stage of the artistic development from fleshy exuberance to sophisticated abstraction of the female form.

All of such idols represent nude females. Most of them stand up straight, some are seated in a simple squatting pose, a few are reclining. The present statuette is the most articulate example of the rare latter class.

The woman represented has the heavy body forms of her type: pendulous breasts, a protruding stomach, marked steatopygy. The lower legs are rendered summarily, ending in stump feet; the arms have simplified ends for hands. The head is missing, but we know it to have had only general contours of simple proportions.

These typical forms are disciplined and arranged by the artist to create an interplay of stylized line and volume. If this figure should rise up straight she would present herself as a precursor of the formal abstractions of Early Cycladic art; but in this case, the artistic transformation of reality is at its most deliberate in the arrangement of the reclining pose.

The upper part of the body is in a frontal position, well organized in symmetrical curves and grooves. An inverted V-shaped dip marks the center between the breasts. The shoulders are firm bulges, the small lower arms are laid on top of the breasts, the stump hands not touching. The lower parts of the breasts are flattened at the base to make a proper resting surface for the upper part of the body.

At the back, the shoulders are simply smoothed. Grooves mark off the arms. The head was not set in the exact middle between the shoulders, but nearer the left side of the figurine, giving it a slight asymmetry.

At the waist, the body twists from a vertical to a reclining pose. A deep groove around the back and sides of the figure almost slices off the lower part of the body. To rest the steatopygous bulk comfortably on the ground, the lower part is made to recline sideways, giving the spine a torsional curve.

The abdomen rests safely on ground level, its right side flattened for support, its left side firm but rounded, and the navel showing as a small (drilled) pocket just above base level. In spite of its controlled curves, the stomach projects enough to suggest pregnancy.

The buttocks continue the torsional motion of the body. They tilt over forward, allowing about a three-quarter view of the lower back. The legs are drawn up sideways under the left haunch, pushing this up so it projects above shoulder height, its enormous but firm bulk separated from the right buttock by a sharp groove. The right buttock is much smaller, foreshortened and flattened at the base to make a resting surface for the weight of the hips. The pubic area is hidden under the fold where stomach and thighs meet. The legs recline sideways without the slightest trace of torsion remaining. The right leg is flattened below so as to continue the horizontal surface of the base and to leave no doubt about the correct positioning of the figure.

This compact statuette then is not just put together out of a standing upper part and a reclining lower part joined at a 90° angle. Instead, we have a foreshortened rendering of the lower body which freely moves in space, maintaining neither axiality nor symmetry. The groove between the legs is not positioned below the navel, the line separating the buttocks is at an odd angle to that between the legs and never even joins this. The lower part of the body is bulky, and squat in contraction. Its weight must be about four times that of the upper body, which in spite of the pendulous

breasts seems to announce the new Cycladic style.

The present figurine, whether it represents a pregnant fertility goddess of the Hacilar villagers or a general amuletic charm to promote abundance, expresses an attempt on the part of early humanity to influence the forces of nature and the divine. As a work of art, it demonstrates that the neolithic artists had begun to reshape the forms of nature into images controlled by ideas and aesthetic choice.

NEOLITHIC FEMALE IDOL

Length 2.8″

Turkey, Late Neolithic, *c.* 5600 B. C.

PROVENANCE: Probably from the area of Hacilar, Turkey.

EXHIBITED: Metropolitan Museum of Art since 1967.

———

LEONINE FIGURE

ONE of the earliest and most outstanding pieces of ancient Near Eastern sculpture represented in the Collection is a small leonine figure of hard white stone, probably magnesite. This piece has been carved with great skill and has been given a most exquisite polished surface. The pose is dramatic and expresses to our modern eyes a feeling of intense power even though the modeling is soft and the object small. What it expressed to the man who created it and to those for whom it was made we cannot tell, though obviously the lion is no ordinary lion but rather the embodiment of almost sinister power in leonine form. The muscles are indicated in a very subtle way, and, at the back, there are

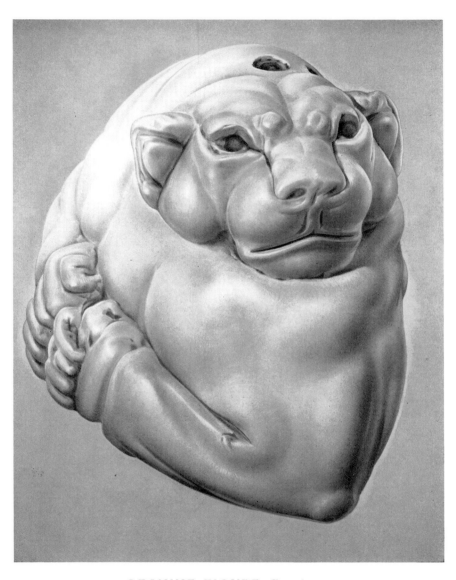

LEONINE FIGURE – *Drawing*

two curls of hair which are those of a human being rather than the mane of a lion. It is not impossible that into the two holes which are to be seen at the top of the head hair was inserted so as to form a mane, an arrangement suggested by Edith Porada in her article on this figure.[1] If this were done, however, the hair would be rather one-sided, for one hole is on the central axis and the other is to one side. It is very probable that the holes were used to suspend the figure as if this is done it balances perfectly. Porada also makes the suggestion that the legs of the creature were finished in silver or some other metal, as was done on a small stone bull that was unearthed at Warka and which is now in the Iraq Museum in Baghdad. It must be observed, however, that only one stump has a small hole in it; the other has merely a minute depression. The four separate holes above the rump were undoubtedly used, as Porada also suggests, for the insertion of some kind of tail of hair, or for several tail-like streamers fashioned like those of the leonine figure in one of the seals from Susa that she illustrates.[2] The eye sockets were once filled with such substances as shell and lapis lazuli.

It will be noticed that for carvings in the round, whether small amulets or larger pieces of sculpture, the Sumerians generally chose a compact form whenever it was possible to do so. They did not care to hazard making long thin extremities in stone. No matter how this leonine figure of the beginning of the third millennium B. C. appeared when complete, it remains a very striking piece of sculpture in spite of its small scale.

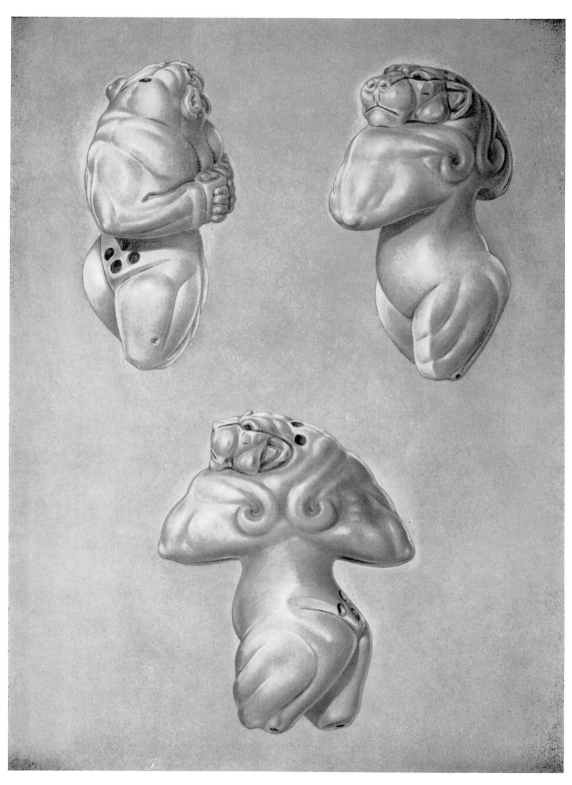

LEONINE FIGURE—*Drawings of three views*

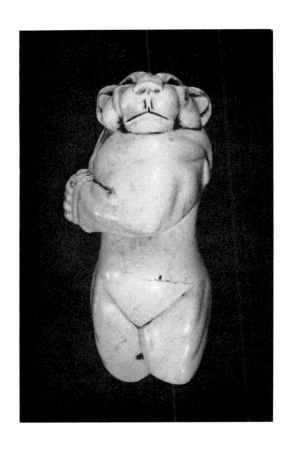

LEONINE FIGURE

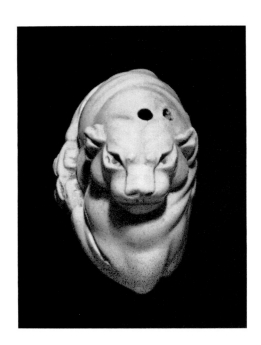

LEONINE FIGURE

Height 3.3″

Sumerian, beginning of the third millennium B. C.

EX COLL.: Joseph Brummer, New York.

BIBLIOGRAPHY: A. Gallatin, *The Pursuit of Happiness*, New York, 1950, p. 140; E. Porada, "A Leonine Figure of the Protoliterate Period in Mesopotamia," *Journal of the American Oriental Society*, LXX, 4, 1950, pp. 223–226; H. Frankfort, *The Art and Architecture of the Ancient Orient*, Baltimore, 1955, p. 13, pls. 9c, 10; G. M. A. Hanfmann, "Ancient Art in American Collections," Notes on Special Exhibitions, *The Art Quarterly*, Spring 1955, p. 63; *The Illustrated London News*, April 9, 1955, p. 652, fig. 1; *Encyclopedia of World Art*, London, 1959, I, p. 860; A. Parrot, *Sumer*, Paris, 1960, pp. 78–79, fig. 97 (photograph reversed); P. Amiet, *La Glyptique mésopotamienne archaique*, Paris, 1961, fig. 579, pl. 37; *Enciclopedia dell' arte antica*, Rome, 1961, IV, p. 1054; S. Lloyd, *The Art of the Ancient Near East*, London, 1961, pp. 40–41, fig. 19; B. L. Goff, *Symbols of Prehistoric Mesopotamia*, New Haven–London, 1963; J. G. MacGowan, *Babylon*, New York, 1964, p. 69, fig. 4A (drawing); M. E. L. Mallowan, *Early Mesopotamia and Iran*, New York [1965], p. 50, fig. 42; E. Porada, *The Art of Ancient Iran*, New York [1965], p. 35, pl. 6 in color; P. Amiet, *Elam*, Auvers-sur-Oise, 1966, pp. 93–94, figs. 60 A, B.

EXHIBITED: Fogg Art Museum, Cambridge, Massachusetts, *Ancient Art in American Private Collections*, December 1954–February 1955, no. 58, pl. XVIII; see also p. 10; Jewish Museum, New York, *Thou Shalt Have No Other Gods before Me*, May–September 1964, no. 90, ill.; Brooklyn Museum since 1948.

NOTES

1. E. Porada, "A Leonine Figure," pp. 223–226, figs. 1–4.

2. *Ibid.*, fig. 6A.

STONE BULL

THIS bull is made of bituminous limestone and is gray-black in color. The body is covered with shallow drilled holes which show very clearly that they were made by tubular drills. These holes were originally filled with some other material, probably shell. The head is without ears or horns, and only the holes in which they were once inserted remain. It is possible that these appendages were of metal, but not necessarily so. The eyeballs were inserted, but only one has survived, one socket remaining empty. At the rear is a small drilled hole for the insertion of a tail, and a groove has been cut so that it would fall nicely over the rump. The scrotum of the animal also was made separately—perhaps of metal, as was that of a small bull found at Warka[1]—and it was fitted into the drilled cavity. Despite all these mutilations and losses there is a definite dignity to the animal and a sensitivity in the modeling of the forms.

In addition to the slots and drillings mentioned above, which are either for superficial decoration or for the insertion of various natural appendages, there are others which must be there for an entirely different function. Three holes, bored at different angles, are so arranged that the animal is pierced from end to end. The figure is not unique in this respect. There is, for example, another stone bull, formerly in the Roselle Collection[2] and now in the collection of Albert Gallatin, which has similar borings except that it has one hole bored directly through the animal from chest to tail and undoubtedly plugged at the chest. Both bulls have a small orifice in the muzzle and a large one by the tail. In the Guennol bull there is a hole three-eighths of an inch in diameter which has been drilled upwards from the muzzle. This meets another which follows the line of the neck and

was made by boring through an opening located in the forehead and closed with a triangular plug. It is one inch in diameter and meets a third hole which tapers somewhat as it goes forward from a maximum width of one and a half inches at the point of entry below the tail. Another tube descends vertically from the top of the back to join one that goes lengthwise through the animal.

There are still other stone bulls which are closely related to that in the Collection, and all have these mysterious tubes. The Gallatin bull is a couchant animal decorated with groups of three shallow holes touching one another, forming trefoils. Another couchant bull, in the Louvre, has trefoil markings on the body which were once filled with inlays, and connecting holes through the body from the rear to the muzzle. This bull, like the Guennol bull, has a hole bored from the top of the back to meet the hole that goes from the muzzle to the tail. In the British Museum there is still another bull which has this system of internal tubes. It came from Senkarah (Larsa) and resembles the one in the Collection in that it is in a standing posture though the legs are now missing. It is plain and is without any inlays or holes for them. It is quite possible that these two standing bulls, both now without legs, once had metal ones like the small bull mentioned above that was found at Warka.

There seems little doubt that these stone animals were made for religious purposes, the trefoils perhaps representing stars and the animal being the Bull of Heaven. In Egypt the cow of Hathor is distinguished by quatrefoils, and this pattern also appears on animal rhytons found in Crete. Sidney Smith has put forward a theory as to how these stone animals were used, suggesting that they perhaps dispensed oil, but there is no clear and completely convincing evidence on the point.[3] It is not impossible that they are a development of the bull-shaped libation vessels such as were dis-

64

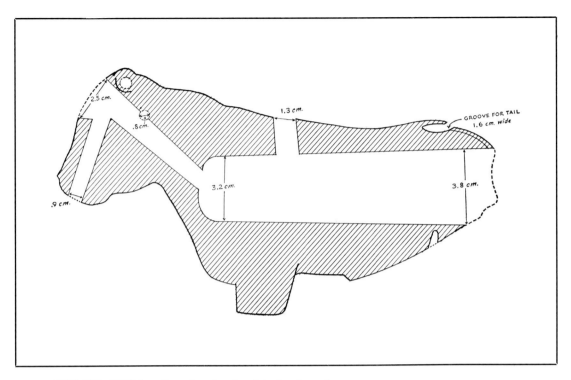

STONE BULL—*Drawing showing interior channels*

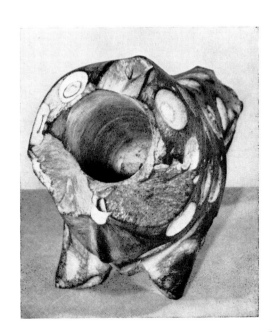

STONE BULL
View of interior

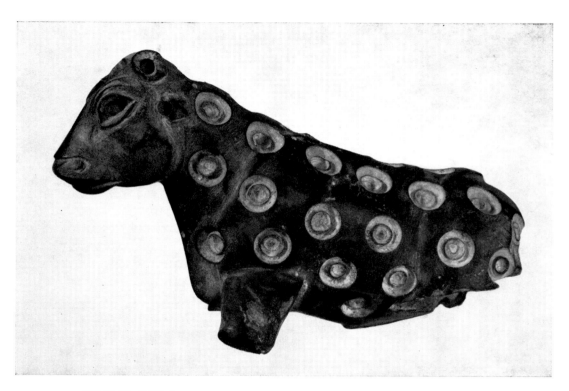

STONE BULL

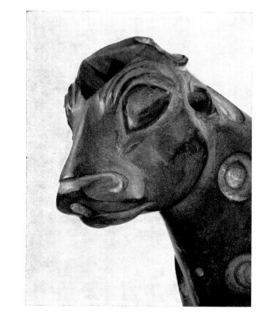

STONE BULL
Detail of head

covered by the Iraq Expedition of the Oriental Institute of Chicago University.⁴ These pottery vessels with large cavities in their bodies, a hole at the mouth, and an inlet in the back, could conceivably have been used for libations, but unfortunately they in no way solve the mystery of the function of the bulls furnished with hollow tubes.

STONE BULL

Length about 9″

Sumerian, probably second half of the third millennium B. C.

PROVENANCE: Said to have been found at Tell Yokha (Umma).

EX COLL.: Joseph Brummer, New York.

BIBLIOGRAPHY: *Die Weltkunst*, February 15, 1955, p. 3.

EXHIBITED: Fogg Art Museum, Cambridge, Massachusetts, *Ancient Art in American Private Collections*, December 1954–February 1955, no. 59, pl. XVII; Brooklyn Museum since 1948.

NOTES

1. Now in the Baghdad Museum. See H. Lenzen, "Die archaischen Schichten von Eanna," in A. Nöldeke et al., *Siebenter vorläufiger bericht über die von der Deutschen forschungsgemeinschaft in Uruk-Warka unternommenen ausgrabungen*, Berlin, 1936, pp. 15 ff., pl. 24b. See also J. Jordan, *The Illustrated London News*, June 7, 1930, p. 1019. The modeling on this is far less sensitive, and the treatment of the eyebrows and veins on the face is quite crude.

2. A. J. Evans, *The Palace of Minos*, London, 1928, II, pt. I, pp. 260 ff., fig. 156.

3. "Tricks of Babylonian Priestcraft: Bulls with Internal Borings," *The Illustrated London News*, November 13, 1926, p. 945.

4. H. Frankfort, *The Illustrated London News*, September 26, 1936, p. 525.

COUCHANT RAM

THE period of the first dynasty of Babylon is represented in the Collection by a bronze couchant ram which has a mask of gold foil. In fashioning this piece the ancient sculptor combined his interest in naturalism with his love of formal pattern; the modeling of the ram's body is quite realistic, whereas the orderly rows of curls—still faintly representing the fleece—are stylized, each coiled to the right. This combination may indeed be considered one of the marks of the best work of Mesopotamia, and it can be seen in other examples in the Collection.

In this specimen the right eye is still intact but the left is missing; only the empty socket remains. It is evident that this bronze is related to other bronze pieces preserved in the Louvre which likewise have faces covered with gold. One of these consists of a group of three ibexes, or wild goats, standing on their hind legs, their backs touching and their horns interlocked. The chief figure of another related piece in the Louvre is a turbaned and bearded man on one knee, with one hand before his face and the other, clenched, in front of his body with his forearm on his thigh.[1] On one of the long sides of the pedestal on which he appears is a kneeling ram in relief, very like the ram in the Collection except that both body and face are in strict profile. On the pedestal's opposite side is a worshiper kneeling in front of a seated divinity clothed in a *kaunakes*. Fortunately part of the inscription still exists, and it has been translated by M. Thureau-Dangin as: "To Amurru, his god, for the life of Hammurabi, king of Babylon, Awîl-Nannar, the son of Sin . . . a statue in prayer . . . , he made it; for his servant he has dedicated it." The inscription is on the base, which has a small basin projecting from the front. This feature is also to

68

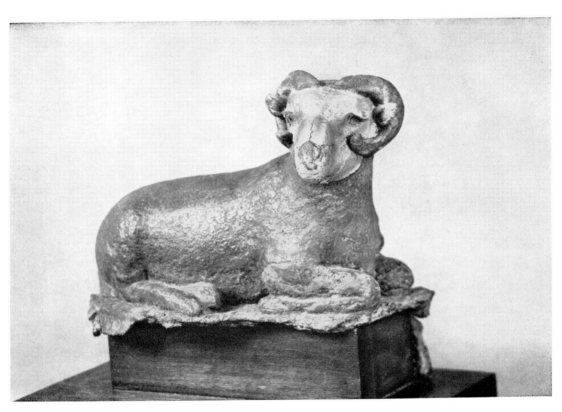

COUCHANT RAM

be seen on the bronze with the three standing ibexes; however, the base beneath them is more elaborate, for it has two genii supporting the basin. It is almost certain that there was such a receptacle in front of the couchant ram in the Collection. That base is more fragmentary and there are now no visible signs of the basin. On the long side of the base at the back of the ram is an inscription of which the little that remains has been read by A. Goetze as:

I	II
[dingir MAR]—TU	lugal Larsam ki ma
[lugal—a] ni—ir	x [] x x x
[- - - - - - - - - -] x	dumu []
[- - - - - - - - - -] x	x []

"To the god Amurru, his king (?) king of Larsa . . . child of . . ."

This bronze reputedly came from Tell Sifr, which is not a great distance from Senkarah (Larsa), whence the two bronzes in the Louvre are alleged to have come.

COUCHANT RAM

Height (pedestal) 1.5″ Height (total) 4.8″ Length 4.8″
Babylonian, first half of the second millennium B. C.

PROVENANCE: Said to have been found at Tell Sifr, near Larsa.

EX COLL.: Joseph Brummer. Sold Parke-Bernet Galleries, New York, April 20, 1949, no. 64, ill.

BIBLIOGRAPHY: R. Dussaud, "Ex-voto au dieu Amourrou pour la vie de Hammourabi," *Monuments Piot*, XXXIII, 1933, pp. 1, 8 note 1; G. Contenau, *Manuel d'archéologie orientale*, Paris, 1947, IV, p. 2126.

EXHIBITED: Brooklyn Museum since 1949.

NOTE

1. Contenau, fig. 1175; Dussaud, pp. 1–10, pls. 1, 2.

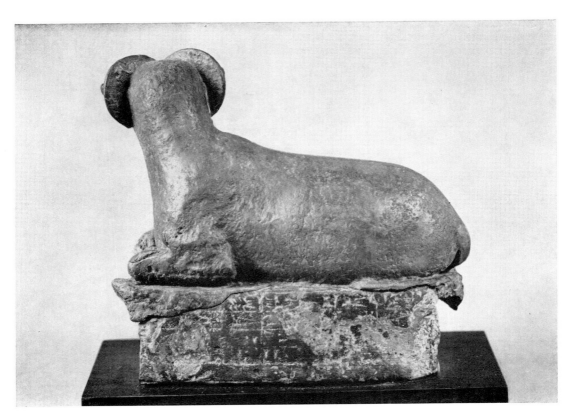

COUCHANT RAM—*Rear view*

GOLD STAG CUP

THIS gold stag cup comes from the province of Gilan in northwest Iran, and is similar to vessels unearthed at the archaeological site of Marlik in the same province.

The Guennol cup is raised from a single piece of gold and has a flat base. As the vessel approaches the top it tapers and finishes with a narrow flat projecting rim. The decoration is repoussé with the outlines and the details chased. On the wall of the cup four stags, represented in profile, form a procession which moves to the right. The hair on the animals' bodies is depicted by a series of scale-like shapes, each containing a few chased lines; but the face, the shoulder, and the legs of the animals are left bare except for semicircular lines at the joints and at the top of the shoulder. The front of the lower neck and chest is marked by a series of bristle-like strokes. The antlers are drawn as though seen from the front and not in profile, and they are furnished with numerous points. Although not easily seen in the illustration, the antlers are covered with short slanting lines. The deer have, in proportion to their bodies, very small heads and exceedingly thin long legs so that they seem to move with both lightness and grace. Beneath them, at the bottom and again above them just below the projecting rim, are two superimposed rows of small connected semicircles. In ancient Near Eastern art this is the usual convention for representing mountains, but, in this instance, it is doubtful whether this interpretation is correct in view of the fact that they are above as well as below the animals. Furthermore, such forms appear on a gold vessel definitely found at Marlik and there they are further embellished with a sort of miniature tree design within them. It is therefore distinctly probable that in the Guennol gold cup the double rows are provided

72

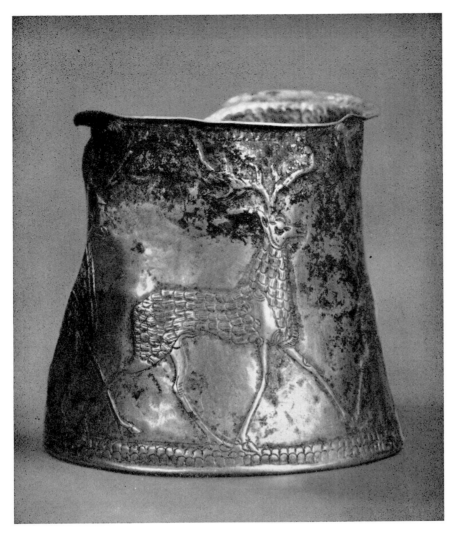

GOLD STAG CUP

View of base

as decorative border patterns; it is also possible that the craftsman had hills and mountains in mind, they being the natural habitat for these animals in Iran. The base of the cup is adorned with a rosette of sixteen petals of which the rounded ends are doubly outlined. The whole rosette is enclosed within a circle.

As mentioned, the Guennol gold cup has several points of resemblance with vessels excavated by E. O. Negahban at Marlik, in the province of Gilan, in northwest Iran.[1] One of these in particular, of silver, is very similar in both general shape and subject matter. Although it is a little larger, it too is decorated with deer, but they are more crudely drawn than those on the Guennol cup and have shorter legs and larger heads.[2] The borders are exactly the same. The hair is treated in the same peculiar scale-like way, but in the silver cup they are without the supplementary lines either on the body or on the antlers. Although the curious semicircular marks at the shoulders are not present on the Marlik silver cup, they do appear on another gold vessel from the same site, also discovered by Negahban, which is decorated with couchant animals instead of standing ones.[3] There can be no question but that the Guennol cup is a product of the same culture as those that were excavated at Marlik and it may well have come from the immediate vicinity. The date of these pieces has not yet been precisely determined, but the Guennol cup can be attributed to the end of the second millennium or the beginning of the first.

GOLD STAG CUP

Height 2.7″ Diameter (of base) 2.8″
Southwest Caspian, Iran, late second millennium B. C.

PROVENANCE: Gilan, Iran.

BIBLIOGRAPHY: C. K. Wilkinson, "Art of the Marlik Culture," *The Metropolitan Museum of Art Bulletin*, XXIV, November 1965, pp. 106–107, figs. 7, 8.

EXHIBITED: Metropolitan Museum of Art since 1965.

NOTES

1. E. O. Negahban, *A Preliminary Report on Marlik*, Teheran, 1964.
2. *Ibid.*, fig. 103.
3. *Ibid.*, fig. 112.

———

TWO IVORY PLAQUES

Two pieces of exquisitely carved ivory of the eighth century B. C. are to be seen in the Collection. They come from the extraordinary find that was made in 1947 at Ziwiyeh, near Saqqiz, Kurdistan, in northwest Persia. A number of other and similar ivories were found with them, but none is in finer condition than these two pieces.

The treasure consisted of objects of gold, silver, and ivory, contained in a large bronze receptacle, perhaps a coffin, that had a rim engraved with a procession of human figures. They represent Assyrian soldiers and officials and a number of tribute bearers who are being led to the chief figure, a man appearing to be not the Assyrian king himself but a prince or an official of the highest rank. The style of these figures is entirely Assyrian, as is that of the first of the two ivories of the Collection. This ivory is either part of a cylindrical box or the casing of a slender column of furniture.

75

It is in a remarkably good state of preservation. Carved upon it in low relief is a winged genie of a type that is very widely known, for many similar figures are to be seen on the Assyrian sculptures from Nimrud that were found by Austen H. Layard and his successors. In one hand the genie holds a fir cone of which only the base is visible. In the other, he holds the handle of a bucket or bag. Both are cult objects, and two models of such receptacles made in stone may be seen; one is in the British Museum, and the other is in the Archaeological Museum in Teheran.[1]

The beneficent genie wears a helmet surmounted by a "fleur-de-lis," while near the brim bull's horns project to indicate he is superhuman. The figure looks at first sight as though he has two wings; to a certain extent this is correct, but it has to be remembered that the Assyrian wing is composed of two members, one going upwards and the other sweeping down. In this ivory the representation is therefore in strict profile, and if seen from the front[2] there would be exactly the same double wing on either side of the body. A close examination will show an elaborate tassel hanging over the shoulder, perhaps serving as a counterweight to a gorget that is not indicated.

From another ivory piece of the same height, which is illustrated by André Godard in *Le Trésor de Ziwiyè*, we can complete the scene. The genie stood in front of a "tree of life," composed of a "trunk" treated in the most conventional way and surmounted by a palmette contained within a group of five other palmettes linked together by curved forms. From the trunk extend horizontal bands, each with a knot in the center and each ending in a bud. On the other side, facing the tree, was another genie which was similar to the one in the Collection. Other fragments show that another subject on curved ivories of this size consisted of a similar tree of life between two goats standing on their

76

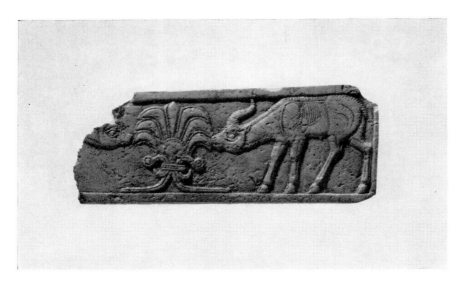

IVORY ANTELOPE PLAQUE

IVORY GENIE PLAQUE

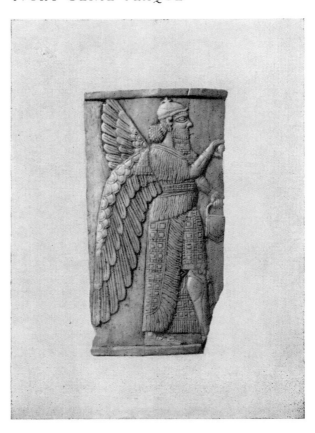

77

hind legs and nibbling at the upper palmette. Yet another fragment[3] indicates that the winged genii were not always drawn in the same way: one of them, for instance, has a wing that comes to a point at the level of the shoulder blade instead of being nicely rounded as in the Guennol ivory; in addition, the cap of the genie is divided by radial seams. There are thus indications that within the very strict limits of religious art there was room for individual touches and differences.

The second Guennol ivory is part of a band that was probably the inlay of a box or some other object made of wood. Many strips of ivory inlay were in the Ziwiyeh treasure, and, though animals appear to figure in all of them, they do not all have the same motif as this one. Here two antelopes nibble the end "petals" of a conventional palmette. Sometimes they are shown kneeling before a palm tree, one on each side. In another strip, now in the Metropolitan Museum, there is no conventional vegetation and, among the animals, one doe suckles a fawn. This strip seems to have been made by the very same hand as that which carved the piece in the Collection. The Guennol ivory strip, like a number of other works of art from the ancient Near East, successfully combines realism and convention; despite the formality of the palmette, the strict balancing of the composition, and the unrealistic way of indicating the hair, the animals are portrayed in a most sensitive and exquisite manner.

WINGED GENIE PLAQUE

Height 2.4″ Width (maximum) 1.3″ Thickness (maximum) .2″

Assyrian, VIII century B. C.

PROVENANCE: Ziwiyeh, Kurdistan, in northwest Persia.

BIBLIOGRAPHY: R. Ghirshman, *Artibus Asiae*, XIII, 3, 1950, pp. 181–206; A. Godard, *Le Trésor de Ziwiyè*, Haarlem, 1950, has published similar pieces; C. K. Wilkinson, "Some New Contacts with Nimrud and Assyria," *The Metropolitan Museum of Art Bulletin*, X, April 1952, pp. 233 ff.; *idem*, "The First Millennium B. C.," *The Metropolitan Museum of Art Bulletin*, XVIII, April 1960, p. 264.

EXHIBITED: Metropolitan Museum of Art, New York, *Ancient Art from New York Private Collections*, December 1959–February 1960, no. 31, pls. 9, 102; Jewish Museum, New York, *Thou Shalt Have No Other Gods before Me*, May–September 1964, no. 99; Metropolitan Museum of Art since 1952.

ANTELOPE PLAQUE

Height 1.1″ Length 2.6″ Thickness .1″

Phoenician, VIII century B. C.

PROVENANCE: See above.

BIBLIOGRAPHY: See above.

EXHIBITED: Metropolitan Museum of Art, New York, *Ancient Art from New York Private Collections*, December 1959–February 1960, no. 32, pls. 9, 102; Metropolitan Museum of Art since 1952.

NOTES

1. A. Godard, *Athar-é Iran*, III, 1938, figs. 210, 211.

2. Two examples of the front view are: an incised drawing on an ivory panel from Nimrud (M. E. L. Mallowan, *The Illustrated London News*, August 22, 1953, p. 297, fig. 6), and another drawing on a stone slab where a winged female appears on the garment of Ashur-nasir-pal II (883–859 B. C.) (O. E. Ravn, in *Archiv für Orientforschung*, XVI, 2, 1953, p. 240, figs. 25, 26).

3. Godard, *Le Trésor de Ziwiyè*, fig. 76.

GOLD BRACELET

IMPRESSIVE gold ornaments earlier than the Achaemenian period of Iran (VI–IV centuries B. C.) were conspicuously lacking until the past decade when several finds changed this situation. The most important of them took place in 1947, when, as has been mentioned already, a great treasure of ivory, silver, and gold was discovered at Ziwiyeh in Persian Kurdistan. Among the finest of the objects that were unearthed there was a pair of gold bracelets, of which one is now in the Archaeological Museum in Teheran[1] and the other is part of the Collection. They not only are superb examples of the goldsmiths' craft but are most interesting from an archaeological point of view.

The bracelet is of thick hollow gold and has a central ornament which consists of two lions above and two below the angular encircling band. At the back of this ornament is a plain smooth surface for comfort when worn. The bracelet terminates in lions' heads, one of which is removable for ease in fastening and safety in wearing. The loose head was originally made secure by a pin which passed through two holes in the neck corresponding with those on either side of the bracelet itself. The front of the hoop is remarkable for the variety of plane surfaces and the sharpness of the dividing edges. The central ridge is far more prominent than the others. The sharply angular motif is consistently carried out in other parts of the design: in the triangular projections above each pair of couchant lions, and again in the heads of these lions, for each has, so to speak, a gabled skull. This peculiar form of angular head is not unknown outside of Persia. It is not an Assyrian fashion but is to be seen on the remarkable lions' heads from a bronze throne unearthed at Toprak Kaleh near Lake Van in Armenia,[2] the

80

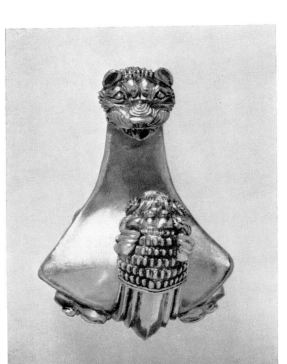

GOLD BRACELET

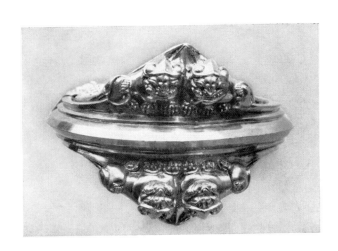

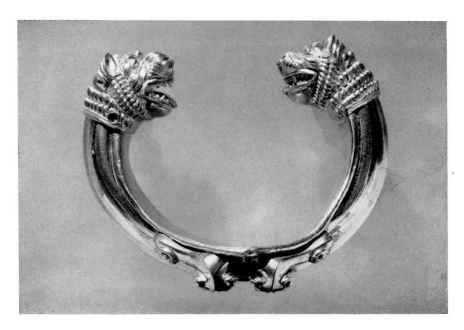

GOLD BRACELET

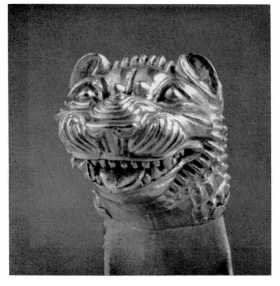

GOLD BRACELET
*Detail showing
terminal lion's head*

land called Urartu by the Assyrians. In neo-Hittite art the fringe of hair above lions' heads is sometimes brought up to a point in the center, as can be seen in sculptures from Sakje-gözü and Zinjirli[3] and on an ivory lion's head from Nimrud, which is probably an imported piece,[4] but in the couchant lions of the bracelet there is a difference from these and from the Urartean examples mentioned above. The fringe is developed into two sweeping curves that suggest horns curled up at the ends, which do duty for ears. The nearest example to this is to be seen in a gold plaque, also from Ziwiyeh, that once covered a box or some such object. There are pieces of this plaque in the Teheran Museum, the Metropolitan Museum, and elsewhere.[5] On it the lions' heads are repoussé, but there is the same gable form. In this plaque the connections with Scythian art are clear and unmistakable. Another thing to be noted is the surprising difference between the couchant lions' heads and those that terminate the hoop of the bracelet, which are far more natural and fierce,[6] a pleasing variation of the same subject on the same work of art. Different though they are, they have in common radiating furrows on the forehead. This appears to be a fashion prevalent only at the end of the Assyrian period. It is on the "Scythian"-looking plaque from Ziwiyeh; it occurs, too, in Mesopotamia and in a late Babylonian demon with a lion's head.[7]

It can be said of this bracelet that it shows connections with the arts of several lands and peoples, but in all probability it is an example of Mannean gold work of the seventh century B. C. During the eighth and seventh centuries the land of the Minni, as the country is called in the Bible, was alternately under the influence and domination of Assyria and Urartu, and both the Scythians and the Medes were important powers, the Medes finally becoming supreme. When the Persian Achaemenians in turn became

supreme they made use of the Medean skill in gold working. This we know as a fact, for, interestingly enough, they gave credit to the Medes in their inscriptions. One example, given by Herzfeld, states: "The goldsmiths who worked gold are Medes and Egyptians."[8] These magnificent bracelets are clear and visible evidence of what a fine tradition in the goldsmiths' art the Achaemenians inherited.

GOLD BRACELET

Height 2.6″ Diameter (maximum) 3.8″

Mannean, VII century b. c.

PROVENANCE: Ziwiyeh, Kurdistan, in northwest Persia.

BIBLIOGRAPHY: R. Ghirshman, *Artibus Asiae*, XIII, 3, 1950, p. 181, in mentioning the bracelet writes: "La pièce est une merveille d'art des ciseleurs assyriens"; *The Illustrated London News*, April 16, 1955, p. 699; C. K. Wilkinson, *The Metropolitan Museum of Art Bulletin*, XIII, March 1955, pp. 218–219; P. Amandry "Orfèvrerie achéménide," *Antike Kunst*, I, 1, 1958, ills. 37, 38.

EXHIBITED: Metropolitan Museum of Art, New York, *Ancient Art from New York Private Collections*, December 1959–February 1960, no. 40, pls. 13, 102; Metropolitan Museum of Art since 1954.

NOTES

1. A. Godard, *Le Trésor de Ziwiyè*, Haarlem, 1950, pp. 50–52, figs. 40–42.

2. R. D. Barnett, "The Excavations of the British Museum at Toprak Kale near Van," *Iraq*, XII, 1, 1950, pls. XI, XIX.

3. H. T. Bossert, *Altanatolien*, Berlin, 1942, pls. 225, 230.

4. M. E. L. Mallowan, *The Illustrated London News*, August 22, 1953, p. 296, fig. 2.

5. Godard, fig. 48; Wilkinson, p. 219, ill.

6. They resemble nothing to be seen in Scythian art, but are very similar to six lions' heads that form the repoussé ornament of a gold bracelet which was discovered many years ago in Persia and is now in the Louvre. See A. Parrot, *Syria*, XXX, 1, 1953, pl. 36.

7. *British Museum: A Guide to the Babylonian and Assyrian Antiquities*, 3rd ed., rev., comp. E. A. Wallis Budge, London, 1922, p. 194.

8. E. Herzfeld, "Die Magna Charta von Susa. Part 1," *Archaeologische Mitteilungen aus Iran*, III, 2, 1931, p. 39.

BRONZE LION

O F a somewhat indeterminate date is this bronze lion, which is reputed to have come from Persia. It appeared on the market with two other pieces, a bull now in the Kevorkian Collection and a winged female sphinx. None of the legs of the lion is now complete, and a portion of the left rump has been restored. The tail is broken off near the base, and almost all of the inlay from the eyes has disappeared. The tongue protrudes from the mouth, which is partly open showing the array of upper front teeth but only two of the lower ones, as often occurs in the stone lions of South Anatolia. The nose is wrinkled in the snarl so common to lions in ancient Near Eastern art, but the manner of the wrinkling is unique, for the furrows in the center of the forehead form a very strongly marked U which is opposed by two other vertical ridges coming down from the top of the center of the forehead. Another peculiarity is the heavy brow extending to the bottom of the ears. There are no "warts of strength," the two circular lumps usual in Assyrian and especially Achaemenian lions' heads. The cheeks of the animal are smooth and not wrinkled.

Of these peculiarities one of the most significant is the curious brooding appearance given by the continuation of the brow to the lower part of the ear. This is foreign to the neo-Hittite lions and to those from Iraq, both from Assyria and the southern part of the land. There is one parallel to this and that is in the bronzes from Toprak Kaleh near Lake Van[1]—the product of Urartu, a kingdom that flourished particularly from the ninth to the seventh century B. C. It was a rival of Assyria and suffered some major reverses in the wars between the two countries. The quality of the Urarteans' workmanship in metal was extremely good, and

85

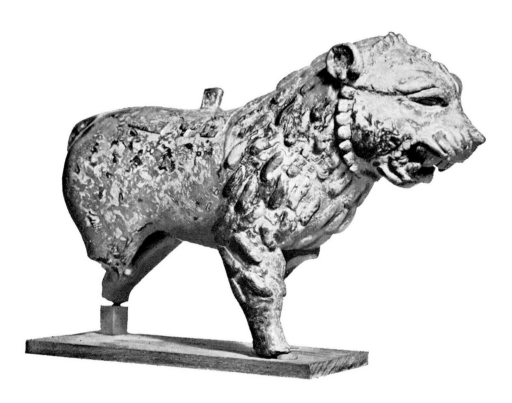

BRONZE LION

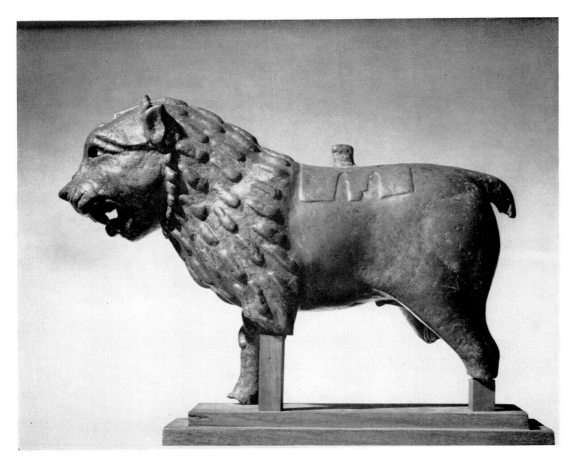

BRONZE LION

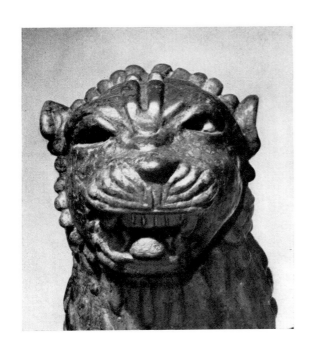

BRONZE LION
Detail of head

87

they were famous for it in antiquity. A number of their metal objects have been preserved, the greatest part in the British Museum. The lions' heads are very stylized, appearing far more precise, almost mechanically so, than that of the Guennol lion which, in spite of its fierce head, shows a provincial style. The Urarteans conquered the land of the Minni in the northwest of Persia and were evicted from time to time by the Assyrians. It seems not improbable that this bronze lion in the Collection was made in Persia during a period of invasion, for although the treatment of the hair does not conform to the especially fine and detailed work on the Urartean throne in the British Museum, one can look to no other source of influence which would have imposed this marked characteristic on the head.

On the back of the lion is a projecting lug that emerges from a curiously shaped "saddlecloth." It is not certain just what was affixed to this lug. If it were the figure of a divinity (which is by no means impossible) the divinity would probably have been a goddess corresponding to Ishtar. The custom of putting divinities on the backs of animals, however, is not a Persian one, though it was greatly practiced in Assyria and more particularly in Syria and Anatolia. Also, and the point is perhaps significant, in Urartu bulls and lions were among the animals chosen to perform this function. The links with Persia are very slight, and it is possible that the key to this interesting lion may be found in South Arabia.

BRONZE LION

Height 7.3″ Length 10.5″

Near Eastern, *c.* V century B. C.

Exhibited: Brooklyn Museum since 1950.

Note

1. R. D. Barnett, "The Excavations of the British Museum at Toprak Kale near Van," *Iraq*, XII, 1, 1950, pl. xi, fig. 2.

GOLD NECKLET

A GOLD Achaemenian piece in the Collection is part of a necklet, of which one end is cast in the form of an ibex or wild goat. This animal was a favorite with the Iranians, and some of the finest specimens of their work are based on it. In the British Museum there are several examples which came from the Oxus Treasure, that famous find of 1877. The Guennol necklet itself is ringed, but beyond this is undecorated. The animal, however, is furnished with holes for inlays, some of which are still extant though now in rather poor condition. One of them is greenish and may be feldspar, and the others are brownish. On each side there are two circular holes for inlay, one by the foreleg and another by the hind leg, that on the latter being partly encircled by inlay in the shape of a kidney. On the back of the animal are seven slots and one triangular cavity. The forehead of the animal was adorned with a triangular inlay, but it is now missing. This mark on the forehead was greatly favored in the Near East from very early times. It appears, for instance, on the stone bull in the Collection made almost two millennia earlier than this necklet. On the flanks of the wild goat is the decorative mark shaped like an ostrich feather that is so common on representations of animals in the Achaemenian period. This sometimes seems to be an area of curly hair, as on the friezes of lions at Babylon, but on the Guennol necklet it is more than possible that the idea of a wing was in the mind of the designer. Such an intention gains credibility when one thinks of the silver winged ibexes in the Louvre and the Hermitage. The wild goat on this necklet is shown in a flying leap, with its front legs tucked in and its hind legs extended backwards in a straight line—a pose that indicates the liveliness of the ani-

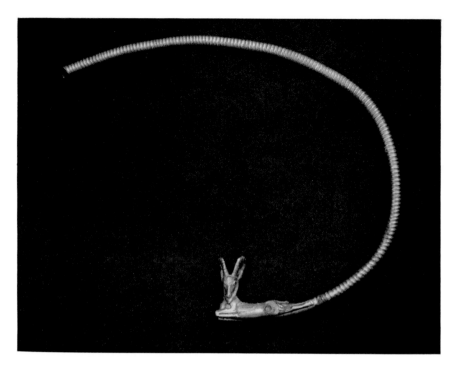

GOLD NECKLET

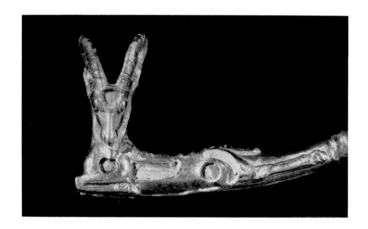

GOLD NECKLET—*Details showing terminal ibex*

90

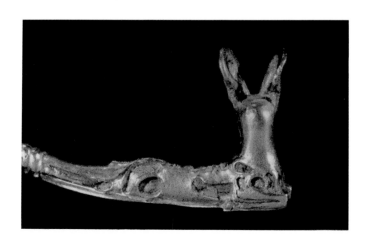

mal without interfering with the function for which this object was made. The pose was quite common during the Achaemenian period and was used for other animals as well. It is to be seen, for example, on the fayence handles of fly whisks found in Egypt. There are two of these in the Metropolitan Museum: one of a horse and one of a bull. The fact that this pose was used for a variety of animals shows that it was a matter of style rather than of actual observation of the habits of the animals.

In the British Museum is another wild goat of gold that formed one end of a necklet, but it does not seem to be the other end of that in the Collection.[1] There is a difference in the position of the slots on the back and a slightly different treatment of the horns. A statue, unfortunately headless, has been preserved which shows a necklet somewhat similar to that in the Collection; it is worn by an official named Ptah-hotep of the period of the Achaemenians. The statue, which is in the Brooklyn Museum, is of dark gray schist and comes from Egypt, one of the lands that fell under the sway of the Persians.[2] The necklet in this example ends in the heads of ibexes, and these are turned so that each animal looks backwards at its own tail instead of sideways as in the beautiful Guennol gold necklet.

GOLD NECKLET

Height (of ibex) 1.2″ Height (total) 5.4″

Achaemenian, late VI–V century B. C.

Ex Coll.: Joseph Brummer, New York.

Bibliography: A. U. Pope, *Masterpieces of Persian Art*, New York, 1945, p. 46, pl. 30c; P. Amandry, "Orfèvrerie achéménide," *Antike Kunst*, I, 1, 1958, p. 13; W. E. Caldwell and M. F. Gyles, *The Ancient World*, 3rd ed., New York, 1966, p. 168, ill.

Exhibited: Iranian Institute, New York, *Persian Art*, April–May 1940, p. 319, Case 31, no. H; Cleveland Museum of Art, *Exhibition of Gold*, October 1947–January 1948; Fogg Art Museum, Cambridge, Massachusetts, *Ancient*

Art in American Private Collections, December 1954–February 1955, no. 119; Brooklyn Museum since 1948.

NOTES

1. O. M. Dalton, *The Treasure of the Oxus*, 2nd ed., London, 1926, pl. xx, no. 136; A. U. Pope and P. Ackerman, eds., *A Survey of Persian Art*, London–New York, 1938, IV, pl. 122F.

2. J. D. Cooney, "Portrait of an Egyptian Collaborator," *The Brooklyn Museum Bulletin*, XV, 2, 1953, pp. 1–16.

FRAGMENT OF A LION'S HEAD

CROWNING the columns of Achaemenian palaces in Persia were impost blocks to carry the great timbers of the roof.[1] The ends of these blocks were fashioned as the protomas, or foreparts, of bulls, lions, and, judging from an unfinished one, griffins also.[2] The piece of a lion's head in the Collection is part of such a block that came from Persepolis, where Darius and Xerxes had their palaces. The stone, a form of limestone, was locally quarried and, when polished, achieved a glossy black surface. The illustration gives an idea of the extraordinarily silky texture that can be obtained on this bituminous limestone.

Persepolis is some thirty-five miles to the northeast of Shiraz in the province of Fars (the modern equivalent of Pars—whence Persia). Here Darius founded his palace, probably about 520 B.C., and work was continued by Xerxes and Artaxerxes, who are known to most people through Greek rather than Persian history. Some of the building still remains despite the destruction by fire that followed the conquest by Alexander the Great in 330 B.C. Although the brick walls have almost entirely disappeared, one can see a number of the stone frames of the openings in them,

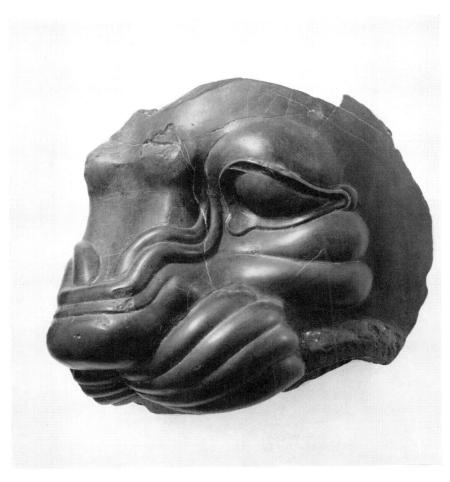

FRAGMENT OF A LION'S HEAD

some staircases, and a few of the lofty stone columns, none of which has all its topmost decoration intact. Some of the protomas were found buried in the dirt on the ground, and several of them are now in various museums and collections.

The Guennol fragment of a lion's head indicates very clearly a few of the peculiarities that Achaemenian sculpture inherited from earlier ages, for example the eyelids cut as wide sloping bevels. There are also features peculiar to sculpture of the Achaemenian era as opposed to those that had been prevalent in the ancient Near East before that time. The wrinkles caused by the lion snarling have become conventional decoration and are less related to nature than are those in some of the older sculpture. Both the whiskers and the folds of the skin on the cheek have been treated in precisely the same way—as soft widening swellings with rounded ends. The distinction between one substance and another, between bristle and flesh, has therefore to be made by the person who looks at the head: it has not been made evident by the sculptor.

FRAGMENT OF A LION'S HEAD

Height 8.9″ Width 9.9″

Achaemenian, VI–IV century B. C.

PROVENANCE: Persepolis.

EX COLL.: Oriental Institute, Chicago.

BIBLIOGRAPHY: The authorities cited below illustrate Achaemenian sculpture of this type: A. U. Pope and P. Ackerman, eds., *A Survey of Persian Art*, London–New York, 1938, IV, pl. 95; E. E. Herzfeld, *Iran in the Ancient East*, London–New York, 1941, pls. LVIII, LXII; E. Schmidt, *Persepolis*, Chicago, 1953, I.

EXHIBITED: Fogg Art Museum, Cambridge, Massachusetts, *Ancient Art in American Private Collections*, December 1954–February 1955, no. 62, pl. XX, and also p. 11; Brooklyn Museum since 1954.

NOTES

1. Herzfeld, pp. 210, 239. See also *Encyclopédie photographique de l'art*, Paris, 1936, II, pl. 48.

2. A. Godard, *The Illustrated London News*, January 2, 1954, p. 18, figs. 5–8.

BRONZE LAMP

A<small>N</small> object of great interest is this bronze lamp in the form of a bull with its forelegs extended in a V. Projecting beyond them are two tubes that form the wick holders. In the middle of the back is a hole for filling the lamp with oil. The tail of the bull has been broken off, but it can be seen that it originally formed a loop, part of which was free from the body of the animal. The bushy tip still remains, and it rests on the animal's rump. The animal is modeled with sensitivity and in a way that indicates Hellenistic influence. There are several very interesting features about this lamp, and it well repays careful study. Very obvious is the peculiar treatment of the hairy curls. Down the center of the breast is a strip that consists of four parallel rows of curls. Another strip, also of four parallel rows, extends from the top of the head down the center of the back to the root of the tail, interrupted only by the hole for oil on the top of the back. In addition to these are four short lateral "tabs," also four rows wide. There are two of these on the shoulders and two over the haunches, in accordance with the pattern that is characteristic of Assyrian bulls and, later, of the neo-Babylonian and Achaemenian bulls. This treatment of the hair also is to be seen—drawn in a very prim and conventional way—on the metal animals from Toprak Kaleh, a town near Lake Van in Urartu, the present-day Armenia. Why these peculiar hirsute decorations ever were developed is something that we do not know, for they do not exist in nature and can hardly be considered as very successful decorations, although one can soon learn to accept them. All these details so far described are typical Achaemenian details. But there are some others which are not exactly true to type, quite apart from the position of the animal's

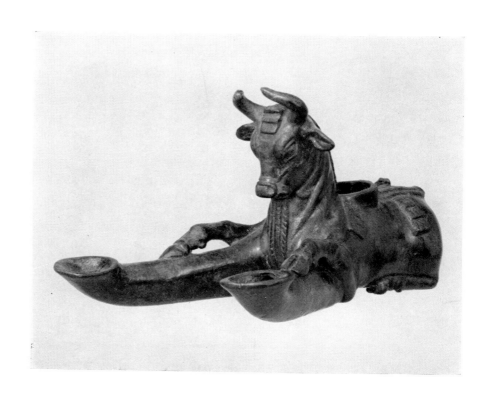

BRONZE LAMP

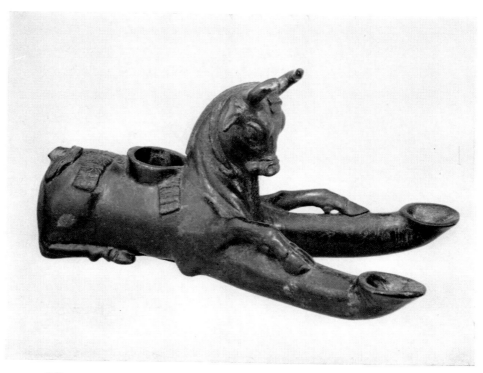

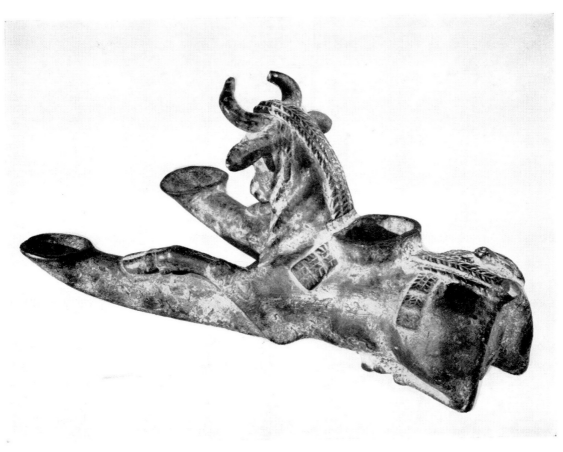

BRONZE LAMP

legs and the folds in the neck which are very naturalistic.

It will be observed that on each side of the head and framing it there is a ridge which turns down at each end as though it were a torc. On many Achaemenian bulls' heads there is a row of curls that frames the animal's face, but it ends merely in a larger curl. In Sidon, however, some parts of bulls' heads were found in which this row of curls is misunderstood and turns back in just such a way as they do on this lamp.[1] This suggests that the lamp, in which the treatment of these curls is even less close to the original, was not made in Achaemenian times in Iran itself and points rather to its manufacture outside the country, probably somewhere nearer the Mediterranean Sea. It can also be observed that unlike those of the customary Achaemenian animals, the eyebrows are not made up of several parallel lines but are merely ridges. The treatment of the veins on the face is also less exaggerated. If these suggestions are correct, the lamp is an extraordinarily good example of the carrying on of the Achaemenian tradition into later Hellenistic times. There is another bronze bull lamp, now in the British Museum, which is obviously closely related to the Guennol lamp. It is less realistic, but it has similar Achaemenian conventions. Unfortunately, the details of its provenance are obscure, but it seems likely that it was from a large collection dispatched pell-mell from Mesopotamia by Rassam between 1880 and 1882.[2]

Further illustration of the survival of the Achaemenian tradition is to be seen in a small silver lamp, probably made in Egypt in Ptolemaic times, which has on each side of the rim two ducks' heads separated by a small floral motif.[3]

It is, however, a mistake to look at the Guennol bronze lamp merely as an example of the survival of an ancient tradition, for the conventional and the natural are here so subtly blended that the combination is completely satisfying.

98

BRONZE LAMP

Height 3.8" Length 7.5"

III–II century B. C.

Ex Coll.: Joseph Brummer, New York.

Exhibited: Brooklyn Museum since 1950.

NOTES

1. R. Dussaud, *Syria*, IV, 1923, pl. XLIV.

2. Information provided by R. D. Barnett, Deputy Keeper of Egyptian and Assyrian antiquities of the British Museum.

3. T. Schreiber, *Die alexandrinische Toreutik: Untersuchungen über die griechische Goldschmiedekunst im Ptolemaeerreiche*, Leipzig, 1894, p. 333, fig. 70.

SILVER BOWL

THIS simple but beautiful shallow basin, which is really a bowl for drinking wine, is one of two that were found together. The other is now in the William Rockhill Nelson Gallery of Kansas City, and has been published by Phyllis Ackerman in *Survey of Persian Art*. They are reputed to have been discovered in Mazanderan, but there have also been rumors that they came from Hamadan. These twin pieces were raised from the flat and are thicker near the rim. The edges have been beautifully chased and gilded. As P. Ackerman indicates in her article on metalwork in *Survey of Persian Art*, there is a strong Greek feeling in the spirit of these bowls, the cleanly designed but elaborate rim contrasting with the complete simplicity of the rest of the vessel. The design, although so closely related to classical models,

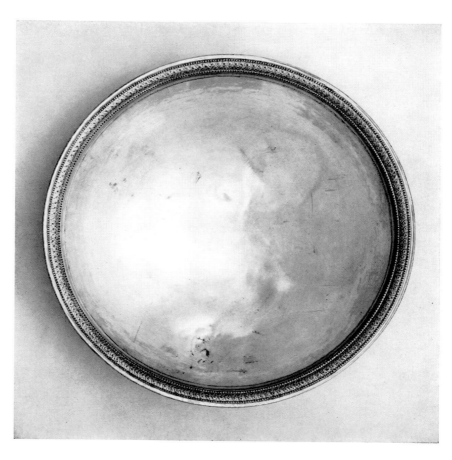

SILVER BOWL—*View from above*

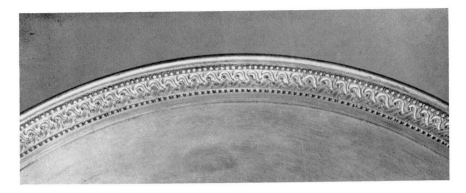

Detail of rim

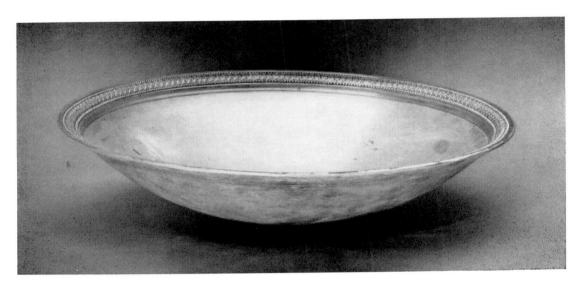

SILVER BOWL

Detail showing inscription

is not entirely without Iranian connections. As an example of this, reference may be made to a bronze vase, or goblet, that came from Luristan and entered the David-Weill Collection. It is decorated with interwoven bands having a double row of circular spots at the points of overlapping. Although in this case the bands are composed of many strands, the progression of the dots is precisely the same as that in the Guennol bowl. The pattern in the silver dish does not conform exactly to the well-known Greek patterns either, and a little linear nick interrupts the flow of the curves. Nevertheless, there is no doubt whatsoever that this hybrid design is a most successful one and the bowl an object of real beauty. Although it cannot be dated precisely, it was most probably made not later than the second century B. C. On the back of the bowl are a few faint traces of some engraved Aramaic characters.

SILVER BOWL

Height 2.5″ Diameter 10.5″

Seleucid or Arsacid, III–II century B. C.

Ex Coll.: Ernst Herzfeld; Joseph Brummer, New York.

Bibliography: A. U. Pope and P. Ackerman, eds., *A Survey of Persian Art* London–New York, 1938, I, pp. 459 ff., and cf. *ibid.*, IV, pl. 136, illustrated, the bowl in the William Rockhill Nelson Gallery, Kansas City, Missouri; *The Metropolitan Museum of Art Bulletin*, VII, March 1949, p. 197, and *ibid.*, IX, Summer 1950, p. 15; M. T. Mostafavi, *Hagmateneh* [in Persian], Teheran, 1953, pl. 25, lower cut.

Exhibited: Burlington House, London, *International Exhibition of Persian Art*, January–March 1931, no. 22g; Metropolitan Museum of Art, New York, *Ancient Art from New York Private Collections*, December 1959–February 1960, no. 45, pls. 15, 100; Metropolitan Museum of Art since 1949.

BAHRAM GUR SILVER PLATE

THE popularity of hunting scenes as subjects for the deco-
ration of silver plates in the Sasanian period is well
illustrated by a number of examples in museums throughout
the world. The scene which appears on the Guennol plate,
however, illustrates a particular story. The archer sits
astride a camel holding his bow ready to let loose an arrow
at the gazelles before and beneath him. Behind him, seated
side-saddle, is a small female who carries his quiver and
holds an arrow out towards him. The camel is lavishly
bedecked with a rich saddle blanket and various harness
decorations. The small female wears a dotted garment, and
a fillet is bound around her forehead, the ends of which
flutter behind. The archer is the main figure. His crown, or
headdress, consists of a row of discs resting on a pearled
band. Above the head the hair is gathered into a ball and
covered with a cloth which is bound by a small fillet. The
ends of a large fillet which encircles the forehead can be seen
spreading out behind the figure's head. In addition he wears
earrings and a necklace, and the straps over his shoulders
and across his chest meet in a central roundel. A belt is
wound around his waist and a sword belt around his hips.
The garments seem loose and light, and the long pants fall
free in wrinkles from the legs. In all these details the figure
is typical of a Sasanian king. Nobles or gods are differently
represented both in the arrangement of the hair and in their
dress. But if this is a king, he is not one who can be iden-
tified by his crown. There are no parallels on Sasanian coins
for this crown. The closest is that of a late Sasanian queen,
Buran (A.D. 630–631), whose crown likewise has discs but
is, in the inclusion of other details, totally different. Discs
also decorate the bottom rim of tall caps worn by priests on

103

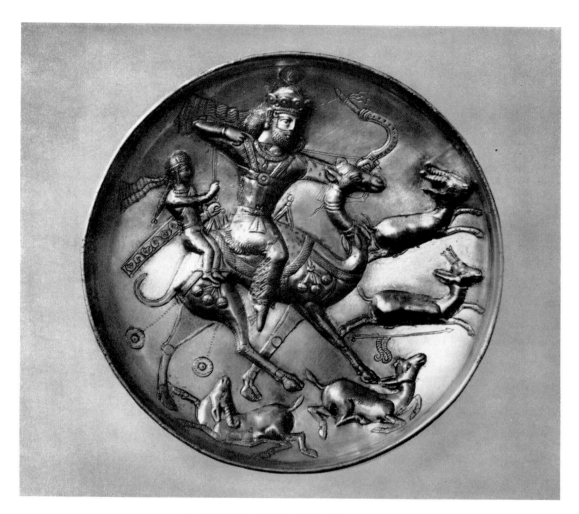

BAHRAM GUR SILVER PLATE

Inscription on bottom

104

Sasanian seals,[1] and on a Sasanian vessel with representations of Bahram II (A.D. 276–293) and his family, the queen wears a tall cap with discs along the lower rim.[2] This form of headgear with discs was therefore known and used by Sasanian royalty and dignitaries from early times.

The scene represented here is one which is familiar to us from Islamic sources no earlier in date than the tenth century. The story is told of the Sasanian king Bahram V, "Bahram Gur," (A.D. 430–438), and his favorite, Azadeh. The king, taunted by Azadeh, changes a male gazelle to a female and a female to a male and pins the foot of another gazelle to its ear. The first two feats, which are the only ones illustrated here, the king accomplishes by removing the horns from a male animal with a single arrow and by shooting two additional arrows into the head of a female to represent horns. Two other illustrations of this story exist on two crudely made silver plates, one possibly late Sasanian and the other post-Sasanian, which are in the Hermitage Museum.[3] In neither instance is the crown worn that of Bahram V. A seal that is probably late Sasanian in date also has the same scene, but is too minute to reveal such details as the rider's crown.[4] The plate in the Collection is the only representation of this subject, which on formal, stylistic, and technical grounds might be dated with some certainty to the Sasanian period and attributed to a court workshop. If this is not Bahram V, and it certainly is not the official crown seen on the coins of that king, then it must be some other royal figure.[5] It is inconceivable within the iconography of Sasanian art that this is not a royal personage. The narrative type of design seen on this plate is rare in Sasanian art although there are many examples in the pre-Islamic art of Central Asia.

The plate is made from a single shell to which separate pieces were added to form the highest parts of the relief. The

head of the upper right-hand gazelle is, in fact, partly in the round. Such high pieces were either carved from solid metal, or slightly raised by hammering, or cast and then chased. In all cases the added parts were crimped in place and held on the shell of the bowl by a narrow lip of metal, cut and raised from the shell. The rest of the design was either chased or engraved on the plate or left in relief by slightly reducing the background surface. The rim of the vessel and the design, with the exception of the human faces and hands, were mercury-gilded. A ring foot is soldered to the reverse and within the foot is a dotted Pahlevi inscription.

Christopher J. Brunner has supplied the following translation of the first line of the inscription: *Tahmagdast*, "Of mighty hand." The second line is, in Brunner's opinion, an indication of weight, although there are no orthographic parallels for the form of the numbers as they appear here.

BAHRAM GUR SILVER PLATE

Diameter 7.9″

Sasanian, *c.* V–VI century A. D.

PROVENANCE: Northwest Iran.

EXHIBITED: Museum of Art, University of Michigan, Ann Arbor, *Sasanian Silver: Late Antique and Early Mediaeval Arts of Luxury from Iran*, August–September 1967, p. 92, no. 3, ill. on cover; see pp. 47, 51–53, 78.

NOTES

1. J. M. Upton, "The Persian Expedition: 1933–1934," *The Metropolitan Museum of Art Bulletin*, December 1934, p. 17, fig. 25A.

2. V. G. Lukonin, *Iran v epokhu pervykh Sasanidov*, Leningrad, 1961, pl. XIV.

3. I. A. Orbeli and C. Trever, *Orfèvrerie sasanide*, Moscow–Leningrad, 1935, pls. 11, 12, illustrate the other two silver plates with Bahram Gur and Azadeh.

4. A. U. Pope and P. Ackerman, eds., *A Survey of Persian Art*, London–New York, 1938, I, p. 793; and *ibid.*, III, pl. 256A.

5. Oleg Grabar thinks that this cannot be Bahram V but that some specific legend is here represented which was later in Islamic times ascribed to Bahram V. O. Grabar, "An Introduction to the Art of Sasanian Silver," *Sasanian Silver*, pp. 51–52.

SILVER SAIGA RHYTON

FEW hollow animal heads, so common in the Achaemenian and Parthian eras, made in the form of rhyta and finials are known to have survived from the Sasanian period of Iran (III-VII centuries A.D.). For the most part Sasanian metal work as we know it consists chiefly of bowls, ewers, or vases. The Guennol head of an antelope is outstanding because of its rarity, its excellent state of preservation, and its cleanness of design and execution. The craftsman's touch is sure, his statement clear and firm; but precision is not always identical with clarity, and identification of a firm statement in art cannot always be described by an equally firm statement in prose. Certainly identification of the animal portrayed is by no means so simple as might first be thought. It is apparent at first glance to anyone cognisant of the fauna of Iran that the animal's head is a skillful combination of realistic and stylized elements and, as we shall see, they may not be derived from one and the same animal.

That the animal is an antelope is fairly obvious, but what kind of antelope? One thinks of a silver rhyton in the form of a saiga head in the Metropolitan Museum.[1] It is one of two that were found in Choniakov, Poland. The other one is now in the Hermitage.[2] The saiga is an antelope that was once common from Poland to China and was also known in the Caucasus. Two of its chief characteristics are the bombous profile of the head and the rather unattractive nostrils which are so lengthened that it is said, incorrectly, it is necessary for the animal to walk backwards when it feeds.[3] The silver heads from Choniakov have these nasal apertures rendered in a fairly accurate fashion, but the Guennol head shows some variations. For example, the muzzle is treated in a way much more reminiscent of other

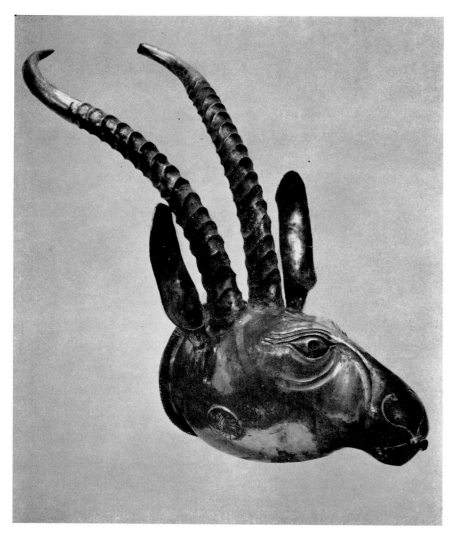

SILVER SAIGA RHYTON

BACK OF HEAD—
Detail

108

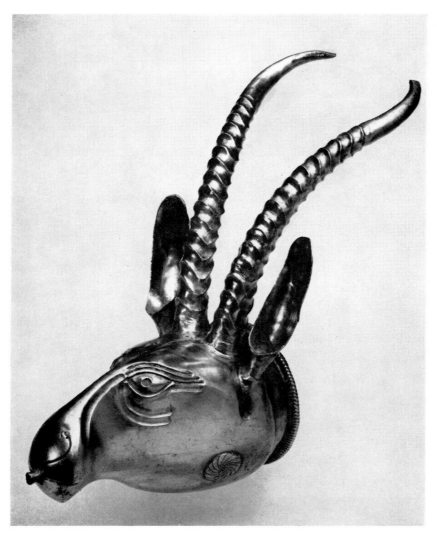

SILVER SAIGA RHYTON

and better-looking antelopes. They are indicated by two opposed volutes that form what in iconographical jargon is called an "open heart." Another divergence from a true saiga head is to be seen in the ears (it is a pity they are missing in both Choniakov heads) which are tall and erect and are most sensitively treated. The actual animal has rather short ears that almost give the appearance of long ears cut short. Still another difference is that whereas a saiga's head tapers regularly from the top of the head to the muzzle, the Guennol head is elegantly narrowed just above the muzzle. The head, in spite of all these differences, has some relationship to the saiga, particularly in the lyre-like horns of the male. There is also the peculiar convex profile. On the cheeks are two projecting whorls which at first glance might be considered purely decorative. Actually the saiga has tufts of hair on its cheeks, and these must be considered as an indication that the designer of this head certainly knew the saiga or a very closely allied antelope. The provenance of the piece is Amlash in the north of Iran between Kazvin and the Caspian Sea.

The eyebrows and eyelids are extended to a considerable distance, a peculiarity that was still very much in favor in the delineation of both human and animal heads into early Islamic times. Like the other rhyta from Choniakov, the head is partly gilded: at the base of the ears, around the eyes, on some of the grooves, and at the tips of the horns. The circular flat plate which covers the back of the head is also gilded, with the exception of the four petals of the rosette which adorn it.

The head itself was raised from one piece of metal, and the details of the eyes, eyebrows, nostrils, and mouth were added later by chasing. The ears, horns, and the flat back plate were made separately and soldered onto the cup of the head under a molding which is closely ridged. A single hole

pierces the head between and just behind the horns, and a tiny spout is attached to the mouth. These two features indicate that the head was originally used to hold liquid, which entered at the hole and was emitted through the projecting spout in the center of the mouth.

Under the lower jaw is a short inscription in Pahlevi, which, according to Richard N. Frye of Harvard, is an indication of weight. This is a feature in common with certain other Sasanian silver pieces, for example, three bowls found in Mazanderan now in the Teheran Museum, and a plate now in the Metropolitan Museum.[4] The inscription is indicated in the customary Sasanian way, that is by a sequence of dots rather than a chased line.

Because of the more naturalistic and modeled quality, the Metropolitan Museum head has been dated at various times from the Achaemenian to the Sasanian periods. When compared to the Guennol head, it seems likely that the less stylized saigas in the Metropolitan and Hermitage belong to the Sasanian period about the third or fourth centuries A. D. This saiga with the exaggerated shape of the head, the bold treatment of the eyes, and the typically Sasanian floral design on the back plate must belong in the late Sasanian period, perhaps the sixth century A. D., when Sasanian art had freed itself of Western naturalism and had returned to a more schematic and stylized interpretation of the forms of nature. The head of a saiga antelope in the Collection is a most striking work of art, in magnificent condition, and a masterpiece of the late Sasanian period.

SILVER SAIGA RHYTON

Height (base of head to tip of horns) 9.5

Length (back of head to tip of spout) 7.5

Diameter (back of head) 3.5"

Sasanian, *c.* VI century A.D.

PROVENANCE: Amlash, north Iran.

BIBLIOGRAPHY: R. Ghirshman, "Rich Treasures of Persian Animal Art—Recently Discovered," *The Illustrated London News*, April 2, 1960, p. 551, fig. 6; *idem*, *Persian Art: The Parthian and Sassanian Dynasties: 249 B. C.—A. D. 651*, The Arts of Mankind, III, ed. A. Malraux and G. Salles, New York, 1962, p. 220, fig. 263–(A); R. N. Frye, *The Heritage of Persia*, New York, 1962, figs. 59, 61.

EXHIBITED: Metropolitan Museum of Art since 1960.

NOTES

1. Accession number 47.100.82, Rogers Fund, 1947.

2. Both heads are illustrated in *Syria*, XII, 1931, p. 292, figs. 3, 4. For further bibliography on the Metropolitan Museum head and the Hermitage head see Y. Smirnoff, *Argenterie orientale*, Paris, 1909, figs. 11, 12, pl. XLIII; A. U. Pope and P. Ackerman, eds., *A Survey of Persian Art*, London–New York, 1938, IV, pl. 109a,b; R. Ettinghausen, "Six Thousand Years of Persian Art: The Exhibition of Iranian Art, New York, 1940," *Ars Islamica*, XII, 1, 1940, p. 114, fig. 13.

3. R. Lydekker, *The Great and Small Game of Europe, Western and Northern Asia and America*, London, 1901, p. 188. See also "Presented to the London Zoo: Six Rare and Ugly Saiga Antelopes from Prague," *The Illustrated London News*, February 4, 1956, p. 164, fig. 8, pl. II.

4. Accession number 57.51.19, bequest of Cora Timken Burnett, 1957.

MEDIEVAL OBJECTS

Harry Bober

MEDIEVAL ART

FIRST and foremost, the claim of the Guennol selection of medieval art upon the attention of amateur and specialist alike lies in the sustained level of artistic excellence of the individual works.

Given the initial condition of aesthetic quality, the selection was indeed determined, and the collection shaped, by a principle and an idea. The principle, that of catholicity, allowed for the admission of works from diverse periods and regions, highly varied materials and media. Certain historical areas, notably the period from the seventh to the eleventh centuries, are not represented—hardly by design but rather because of the scarcity of pieces from this difficult period. The absence of Byzantine art, however, must be interpreted in the light of the collectors' personal preference.

It would be too much to suggest that each object was selected to serve toward the direct expression and development of a single idea, theme, or dominant approach in the interpretation of medieval art. Nevertheless, the peculiar stamp of the collectors' view is in evidence throughout. Much as a prelude or overture declares the theme and pre-

115

pares the ideological ground for a musical composition, so does the earliest group of items in this section announce the underlying character of the whole. The first three objects are not medieval and were to have been placed separately under the heading of "Early European Art." One of them dates from the Bronze Age, another from Celtic Belgium, and a third from transalpine Roman Europe. In these is adumbrated that particular element in the formal character of medieval art which, above all other manifestations, seems to have intrigued the collectors: its antinaturalistic and, as a corollary, its anticlassical strain. Herein is also a clue as to why our collectors may have been so little drawn to Byzantine art which, of all the medieval styles, was the most directly formed on classical foundations and remained the most persistently classicizing art of the Middle Ages. On the other hand, Byzantine formal inspiration as translated into the Western artistic idiom was found welcome and is magnificently exemplified in the Guennol Triptych.

Prehistoric and barbaric abstraction, in works from those pre-Christian and pagan cultures whose aesthetic anticipates elements of basic medieval interest, is superbly illustrated in the first items. The designs engraved upon the surface of the Bronze Age Disc (p. 122) approach pure geometry, avoiding strict geometrical figures in the main ornamental bands in favor of more dynamic line and movement, expressive of tensions and vital essences. In the pieces from the Frasnes Hoard (p. 129) and especially in the decoration of the large torc, we may see how Celtic art wrought a new aesthetic of form out of such seeming opposites as prehistoric abstraction and classical naturalism. Even after the Roman conquest of western Europe the force of Celtic art continued to be felt, its vitality and character visibly effective in the instance of the Disc Fibula (p. 140). Roman art ruled in the monumental media of

116

architecture and large-scale sculpture. In the smaller objects of metalwork and enameling craft, however, it could never entirely submerge the indigenous Celtic tradition which had so excelled in this area. After the Roman collapse the barbaric element came to the fore again, reinforced by new waves of tribal migrations from across the old frontiers, to consolidate the Celtic aesthetic. Together with Christian motifs and themes, the barbaric artistic inheritance of forms worked in the shaping of an essentially anticlassical style in the early medieval art of Europe.

Within that complex of elements which makes up the barbaric component of medieval art, the antinaturalistic approach in the representation of living forms plays an important part. Animals, especially, are the favored subjects for barbaric craftsmen. Out of imaginative fantasy and a borrowing of recognizable elements from the real world of birds, beasts, reptiles, and fish, they created bizarre hybrids. Their beasts and monsters are wilfully and arbitrarily distorted and contorted, biting or fighting themselves or each other; when not involved in entangled action, they may be ferociously introverted or merely threatening. These creatures provide a dominant element of Hiberno-Saxon art of seventh and eighth century England and France. But they are to be found in contemporary Continental art and continue even after the Carolingian revival of the ninth century restored the framed and figured scenes to prominence. The world of capricious monsters, now subordinated to the sculptured and painted scenes, remains an established element in the repertoire of medieval art.

The Haute-Savoie Cloisonné Enamel with a reptilian beast (p. 146) belongs to this area of medieval invention. It serves to recall the myriad beasts which inhabit initials of illustrated manuscripts throughout the Middle Ages. The animals provide one of the most favored themes of Roman-

117

esque art, where they are elevated to considerable prominence in monumental form, to be found over most of Western Europe during the eleventh and twelfth centuries. They may be carved on a trumeau, at the center of a main portal, or embellish pier capitals in the church interior, side by side with narrative religious subjects. St. Bernard of Clairvaux (d.1153), while protesting against their presence, nevertheless betrays his admiration for the "marvelous and deformed comeliness, that comely deformity" of "those ridiculous monsters" in the Romanesque capitals.

Even the utilitarian vessels of the period, or at least the finest pieces, employ similar animal themes as one of their principal motifs. As an example of these sculptured bronze equivalents of the stone capitals, the Collection offers one which is shaped as a Lion-Head Aquamanile (p. 165).

The interpretation of the meaning of such animals and monsters could not possibly be embraced by any single categoric heading. Certainly there are those lions, whales, and pelicans whose sense in a Christian interpretation is revealed explicitly in the medieval bestiary as allusive to the divine nature of Christ, His miracles, and to ethical allegories. Others, from context, may be shown to have demonic connotations, bearing upon evil, sin, hell, and damnation. To a large extent, many of the animals, especially those in manuscript initials, suggest a generic Christian letter and word magic, punctuating the pages of sacred and profane writing with vigorous accents of mysterious life. But an equally large number must have been free inventions, born of wit, whimsy, and irrepressible fantasy, and it was against these that St. Bernard railed.

In a special class are the mystical beasts which are the symbols of the evangelists, associated with the vision of Ezekiel and described in its New Testament counterpart, the apocalyptic vision of Christ in Revelation. The superb

Limoges Enamel Plaque shows the familiar symbol of Luke as the winged ox (p. 183).

The main themes of Christian history, dogma, and ethics were carried primarily by the figural imagery and scenic representations. In the religious edifice it is necessary to see all the sculptures of the portals and even those of the interior to arrive at a complete reading of the didactic program which they were meant to serve. In the single object, however, similar programs could be concentrated either in abbreviated versions or as more abstract distillations. On bookcovers, fonts, altarpieces, and the like, there may be represented straightforward religious narrative from the lives of the Virgin, Christ, or the saints. But these objects may also present complex ideas of theological doctrine, and in this area we find the most distinctive achievements of medieval art. For in such works the artists depart radically from the ancient conventions of scenic and narrative style to make full use of compositional abstraction. The Mosan Reliquary Triptych (p. 151) is a brilliant example of this kind and a superb work of Romanesque art. There is, in the design and disposition of the figures of this triptych, something of the iconic force and depth of Byzantine art. Indeed, from the beginning of the twelfth century the art of Western Europe had begun to respond with profound interest to the qualities and themes which Byzantium had to offer for the enhancement of Romanesque works. Here was no superficial borrowing, but sympathetic absorption and reinterpretation for kindred purpose. The figures and composition of this triptych could hardly be mistaken for Byzantine work.

By the middle of the twelfth century Romanesque art had begun to give way to a new style, the Gothic, which was to prevail until the end of the fourteenth century and beyond. In the French Altar Angel of the Collection (p. 203) is epitomized the essence of that style. It is as if, in the

119

change from winter to spring, the warming sun had begun to melt the marvelously frozen forms of the Romanesque (cf. Auvergne Madonna, p. 171), freeing them to the light and air of this world. The transformation signifies more than a formalistic development over the interval of time between the Romanesque of the twelfth and the Gothic of the thirteenth century. Those changes were synchronous with others, affecting the entire cultural, religious, and intellectual climate. Philosophers were discovering a new world in Aristotelian naturalism. In the urban life of the recently created cities there was a spirited class of free citizens whose economic enterprise brought wealth to the cities and lucrative secular patronage for the arts. Even in the religious realm the changes were manifest and are best known in the rapid development of Franciscan humanism.

The unfolding of naturalism in later medieval art may be followed through representative stages in the diverse objects of the Collection. Early Gothic style is beautifully shown in the Stained Glass from the Cathedral of Troyes (p. 191). In place of Romanesque figure style, with its abstract compartmentation into patterned color areas, the Gothic painter began to unify the entire figure through sweeping drapery lines and the suggestion of organic volume. In the textile arts it is to be expected that the designers would have preferred to limit the suggestion of scenic depth because the cloth would serve to cover walls, altars, liturgical objects, or the body of a person. Decorated cloth could enhance the planes or volumes of the objects for which it was made. The figures in an early fourteenth century English embroidered Orphrey (p. 211) effect broad sculptured forms set against a gold ground.

The rise of panel painting, already a major force in fourteenth century Italy, assumed overwhelming importance in the North during the fifteenth century. Not even the

leading painters of illuminated manuscripts could resist the tide of panel painting. Small wonder, then, that even the textile arts should have succumbed to the new pictorial style. The panels with Scenes from the Life of St. Martin (p. 242), have become "needle paintings." They are, virtually, translations in stitched thread of the painted brushwork of easel pictures.*

* In the preparation of this section of the catalogue the author received unstinting assistance from the Medieval Department of the Metropolitan Museum of Art whose resources were placed at his disposal and whose staff provided friendly counsel and valuable information on countless occasions. William H. Forsyth, Associate Curator, and Richard H. Randall, Jr. (now of the Museum of Fine Arts, Boston), contributed many of their own findings for incorporation in this work. Margaret B. Freeman, Curator of The Cloisters, and Thomas P. F. Hoving, gave freely of their time and knowledge to the author. To the Director of the Museum, James J. Rorimer, special thanks are due for advice and encouragement but particularly for expert opinion on critical problems of connoisseurship. For ready helpfulness on various problems the author is also indebted to: K. G. Boon, of the Rijksprentenkabinet of the Rijksmuseum, Amsterdam; Richard Ettinghausen, Curator of Near Eastern Art at the Freer Gallery of Art, Washington, D. C.; Ilene Haering Forsyth, of Columbia University; and Dorothy E. Miner, Librarian and Keeper of Manuscripts at the Walters Art Gallery, Baltimore.

The author found immensely helpful the accumulation of notes, bibliography and documentation, gathered at the behest of the Collectors during the period before he was asked to write this section. Among those whose part in this preliminary work is known to the author, thanks are due to Jane Durgin and to Yvonne Hackenbroch whose typescript essays on most of the objects afforded a welcome beginning. Considerable help was given by R. Rainbird Clarke for the study of the Frasnes Hoard, and by Louis Grodecki for the stained glass from Troyes.

BRONZE AGE DISC

THE Bronze Age may seem so remote as to have little, if any, relevance to the art of the Middle Ages, which is the principal subject of this section. It was, nevertheless, on this prehistoric horizon that the diverse trends in the antecedent epochs were consolidated to form an enduring and systematic art on a broad European base. From this point of departure may be traced an essentially consistent process of formal development through the rest of prehistory and, in historical times, beyond the end of the first millennium of the Christian era. Between the Bronze Age and Roman times the widespread Celtic tribes were the catalytic agents in the transformation of Northern geometric art into a major European style, incorporating figural and floral elements from Near Eastern and sub-archaic Greek sources. Antithetical to this style in principle was that of the Greco-Roman tradition, spread over Europe through the Roman conquests. But with the collapse of Rome, traditional native style and craft came out of hiding and even flourished, however modified, throughout the provinces of the dismembered empire. The most profound effects of this renewal of the pre-Roman line of development are best observed in the British Isles, where it contributed the determinant stylistic ingredient of the earliest non-classically grounded Christian art of the Middle Ages—that of Ireland and Anglo-Saxon England. In Scandinavia, Bronze Age continuity follows a more direct line deep into the Christian era, without such interruptions. Nor was it an isolated survival, as we well know from the impressive conquests and forays of the terrible Vikings, which extended, during the ninth and tenth centuries, from Russia to Ireland and even across the Atlantic.

122

Of all the prehistoric periods, the Bronze Age most nearly achieved an art of pure geometrical abstraction. Their simple artistic vocabulary of dots, lines, and basic geometrical figures was employed with astonishing virtuosity and inventiveness. Straight lines were developed in zigzag, chevron, and lozenge patterns, and were filled with different combinations of dotting, striations, and hatching strokes. Instead of static effects, which might seem the more natural property of rectilinear design, they exploited its maximum potential for enlivenment. As for the curvilinear elements, perfect circles became surcharged with illusory motion by means of concentric filling rings, densely multiplied. Through the use of spirals, varied with ingenious versatility, their elemental linear technique became expressive of continuously interacting energies and tensions.

Unlike that of the classical world, where works of art were so commonly created as independent objects, Bronze Age art is for the most part integral with objects and implements of religious and secular utility. It is to be seen on pottery for daily and ceremonial use, from food vessels to cinerary urns, or on costume accessories, including armlets, brooches, torcs, and gorgets. Arms and military paraphernalia rank as major vehicles for this art; bucklers being particularly favored with the efforts of their most ambitious craft. Similarly endowed are those works made for religious ritual, such as the sun-discs, which are not only richly worked but often finished with gold over the bronze form.

It would be misleading to view this art of embellished objects as one of mere ornament. The phrase usually suggests relatively subordinate evaluation, either in relation to a presumably higher artistic level or kind, or to the immediate utilitarian function of the object. But this art is, in fact, the primary form of artistic expression in the period. Moreover, it would be difficult justifiably to differentiate, in artistic

123

BRONZE AGE DISC

kind, from Greek vase painting, Byzantine textiles, or much of Romanesque sculpture. As for their relationship to the practical purpose of the object, it is probable that the designs were generally applied for symbolic or magical purpose. Rather than being subordinate, such meaning is coincident with utilitarian function, perhaps magically essential to it. Talismanic and apotropaic functions of geometric art on kindred objects from primitive New Zealand and New Guinea afford suggestive parallels for such an interpretation. Within the Bronze Age the sun-discs provide our main clue to their use of abstract motifs for symbolic meaning and, therewith, a caution against any exclusively formalistic view of this art.

Some of the finest in this elite class of shields and discs appear to have originated in Denmark, England, and Ireland, centers which were in close contact with each other through trade and war. The Guennol disc is thus typical, for it is of Danish workmanship but was found in the Thames, probably brought to England via the trade routes or, more likely, military interchange.

By the time the Bronze Age had entered its second stage in Denmark a highly sophisticated and linear style of geometric abstraction characterized the art. This phase, known as Montelius' Period II from the classification system of the famous Danish archaeologist, produced the truly "classic" works of the age. Among these the Guennol disc ranks as a superb example on this high level in their art. The compositional scheme is that of concentric circular arrangement of borders and wide decorated zones. The theme of the main zones is the spiral, developed with variations from the simple to the complex, beginning with the innermost zone which shows an uncomplicated running spiral. The total effect is that of a system of coiled springs, rhythmically modulated so that the tension is absolutely unvaried at the

innermost band, delicately disrupted in the middle, and reformed in the framing zone as alternating swells and swirls.

Design and composition of the Guennol disc are typologically close to a number of works generally assigned to the second phase of Denmark's Bronze Age. The same composition in three circular fields is found on a fine buckler from Rogaland (southwest Norway), now in the Bergen Museum. Since the Rogaland design employs the running spiral throughout, making only scant use of the double-line, it would seem to represent a slightly earlier phase than this disc, within Montelius II. From Langestrup, Denmark, comes an example of substantially the same design as that from Rogaland, different mainly in having four zones and highly refined in technique.[1] The Langestrup buckler thus represents an extreme in the possibility of using a single motif, that of running spirals, and may be a very late instance of the single-line phase. The Guennol buckler, on the other hand, shows the very beginnings of a new trend, concerned with articulated rhythms, varied motifs, and enrichment of the linear technique.

Another example which deserves mention is the famous gold-covered disc found at Trundholm, in the north of Zealand.[2] While differing from the Guennol buckler in many ways, it has important basic features, which are definitely related. The Trundholm disc is composed in three zones, and the pattern of design in relation to the surface has analogous formal qualities. Of particular interest is the "eye" motif, which figures so prominently on both faces of the Trundholm disc, where it occupies the middle zone. It is widely believed that the disc dates late in Montelius II, possibly some time before about 1000 B.C. This would place it toward the beginning of the Danish Bronze Age with works of the so-called "Grand Style." The Guennol

126

buckler would belong somewhere in the interval between the style represented by the Rogaland buckler and that of the Trundholm disc, which may be estimated as the eleventh century B. C.[3]

The Trundholm disc is but part of a composite work, which has been called the principal monument of Bronze Age religion.[4] The group shows that the disc was drawn by a horse; both were mounted on a six-wheeled carriage. Scholars are agreed that this must have been a cult-object for sun-worship ceremonial. In this connection, a number of gold discs, found in Denmark, Germany, England, and Ireland, have been similarly interpreted as sun-discs used in a solar religion.[5] On the Danish sun-discs, curvilinear designs are characteristic; the insular examples favor rectilinear motifs. Obviously these motifs on the Guennol disc and kindred pieces are related to those on the sun-discs. If that relationship of design elements could be accepted as indicative of application of similar symbolic meaning, then the embellishment might be interpreted as having served to charge them with talismanic power. The designs would thus convey the sense of dispelling inimical forces and, at the same time, the embodiment of birth and growth from the life-nurturing sun.

This disc must be distinguished, with respect to original use and function, from that in the altogether exceptional chariot from Trundholm, which must have been a religious object from an unknown ritual. The Guennol disc is of a type which is well known from Danish Bronze Age excavations and has been identified as an important article of female dress. Thus, in one of the best-preserved graves of the period, that from Egtved (west of Vejle, Jutland), we have a woman's costume, complete with its ornamental accessories.[6] Still attached to a leather belt around her waist we see a disc of about the same size and design. But such practical use would not, of necessity, argue against the sym-

127

bolic meaning of the belt disc and its decoration. On the contrary, the fact that type and embellishment are so consistently used, taken together with the clue from the Trundholm chariot, would suggest that these belt discs were the carriers of an essential theme of religious import, worn as a procreative talisman in life and, perhaps, carrying magical meaning for the after life.

BRONZE AGE DISC

Diameter 9.9″

Danish, Montelius II, *c.* XI century B. C.

PROVENANCE: Found in the River Thames at Brentwood, Middlesex.

EX COLL.: An English provincial museum.

EXHIBITED: Fogg Art Museum, Cambridge, Massachusetts, *Ancient Art in American Private Collections*, December 1954–February 1955, no. 366, pl. XCVII.

NOTES

1. Illustrated in F. A. van Scheltema, *Die Kunst unserer Vorzeit*, Leipzig, 1936, pl. XLI, 3; A. Roussell, ed., *The National Museum of Denmark*, Copenhagen, 1957, p. 43.

2. S. Müller, "Solbilledet fra Trundholm," *Nordiske Fortidsminder*, Copenhagen, 1890–1903, I, pp. 303 ff.

3. For further related examples cf: E. von Sydow, *Die Kunst der Naturvölker und der Vorzeit*, Berlin, 1923, p. 449, from Tomarp; H. Kühn, *Die vorgeschichtliche Kunst Deutschlands*, Berlin [1935], p. 229, from Lüneberg; S. Müller, *Nordische Altertumskunde*, Strasbourg, 1897, I, p. 275, from Bornholm.

4. J. Bing, "Der Kultwagen von Trundholm und die nordischen Felsenzeichnungen," *Ipek: Jahrbuch für prähistorische & ethnographische Kunst*, 1926, pp. 236 ff.

5. K. H. Jacob-Friesen, "Dei Goldscheibe von Moordorf bei Aurich mit ihren britischen und nordischen Parallelen," in *ibid.*, 1931, pp. 25 ff.

6. Roussell, pp. 44–45, and cf. p. 42.

FRASNES HOARD

Two Torcs and Nine Coins

THE hoard and the torc! The words are almost magical for their deep romantic aura of archaeological adventure. The hoard speaks as the living witness to an arrested moment out of an ancient life drama. The torc, above any other single object, stands for the Celts, a mysterious and colorful barbaric people at the threshold between prehistory and history in Western Europe.

The torc is the very emblem of the Celts and the recognized symbolic attribute of barbaric protagonists in a long struggle between the classical and the non-classical world. It is in this cultural and aesthetic dichotomy that one of the critical essentials of medieval art—as opposed to Greco-Roman—is to be found. To the Greeks the torc signified non-Greek, or "barbarian," as they called anyone who was not Greek. This is the primary sense of the torc worn by King Darius in the famous mosaic of Alexander's victory over the Persians in the Battle of Issus (333 B.C.). But it is also true that torcs were actually used in Persia, from ancient Iranian to Achaemenid times. Among the Gauls the torc is the most distinctive article of adornment for their gods as shown in the sculptured representations of Cernunnos as well as other less precisely identified divinities of the Celtic pantheon. But in actual life, as well, this was both a national and social badge for their chiefs, dignitaries, and heroes. In death it must have been no less important, judging from those burials in which the torc is placed on the head of the deceased, as a crown. The torc became a prized battle trophy, sought by their rivals. Titus Manlius, a Roman of the fourth century B.C., assumed the epithet *Torquatus* to

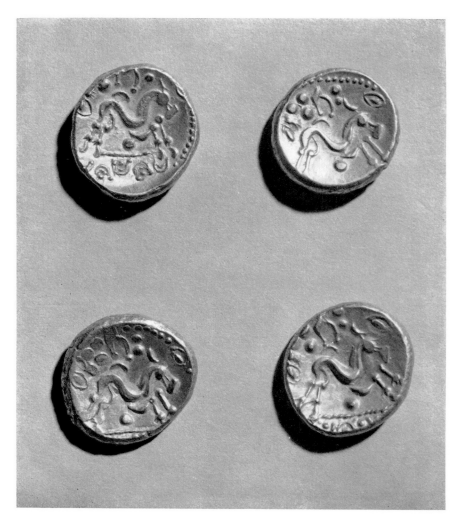

FOUR COINS

commemorate his defeat of an allegedly gigantic Gaul, presumably having also taken the torc of the defeated tribesman. The celebrated Dying Gaul in the Capitoline Museum wears the torc as his only body adornment and as the symbol of his people who were defeated by the Pergamene King Attalus in the second century B. C.

These were the Celts against whom Julius Caesar fought in the campaign which he chronicled in *The Gallic Wars* (58 B. C.), the book which opens with the classic of all schoolboys: "All Gaul is divided into three parts," the Belgae, the Aquitani, and the Celts. It is from the territory of the Belgae that the Guennol torcs came, and very likely from a time close to that of Caesar's campaign in northern Gaul. The large torc of the Collection is one of the most splendid of Celtic torcs to come down to us.

The hoard, of which the Guennol pieces are not only the finest, but also the sole remaining portion preserved as a group, was found in 1864 in the woods of Martimont, near Frasnes-lez-Buissenal, in the Hainaut, Belgium. The circumstances of the discovery have all the elements of suspense and fortuity of treasure-trove lore. On Febuary 5, 1864, a workman on the estates of Count Gustave de Lannoy, planting a tree near a spring called "The Fountain of Hell," found some gold objects just below the surface of the ground. In the contemporary report by E. Joly we read:[1]

It seems hard to believe, but such was the indifference of the finders to their discovery, that they didn't even bother to turn over more of the ground at the spot. Some neighbors, however, were more alert and picked up a few medallions simply by poking about the earth that was removed. It was really only after our first visit to the site, and after it was realized that the objects had some value, that real digging began, leading to the discovery of more medallions. This was soon pursued with such ardor that a crowd of men, women, and children, swarming from

*everywhere, armed with spades, pickaxes, and rakes, would soon
have turned over the entire woods, had not Count Lannoy re-
stored some order.*

*We see again, by another example, that you cannot get to a
site too soon after the first rumor of a find. Whatever else might
come of it, there is always some good that can be done. We are
told that from the first moment of the discovery, the objects were
carelessly tossed into the bottom of a cupboard, among household
utensils, after having satisfied the curiosity of those who were
there and after having been put through a rough and slipshod
examination. Luckily, no scrap-iron monger, or hide peddler,
happened along, for they are always keen on the scent of a good
windfall. This is what happened a few years ago at Beloeil just
when there was an important find of Roman medallions. No
doubt they would have gotten away with everything for a few
cents, as the supposed effects of some bishop, and nobody would
ever have heard of the precious antiquities of Frasnes.*

Of the fifty coins and two torcs which were found, only
the torcs and nine coins still remain together. Whether
other pieces were pilfered we will never know, nor can we
say what became of the other coins. What is known is that
the choice portion of the hoard went to Brussels with the
Count de Lannoy, and was soon sold to one of the dukes
of Arenberg, possibly to Englebert Auguste who died in
1875. The treasure remained in the Arenberg family's
possession until 1953, when it came to this country and was
sold to the present owners. Until about 1914 the hoard was
known to be in Belgium, but between 1914 and 1953 it was
lost from public sight. It could never be adequately published,
for it was known only from the old drawings of the first
publication by Joly in 1865. The treasure is deservedly
prized for its place in history, and archaeology in general,
but especially for Belgium, since it is one of the few im-

132

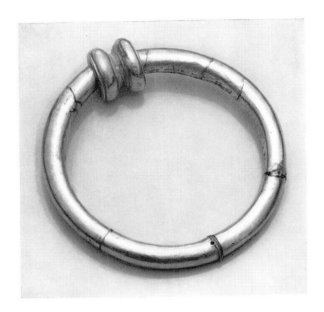

TWO TORCS

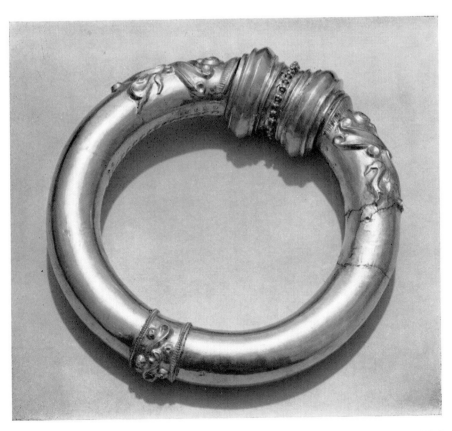

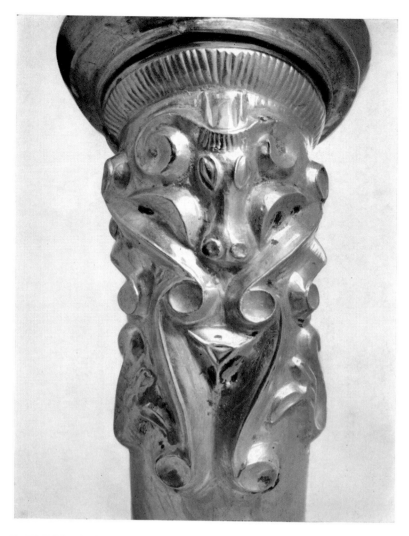

LARGER TORC—*Details*

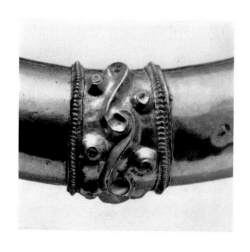

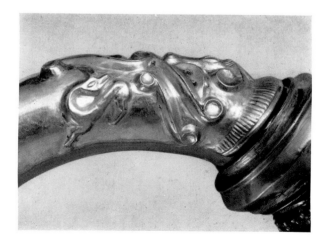

portant Celtic hoards found on Belgian soil.[2] The artistic quality, particularly of the large torc, makes this treasure worthy of considerable interest for the history of art as well.

The most valuable clue for dating the Frasnes hoard comes from the coins. Those nine which are still preserved are representative of the larger original group, judging from the report of Joly. They are what is known as uniface, "scyphate," gold staters, made of an alloy of gold and silver. In other words, the coins are struck on only one side —in this case, the convex face of the shallow dish-shape of the coin. They are typical of the Gallic coinage, showing a highly stylized and abstract galloping horse, identifiable with the coins issued by the Morini and the Nervii, between 75 B.C. and 50 B.C.[3] Both were Belgian tribes, the Nervii, in fact, dominating the region of the Hainaut where the hoard was discovered. As for the Morini, from the area around present Boulogne and not far from the Hainaut, their position in coastal trade might provide a simple explanation for the presence of their coins outside their own area. Since the coins show little wear, the assumption must be that the hoard was buried not too long after they were minted. The most serious disturbance in that period was the invasion by the Roman legions under Julius Caesar in 57 B.C. The hoard could easily represent hasty concealment in the face of the advancing legionnaires.

Before the Frasnes treasure came to the Collection in 1953, scholars had only the drawings of 1865 from which to study the torcs. On stylistic grounds, they were placed as early as the third or second century B.C. but with considerable hesitation.[4] The most recent opinion places them in the same period as the coins. Indeed, R. Rainbird Clarke considers the Frasnes torc to be of the same general type as one found in Snettisham (Norfolk), and the Broighter torc (Northern Ireland), both datable in the first century B.C.[5]

Both the Guennol torcs are formed on an iron ring core which is covered with a stiff paste of beeswax and resin, over which the thin "gold" shell was placed. The shell, mainly an alloy of gold with some silver, is more properly identifiable as electrum.[6] The torcs open laterally and may be pulled open to form two halves, separated on the axis of the terminal buffers on the frontal side and the simple rings at the back. The smaller torc is almost entirely plain, with buffers of rounded profile in the front, and narrow little hatched rings at the dorsal ends which also show a pin hole, used for locking the halves in place.[7]

It is the large torc which stands as the great work of these artisans of the late Iron Age. In every way its form and embellishment place it in the rank of the most magnificent of existing Celtic torcs. The buffers are enhanced by subordinate moldings and, at the center, by a delicate ring with beaded elements.[8] Both frontal surfaces are embossed with symmetrically matched reliefs of animal and geometrical designs. The dorsal ring is also embossed with a simpler motif. The composition of the frontal reliefs consists of a ram's head with volute horns as the central element, framed at the sides and below by elongated S-scrolls which meet on a center line and flow into each other, constituting "lyre" patterns. A pair of contorted animals, whose heads are turned backward, flank the lower scrolls.

While much of the geometrical vocabulary of Celtic art reaches back to indigenous roots in prehistoric subsoil, many of the characteristic motifs of their artistic repertoire derive from Scythian and Sarmatian inspiration. The motif of the animal mask enframed by scrolls is one of those derivative elements. Not less interesting in this respect is the practice of angular shaping of the volumes, to be seen in the profiles of the buffers, and in the modeling of the scrolls. The latter also show another peculiarity, that of a "ridge

136

rib" along the crest of the relief. Both devices are essentially unclassical, if not anticlassical, in that they tend to transform the roundness of natural volumes into geometric abstraction. They are common formal modes in Scythian art, but by the time we encounter them in these Celtic works they have been thoroughly assimilated and transformed within a homogenous Celtic artistic idiom. The shallow circular depressions at the terminals of the scrolls may reflect Sarmatian technical practice, where they would have been more deeply recessed and employed to hold colored inlays.

The large size of the Guennol torc is unusual, although one of the torcs found at Snettisham is even larger. It must have belonged to a huge man.[9] The use of gold, rather than iron or bronze, would point to an owner of some rank in his tribe. Considering the use of such torcs on statues of divinities, their curious ceremonial use in burials, and their obvious implications for status and wealth, their decoration could scarcely be of superficial intention. The ram heads—in some instances bulls and other animals are used—must have been selected for their religious meaning, either in the apotropaic sense of protection, or in some kind of magical transference of animal power to the owner. Joly thought the smaller torc might have been an armlet, in which case it would have adorned a powerful arm indeed. In a hoard as homogenous as that from Frasnes-lez-Buissenal, it is conceivable that all the pieces belonged to one person. The unknown owner would have been a man of considerable physical stature, one of those "giants" of whom the Romans stood in awe. Even Julius Caesar, at the beginning of his book on the Gallic wars, remarked that of all the tribes, "the mightiest are the Belgae." If, as supposed, the hoard was buried at the time of the Roman wars, it must have been by the family or retainers of the unknown hero, whom we could not imagine being separated from his torcs except in

death. His most treasured possessions were concealed in a secret place, probably oriented in relation to "The Fountain of Hell" as an easily found landmark. It was surely meant to be recovered, by his family or tribesmen, when they could safely return from a temporary retreat. The day never came. After lying buried for nearly two millennia it came to light again on a peaceful horizon and, miraculously, remains for us today.

FRASNES HOARD

Large torque: diameter 7.9"; diameter of
tube .5"; thickness of gold
shell .0009"

Smaller torque: diameter 4.8"; diameter of
tube 1.1"; thickness of gold
shell .0009"

Celtic (Belgian). Coins of the
Nervii and Morini, 75–57 B. C.

PROVENANCE: Found in the woods of Martinot, near Frasnes-lez-Buissenal (Hainaut), Belgium, by Fidele Teintenier on February 5, 1864. Taken to Brussels by Count Gustave de Lannoy.

EX COLL.: Sold to the d'Arenberg family, Brussels, possibly to the Duke Englebert August (d. 1875). It remained in the possession of the d'Arenbergs until 1953. Until 1914 it was in Belgium but was probably in Germany between 1914 and 1953.

BIBLIOGRAPHY: In addition to the items cited in the notes below, the Frasnes treasure is mentioned, discussed, or reproduced in the following works: *Dictionnaire . . . du Hainaut*, Mons, 1879, p. 197; E. F. Von Tröltsch, *Fund-Statistik der vorrömischen Metallzeit in Rheingebiete*, Stuttgart, 1884, pp. 79–89 (reviewed by H. Schuermans, in *Bulletin des commissions royales d'art et d'archéologie*, XXIV, 1885, pp. 205–213); C. Van Dessel, *Topographie des voies romaines de la Belgique*, Brussels, 1877, p. 93; A. Blanchet, *Traité des monnaies gauloises*, Paris, 1905, II, p. 605, pl. 51; J. Déchelette, *Manuel d'archéologie préhistorique, celtique et gallo-romaine*, Paris, 1927, IV, pp. 843–845, fig. 586; A. Loë, *Belgique ancienne: Catalogue descriptif et raisonné*, Brussels, 1931, II, pp. 201, 235, fig. 111; J. Harmand, *La Préhistoire. Encyclopedie par l'image*, Paris, 1931, p. 45, ill.; H. Danthine, "De praehistorie van het suiden," in J. A. Van Houtte et al., eds., *Algemene Geschiedenis der Nederlanden*, Utrecht, 1949, pt. I, p. 35, pl. v, 2; S. Collen-Gevaert, *Histoire des arts du métal en Belgique*, Académie royale de Belgique, *Mémoires* VII, Brussels, 1951, p. 93; M. E. Mariën, *Oud-België, van de Eerste landbouwers tot de Komst van Caesar*, Antwerp, 1952, pp. 401–402, 491; S. J. de Laet, *The Low Countries*, New York [1955], pp. 165, 166, figs. 58–59; *Enciclopedia dell'arte antica*, Rome, 1959, II, p. 465.

138

NOTES

1. E. Joly, "Antiquités celtiques trouvées sur le térritoire de Frasnes-les-Buissenal, 5 février, 1864" in *Annales du cercle archéologique de Mons*, VI, 1865, pp. 353–364, pl. I–III; and in *ibid.*, VII, p. 193. Substantially the same as the report by Joly in *L'Echo de Renaix*, February 21, 1864.

2. Cf. S. J. de Laet, *Archaeology and Its Problems*, New York, 1956, p. 122, "It is high time, too, to put a stop to the exportation to foreign countries of the best pieces found in Belgian soil. The silver vase of Neerharen is to be found in the Leyden Museum, the gold torques from Frasnes-les-Buissenal, that were thought to have been lost, have just reappeared in the Metropolitan Museum of New York."

3. Although generally recognized as Gallic staters by early scholars, it was Professor Pink (Bundessammlung von Medaillen, Münzen und Geldzeichen, Vienna) who first identified them as belonging to the second quarter of the first century B. C. (see P. Jacobsthal, *Early Celtic Art*, Oxford, 1944, p. 99). This identification was confirmed by R. R. Clarke (see note 5 below). For earlier bibliography on the coins, see C. J. Comhaire, "Les Premiers Âges du métal dans les bassins de la Meuse et de l'Escaut," *Bulletin de la Société d'anthropologie de Bruxelles*, XIII, 1894–1895, works cited on pp. 123, 126 note 8, 127 note 1.

4. Jacobsthal, pp. 98–99, no. 70, pl. 51. See also J. Hawkes, *Aspects of Archaeology*, London, 1951, p. 192, no. 86.

5. See R. R. Clarke, "The Early Iron Age Treasure from Snettisham, Norfolk," in *Proceedings of the Prehistoric Society*, XX, 1951, pp. 43–44. The Frasnes treasure is also cited by Clarke in his early reports on the Snettisham find: *The Illustrated London News*, January 1, 1949, p. 22, and *East Anglian Magazine*, February 1949, p. 287. Comparisons between the Broighter torc and the Frasnes torcs are cited by: A. J. Evans, in *Archaeologia*, LV, 2, 1897, p. 399, fig. 4, p. 401, fig. 7; W. Ridgeway, "The Date of the First Shaping of the Cuchulainn Saga," *Proceedings of the British Academy*, 1905–1906, p. 159; E. C. R. Armstrong, *Guide to the Collection of Irish Antiquities, Catalogue of Irish Gold Ornaments in the Collection of the Royal Irish Academy*, 2nd ed., Dublin, 1933, p. 26; E. T. Leeds, *Celtic Ornament in the British Isles down to A. D. 700*, Oxford, 1933, p. 134.

6. The following spectrographic analysis, made in August 1953, is reported by Marie Farnsworth:

The sample from the large torque has a trace of iron, a small amount of copper and a larger amount of silver. Other trace impurities were not found. I estimate the iron to be small, not more than 0.1 per cent. The amount of copper is certainly more than a trace but in fairly small amount; I believe I can safely estimate it to be between 2 and 2.5 per cent. Since the sample is 87.76 per cent gold, the silver must be close to 10 per cent.

The sample from the small torque also has a trace of iron. The spectrogram shows considerably more copper than silver than [the spectrogram] for the large torque and considerably less gold. In addition tin and lead are present in trace amounts, very probably not more than 0.001 per cent for either metal. The iron is almost identical with the amount found in the other sample, not more than 0.01 per cent. Since the copper and silver are both present in large amount, it is not possible to estimate the percentage of each too closely. I feel fairly safe in saying, however, that the silver is probably somewhat more than 15 per cent and the copper somewhat more than 20 per cent.

Clarke reports that analysis of the Snettisham torc shows an average content of 69 per cent gold, 27 per cent silver, 3 per cent copper, and 0.2 per cent iron.

7. Both torcs show a series of punchmarks with dot-and-circle pattern on the inner face of the tube. Similar marks are reported for the tubular torcs from the Snettisham find. These marks have no apparent technical function and may be ownership indications of some sort.

8. Recent restoration, for the present owners, has been questioned with respect to the placing of this pearled ring. However, the ring showed a piece of sheet metal from the large torc, still attached to the inner surface of the ring. Comhaire, in 1894 (see note 2, above), corrects his opinion expressed in the text, when he comments on the illustrations to pl. xii. He had thought the ring was a separate piece but states that it is indeed in its proper place as he saw it restored and displayed in the Arenberg Collection.

9. Clarke suggested the possibility that this torc might have been placed on the neck of a wooden idol. His conclusion was based on the question of the working of the torc for adjustment in actual wear. Since the torc is not rigid, and may be opened by pulling apart laterally, the opinion that it was used only for an idol is weakened. Moreover, it has been observed that where the sharp repoussé designs would have touched the neck, they have been summarily and roughly filed down. This would indicate hasty reworking for practical comfort in actual wear.

GALLO-ROMAN DISC FIBULA

THE barbaric sophistication of the Guennol fibula may be read as both a symbol and an artistic expression of the primary component forces in early European art. One of these is the Greco-Roman tradition, whose naturalistic style of anthropocentric orientation gave Mediterranean art its ineradicable stamp. The other, deeply established on prehistoric foundations and fused with diverse barbaric strains, became the indigenous Northern art of essentially abstract principle and anticlassical predisposition. An epitome of axial balance and symmetry, regularity and clarity of articulation and composition, the Guennol fibula is at the same time an expression of such opposite traits as unrefined vigor of line and untamed, barbaric color contrasts. Whereas the former qualities stem from the art of Rome in classical antiquity, the latter betray the Northern, Celtic subsoil in which Roman dominion grew during the second century A. D., when the fibula was probably made.

140

This fibula is a distinctive type whose characteristics must be noted for every possible significance. It is of gilt bronze in scalloped circular shape, with three concentric zones of colored enamel. The two outer zones are divided into radial sectors of blue, white, and red, and the inner zone is a band of orange dotted with blue.[1] At the center is a spherical metal hub connected with the main body of the disc by four slender spokes on the cardinal axes. Each of its elements, technical and formal, bears interestingly on the identification of this piece and the interpretation of its place in the history of art.

The technique of champlevé enamel is that of filling areas of the surface, previously scooped out in the desired shapes, with heat-fused vitreous colored powders to achieve a permanent color decoration for metal objects. It is typically Celtic, for the primitive stages of the technique go back to the Early Iron Age, and it reaches culminating refinement in Celtic Britain well before the Roman conquest. An early third century writer at the court in Rome (Philostratus) still found this fascinating non-Roman craft worthy of a lengthy aside, reporting: "they say that the barbarians . . . pour these colors on heated bronze, and that they adhere, become as hard as stone, and preserve the designs that are made in them." Here, then, is one of the most characteristic and important contributions of the Celtic artisans to Roman Europe and to the art of the Christian Middle Ages.

In the Roman Empire enameled fibulae appear only toward the end of the first century A. D. and reach their highest popularity between about A. D. 125 and A. D. 225. It is almost to be expected that the principal centers of their manufacture lie outside of Italy—in northern Gaul (including the Low Countries), the Rhineland, and Great Britain. The actual site from which our fibula originally came is un-

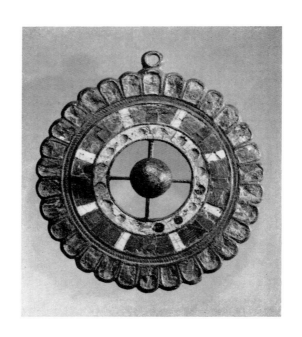

GALLO-ROMAN DISC FIBULA

known. It is, however, plausibly reported to have been found in Germany and could well have been made in the Rhineland where closely related pieces have been discovered *in situ*.[2] From the finds it is believed that the main Rhenish centers were in or near Cologne, Trier, and Mainz.

Fibulae with this particular combination of elements— circular shape, scalloped rim, concentric enameled sectors, openwork spokes and hub—are also to be found in France,[3] and in the regions of modern Belgium and Holland[4]; one of the concentration points for their production and distribution was in the zone between the Sambre and the Meuse. When they appear outside the centers mentioned they are apparently intrusive, as in the instance of a fine example found in Pannonia (modern Hungary), which has been explained as an import via the Danube trade route from Gaul.[5]

Although our example may be most simply described as a disc fibula, it incorporates two basic forms which are to be identified separately, thus affording evidence for their history and meaning. On the one hand we find unperforated disc fibulae with scalloped edges, which may be called rosette fibulae. On the other hand, there exists an equally frequent type consisting of a single circular band, or rim, with a central hub and openwork spokes; this deserves the name of wheel fibula. Typologically the Guennol fibula must be placed after the wheel form but somewhat late in the development of the rosette variety, which postdates the wheel fibula. Chronologically, its date may be estimated between A. D. 125 and A. D. 175. For the development of Roman art this example stands at an approximate midpoint, when the more classicizing restraint of earlier imperial art is both receptive to anticlassical colorism and still capable of containing it within a rational architectonic order. That classical containing element resides largely in the composition and is expressed by the decisive metal limiting lines

143

between the zones and sectors, and by the hub and the spokes in the pronounced accentuation of the radial structure.

Already in the Bronze Age, from northern Europe to the Urals, wheels, discs, and even rosettes figured as emblems and objects in connection with solar worship.[6] There can be no mistaking the deliberate wheel shape among the earlier enameled fibulae, and from this the interpretation of the inner zones of our fibula must follow. This central motif is separated from the outer rosette rim by a heavy, ornamented metal border as if to underline the point of juncture of the two components. As for the rosette ring, its thirty divisions, if not an accident, may have been meant to express the corollary symbolism of a lunar month. Be that as it may, it is sufficient for the main argument to note that the wheel fibula as a type, with admitted variations, is both recognizable and consistent. That the motif could be explained as arbitrary decoration seems hardly conceivable, for the Celtic peoples in Roman times were still fresh from the age-old tradition of solar religion, which they had nurtured during so many centuries of prehistory. The Guennol fibula, one of the largest as well as richest of the wheel forms to preserve distinct hub and spokes, must have been prized for both its visual splendor and the talismanic solar potency which the design and color symbolically embodied.

With the fall of the Roman Empire and the coincidental upheavals of the new migrations, the wheel fibula as found in Gallo-Roman art seems to disappear. If it did not appeal to the later barbarians, it may well have been because of differences in religious practice or because to them the Roman ingredient of this form loomed more prominently than the Gallic. Whatever the reasons, about which one can only guess, the rosette type alone survives and is found in Frankish and Germanic examples of the sixth and seventh centuries.[7] It is possible that the rosette fibula became the

144

bearer of the original solar meaning. For the Christians of those centuries any overt reference to pagan solar belief would have been anathema and its more conspicuous symbols rejected. It is noteworthy that round brooches and pendants of Anglo-Saxon England commonly show a cruciform design as the central element.[8]

GALLO-ROMAN DISC FIBULA

Diameter 2.4″

Gallo-Roman, Rhenish (?), c. A. D. 125–175.

PROVENANCE: Said to have been found in Germany.

EXHIBITED: Metropolitan Museum of Art, New York, *Ancient Art from New York Private Collections*, December 1959–February 1960, p. 81, no. 313, pl. 102; Metropolitan Museum of Art since 1955.

NOTES

1. The technique employed in the inner zones, where the single enamel colors are not separated by the metal, is a distinctive and curious feature of these fibulae. There has been much speculation on the problem of how the different colors were kept from melting into each other in the course of enameling, e.g.: E. E. Viollet-le-Duc, *Dictionnaire raisonné du mobilier français*, Paris, 1871, II, pp. 208–211; L. F. Day, *Enameling*, London, 1907, pp. 22–23.

2. Among the published examples, similar fibulae are to be noted as follows: K. Exner, "Die provinzialrömischen Emailfibeln der Rheinlande," *Bericht der Römisch-Germanischen Kommission, 29, 1939*, Berlin, 1941, pp. 63, 106, pl. 14, nos. 5 III.28 and 11 III.28; C. Koenen, "Die vorrömischen, römischen und fränkischen Gräber in Andernach," *Jahrbücher des Vereins von Alterthumsfreunden im Rheinlande*, LXXXVI, 1888, pp. 148–230, no. 13, pl. IV.

3. F. Henry, *Emailleurs d'Occident*, Paris, 1933, pp. 65 ff., note fig. 35 (no. 2).

4. A. de Loë, *Belgique ancienne: Catalogue descriptif et raisonné*, Brussels, 1937, III, fig. 104 (7, 10) and cf. figs. 104 (12), 106 (12, 16), which are related but without openwork center; H. van de Weerd, *Inleiding tot de Gallo-Romeinsche Archeologie der Nederlanden*, Antwerp, 1944, figs. 69 (24c), 70.

5. I. Kovrig, *Pannonia*, Budapest, 1942, fig. 3; Cf. M. Abrami and A. Colnago, in *Jahreshefte des Osterreichischen Archäologischen Institutes in Wien*, XII, 1909, *Beiblatt*, p. 94, fig. 58 (Dalmatian).

6. B. N. Grabkov, "Deux Tombeaux de l'époque scythique aux environs de la ville d'Orenbourg," *Eurasia septentrionalis antiqua*, IV, 1929, p. 177, fig. 10, and p. 179, fig. 15. Cf. J. Baltrusaitis, "Quelques Survivances des symboles solaires dans l'art du moyen âge," *Gazette des beaux-arts*, XVII, 1937, pp. 75–82. For Iron Age and Bronze Age examples, cf. N. Aberg, *Bronzezeitliche und früheisenzeitliche Chronologie*, Stockholm, 1931, pt. II, *Hallstattzeit*, figs. 25, 136, 224, and 1935, pt. V, *Mitteleuropäische Hochbronzezeit*, fig. 32.

7. E. Salin, *Rhin et Orient*, Paris, 1939, I, pls. III.1, XVII. 6–4.

8. N. Aberg, *The Anglo-Saxons in England*, Uppsala, 1926, figs. 192–196, 240–245, 258–262.

HAUTE-SAVOIE
CLOISONNE ENAMEL

CONCERNING the given history of this enigmatic green beast and the beautiful little enameled gold plaque which it inhabits, we have only the report that it is said to have been found in Haute-Savoie about 1860. It is as bold and free in design as it is fine in enameling quality. The green and brown vitreous glazes have a most delicate translucency, and the white a pristine clarity. On the technical side this piece leads us back to Byzantium, the Christian center for the most refined practice of cloisonné enamelwork, and the source of models for technique and style in Western Europe. But the drawing leaves no doubt that this is a product of European craft, for here there is none of the characteristic Byzantine surface patterned in tiny ornamental units and fine webs of gold line. Instead, the gold filaments which make the cellular partitions between the colors establish a vigorous, if meandering, drawing line, boldly delineating the beast and his surrounding foliate environment. Indeed, this uniform gold line is used further, within the main contours of the figured elements, in a swift calligraphy of spiky, scaly, and wavy patterns. As for the beast, he is a hybrid monster, snouted, winged, and altogether dragon-like. Such creatures are familiar throughout Western medieval art, although an exact counterpart cannot be cited, but they are rare, if at all to be found, in Byzantium. What these inventions of medieval fantasy meant in Christian art is not easy to say, except when they appear in a clearly demonic aspect and context where they are allusive of evil, sin, and the devil. On the other hand, we have the famous challenge by St. Bernard of Clairvaux, in the first half of the twelfth century: "What profit is there in those ridiculous monsters,

146

in that marvelous and deformed comeliness, that comely deformity?" Only if we knew the original context of this plaque could we hope to say just what the green beast signified, if it did have a definable meaning.

Considering that the Guennol plaque shows but a single animal and some ornament, and that it must originally have been but a small unit in a more or less complex work, the problem of determining its date and place of origin presents obvious difficulties. Nevertheless, even on the circumscribed evidence of the piece alone, it is still possible to proceed to a hypothetical solution, the final test of which must await future findings. The simple and brusque character of the drawing might point either to an early style, or to provincial production in a late period. Given the lovely quality of the enamelwork, however, the plaque could hardly be regarded as provincial and must antedate the twelfth century, when technique, as well as design, had become more complex and elaborate. Nor could this piece be easily placed at the earlier end of the scale in the European history of cloisonné enamels. The early works of Langobardic, Frankish, and Anglo-Saxon artisans in the seventh and eighth centuries are distinctly rudimentary, especially in comparison with this plaque. Their gold wires are rather heavy and the drawing is rigidly archaic. Not before the end of the tenth or the early eleventh century do we encounter cloisonné enamels which afford promising comparisons with our plaque. Those related pieces come, in the main, from centers in old Lorraine, as well as in the Ottonian Empire, where cloisonné enamels were being produced in considerable quantity and under the direct inspiration of Byzantine models.

While the style of our enamel is adumbrated in several late tenth century pieces thought to come from Champagne and Maastricht,[1] it becomes further approximated as we turn to Ottonian works from the region of the Rhine,

147

toward the year A.D. 1000. The so-called "second" and "third" processional crosses in the Essen Minster have cloisonné plaques set in the terminals of the arms.[2] It is in these plaques that we may observe freedom in delineation of contours, calligraphic scaling, and scalloping patterns, as well as fine enamel firing, which suggest that these come from the ateliers to which the style of the plaque in the Collection must be related. Again, on the hemisphere bands of the famous Holy Crown of Hungary of about the same date, the paired animals flanking the heads of the apostles show analogous qualities.[3] The origin, and even the date of this crown has been much debated, mainly with respect to the workmanship of the elements of the hemisphere. It has been dated as late as the beginning of the twelfth century, and placed in Regensburg and in Rome. The alternative localizations of the crown are not fortuitous in view of the close political and cultural ties between Italy and Ottonian Germany. Thus, it is hardly surprising that a number of pieces of presumed Lombardic origin also show points of similarity with the Guennol enamel.[4]

Obviously, then, even among some of the best-known works of the eleventh century, it is not always possible to determine an exact point of origin or date. The similarities adduced in relationship to this plaque are not entirely definitive. The green beast has nascent elements of compactness, and systematization of composition and ornament, which hint at a somewhat later date than the cloisonné style of the Essen crosses. As for its style, this work seems to be quite free of those Byzantine traits which have left such a strong impression on the Italian and Ottonian German centers. It is therefore proposed that the Guennol cloisonné plaque be dated toward the middle of the eleventh century, and that it originated in the region of old Lorraine, paralleling developments in the Upper Rhineland. Curiously

148

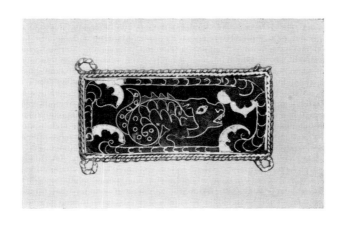

HAUTE-SAVOIE
CLOISONNE ENAMEL

enough, the location of its reported find in Haute-Savoie places the Guennol enamel not too far from this hypothetical center of origin.

How the Guennol enamel was originally used would depend in part on whether or not the gold border strips with looped ends are contemporary with the rest. If they are, then the plaque must have been one element in a connected series, possibly used as body or costume ornament. But if they are not, then we can only observe that oblong little plaques of this type were employed in a number of different ways on various articles of the church treasures. Plaques of similar size and proportion are used to frame the edges of reliquary chests, such as the St. Andrew reliquary in the cathedral treasury in Trier, and the St. Felix reliquary in Aachen. In both works the plaques are mainly floral, but an occasional single animal does appear. Again, on the late tenth century paten of St. Gauzelin in Nancy Cathedral, one of the remaining enamels, set in the rim, shows a single animal. On the rim of the guard of the splendid Cosmas and Damianus sword in the Essen Minster treasury, ornamental cloisonné plaques of long rectangular proportions are also to be noted. As early as the eighth century we find little rectangular enameled plaques showing a variety of beasts and birds, forming the framing border of the famous Lindau Gospel book cover in the Morgan Library. So far as may be discovered from published material, only one work with paired loops, resembling those in this enamel, is to be found. That work is a necklace of seventeen linked enamel plaques formerly in the Figdor Collection of Vienna, but the necklace dates from the sixteenth century.[5] It is conceivable that during this same period, the very latest phase of the Middle Ages in the North, the loops may have been added to our plaque.

Length 2.1″

Lorraine (?), mid-XI century

Ex Coll.: Formerly in a private collection near Lyons.

Exhibited: Metropolitan Museum of Art since 1951.

NOTES

1. Evangelist plaques in the cathedral of Troyes, late tenth century, possibly from Champagne; enamel plaques on bookcover from Saint-Denis, now in the Louvre, from Maastricht, or Reims. (Reproduced in H. Swarzenski, *Monuments of Romanesque Art*, Chicago, 1954, figs. 57–60.)

2. Cf. Swarzenski, figs. 64–65.

3. See P. J. Kelleher, *The Holy Crown of Hungary*, American Academy in Rome. Papers and Monographs XIII, Rome, 1951, pls. xiv–xv.

4. For example, the reliquary cross in the cathedral of Velletri, reproduced in Y. Hackenbroch, *Italienisches Email des frühen Mittelalters*, Basel-Leipzig, 1938, figs. 42–45.

5. M. Rosenberg, *Studien über Goldschmiedekunst in der Sammlung Figdor*, Kunst und Handwerk, XIV, Vienna, 1911, fig. 67 and frontispiece.

MOSAN RELIQUARY TRIPTYCH

Upon those special articles needed for church services in the Middle Ages were lavished the most splendid materials, the finest possible craftsmanship. In this class of work, so deceptively known as the "minor arts" but better called the sumptuous arts, the Guennol reliquary triptych stands as a masterpiece. Its distinction is well in keeping with the fact that it comes from the region of the Meuse, leading among European centers for the production of such

151

works, and from the height of the Romanesque period. Nor is it surprising that our triptych has been attributed to the workshop of Godefroid de Huy, a master already recognized in his own day as "second to no other goldsmith of his time."[1] This piece, worked with the precious perfection of jewelry, is less than eleven inches high, but the formal conception is expressed with the grandeur and monumentality of large-scale painting. The triptych was made to provide a container which might worthily preserve, and meaningfully present, a prized relic, that of the True Cross. Inspired by this important function and requisite to it, the superb qualities of art and craft, and the sophisticated program of embellishment of this triptych, are highly appropriate.

The importance of reliquaries in the church is witnessed by their place in the liturgy, and by the requirement of holy relics for the consecration of an altar and, therewith, of the church building. Such was the popular appeal of relics that, despite official disapproval, their veneration often transcended the bounds of propriety to extremes of idolatrous intensity.

While the actual relic in the Guennol triptych is less than an inch or so in size, the rest of the work is not merely arbitrary or gratuitous embellishment. Indeed, the entire setting served two correlative purposes: to dramatize the relic, and to propound the message of its theological significance in clear, didactic terms. For the purpose of dramatization, the use of a triptych with hinged wings proved most effective. Under ordinary circumstances this triptych would have been shown with the wings in a closed position, covering the central panel. Thus closed, only the brown monochrome ornamental decoration on the outer side of the shutters would be visible. At the top, however, the figured and polychrome treatment of the lunette remained in sight, providing a visual prelude, in which the theme and the promise

152

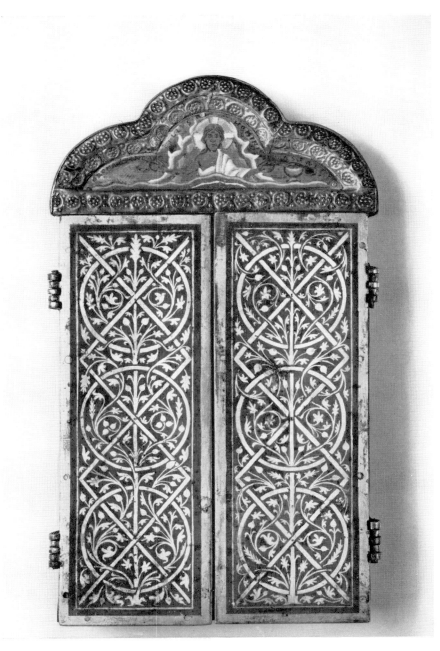

TRIPTYCH CLOSED

153

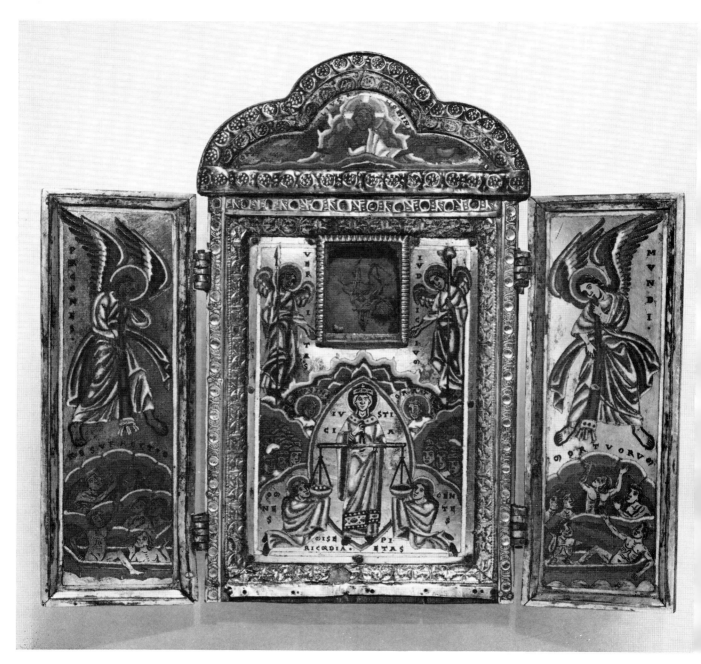

TRIPTYCH OPEN

154

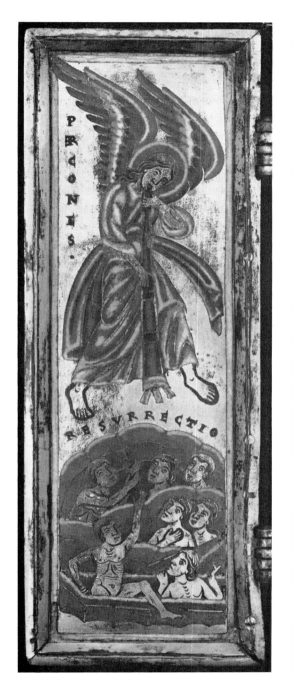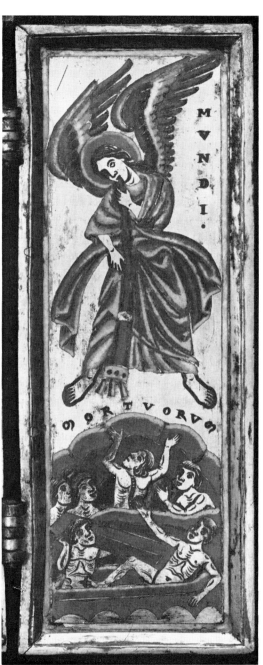

WINGS OF TRIPTYCH

of colorful splendor of the interior were announced. Once opened, the triptych presents the mystery unveiled, in a glorious gold and polychrome spectacle, unfolding the theme of the lunette, and revealing the focus of the occasion, the relic set and framed in the little rectangular compartment of the central panel. The receptacle is enclosed by glass, originally probably a piece of rock crystal, thus leaving the relic visible but protected.

What is the program which the triptych develops, through figures and scenes, in propounding the significance of the relic?[2] The relic itself is the material token of the Cross and the Crucifixion, harking back to the last hours of Christ the Man, in earthly life and time. The rest of the triptych expresses the ultimate fulfillment of that event for all of mankind at the end of time, on the final day of the world. That fulfillment is interpreted at two levels, coinciding with two different kinds of visual imagery, one primarily historical, the other allegorical.

The historical scenes, or those which depict events recounted in Scripture, are found in the lunette and the wings. The beginning of the end is instituted with the Second Coming of the Son of Man (*Filius Hominis*) who appears in the clouds of heaven, crowning the triptych. At this sign, the angelic heralds of the world (*Praecones Mundi*) trumpet the Resurrection of the Dead (*Resurrectio Mortuorum*), the subject of the wings. Since Christ is depicted with extended hands, showing His wounds, and accompanied by the cup of vinegar and the crown of thorns (*Vas Aceti*, and *Corona Spinea*), the Second Coming is linked with the Crucifixion and the doctrine that Christ the Man suffered death on the Cross for the salvation of mankind.

As if in response to the mystical presence of the relic, the central panel abandons the historical method in favor of an allegorical mode and schematic composition. The change is

156

geared to the shift from those events which lead to the Resurrection of the Dead, to a didactic exposition of Salvation through the Cross. This is not a Judgment scene, in which the crucial alternatives of salvation and damnation are both expressed. Instead, it is a one-sided exposition of redemption through Virtue in a perfect final balance, through the Grace brought by Christ (symbolically, the Cross), and 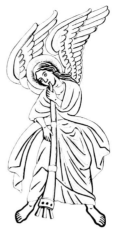 the Church, as the way of salvation. The use of images on a reliquary for the purpose of such moral teaching is not only appropriate, it was indeed urged by the churchmen of the period. One early twelfth century sermon says: "If the relics of the saints were to remain hidden and did not shine forth with the symbols of the virtues, what could stir up a longing for heaven in the hard and stony heart of man? What would be capable of freeing it from vice and restoring it to virtue?"[3]

The composition of the upper half of the central plaque derives its formula from Byzantine icons in which a pair of angels, holding lance and sponge, flank an empty cross.[4] This conscious borrowing is ingeniously conceived, for the hieratic Byzantine treatment lends itself well to the purpose of the Mosan artist which was to present a symbolic statement of the meaning of the Cross, rather than the event of the Crucifixion. Thus, the angels are designated as Truth (*Veritas*), and Judgment (*Judicium*), an explicit designation not to be found in any of the Byzantine prototypes. Therewith, the Cross becomes equated with Christ, for the *Lignum Vitae* must now signify "the King of Heaven, all whose works are truth and his ways judgment" (Daniel iv: 37). This concept finds expression in the New Testament, too, as in the Pauline epistle where the judgment of God according to truth, is invoked (Romans ii: 2).

In the lower half we find the theme of the Cross equated with the idea of a balance, since that is the critical attribute of the main figure, who is also crowned, wears queenly robes, and is set in a mandorla. That figure is labeled *Justitia*, personifying the cardinal virtue which bears pertinently on both Truth and Judgment, above. But the complex of attributes of Justice points to complementary meaning which this figure is intended to carry, that of *Ecclesia*. As for the scales, which might seem to resolve the interpretation in favor of Justice as the exclusive symbolic intention, there is a strong line of medieval exegesis which confirms the *Ecclesia* reading. In a sermon attributed to St. Bernard, the Cross is described as "the balance of Christ's body, who is Ecclesia."[5]

The theme of the central panel has been explained as a Disputation among the Virtues, who contend for the soul of man.[6] However, the Virtues in our plaque do not dispute, nor do they match the texts of such disputations in the action of the figures, their place in the composition, or in the particular participants. In every way, the theme of our plaque appears to be that of the perfect equilibrium in the salvation made possible to all the nations *(Omnes Gentes)* through the Grace which came by Christ. It is the scheme of salvation and not judgment which is enunciated here, in the sense in which John writes: "for I am not come to judge the world but to save the world" (John xii: 47)—hence the tripartite equation which dominates the main panel; that of the Cross, the Balance, and Ecclesia. As for the bearing of Truth and Judgment on this theme, the sense may be clarified if we recall the words of Christ: "and yet if I judge, my judgement is true" (John viii: 16). Thus Truth and Judgment relate to and explain the particular Virtues which appear, at right and left, under *Veritas* and *Judicium*. In the King of Heaven, "all whose works are truth"[7] we have the divine

158

prototype for the works of man which will lead to salvation, namely: Mercy and Almsgiving *(Misericordia* and *Elemosina).* Where the Lord's way is judgment, the way for man is through Piety *(Pietas)* and Prayer *(Oratio).* As for the scale pans, these are in perfect balance and actually have three little weights indicated on either side.[8] The interpretation of this measured balance may also derive from the Cross and the Balance, in which the Christ's sacrifice balanced out sin, which became the lot of man after the Fall.

If there is a single textual source which might account for all the elements in the main panel of this triptych, as well as the related subjects on the rest of the work, it has not yet been found. As for those citations from Scripture and Commentaries, given above, these are not meant to show actual sources but to serve as examples of the kind of scriptural evidence available to support a consistent reading of what is shown in the triptych. All that we can find in the texts, and much more that we may never know, would have been familiar knowledge to the theologians and the learned artists who planned and carried out this subtle pictorial exegesis on the theme of the Cross and the Balance in the plan of salvation. That this composition cannot be rigidly ascribed to some unknown yet specific written text may be readily demonstrated from a number of other reliquaries created in this same region and time. In those reliquaries we find that the system of grouping and composition of personifications may be flexibly manipulated to effect varied accents in the interpretation. The Cross reliquary of the church of Sainte-Croix, in Liège, employs the same group of Truth and Judgment flanking the relic, but the only other Virtue present is Mercy, placed between the two figures, above the relic.[9] Below this group are the resurrected dead, depicted in the passive attitudes of *Omnes Gentes* in our central panel.

159

Veritas, in some of the shrines, occupies the central and primary position, presiding over the Cardinal Virtues on the Brussels reliquary of St. Gondulf,[10] or holding the scales, as on the shrine of St. Servatius, in Maastricht.[11]

Just as the sophisticated intellectual program places our triptych among the most brilliant productions from the valley of the Meuse, so also does its more purely formal character place it in the forefront of artistic creations of the period. Romanesque style during the first half of the twelfth century, as manifested in metalwork and enamels, tended to stress strictly enclosed silhouettes, strong patterning of pure color areas, and the use of firm lines within the main contours to create separated compartments. The phase of development epitomized in the group of works attributed to Godefroid and his circle represents a significant change over the older conventions.[12] The style now explores new means to unify modeling of the figure as a whole, and to achieve organic homogeneity and plasticity.[13] In our triptych this may be seen in the departures from continuous silhouetting contour lines. Those lines are interrupted at various points and brought into the main interior forms to some extent, strengthening the modeling of the figures and accentuating their organic articulation. As for the metallic divisions which once made for the compartmentation within the figures, these are now reduced in number and in thickness, thus attenuating their separative force and subordinating them to color. In place of the system of distinct areas of uniformly intense color, our artist employs gradations in value and hue of single and related colors, within an area. Some figures, like that of Justice, are colored in hue and value gradations nicely selected to approach monochrome, through which the simple volumes are clarified and united.

The use of metal plaques mounted on wood, in the making of this triptych, is motivated by the fact that it is, after all,

an object for use, however specialized. As for the enamel-work, fired glazes had long been proven to be the most effective way of adding lasting color embellishment to metal surfaces. Champlevé enamel, which is used for all the figure decoration of our triptych, makes for colors of remarkable purity, depth, and permanence, due to the thickness of the glaze, and degree of translucence, and impermeability. Set in a framework of gilt copper, the result is one of shining splendor. Moreover, the use of different materials of palpable thickness has the effect of lending tangible reality to the symbolic eschatological message. The shutters alone are decorated in *émail brun*, in which a brown color is obtained by applying linseed oil to the heated copper to form an adhering film; through this the design is scraped, exposing bare copper which may then be gilt.[14] This negative, and purely surface technique, contrasts nicely with the positive character of champlevé, with the result that the shutter decoration—even on these technical grounds—provides an appropriate monochrome veil of abstract and geometric pattern, to conceal the real mystery.[15]

Thus, neither the artistic means nor the program of subject matter may be properly or completely understood apart from each other.[16] We may observe that for the narrative event of the Resurrection the artist has chosen to compose his subject in scenic fashion. The angels in the skies, with sweeping wings and fluttering robes, energetically blow their trumpets. Responding to this call, the dead are roused to gesticulating life as they rise from the earth or climb out of their coffins. On the other hand, for the highly abstract exegesis of the central plaque, the artist has devised a quasi-geometrical compositional schema within which the figures are essentially symbolic hieroglyphs, inactive but for those limited didactic gestures requisite to their emblematic function. The compositional network here serves to distinguish

161

the component symbolic elements and, at the same time, to show how they work and relate to each other for the meaning of the whole. Linking these two types of composition and subject matter is the representation of the Second Coming of Christ, which is historical and yet highly symbolic. Moreover, its position at the apex requires that it relate to the axial composition of the central panel. Thus, Christ is shown in frontal symmetry, while the emblems of the Passion are evenly balanced on either side. When the triptych is closed, the function of the lunette is even more important, for it then becomes the designated beginning in the reading of the scheme of salvation.

Whether or not the Guennol triptych was made in the atelier of Godefroid de Huy can hardly be decided at this time and in the present state of our knowledge of his works and style.[17] There can be no question, however, that the style, technique, and iconography relate our triptych very closely to some of the finest of the works attributed, more or less certainly, to this master. The few which bear documented connections with Godefroid de Huy were commissioned by the Abbot Wibald of Stavelot, whose scholarly exchange of letters with the artist attests to the intellectual climate in which works such as our triptych could be produced.

TRIPTYCH

Height 10.6″ Width (when open) 11.5″

Mosan (Stavelot?), c. 1160

Ex Coll.: Archbishop of Liège; the dukes of Arenberg, Brussels and Schloss Nordkirchen.

Bibliography: *La Collection Dutuit*, exhibition catalogue, Paris, n.d., description for pl. xxviii; O. von Falke and H. Grauberger, eds., *Deutsche Schmelzarbeiten des Mittelalters und andere Kunstwerke*, Frankfort, 1904, p. 68; J. Helbig, in *Art flamand et hollandais*, V, 1906, p. 89, fig. 90; M. Creutz, "Die Goldschmiedekunst des Rhein-Maas-Gebietes," in *Belgische Kunstdenkmäler*, ed. P. Clemen,

Munich, 1923, I, p. 133; G. Terme, *L'Art ancien au pays de Liège*, Liège, 1929, I, pl. 9; J. Compte de Borchgrave d'Altena, "Des Figures de vertues dans l'art mosan au XIIe siècle," *Bulletin des Musées royaux d'art et d'histoire*, V, 1933, p. 16; A. Katzenellenbogen, *Allegories of the Virtues and Vices in Mediaeval Art*, London, 1939, p. 48, note 2; E. B. Garrison, Jr., in *The Burlington Magazine*, LXXXVIII, September 1946, pp. 217 ff., pl. 11 F; *idem, Italian Romanesque Panel Painting*, Florence, 1949, p. 137; S. Collon-Gevaert, *Histoire des arts du métal en Belgique*, Académie Royal de Belgique, *Mémoires* VII, Brussels, 1951, p. 188; J. Lejeune, *Art mosan et arts anciens du pays de Liège*, exhibition catalogue, Liège, 1951, mentioned under no. 84; *The Metropolitan Museum of Art Bulletin*, XIV, June 1951, p. 253, ill.; H. Comstock, "The Connoisseur in America: Treasury for the Cloisters," *The Connoisseur*, CXXVII, January 1952, p. 212, ill.; H. Swarzenski, "Italian and Mosan Shows in the Light of the Great Art Exhibitions," *The Burlington Magazine*, XCV, May 1953, p. 157; Y. Hackenbroch, "A Triptych in the Style of Godefroi de Clair," *The Connoisseur*, CXXXIV, December 1954, pp. 185–188, ill.; H. Swarzenski, *Monuments of Romanesque Art*, Chicago, 1954, pls. 170, 172, figs. 376, 379; *The Brooklyn Museum Bulletin*, XVII, 1956, p. 10, fig. 3; *The Metropolitan Museum of Art Bulletin*, XIV, June 1956, p 244; H. Swarzenski, "The Trip Song of the Three Worthies," *Bulletin of the Museum of Fine Arts, Boston*, LVI, Spring 1958, pp. 31, 37, fig. 11.

EXHIBITED: Hotel Gruuthuuse, Bruges, *Exposition des primitifs flamands*, 1902; Liège, *Exposition de l'art ancien au pays de Liège*, 1905, Class I, no. IA, 16; The Cloisters of The Metropolitan Museum of Art since 1951.

<div align="center">NOTES</div>

1. Hackenbroch, pp. 185–188; the only detailed analysis and interpretation of the triptych. The present catalogue prefers the usage of Godefroid *de Huy* since the appellation "de Clair" appears to be an unfounded change as against contemporary documents.

2. The interpretation proposed in the following pages is no mere modification of earlier views, but differs radically in principle and method as well as in conclusions put forth by others. Concerning that method, see note 16, below.

3. Cf. Katzenellenbogen, pp. 46–47.

4. Cf. A. Grabar, "Orfèvrerie mosane—orfèvrerie byzantine," in *L'Art mosan*, ed. P. Francastel, Paris, 1953, pp. 119–137; Cf. pl. XIX 1, 2.

5. The interpretation of *Justice* as an *Ecclesia* figural type is proposed by Hackenbroch. For the Cross and the Balance, see F. Wormald, "The Crucifix and the Balance," in *Journal of the Warburg Institute*, I, 1938, pp. 276 ff.; the sentence quoted from St. Bernard reads *Crux facta est statera corporis Christi, quod est Ecclesia*. It is given in fuller context by Wormald and discussed on pp. 279–280.

6. This is the interpretation applied by Hackenbroch. The theme of the Dispute of the Virtues is discussed by Katzenellenbogen, pp. 40–41.

7. Cf. Psalm 119:30, where the Psalmist says "I have chosen the way of truth: thy judgments have I laid before me." The idea of truth as the guiding way of God is also found in the Gospels, as in John 16:13, where Christ says that when "the Spirit of truth is come, he will guide you into all truth."

8. Close observation reveals that there are, in fact, three weights in *each* of the scale pans. Those in the pan to the observer's right are not visible in photographs and could easily escape detection in the original, on account of discoloration. Hackenbroch, pp. 185, 187, believing one of the pans to be empty, has construed a dichotomy between "good deeds" and "the absence of good deeds" out of this mistaken contrast.

9. See Lejeune, no. 92, pl. xv.

10. *Ibid.*, no. 87, pl. xii.

11. Swarzenski, *Monuments*, p. 70, no. 171, fig. 377.

12. Cf. a recent review of the main Godefroi problems by H. Landais, "Essai de groupement de quelques émaux autour de Godefroid de Huy," in *L'Art mosan*, pp. 139 ff.

13. Swarzenski, *Monuments*, pp. 29–32.

14. For a valuable discussion of this so-called émail brun technique, and citation of medieval sources, see especially J. Helbig in *Société de l'art ancien en Belgique*: *Orfèvrerie, dinanderie, ferronnerie*, fasc. 1, Bruges, n.d., article to pl. 18. See also, K. Hermann Usener, "Braunfirnis," in *Reallexikon zur deutschen Kunstgeschichte*, ed. O. Schmitt, Stuttgart-Waldsee, 1948, II, cols. 1107–1110.

15. Helbig, *Société de l'art ancien*, states rather nicely that this technique was generally used for those parts of the objects "qui devaient en quelque façon, servir de point de repos à côté de membres plus richement décorés."

16. The method employed in this analysis rejects the usual procedure of ascribing figured compositions, themes, and motifs directly to single or multiple textual sources. In place of this type of literary iconography, the author seeks to discover the tradition of artistic exegesis which develops in the works of art themselves, on the basis of what he calls schematic principle. Cf. H. Bober, "In Principio. Creation Before Time," in *De Artibus Opuscula XL, Essays in Honor of Erwin Panofsky*, ed. M. Meiss, New York, 1961, I, pp. 13–28, and II, figs. on pp. 5–8, offers a more detailed and documented application of this method to an earlier work of Mosan art.

17. Hackenbroch dates the triptych to *c.* 1160 and assigns it to the workshop of Godefroi; Swarzenski, *Monuments*, no. 170 (fig. 376), does not give it to Godefroi or his shop, and places it in "Maastricht (?)."

A ROMANESQUE
LION-HEAD AQUAMANILE

WHETHER for rare works in jeweled gold or ordinary objects in common materials, the medieval artisan employed his art and skill to create the finest pieces that he could.[1] Water ewers, particularly in the form of aquamanilia, are an outstanding case in point. Serving a humble function, they nevertheless constitute a class of medieval art acknowledged to rank with independent sculpture. From such a fine example as the Guennol aquamanile it may be seen how these vessels could be endowed with all of the essential qualities of the larger works. Indeed, the aquamanilia were especially favored as an area for a high degree of invention and fantasy.

As a work of Romanesque bronze sculpture, the Guennol aquamanile resonates with the power and conviction so characteristic of that style. The form as a whole is typically expressed in a quasi-geometrical abstraction which makes it possible for the animal head and conical body of the vessel to co-exist formally as an harmonious entity. The modeling of the lion's head stylizes the features with vigorous simplicity over a denominator of spherical volumes. Bold grooves for descriptive lines and, in places, texturing gashes, define and articulate the anatomical forms. Thus, while the natural component of the animal head has been translated into abstract terms, the abstract conical body of the vessel *qua* vessel has been charged with a quality of fluidity drawn from natural forms. Abstract and natural elements which comprise the aquamanile have become consubstantial; their formal terms are neither those of nature, nor yet those of geometry. To these qualities there is another, a dynamic

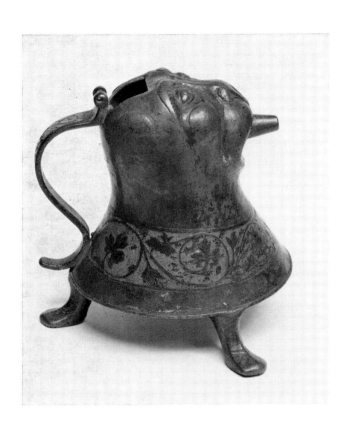

LION-HEAD AQUAMANILE

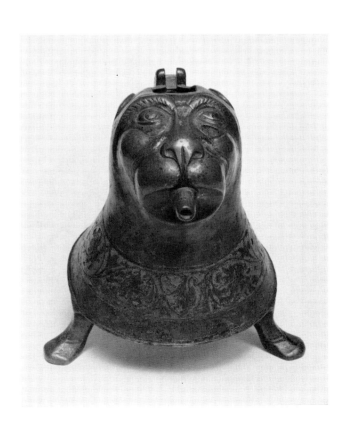

166

quality of tension which gives vitality to the forms. The springing curve of the handle gives a thematic key to that aspect of the work, and provides a terminal accent to the whole. It is felt in the steely resilience of the main curves of the entire silhouette. It is felt even in the stylized feet of the vessel, which seem at once inert and stable for their function as support and at the same time expressive of a springy feline quality appropriate to the main leonine motif. The preservation of this aquamanile is nearly perfect, lacking only the little lid, which was hinged at the top. Its original effect as to color must have been quite different, however. There are traces to show that it was entirely covered with gold but for the ornamental bands which still show the original enamel colors. The wide foliate band which encircles the lower part of the vessel and a smaller band on the handle are filled with blue champlevé enamel, and the heraldic lion in the central shield at the very front is set against a red enameled field.

The aquamanile, a vessel for holding and pouring water, was used in the washing of hands between courses at meals, quite necessary in those days before the use of forks. Prob-

ORNAMENTAL BAND—*Drawing*

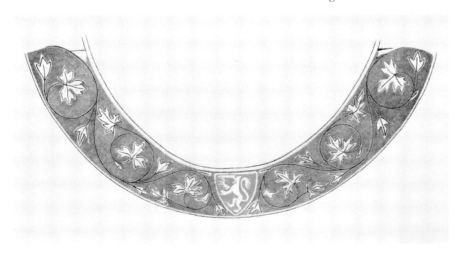

ably vessels of pottery served this function before the twelfth century when we first encounter the characteristic aquamanilia of metal in human and animal forms. The figured vessel for liquids appears to be age-old and almost universal. In the main cultures of Pre-Columbian Central and South America, theriomorphic forms are common and, indeed, highly developed. The rhytons of classical antiquity, combining an animal (or human) head and drinking vessel, may be peripherally related in kind. In the provinces of the Roman Empire, whether in Britain, Gaul, Germany, or the Low Countries, face-vases and face-urns are frequent. Georg Swarzenski pointed out the close relationship to the Romanesque aquamanilia of the bronzes of Fatimid Egypt and Moorish Spain.[2] Conceivably, the figured aquamanile in metal came to the West via Islam during that same twelfth century which saw a general European awakening to Arab culture and learning.

Our aquamanile is altogether exceptional among the medieval examples, for it is unique in showing only the lion head. Generally the entire vessel is made up of an animal body, the four legs serving as supports and the curled tail as handle. The vessel would be filled at an opening in the animal's back, or somewhere in the upper parts, and poured from a spout of some kind, usually in the mouth of the animal. Fantastic beasts, griffons, centaurs, lions, and horses are the main subjects for the aquamanilia. They are often combined with other beasts, or are given human riders, the knight being the most common. Only one variety even suggests the possibility of religious iconography, namely, the Samson aquamanilia, which show the hero astride and wrestling the lion. The subjects may be regarded as part of a repertoire of fancy and fantasy, and there is no significant evidence to contradict the hypothesis that such aquamanilia were predominantly secular in origin and destination.

168

Those human-headed vessels which were the principal figured variety of provincial Roman art[3] are among the more rare types in Romanesque metalwork, appearing as bust-figures in some few examples. The Guennol lion head, however, remains unique.

Because of its unusual features, namely the lion-head shape and the bands of enameled ornament, there has been some question as to the place of origin of our piece. One scholar recently suggested it might be French, originating either in the Limousin or, perhaps, in Lorraine.[4] However, in an extended study of this work, the late Georg Swarzenski made an entirely convincing case for attributing the Guennol aquamanile to Northern Saxony, around A.D. 1200.[5] Not only does Saxony preserve an old tradition for bronze working, going back to the early tenth century, but the lion motif was always highly favored there. In that same region, at Brunswick, Duke Henry the Lion had erected in A.D. 1166 a bronze statue of a lion, one of the great monuments of Saxon and Romanesque art. Swarzenski points out specific parallels in a number of Saxon pieces shaped as human busts[6] for the wide band of foliate and enameled ornament of the Guennol aquamanile. Finally, he suggests the aquamanile in the Collection must have been made for some prominent family of Brunswick or Luneberg nobility, since the armorial lion was a Guelf heraldic device in use by the ruling classes of those cities.

AQUAMANILE

Height 6.5″ Width 6″

German (North Saxon), *c.* 1200

Ex Coll.: Edson Bradley, Washington, D. C., and Newport, Rhode Island.

Bibliography: G. Swarzenski, "Romanesque Aquamanile of the Guennol Collection," *The Brooklyn Museum Bulletin*, X, 4, 1949, pp. 1–10, ill.

Exhibited: Brooklyn Museum, 1948–1955; Metropolitan Museum of Art since 1955.

1. Patrons of especially sumptuous works were often diffident or even apologetic over their extravagance. They would go to some trouble to express a pious hope that the real offering would be recognized in the very art and craft of the work, rather than in its material opulence. Thus, for instance, Henry of Blois, bishop of Winchester, had inscribed on an elaborate enameled shrine: *Ars auro gemnisque prior*, invoking its craft (*ars*) above its gems and gold (cited by H. Swarzenski, *Monuments of Romanesque Art*, Chicago, 1954, p. 13, fig. 446, pl. 195). Compare the poem for the gilded bronze doors of the abbey church of Saint-Denis, composed by the Abbot Suger (*c.* 1140):

Whoever thou art, if thou seekest to extol the glory of these doors,

Marvel not at the gold and the expense but at the craftsmanship of the work.

(See E. Panofsky, ed. and trans., *Abbot Suger on the Abbey Church of St.-Denis and Its Art Treasures*, Princeton, 1946, pp. 46–47 ff.)

2. G. Swarzenski.

3. E.g., W. E. Collinge, "Notes on Some Roman Mask or Face Vases in the Yorkshire Museum," in *Proceedings of the Yorkshire Philosophical Society for 1936*, York, 1937, pp. 4–7, cf. pls. II-VI.

4. E. Meyer, Museum für Kunst und Gewerbe, Hamburg, in a letter of August 20, 1956:

Für Niedersachsen sind im 13.Jhd.keine mit Emails verzierten rundflächigen Geräte nachzuweisen, sondern ausschliesslich flache Platten. In Limoges dagegen hat man Rauchfässer, Eimer, plastische Figuren häufig mit Emails ausgeschmolzen.

Die sächsischen Aquamanilien bestehen ausserdem alle aus einer gelblichen stark mit Zink legierten Bronze, während Ihre Kanne rötlich ist, also einen grösseren Kupfergehalt hat.

Unsere Kenntnis der mittelalterlichen Werkstatten ist meiner Ansicht nach noch nicht gross genug, um das Gefäss sicher lokalisieren zu können. Ich halte zwar die Verwandtschaft der Kanne mit Limogesarbeiten für wesentlich grösser als mit niedersächsischen, weiss aber nicht, ob man an Limoges selbst denken muss. Es mag in Frankreich-vielleicht auch in Lothringen-noch andere Orte gegeben haben, wo man derartige Emails hergestellt hat.

5. G. Swarzenski.

6. O. von Falke and E. Meyer, *Bronzegeräte des Mittelalters*, I, *Romanische Leuchter und Gefässe der Gotik*, Berlin, 1935, cf. illustrations 317 and 318 (nos. 340 and 342) cited by G. Swarzenski. Given the exceptional form and unusual detail of the Guennol aquamanile, it is not surprising that the essential question of authenticity has been voiced on at least one occasion. The writer and Thomas P. F. Hoving, of the Medieval Department of The Metropolitan Museum of Art, have examined the piece carefully and discussed it at length. We have found nothing disturbing about the general style of the aquamanile, or in any of its parts. Patina, traces of gilding, and surface in general meet all preliminary tests to eminent satisfaction.

A MAJESTY OF SAINT MARY
FROM AUVERGNE

With wonder and with ever-growing warmth the Middle Ages extolled the Virgin Mary in prayer and song, literature and art. In their veneration of the Virgin was the great awe of the God-bearer, the *Theotokos*. The warmth came of the recognition in her of a humble maiden and loving mother, one who tasted the precious joys of all motherhood, as well as one who was to bear the terrible sorrows attendant upon her divine maternity.

The painter, or the sculptor of reliefs, could depict the Virgin in her supreme dignity as Mother of God. They could also show the events of her life in pictures where the devout could "read" the favorite perennial narrative of the most blessed among women. For the sculptor of free-standing statuary, such as the Guennol Majesty of St. Mary, there were peculiar difficulties. On the one hand his statue had to be such as to be recognizably disassociated from "idols" in form and, therewith, dissuasive of idolatrous suggestion to the worshiper. On the other hand the individual statue had to express the essentials in the idea of the Mother of Christ. Central in this idea, as it took shape in the writings of the churchmen, was the doctrine of an inseparable bond which linked the distinct natures of the human mother and the divine Child: the Child embodied in the mother's humanity, the mother enshrining the Child's divinity.

> *O Maria, Redemptoris*
> *Creatura, Creatoris*[1]

This concept of the Virgin took its authority and impetus from the early church decrees at the councils of Ephesus

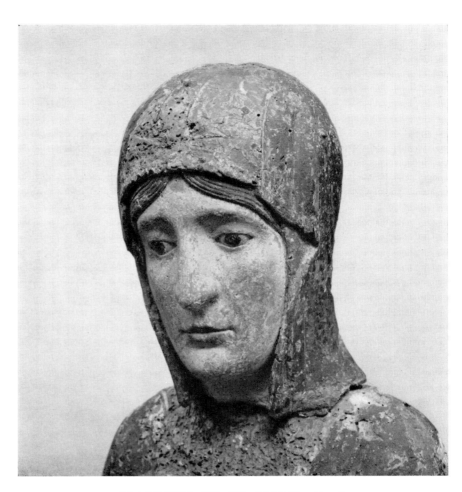

MAJESTY OF ST. MARY—*Detail*

172

(A.D. 431) and Chalcedon (A.D. 451), which officially declared her to be human by nature but also the God-bearer by divine will. It was concluded that from the human body of the Virgin was born the reality of Christ's body, yet this Incarnation entailed no separation between his divine and human nature. This was no mere coupling of the two natures but a mysterious indivisible unity: "He was born of a woman; but he did not cast aside his being God and his having been begotten of God the Father. He assumed our flesh; but he continued to be what he was"[2] For art in general and especially for the representation of the Virgin this was crucial. It meant that such imagery could be acceptable on the precedent of the Christ who consented to manifest himself in human form, begotten of the Virgin.

Between the fifth and the tenth century images of the Virgin, whether in narrative scenes or independent representations, are found only in the two-dimensional arts, mainly painting and mosaic. Paintings were accepted for their didactic value in religious teaching of history and dogma. The churchmen justified the value of pictures in this sense by citing the famous declaration of Pope Gregory I (c. A.D. 600) who had pointed out that the objections lay only in the idolatrous worship of such pictures:

It is one thing to offer homage to (adorare) a picture, and quite another thing to learn, by a story told in a picture, to what homage ought to be offered. For that which writing is to those who can read, a picture is to the illiterate who look at it.[3]

If, then, there was abuse even of two-dimensional pictures (against which St. Gregory's remarks were directed), how much more susceptible to idolatry might sculptured statues have seemed. Such a factor might best explain the absence of religious statuary virtually to the end of the first millennium.

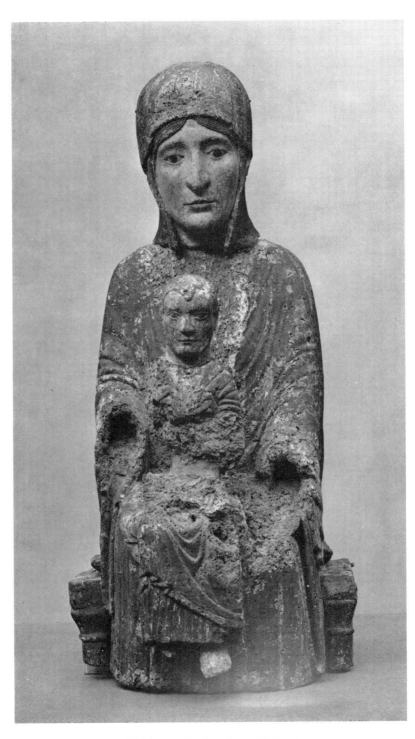

MAJESTY OF ST. MARY

174

In Byzantium, even more strictly than in the West, the question of religious images became the issue of violent theological disputes, climaxed in the Iconoclastic Controversy (A. D. 726–843), when all such images were declared to be idols and their destruction ordered. Icons of Christ and the Virgin were focal in this connection because they allegedly showed only the human aspect of Christ, expressing thus a heretically divisive interpretation of His essential and indivisible unity. The controversy ended in the restoration of images but not without profound consequences for the reinstated art. Icons of Christ, the Virgin, the saints, and religious scenes could be shown only as fixed types and in a prescribed manner, virtually a religious picture-writing ritualistically established. In the midst of the controversy, at the Second Council of Nicaea (A. D. 787), a formula for the acceptable approach to such images had been devised which made the distinction between improper worship of the actual icon, and proper worship to which the image was an instrumental object. This formula provided the basis for later attitudes towards such images:

For the honor paid to the image passes to its original, and he that adores an image adores in it the person depicted thereby.[4]

The consequent religious imagery of Byzantium, tempered in these fires of the great controversy, was infused with depth and power, and seemed to possess the very essence of their subjects in a way which never ceased to appeal to the West. It was almost as in ancient Egypt, where religious imagery was hardly an area for pictorial invention but a sacred precinct in which established types and visual formulae, ritualistically created, were repeated and preserved for millennia.

Only one area of medieval art in the West approximates this situation, namely the Auvergne in France, where a

Byzantine iconographic formula for the seated Virgin and Child was adopted by the tenth century and followed for three centuries. It is paradoxical that while Byzantium shunned the sculptured image, in Auvergne this formula was applied mainly to statuary of the Virgin and Child. Typical of these examples, the Guennol statue shows a solemn Virgin, strictly formal and symmetrical, holding the Christ Child on her lap. In these sculptures the pose of the Child is the one element which shows conspicuous variation, ranging from a position exactly on the same axis as the Virgin, to a profile posture when He is shown seated to one side.

It is important to note that these Auvergnat Virgins are of a type special to that region, and that they were produced in considerable number, but always in conformation to this basic type and with only secondary modifications.[5] They seem to be remarkably impervious to the radical changes in style which, after the middle of the twelfth century, led the development of French medieval art away from Romanesque abstraction to Gothic naturalism. All these factors confirm the general conclusion that the Auvergnat statues of the Virgin and Child preserve and repeat a single model or type which must have been ancient and highly venerated in that region.

Actually it is in Auvergne that we find evidence for the first statue of the Virgin and Child known in French medieval art. While the statue no longer exists, early documents record that towards the middle of the tenth century the bishop Etienne II of Clermont ordered a gold-covered wooden statue of the Virgin and Child to be made by a cleric named Aleaume. It was designed to contain sacred relics and to be used at the altar in connection with special feasts.[6] A tenth century manuscript in the library of Clermont (Ms. 145) contains a drawing showing this type of Vir-

gin (fol. 130v), similar enough to the later statues to suggest that the Guennol Virgin and the rest of this Auvergnat group must indeed reproduce the type of the venerated statue by Aleaume. The lost work must have resembled the gold-covered reliquary statue of Sainte-Foy of Conques. That statue was originally made for Conques, during the period of the same Etienne II who commissioned the Virgin reliquary, and probably at his behest, for he was abbot of Conques as well as Clermont.[7] Outside the Auvergne such images were unknown and must have seemed strange indeed when seen by visitors to the Auvergnat churches. We have the testimony of an early eleventh century scholar named Bernard of Chartres, who recorded a number of these statues on his travels in Auvergne and described one of them as "resembling an idol."[8] To the natives, however, these were neither idols nor mere representations, as may be deduced from their accepted and continued religious use. Moreover, the late tenth century inventory which mentions the Clermont Virgin refers to the statue as "The Majesty of Saint Mary" (*Majestatem sanctae Mariae*), pointing up its symbolic intent and interpretation in the period of its origin.

It is a curious fact that despite this historical priority of Auvergne in the creation and establishment of the sculptured images of the Majesty of St. Mary at this tenth century date, nothing remains of such statues before the twelfth century. However, from the late tenth century through the eleventh, this type is well represented in a number of examples from Ottonian Germany. There we find statues of the enthroned Virgin and Child in similar posture and dress, with analogous variations in the placing of the Child. The Hildesheim Cathedral treasury preserves one from the early eleventh century, and there is another in the Paderborn Museum dated in the third quarter of the century. While in these examples we have only the wooden core of the figures, the

famous Essen Virgin, of the late tenth or early eleventh century, is still covered with its original gold plaques.

The Guennol Majesty of St. Mary has suffered a great deal from the ravages and accidents of time. The lower part of her body, including the throne, has been sawn off, and the hands, as well as parts of the arms, are missing. Large areas of the wood are decayed, entailing the loss of original surface and color. Even so, enough is preserved to show the main forms of this group are those of the typical Auvergnat composition. Fortunately, the head of the Virgin is in very good condition, retaining most of its original form, surface, and color. Here we may observe, in a fine example, that expression of profound solemnity and inwardness which these Auvergnat sculptors gave to their subject. The face has an almost indecipherable impassiveness suited to the Virgin as the humble vessel chosen for divine purpose, and to the exalted mother of the author of all grace. This expression is, at the same time, one of receptivity, most appropriate to the Virgin, mediatrix *par excellence* between man and Christ. It was the Virgin who stood foremost as the intercessor for man, and it is she who is ever invoked in times of perplexity and distress, doubt and sin, affliction and illness.

From an examination of the numerous Auvergnat statues of the Virgin we may readily derive an impression of the original appearance of our Majesty. The drapery covering her head would have continued under her chin to form an enclosing loop, framing the head, and hung in cascading folds over the breast. At the center of her headdress, just above her forehead, there must have been a large stone, possibly a crystal *en cabochon*, and it is likely that there were other stones on the figure, perhaps in the drapery borders and over her breast. The throne, in its typical form, rests on four columns, its seat arcaded at the sides and back,

178

sometimes encrusted with stones set in copper gilt strips which cover the wood.

Because of their conservative and almost ritualistic character, it is notoriously difficult to date these Auvergnat statues. Although essentially Romanesque in the geometric simplicity of its masses and the severity of its line, something of the new Gothic style has nevertheless penetrated the traditional formula of the Guennol Majesty of St. Mary. The drapery of the Christ Child, for instance, is formed in the long sweeping lines of Gothic art, and the face of the Virgin, too, is ever so subtly softened and humanized in a way which betrays the almost imperceptible infiltration of Gothic developments during the second half of the twelfth century. The Guennol statue may perhaps be dated as late as the end of the twelfth century, but such estimates can claim no precise supporting evidence. No less difficult than the dating is the problem of placing such figures within the region of the Auvergne. There are resemblances, physiognomic and stylistic, between the Guennol Virgin and various female saints in the sculptured capitals of the church of Mozac.[9] At Mozac, the forms are treated in broad and simple planes in a way which is also suggestive of the Guennol figure. By contrast, such sculptures as the capitals in Notre-Dame-du-Port at Clermont-Ferrand[10] are more flat and linear, the drapery and detail rather busily slashed and gouged.

It is hardly likely that the differences between the Mozac and Clermont capitals are those of regional styles within the Auvergne; they may be, rather, the work of different ateliers. Thus, the interior capitals of Clermont may be similarly contrasted with the simpler, more monumental style of the tympanum and lintel of the south portal in the same church. Because of their peculiar conservatism and adherence to special venerated cult types, the study of the Auverg-

nat Madonnas may best be approached through the determination of the principal types followed, and their development discovered from comparative relationships within the appropriate group.[11] In the lintel relief from the portal of Notre-Dame-du-Port, the Magi approach an enthroned Virgin and Child which may be reasonably interpreted as a representation of one of those types. It would be logical for the sculptor to have followed in this scene one of the important cult images of the Madonna which existed in the church. The interest which this relief holds for us lies in the fact that the Guennol statue most nearly resembles the cult type of this lintel relief. Despite losses, both in the relief and in our statue, it is still possible to observe significant similarities in the posture of the Christ Child, the placing of His feet, and the line of drapery across His legs.[12] If the presumed original in the church of Notre-Dame-du-Port at Clermont-Ferrand is no longer known, other sculptures which followed the basic type exist. A fine example is preserved at Saint-Philibert in Tournus where, in addition to other points of resemblance, we may note the same basic character in the carving of the Virgin's head.[13] There are differences, no doubt, especially in the delicate elongation of the head in the Guennol statue, but these may be accepted among possible variations within a single type. Only one, among the extant Auvergnat statues, shows marked similarities to the Guennol Majesty, namely that in the choir of Notre-Dame at Orcival.[14] The points of resemblance may be obscured at first glance by the fact that the Orcival statue is covered with gold plaques. However, in the modeling and features of the heads, we find the closest approximation of the essential characteristics of our statue.

The head of the Virgin in our example is one of the most sensitive and profoundly moving of all the Auvergnat statues. It is strange and wonderful that within the given

180

heavy style of these figures, so much subtlety and religious expressiveness could still be conveyed as that in the Guennol head. There is here none of that mask-like density so often found in these Madonnas. To some, perhaps, the Auvergnat Virgins may suggest a certain homely quality, for they rarely aspire to sensuous beauty. Often that quality is exaggerated to disadvantage through unfortunate repainting, and it is a question whether many of these Madonnas originally looked quite as plebeian as they may now appear. It is this quality which evoked a charming but, I feel, misguided apology from Emile Mâle: "Faites pour des paysans, perdues dans les chapelles de la montagne de la forêt, ces Vierges ressemblent à de sérieuses paysannes: elles sont ornées de toutes les vertues; il ne leur manque que la beauté."[15] Insofar as one may wish to admit that there is homeliness in this beauty, it is, rather, to be interpreted as one which expresses the humble simplicity of Mary of Scriptures and the Apocrypha. It is intended to contrast with worldly beauty of the senses. Certainly these Romanesque Virgins neither seek nor pretend to that queenly sophistication with which the later Gothic sculptures of the Virgin were to be endowed. But, to the eye attuned to the internal character of Romanesque style, it is plain to read the unearthly simple beauty in the head of the Guennol statue.

MAJESTY OF ST. MARY

Height 26.5″ Width 11.5″

French (Auvergne), late XII century

Ex Coll.: Major Lambert d'Audenarde, Paris; Baron Edmond de Rothschild, Baron Maurice de Rothschild.

Exhibited: Metropolitan Museum of Art since 1948.

NOTES

1. Only a poet could do justice to this idea in so few words, translated by D. S. Wrangham as:

> Mary, our Redeemer's creature!
> Mother of thine own Creator!

The quotation comes from the twelfth century poem *De Beata Virgine* by Adam of St. Victor. It is published in D. S. Wrangham, trans., *The Liturgical Poetry of Adam of St. Victor*, London, 1881, III, pp. 110–111.

2. From the "Dogmatic Letter" of Cyril, bishop of Alexandria, quoted here from the translation by H. Bettenson, ed., *Documents of the Christian Church*, New York, 1947, p. 68.

3. Cf. E. Bevan, *Holy Images*, London, 1940, pp. 125–126, whose translation, slightly modified, is quoted here. Cf. Bevan's discussion of this text, and the Latin original given by him in a note to p. 126.

4. Translated by Bettenson, p. 132.

5. Cf. *Vièrges romanes d'Auvergne*, Lanzac, 1948, *passim*.

6. See L. Bréhier, "La cathédrale de Clermont au Xme siècle et sa statue d'or de la Vièrge" in *La Renaissance de l'art français*, VII, April 1924, pp. 205–210.

7. Cf. note 6 above, and L. Bréhier's *L'Art chrétien*, 2nd ed., Paris, 1928, pp. 240–241, and, for the golden statue of St. Foy, see also pp. 274–275.

8. See P. Quarré, *La Sculpture romane de la Haute-Auvergne: Décor des chapitaux*, Aurillac, 1938, pp. 59–60.

9. For illustrations see A. K. Porter, *Romanesque Sculpture of the Pilgrimage Roads*, Boston, 1923, VIII, figs. 1225–1226. Some of the capitals from the ambulatory of Issoire also show similarities to the Guennol Virgin (cf. *ibid.*, fig. 1214).

10. Cf. *ibid.*, figs. 1175–1176.

11. Compare the view that these statues are all much alike and may derive from a single original ("Toutes ces statues se ressemblent, et ces ressemblances sont telles qu'elles supposent l'imitation du même original," E. Mâle, *L'Art religieux du XIIe siècle en France*, 2nd ed., Paris, 1924, p. 286). Ilene Haering is currently preparing a study of the Auvergnat Virgins according to their types, as a doctoral dissertation at Columbia University. I am indebted to Miss Haering for pointing out the relationship between the Guennol statue and the Clermont tympanum and for confirmation of my interpretation of the problem.

12. Porter, fig. 1160.

13. Cf. the excellent photographs by G. de Miré reproduced in J. Vallery-Radot, *Saint-Philibert de Tournus*, Paris, 1955, pls. 58–60.

14. The resemblance, striking in the originals, is less evident in the few available reproductions of the Orcival statue. Cf. B. Craplet, *Auvergne romane*, Paris, 1955, color plate opposite p. 76; note that the black-and-white illustration (fig. 17 on unnumbered p. 76) is grossly distorted through unfortunate lighting.

15. Mâle.

LIMOGES ENAMEL PLAQUE

THE medieval art of Limoges, in its most famous and characteristic form, is beautifully exemplified in this diminutive plaque with the winged ox of Luke.[1] It was hardly an isolated or fortuitous circumstance that caused the name "Limoges" to become synonymous with the best-known type of medieval enamelwork and many of the most splendid liturgical works of art of the Middle Ages. The ingenious enameling craft of the native Celts of Gaul had already impressed the conquering Romans during the early centuries of the Christian era (see p. 140, Gallo-Roman Disc Fibula), although we have no information concerning the practice of this art in the Limousin at this early period. For Merovingian France of the seventh century, however, Limoges was in high repute for goldsmiths' and metalwork, sister crafts to enameling. Limoges was then a foremost center for the minting of coins, and it was there that St. Eloy (A.D. 588–660), later famous as patron saint of goldsmiths, was trained in the working of metals, coinage, and, very likely, in enamelwork.

While there are many gaps in our history of the art of Limoges, it is apparent that this city, with its great church of Saint-Martial, was one of the major centers of civilization in the West, from the tenth into the twelfth century.[2] An important crossroad between north and south, and one of the principal junctures on the pilgrimage route to Santiago de Compostela, Limoges prospered, especially from the influx of immense crowds of pilgrims. Yet, for our knowledge of the art of this period, we are dependent primarily upon the evidence of the illuminated manuscripts to span the interval from the tenth to the later twelfth century; works in other media are, for the most part, lost. By the eleventh century,

183

the decoration of these manuscripts proves that a distinctive style had been attained in the Limousin. It is an art which employs a system of firm and clear linear design, inventive patterning of surface, intense colors, deep and rich tonality.[3] These paintings seem to anticipate the qualities of color, drawing, and composition which were yet to come in Limoges enamels of the twelfth century. Even if it is not demonstrable, it is conceivable that by the end of the eleventh century the miniatures may already parallel or reflect the peculiar qualities of enamelwork no longer extant.

As for the enamels which still remain, these date from the second half of the twelfth century, reaching a peak in quantity during the thirteenth, when the fame of Limoges for this technique was at its height, with a brief afterglow in the first quarter of the fourteenth century.[4] In every class of liturgical objects, whether of reliquaries, book covers, croziers, or crosses, the busy Limoges workshops fashioned pieces in metal, enameled with their characteristic stamp. From England to Armenia, and from Russia to Spain, works *de opere lemoviceno* (as they are spoken of in contemporary records) were familiar possessions of the church treasuries.[5]

The importance of the valley of the Meuse, for metal and enamelwork, has been mentioned in connection with another piece in the Collection (cf. p. 151, Mosan Reliquary Triptych). It is not even certain that there was real rivalry between Mosan and Limoges work, for the character of the enamel production at these two centers contrasts with and complements each other in significant ways. Where, in Mosan art, the leading masters are known by name and personal style, there are precious few names from the Limousin ateliers. For the latter, moreover, we have no way of grouping the works around the known names, much less of following their development in any systematic fashion.

184

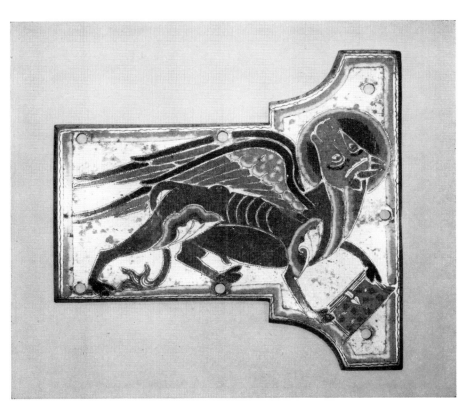

LIMOGES ENAMEL PLAQUE

185

The Mosan works, by and large, seem to have been individually commissioned by richer patrons, secular and ecclesiastical; those of Limoges, with admitted exceptions, were made for the less wealthy foundations,[6] and even for an unknown market. Thus, while the Mosan pieces are highly varied in their range of themes and compositions (cf. Mosan Reliquary Triptych), those from Limoges employ figures, compositions, and ornament, which tend to repeat or vary material from a stock repertoire, probably after pattern books. Limoges, it might be said, pioneered in a system of artistic mass production, which may have been developed to meet an increasing demand for much needed liturgical articles of good quality, but relatively inexpensive in price.[7]

On the face of it, this contrast might appear to rule *a priori* against the Limousin work and in favor of Mosan artistic superiority. Among the later pieces, it is true, a good many pedestrian examples are preserved, but this may only be a factor of the sheer quantity produced and the greater quantity preserved, including a good many pieces from the period of Limoges' artistic decline in the fourteenth century. However, Limoges work is not without its masterpieces, among which one may cite the large funerary plaque of Geoffroy Plantagenet, from the tomb set up in Saint-Julien-du-Mans (between 1155 and 1180),[8] as well as others. Many indeed were the more sumptuous works, commissioned by high patrons, known to us from the inventories and other records, but lost today.[9] One glance at our plaque may be sufficient reminder not only of the superlative quality of which Limoges was capable at its best, but also of the technical and aesthetic achievements which brought these ateliers their reputation in the first place, and sustained the esteem in which they were held.

The plaque in the Collection is but a small, though

precious, remnant of what must have been a magnificent processional cross. Such crosses, carried by the celebrant officiating at the Mass, could be attached to a staff for use during the actual procession. Upon arrival at the altar it would have been set upon a low base, or foot, designed to hold it during the service. It is not difficult to reconstruct the general appearance of the type of cross of which our plaque originally formed part. In a recent book by Paul Thoby[10] most of the known Limousin crosses have been collected and catalogued. These he has classified into three main categories, according to shape and design. Within each category, the iconography and ornamentation seem to preserve fairly constant patterns. The Guennol plaque belongs to the crosses in his first, and oldest, group of the *croix potencée*, which derives its name from the heraldic "crosses potent," i.e., those whose arms terminate in a T-shaped transverse element. Generally, such crosses are about eighteen inches high and about a foot wide, with figured and ornamental decoration on both sides. The principal face shows the crucified Christ on the body of the cross, constituting a crucifix. In the enlarged T-shaped terminals of the arms of the cross, saints and angels are shown; an angel, usually at the top, St. Peter or Adam at the bottom, and the Virgin and John at the lateral terminals. On their reverse these crosses show the Christ in Majesty as their theme. Christ, in a mandorla, appears at the center of the cross, while the four terminal plaques show the symbols of the Evangelists.

Among the more elaborate of these crosses, we may find at least ten separate plaques of enameled decoration, which would have been fastened to a wooden core. These would include the "Crucifixion" plaque and the "Majesty" plaque, the four terminal plaques of the face, and the four Evangelist symbols on the reverse side. Over a long period

of use, most of these crosses must have fallen apart, and, among the one hundred and sixteen examples published by Thoby, only eighteen are complete. Thoby's study does not include the separate pieces which remain from other broken and dismembered crosses; these have yet to be collected and examined. Considering this situation, it is the more astonishing to find that one other plaque from the same cross to which the Guennol piece originally belonged has been identified. William H. Forsyth has observed that a plaque in The Metropolitan Museum of Art, showing the eagle symbol for John, must certainly have been a companion piece to this Luke, part of the same lost cross.[11] The two plaques are almost identical in style, technique, and color; have almost the same pattern of drilled holes. There are seven holes pierced in the Guennol plaque for the nails by which it was attached to the wood core of the cross. The holes appear to be contemporary with the original date of this piece. Finally, both plaques have the same grooved marks of parallel strokes of a graver's tool gouged into the copper on the back surfaces.[12] This mark, which we illustrate, may have been a shop mark or served as a guide for the assembly of the cross. Interestingly enough, both plaques were owned by the Abbé Texier of Limoges, in the nineteenth century, and were already then regarded as a matching pair.[13] The winged ox would have been placed at the end of the right arm of the cross, while the Metropolitan Museum's eagle would have formed the upper terminal of the vertical arm.

A very good idea of the original appearance of the cross from which these plaques are the sole remains may be obtained from an example which was in the collection of Count Ouvaroff, in Moscow, during the nineteenth century.[14] That cross, it may be noted, was acquired in 1858 from the same Abbé Texier of Limoges. Two little figures, that of

188

the ox and the eagle, may seem very little to go on as a basis for proposing any suggestion as to the original character of the lost cross, but they prove, in fact, quite decisive. In many of the crosses, the corresponding plaques show only half-length animal symbols; in others, the symbols are crudely drawn or stilted in style. Only in the Ouvaroff cross do we find all the elements in significantly close proximity to ours; the shape of the plaques, the placing of the nail holes, and the character of the drawing of the ox. This relationship leads to the further realization that since the drawing, technique, and coloring of the Guennol plaque are so superlative and, so far as we can judge, superior even to the elegant Ouvaroff piece, the lost cross represented by this plaque must have been one of the great masterpieces of Limoges art.

If it is to be lamented that this plaque with the winged ox of Luke is only a little part of its original whole, then we are to be consoled by the fact that it is a complete unit of that lost original, and that it ranks easily with the finest productions from the Limousin. Furthermore, it must be recalled how few are the surviving complete crosses, and that even in France there is no longer a single complete example left.[15]

LIMOGES PLAQUE

Height 3.5″ Width 3.6″

French (Limoges), late XII or early XIII century

Ex Coll.: Remi, Limoges; Abbé Hubert Texier, Limoges; Georges Chalandon, Paris.

Bibliography: E. Rupin, *L'Oeuvre de Limoges*, Paris, 1890, pp. 249, 250, fig. 312.

Exhibited: Paris, *Exposition d'objets d'arts du moyen âge et de la renaissance, organisée par la Marquise de Ganay chez M. Jacques Séligmann,* 1913, no. 24; Metropolitan Museum of Art since 1951.

1. I am indebted to William H. Forsyth, of the Medieval Department of The Metropolitan Museum of Art, for a great deal of helpful information and discussion in the preparation of this study of the Limoges plaque.

2. See *L'Art roman à Saint-Martial de Limoges: Les Manuscrits à peintures, historique de l'abbaye, la basilique*, exhibition catalogue, Limoges, 1950, especially pp. 43 ff.

3. The most convenient reference to these manuscripts may be found in the Limoges exhibition catalogue cited above. Compare also, the catalogue of the Paris exhibition: *Les Manuscrits à peintures en France du VIIe au XII siècle*, 2nd ed., Paris, 1954, especially nos. 319–328.

4. Cf. M.-M. S. Gauthier, *Emaux limousins champlevés des XIIe, XIIIe, & XIVe siècles*, Paris, 1950, for a brief, authoritative account. The most comprehensive account of Limoges enamels, covering sources, history, collections, and every possible class of enameled object in this area, is that by Rupin.

5. M. C. Ross, "De Opere Lemoviceno," in *Speculum*, XVI, 1941, pp. 453–458. For the variety of names by which these enamels are called in contemporary documents, see Rupin, p. 87 (*e.g.*, *oeuvre de Limoges, travail de Limoges, labor de Limogia, opus Lemovicense, opus de factura Lemovica*).

6. Cf. J. Evans, *Art in Mediaeval France: 987–1498*, London–New York, 1948, pp. 130–131.

7. See *Emaux limousins: XIIe, XIIIe, XIVe siècles*, exhibition catalogue, Limoges, 1948, p. 8, "ils ont façonné des dizaines de milliers de pieces, dont aucune aujourd'hui ne nous laisse indifferents."

8. Illustrated in Gauthier, pl. 12. Cf. the extended discussion by Rupin, pp. 89–92, of this famous work and note the great gold and enameled funerary monument of Bishop Eulger, dismembered in the sixteenth century, described and illustrated in Rupin, pp. 92–96.

9. For excerpts of such inventories, see Ross, *passim*.

10. P. Thoby, *Les Croix limousines de la fin du XII. siècle au début XIV. siècle*, Paris, 1953.

11. The Metropolitan Museum eagle plaque, bearing the accession number 17.190.771, presented to the Museum by J. Pierpont Morgan in 1917, came from the Hoentschel Collection, and is dated by W. Forsyth to the end of the twelfth or the beginning of the thirteenth century.

12. The Metropolitan Museum plaque is slightly larger (4 x 3⅜ inches), which would not be unusual for a piece intended to be placed on the upper terminal of the vertical arm of the cross.

13. Rupin, p. 249, fig. 312.

14. *Ibid.*, p. 280, fig. 338.

15. Thoby, p. 13.

STAINED GLASS FROM
THE CATHEDRAL OF TROYES

I<small>N</small> the stained glass windows of the twelfth and thirteenth centuries medieval art brought to perfection a medium unsurpassed for expression in color and light. Even the entrancing sparkle of mosaic and the hypnotic gleam of jeweled and enameled gold are but dim compared with the brilliance of these gem-bedewed walls, irradiated with color essences distilled of rubies and garnets, amethysts, emeralds, and sapphires. Nor is there inherent in any other art medium anything like the miraculous gamut of intensities revealed in stained glass, synchronous with the changing light of the day and ever geared to the cosmic cycle of the seasons. With every imperceptible transition in the gradations of this scale of light-time which transforms them, the colors are re-formed in a new key with an infallibly harmonious tonal unity. Their emanations range from the somber moods in the lower register, responsive to wintry skies or twilight and the full intensities of daylight's saturation, to incredible moments of opalescent delirium when the rays of direct sunlight blaze through the glass. Stained glass windows are no less the marvel of marvels of medieval art for us today than they were at the time of their creation. But theirs is no mere tour de force of an abstract aesthetic. On the contrary, they are the final realization in visible form of concepts fundamental to Christian thought and belief, as old as Christianity itself.

Far and above practical necessities, and even at the expense of such needs, calculated qualities of symbolic light were ever the ideal of the church builders.[1] By every means that could be conceived, the earthly House of God was

191

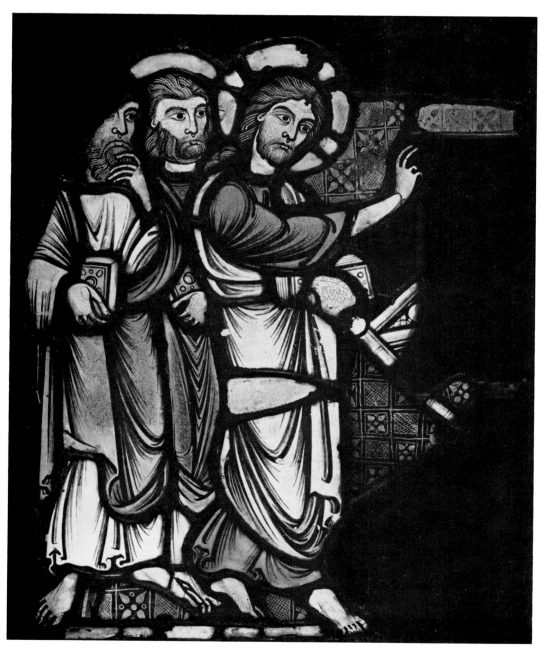

THE MIRACLE AT BETHESDA

meant to emulate, in miniature, its prototype in the Heavenly Jerusalem.[2]

Church illumination of symbolic order was achieved with precocious brilliance in sixth century Byzantium, but in the West another six centuries were to pass before anything comparable was to be seen. Even so, for the Latin world this purpose was nevertheless the long-range ambition, and it may be said that the medieval architect had always really been looking for the Gothic solution. Once attained there was no doubt that this was what they had sought, for we see that thereafter Gothic remained the "final" medieval architectural style. But this is even documented in a remarkable account of the Abbey Church of Saint-Denis (1137–1144), the first Gothic structure, by none other than its "inventor" the Abbot Suger. The verses which he had inscribed on the gilded doors of the new church declare the theme, the theology, and the aesthetic of this art:

> *Bright is the noble work; but, being nobly bright, the work*
> *Should brighten the minds, so that they may travel,*
> *through the true lights,*
> *To the True Light where Christ is the true door.*
> *In what manner it be inherent in this world the golden door*
> *defines:*
> *The dull mind rises to truth through that which is material*
> *And, in seeing this light, is resurrected from its former*
> *submersion.*[3]

And, of the interior effect of the revolutionary church structure, Suger's verses go to the heart of the same theme:

> *For bright is that which is brightly coupled with the bright,*
> *And bright is the noble edifice which is pervaded by the new*
> *light;*[4]

For the worshiper, the dazzle of visible brilliance in the concert of lights and resplendent hues of gold, glass, and jewels was to serve as an initiation into true spiritual enlightenment, the best way conceivable by which mere matter might afford glimmerings to the mind, leading it beyond the material to the immaterial and ultimate Light of Lights.

The Christian aesthetic and metaphysics of light, as set forth by Suger and others of the twelfth and thirteenth centuries, mark a well-known climax in the Western development. But the underlying ideas originally belonged to early Christian neo-Platonism, for which the most influential single source was to be found in the writings, known to Suger, of an early sixth century Syrian, the pseudo-Dionysius the Areopagite. The endless and ingenious speculation on light, developed mainly on "the distinction between *lux spiritualis* (which is God) and *lux corporalis* (which is manifestation of God), or between *lux* and *lumen*, spiritual substance and material substance, the numenal form, you might say, and the phenomenal form of the same reality."[5] In these early centuries there was established a body of principle, doctrine, and interpretation, worked out in commentaries, exegesis, and philosophy, which was to provide the basis in method and to serve as example for the rest of the Middle Ages. This preoccupation did not rest in the speculative sphere alone, for its relevance to acts and objects in the liturgy and ritual, and even the church edifice, were equally propounded and exploited.[6]

The church building was not only generally understood to have symbolic meaning, but this was elaborated, more or less systematically, to explain the particulars of its plan and its components.[7] The windows played a recognized part in that system, for it was from the theology of light of the pseudo-Dionysius that St. Maximus the Confessor (*c.* 580–662)

194

derived the symbolism for his exposition of architectural iconography in the *Mystagogia*. How this was actually applied may be seen in a remarkable hymn of the seventh century which describes a sixth century cathedral in Edessa and sets forth the mysteries to which the building gives visible form. Two strophes make direct reference to the windows:[8]

> *In its choir shines a single light*
> > *through three windows which open into it.*
> *It announces the mystery of the Trinity,*
> > *of the Father and the Son, and the Holy Ghost.*
>
> *Besides, the light of its three sides is produced*
> > *by many windows:*
> *It represents the Apostles, and our Lord and the*
> > *Prophets and the Martyrs and the Confessors.*

Against the loose popular notion that the use of colored glass in churches is peculiar to the Gothic period and its architecture, there is an abundance of contrary evidence which, far from lessening the Gothic achievement, only serves to heighten its position in historical perspective, showing it to be the culmination of all medieval striving in that direction. Mention of such glass appears as early as the fourth century in Prudentius' description of a Constantinian church where he saw: "splendid glass of different hues, like meadows that are bright with flowers in the spring."[9] From the ninth through the eleventh centuries colored and painted windows are mentioned in descriptive, and miraculous contexts, and there even are preserved fragments of the actual glass to prove their true relationship to the well-known Gothic descendants.[10] But such windows would have been rather exceptional in those early churches, especially if we consider the necessarily restricted fenestration of pre-Gothic structures.[11] More than for any other architectural

195

style, glass and Gothic belong essentially to each other. In the skeletal structures of Gothic churches, where walls had been virtually eliminated, these screens of colored and painted glass were ideal for filling the structural web. In that diaphanous cage of light, the stained glass windows completed the effect of an architecture which was an expression of the True Light to which the Church edifice was addressed. From there on, every kind of interpretative exegesis, all along the same thematic lines, could be read in the workings of the stained glass in such churches.

Hazards of time and unfortunate circumstances have brought destruction to a considerable portion of stained glass. During periods of neglect and even in the course of misguided repairs and restoration, entire windows have been lost to their churches and innumerable panels and fragments diverted into the art market, to museums and private collectors. Even in our own day a single dealer could offer for sale over fifty pieces, including entire windows and large panels, many of unique importance.[12] All too often, the place of origin of such stained glass, if not evasively concealed, has been lost and is not easily rediscovered. Even so, any panels of good quality are precious and rare. Fortunately, the fragment in the Collection is not only a work of finest quality from an important atelier, but it is one which can be located quite accurately in place and time, even to the detail of its original location within the church for which it was made.

Louis Grodecki has identified the Guennol piece as having come from the Cathedral of Troyes, in Champagne,[13] which is famous for an extensive series of fine windows ranging in date from the beginning of the thirteenth into the sixteenth century. Much of the stained glass in the major churches and cathedrals of the twelfth and thirteenth centuries was made by traveling shops and teams of glaziers and glass painters.

196

Troyes, however, belonged to a special class of a few centers which had their own resident shops, ateliers of masters who succeeded each other from generation to generation.[14] Well on into the sixteenth century the art of the Troyes glassmakers was widely known, and they even produced windows for export to the rest of France.[15]

The Cathedral of Troyes was begun by the Abbot Hervé, early in the thirteenth century. By the time of his death in 1223, the choir, ambulatory and the apsidal chapels had been completed.[16] It is to this period, at the very beginning of Troyes' history, that the Guennol fragment belongs, for it comes from the main chapel, just behind the apse, and conforms in style to the other early glass of those chapels which still remain. Actually, the only stained and painted glass windows in France which are preserved date from about 1140 on, and until practically the end of the century they remain Romanesque in character. These early windows, at Le Mans and Angers, and even the early glass of Saint-Denis and Chartres, retain much of that linear agitation and movement of the figures and the expressive contortion of the action of Romanesque art. It was in Champagne, in the glass of Saint-Remi at Reims (c. 1180–1200), that the design of the windows began to approximate the more monumental style of the early Gothic stone sculpture. Directly after this development, and at an exciting moment in the history of French stained glass, came the work of the first atelier of the Troyes chapels of the chevet. Simply on the basis of their strikingly early style, one nineteenth century scholar, quite carried away, uses them to argue that the chapels were the earliest part of the first construction carried out in the cathedral:[17]

The design of the ornament and the arrangement of the garments of the figures are altogether of the very purest of

197

Byzantine style. This very precise character allows us to believe that no sooner had the chapels been built and covered than all these windows were set in place, during the life of the founder, the Bishop Hervé—that is, before the construction of the choir.

The style of these windows, as we see it in the Guennol fragment, will hardly seem Byzantine to the observer to-day. What this nineteenth century scholar saw was the new monumentality, the gravity and simplicity of these figures and their inward expressiveness—all contrasting with the outward agitation and arbitrary proportions of the earlier Romanesque style. But it is true that the impact of Byzantine art on the West was an important catalytic agent in the transformation of the Romanesque, giving to the Gothic style the sobriety and the organic figural composition which Byzantium had preserved of the antique tradition. However, as we encounter this transformation in the Guennol figures from the Troyes windows, that Byzantine ingredient has been thoroughly absorbed, and the style is more that of the Early Gothic, recalling that of the sculptured jamb figures in the central portals of the Chartres transepts which belong to this same period, the dawning of the thirteenth century. In the Guennol glass the posture of the striding legs of Christ, with the hint of dancing motion, still harks back to the cross-legged ecstatic stance of Romanesque art. However, in Romanesque art the subdivisions of the main drapery areas and the folds within those areas form arbitrary compartments and stylized linear patterns. The designer and painter of the Troyes glass arranged the drapery to form large unified areas relating to the organic articulation of the whole figure; within those areas the lines of the drapery folds sweep in consonance with the coherent treatment of the drapery modeled on the body structure.

In their present state—in spite of losses, disorder, and much restoration—the original arrangement of the stained

198

glass windows in the apsidal chapels of Troyes can be re-constructed, thanks to detailed nineteenth century descriptions and drawings.[18] The Guennol fragment originally was in the central chapel, directly on the axis of the main altar in the sanctuary. There were seven windows in that chapel, and this piece was in the second window at the right, among scenes of the public life of Christ. Four panels from the series were given by J. Pierpont Morgan to the Victoria and Albert Museum in London, and a small fragment with a single figure of an apostle is now in an American private collection.[19]

These panels are among the few remains of stained glass of the Champagne region of the early thirteenth century, a region from which only one ensemble of glass, incomplete at that, is known: that of the abbey of Orbais.[20] In that Champagne development the Guennol Troyes glass stands at a critical point in time and style. Grodecki's date of *c.* 1200–1205 does not seem too early, and his placing of the style just after the early glass of Saint-Remi, but distinctly before the wave of Chartrain influence from the Ile-de-France seen in the upper choir of Troyes (*c.* 1235), is justified.[21]

Our fragment has been indecisively identified as showing Christ and two apostles without any recognition of its true subject. But there is a significant clue, which has been over-looked: the corner of a piece of furniture seen at the right edge under Christ's arm, which provides a basis for reconstructing the lost half of the composition. In my opinion this piece of furniture can only be interpreted as part of a bed, undoubtedly from the scene of Christ's miracle at Bethesda, where He healed the lame man, commanding him: "Rise, take up thy bed and walk" (John v: 1–9). Among such healing miracles of Christ which might be considered in this connection there is only one other which

might be relevant, that of the raising of the widow's son at Nain (Luke vii: 11), for there the son is carried on a bier in a procession. But only the empty bed of the healed lame man could be so tilted as it is on the Guennol glass. Indeed these two subjects are the only ones to show raised "beds" in such cycles of small scenes for the life and ministry of Christ as are prefixed to psalters. For example, in a psalter of about 1200 (Paris, Bibliothèque Nationale, Ms. lat.8846 fol. 3v) the compositions are very similar to those of the Troyes scenes, always dominated by an erect, gesturing Christ, the apostles standing behind Him, and the subject of His miracles at the right. Even the figure style of that manuscript is remarkably close to that of this Troyes fragment. It is interesting to note that in the most thorough recent study of the subjects and restoration in the Troyes chapels, the author says that of all the subjects restored by Vincent-Larcher (*c.* 1840–1845) to fill the three main lacunae, "the most debatable is the curing of the blind-born."[22] The restored scene is in the very chapel and window from which the Guennol fragment must have come. But nobody has connected this fragment with that window, much less that most problematic restoration. It seems most probable, however, that the panel from which the Guennol fragment came was already incomplete when Vincent-Larcher undertook repairs and restoration. He must have decided to discard it and replace the panel with an entirely new and complete scene, simply making a guess as to the original subject.

As a fragment, our glass cannot begin to suggest the effect and character of an entire window with its brilliant colors set in the controlling geometric web of the armature, the supporting iron bars which hold the glass in place. But the compensation is no less precious, for we can all the better study the dynamic patterns of the binding lead strips and the technique of the black enamel painted lines which de-

lineate features and other details, and we can linger on the incredible loveliness of the color.

THE MIRACLE AT BETHESDA FRAGMENT OF STAINED GLASS

Height 15.5'' Width 12.5''

French (Troyes), *c.* 1200–1205

PROVENANCE: From lateral window of the Chapel of Notre-Dame in the Cathedral of Saint-Pierre at Troyes. Probably removed during restorations of *c.* 1840–1845 by Vincent-Larcher.

EX COLL.: Greau, Paris; G. Bideaux, Paris, until 1934; purchased by Joseph Brummer; Joseph Brummer Sale, Parke-Bernet Galleries, New York, April 21, 1949, no. 823.

BIBLIOGRAPHY: A. F. Arnaud, *Voyage archéologique et pittoresque dans le département de l'Aube et dans l'ancien diocèse de Troyes*, Troyes, 1837, p. 177; F. de Guilhermy, travel notes and descriptions of the windows, 1843 (Paris, Bibliothèque Nationale, ms. nouv. acq. fr. 6111); C. Fichot, *Troyes, ses monuments civils et religieux*, Statistique monumentale du départment de l'Aube III, Troyes, 1894, pp. 33 ff.; *The Metropolitan Museum of Art Bulletin*, IX, Summer 1950, p. 22; Louis Grodecki, *Vitraux de France du XIe au XVIe siècle*, exhibition catalogue, Paris, 1953, p. 53, no. 14; *idem*, report of March 23, 1955, in *Bulletin de la Société nationale des antiquaires de France*, Paris, 1954–1955, p. 127; J. Lafond, "Les Vitraux de la cathédrale Saint-Pierre de Troyes," in *Congrès archéologique de France, CXIIIe session, 1955, Troyes*, Orléans, 1957, p. 45; L. Grodecki, "De 1200 à 1260," in Marcel Aubert et al., *Le Vitrail français*, Paris, 1958, p. 118.

EXHIBITED: Metropolitan Museum of Art since 1949.

NOTES

1. See Grodecki on "Fonctions Spirituelles" of stained glass in *Le Vitrail français*, pp. 39 ff.

2. Revelation XXI describes the Heavenly City as being of a brightness "like some precious stone," whose walls of jasper and streets "of pure gold like transparent glass," its Temple, "the Lord Almighty and the Lamb," required "neither sun nor moon to shine in it; for the glory of God illumines it, and the Lamb is the light thereof." The graphic clarity of Revelation is unusual only in its extravagance, incanting a *magnificat* of light symbolism and metaphor on the lines of Scripture where Christ is the *lux vera* and the *lux mundi* (John i:9 and viii:12), and divine wisdom "an effulgence of everlasting light" (Wisdom vii:26).

3. See E. Panofsky, ed. and trans., *Abbot Suger on the Abbey Church of St.-Denis and Its Art Treasures*, Princeton, 1946, pp. 47–49, from which this translation is quoted; the context of this excerpt is to be found in Panofsky's full translation of the text. See also the brilliant introductory commentary and analysis of Suger in this book.

4. *Ibid.*, pp. 50–51, and, for the discussion which follows in our text, cf. *ibid.*, pp. 18 ff.

5. Grodecki, "Fonctions Spirituelles," p. 40.

6. In Byzantine domes or apse mosaics, best known from twelfth century examples, the Christ Pantokrator presents the message *Ego sum luxi mundi* (John vii : 12). This literal reference makes explicit the mystical sense of the mysterious glitter emanating from the tesserae. It is also the essential clue for architectural iconography and aesthetic with respect to light. Procopius (*c.* A. D. 560) already speaks of churches in such terms. Much in the same way that Revelation describes the Heavenly Jerusalem, Procopius says of two particular edifices that "each equally outshines the sun by the gleam of its stones" (see *Procopius*, ed. and trans. H. B. Dewing and G. Downey, London–Cambridge, Massachusetts, 1950, VII, *Buildings*, I, iv. 5, p. 45). Cf. Procopius I.i.30 on Hagia Sophia: "Indeed one might say that its interiour is not illuminated from without by the sun, but that the radiance comes into being within it. . . ."

7. W. Durandus (1230–1296), *Rationale divinorum officiorum*, devotes the first book of his work to a symbolical interpretation of all parts in the church edifice (see the excellent edition and translation by C. Barthélemy, *Rational, ou, Manuel des divins offices de Guillaume Durand*. . . Paris, 1854, cf. I, pp. 11 ff., and pp. 20–21.

8. A. Dupont-Sommer, "Une Hymne syriaque sur la cathédrale d'Edesse" in *Cahiers archéologiques*, II, 1947, pp. 3–39, and cf. A. Grabar, "Le Témoignage d'une hymne syriaque sur l'architecture de la cathédrale d'Edesse au VIe siècle et sur la symbolique de l'edifice chrétien," in *ibid.*, pp. 41–67.

9. *Peristephanon Liber* (Crowns of Martyrdom), XII, lines 54–55, see *Prudentius*, trans. H. J. Thomson, London–Cambridge, Massachusetts, 1953, II, p. 327.

10. For various texts of this period, see J. L. Fischer, *Handbuch der Glasmalerei*, Leipzig, 1914, chap. II (1. A), pp. 38 ff. For the earliest remaining glass found see Grodecki, "Des Origines à la fin du XIIe siècle," in *Le Vitrail français*, p. 96.

11. See *idem*, "Le Vitrail et l'architecture au XIIe et au XIIIe siècles," in *Gazette des beaux-arts*, XXXVI, July–September 1949, pp. 5 ff.

12. L.-J. Demotte, *Catalogue of an Exhibition of Stained Glass from the XIth to the XVIIIth Cent.*, New York, n.d.

13. Grodecki, report of March 23, 1955.

14. Cf. J.-J. Gruber, "Technique," in *Le Vitrail français*, p. 56.

15. J. Lafond, "Renaissance," in *ibid.*, p. 18.

16. V. de Courcel, "La Cathédrale de Troyes," *Congrès archéologique*, pp. 9–10.

17. Cf. Fichot, p. 349.

18. Cf. Lafond, "Les Vitraux de la cathédrale Saint-Pierre de Troyes," and early references in bibliography above.

19. B. Rackham, *A Guide to the Collections of Stained Glass, Victoria and Albert Museum*, London, 1936, p. 28, pl. 7; cf. reproduction of one of these panels in *Le Vitrail français*, fig. 89. The fragment showing the standing apostle is reproduced in Demotte (see note 12 above), under no. 3, as coming from the Garnier Collection.

20. Grodecki, in *Le Vitrail français*, pp. 117–118.

21. *Ibid.*

22. Lafond, "Les Vitraux de la cathédrale Saint-Pierre de Troyes," p. 41.

A FRENCH GOTHIC
ALTAR ANGEL OF THE PASSION

THE Guennol angel embodies the essence of that lyricism and haunting loveliness which is so much the heart of French Gothic sculpture. Its mood and action present an appealing enigma not without hints of the original setting from which the figure now stands in alien isolation.

Viewed simply as a work of Gothic art, the style of this figure may be contrasted with that of the Romanesque "Majesty" in the Collection (p. 171). There the Virgin and Child are on a rigid vertical axis and in relation to a strict frontal plane, whereas the angel describes a subtly sinuous movement around an elegantly elongated S-curve. The volumes of the Romanesque statue are of a stony geometry, the surfaces an encasing hard shell; in the Gothic sculpture the masses are pliant and fluid, the surfaces softly yielding in an approximation of the materials reproduced. The face of the Auvergnat Virgin is a mask of impenetrable mystery; that of the angel communicates a noble sadness tempered with gentle love, restrained by a higher wisdom.

Considerable as this contrast may seem, it is but the equivalent in visible form of those changes which distinguish the Romanesque era from the Gothic. Romanesque art is essentially the product of a monastic society, relatively austere and rigid in its societal and cultural structure as well as religious philosophy. Romanesque imagery, variously abstract, was markedly removed from the actual world of material existence and experience of the senses. Gothic style belongs to the newly created and increasingly secular culture of cities. There the free citizens—including prosperous merchants, gentlemen, and nobility—worship-

ed in the proud cathedrals and were the avidly competitive patrons of their churches. New cosmopolitan universities flourished, alive with the spirit of vigorous intellectual inquiry. In this urban world theologians and philosophers, grounded in a modified Aristotelianism, sought to reconcile direct experience of things of this world with the idea of God and His Word. All that man could see in nature he might now strive to know, without religious impropriety, as equally marvelous manifestations of the works of the Creator. That Creator, no longer the mysterious Romanesque absolute, appears in Gothic art as the skillful craftsman who made everything at the beginning—the perfect prototype of man, the microcosm, who works at his trades and crafts.

The changes in medieval art which are synchronous with these developments began to unfold during the twelfth century. In the shift from abstraction to idealizing naturalism, Chartres marks the first phase, known as Early Gothic. Beginning with the Royal Portal of the west façade towards the middle of the twelfth century, the sculptured figures are still somewhat rigid and partly embedded in the stone of the structure. By the first quarter of the thirteenth century they have attained more natural proportions, textured surfaces, and individuality of expression; indeed, they are now free-standing sculptures.

The second, and classic, phase of Gothic sculpture prevails in the thirteenth century until about 1260. The freer play of figural action, full and heavy drapery modeling, and the facial serenity of High Gothic statuary owe this character to the inspiration of classical sculpture. A further turn in the development came after about 1260, bringing the final major transformation of this art—the Late Gothic. The reserve of High Gothic yielded to increasing freedom not only in the action and modeling but, more overtly, in the expanding range of emotional expression.

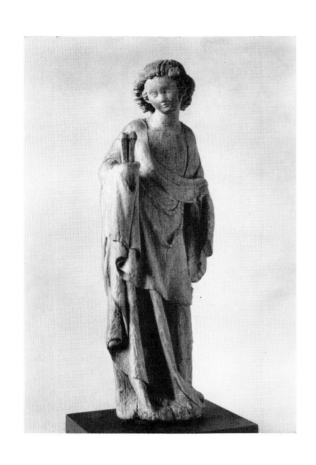

ALTAR ANGEL

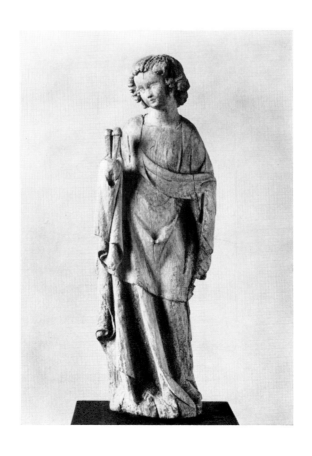

The entire gamut of thirteenth century sculpture may be spanned by the enormous production in the Cathedral of Reims, focus both for the most splendid works of High Gothic, and the indefinable changes which shift the balance to Late Gothic. The art of the great ateliers of Reims is of direct relevance to the Guennol angel. Reims provided the parent style from which this angel is derived. At Reims, too, was established the typology of the angel sculptures which created a vogue of increasing popularity for the remainder of the Middle Ages. The pose of the Guennol angel, particularly in the way the curve of the head reverses that of the upper body, immediately suggests the famous Reims angels, such as those of the Annunciation and of St. Nicaise in the west portals. However, the Guennol angel does not show anything like the high relief in the drapery folds so typical of the High Gothic angels of Reims, dating about 1240. But there exists a group of sculptured wooden angels which supply the link between those of the cathedral and our angel. Among them are two in the Louvre (known as the Jeuniette and the Sachs angels from the names of the donors), which preserve more apparent ties to the ateliers of Reims and are dated in the last third of the century.[1] The faces of the Louvre angels are full, round, and smooth, framed by a scrolled mass of curls in bold relief, much the same in form and line as the Guennol angel. If the gradations in the connections between the Guennol figure and those of the cathedral cannot be more completely filled from examples of sculptured angels, it must be because of the perishability of such wooden sculptures, which must have existed by the hundreds.

Despite the similarities of the heads,[2] comparison between the Guennol and Louvre angels reveals telling differences in the system of drapery modeling. The Louvre figures employ heavy masses in bold relief ridges which

206

stand out against deep shadowed recesses. The relief of the Guennol angel, on the other hand, is gently suppressed and flattened, subordinating drapery modeling and line to the general mass of the statue as a whole. As a sculptured form, the Guennol figure seems to be attenuated by a delicate concavity whose sweep conforms to the dominant rhythm of the curving posture. The Louvre angels, in this respect, relate to the style of the last quarter of the thirteenth century while the Guennol angel reveals its stylistic affiliation with works from the first half of the fourteenth. The later trend is already in evidence in the stone apostles preserved from the Paris church of Saint-Jacques-l'Hôpital (now in the Cluny Museum), known to have been carved between 1319 and 1327.[3] The resemblance to the Guennol angel lies in the way the drapery of the apostles has been absorbed into the mass of the whole figure. But the Guennol angel has not gone so far in that direction. This difference, and the fact that the angel's head is still so true to the thirteenth century tradition, suggests that the angel might be datable within the first decade of the fourteenth century. As for the relative fullness of modeling and melodic sweetness of line in the Guennol angel—as compared with the precious formalism of the Paris apostles—these serve to further support the attribution to the region of Reims and the general style of the ateliers of Champagne.

Our angel belongs to a type well known from similar wooden angels, as for example the Louvre statues cited and the recently acquired pair at The Cloisters of the Metropolitan Museum.[4] While the Guennol angel is one of the smallest of its kind, just under eighteen inches, the others are not much larger, ranging from two to three feet or so in height. Some are preserved as related pairs, but even the single figures show indications of having formed part of a grouped series. Also, such angels hold—or reveal

traces of having held—various objects which when preserved prove to be either candlesticks or instruments of the Passion. Although the original destination of these small angels is even today mistakenly or vaguely explained, their purpose has been known for some time. Viollet-le-Duc, in the middle of the nineteenth century, had already discussed them in relationship to a definite and meaningful scheme of functional embellishment of the area around the main altar.[5] He cites medieval and later sources, documents, descriptions, and drawings which reveal that the altar was screened off on three sides by curtains, hung between colonettes. On top of the colonettes, which ranged from four to six in number, stood the small angels. More recently, this explanation has been taken up by R. H. Randall, Jr., in connection with a pair of angels acquired by the University Museum in Princeton.[6] His study suggests that this type of altar screening together with the angels came into vogue in the later thirteenth century and that their religious meaning might be related to the idea expressed by William Durandus in the thirteenth century of enclosing the "brightness" of the altar.

This interpretation touches upon only one aspect of the complex light symbolism of the later Middle Ages and would pertain to all the altars in general but especially to those with angels bearing candlesticks. However, in the use of angels with instruments of the Passion, there is clearly another kind of accent within the multi-layered depths of meaning which is usual in medieval iconography.[7] The allusion in the Passion series must relate to the idea of the sacrifice of Christ on the Cross and, of course, to the Eucharistic body and blood of Christ. In the medieval legend of the Mass of St. Gregory, the Christ of the Passion appeared to St. Gregory as he was celebrating the Mass at the altar. It can hardly be an irrelevant coincidence that this theme emerged as a subject for art by the middle of the thirteenth

century and gained in popularity through the fourteenth century. In the iconography of that subject, Christ is shown above the altar bearing the wounds of the Crucifixion with the instruments of the Passion which are usually held by angels.[8] A separate image of the dead Christ, supported by angels and surrounded by the instruments of the Passion, also appears at the same time.[9] Such interest in the Passion is one of the most characteristic manifestations in the art of this period.[10]

The Guennol angel is the only one of its kind which has survived in which we can still see an attribute of the Passion, the three nails. A likely reconstruction of the group to which it belonged would include a series of possibly six angels, each bearing one of the instruments of the Passion: the lance, the sponge of vinegar, the column, the crown of thorns, the nails, and the cross. No altars remain today which retain any of the original decoration from such schemes, but there is ample evidence they did exist. There is a question as to whether the missing left hand of our angel might not have held another attribute from this series. Two holes, drilled to hold pegs for the support of an unknown object, are still visible beside the angel's left arm. If that hand held a cross, then the angel might have been part of a group of four, in which one pair held two of the instruments of the Passion. To the visual impression of the Guennol angel as we see it now we must add a mental image of a pair of great wings, sweeping up behind and above the figure (the slots at the back show where the wings once were attached). We are also reminded by the vestiges of gilt which remain in the hair and the traces of blue and vermilion bordered with gilt, which hint at the color of the angel's garment and mantle, of the added splendor of this angel when it originally crowned one of the colonettes enclosing a main altar.

ALTAR ANGEL

Height 17.5″

French (Champagne?), *c.* 1300–1310

BIBLIOGRAPHY: H. Comstock, "The Connoisseur in America," *The Connoisseur*, CXXIII, June 1949, p. 108; J. J. Rorimer, "Two Gothic Angels for The Cloisters," *The Metropolitan Museum of Art Bulletin*, XI, December 1952, p. 105; R. H. Randall, Jr., "Thirteenth Century Altar Angels," *Record of the Art Museum, Princeton University*, XVIII, 1959, p. 14.

EXHIBITED: Metropolitan Museum of Art since 1948.

NOTES

1. M. Aubert, *Description raisonnée des sculptures du moyen âge, de la renaissance, et des temps modernes*, Paris, 1950, I, pp. 102–103, nos. 141, 142.

2. This similarity is rather strong and may be observed in good illustrations, e.g., those reproduced by P. Pradel, *Chefs-d'oeuvre de la sculpture au Musée du Louvre: Têtes gothiques*, Paris, 1946, pl. III (Louvre no. 141, Jeuniette), and pl. IV (Louvre no. 142, Sachs).

3. Cf. E. Haraucourt and F. de Montrémy, *Musée des Thermes et de l'Hôtel de Cluny, Catalogue général*, I, *La Pierre, le marbre et l'albâtre*, Paris, 1922, nos. 252–256, pl. XVI.

4. Rorimer, pp. 105–107.

5. E. E. Viollet-le-Duc, *Dictionnaire raisonné de l'architecture française du XIe au XVIe siècle*, Paris, 1859, II, pp. 24 ff., note illustrations pp. 26, 29, 30. Cf. J. Braun, *Der christliche Altar*, Munich, 1924, II, pp. 143 ff., and pls. 144–146.

6. Randall (see bibliography above). I am grateful to Richard H. Randall, Jr., for making the manuscript of this article available before it appeared in print.

7. *Ibid.*, pp. 10, 16, extends the interpretation of the enclosing altar to include, within the same meaning, the angels "who hold either candles to light the world or the Instruments of the Passion to enlighten the spirit of the beholder." It is highly questionable whether this may be justified, especially since Durandus does not mention the angels in the first place. Even among angels holding candlesticks, we find some who swing censers (e.g., *ibid.*, p. 11, fig. 4), which would be indicative of ritualistic reference. It is plain that the angel iconography must relate *primarily* to the altar, and the ritual in the sanctuary. The Passion angels, more patently, relate to the Eucharist and the sacrifice symbolically celebrated at the altar.

8. Cf. L. Bréhier, *L'Art chrétien*, 2nd ed., Paris, 1928, p. 338, and E. Mâle, *L'Art religieux de la fin du moyen âge en France*, 3rd ed., Paris, 1925, pp. 102 ff., ill. pp. 103, 244.

9. Mâle, pp. 100–101, figs. 49, 50, who, significantly, includes this type in his discussion of the Mass of St. Gregory, calling it "Le Christ de saint Grégoire." Actually it is a distinct type, recognized as such and discussed by E. Panofsky, "Imago Pietatis," in *Festschrift für Max J. Friedlander zum 60. Geburtstage*, Leipzig, 1927, pp. 21 ff.

10. See especially Mâle, pt. I, chap. III, "L'Art religieux traduit des sentiments nouveaux. Le pathétique."

ORPHREY FRAGMENT
OF OPUS ANGLICANUM

ONE of the real triumphs of medieval art was the way in which their artisans could create works of high aesthetic and technical order out of materials and media so ordinary as to have been rarely used for major art forms in any other period. From the mere glazing of windows came their superlative stained glass, and from the weaving of cloth a remarkable new mural art, that of tapestry. Less generally familiar than tapestries, but by no means less brilliant, was the medieval art and craft of embroidery.

Evocative of Homer's Penelope, the medieval chronicles preserve abundant tales of saints, bishops, and queens renowned for superb embroidery.[1] These records go back to the seventh century A. D. and by the eleventh had reached an early climax in the famous pictorial epic known as the Bayeux Tapestry, which, as everyone knows, was actually embroidered. This tradition continued without interruption and with ever-renewed vitality to the end of the Middle Ages and beyond. Supreme in this class of needlework was the art of the English embroiderers who gave their country pre-eminence in Western Europe from *c.* A. D. 1250 to 1350.[2] Archives tell us again and again of *opus Anglicanum* in connection with the most splendid gifts to popes, high prelates, and princes and, in turn, their donations to church treasuries where many of these embroideries are still so highly prized.

The embroidered piece of *opus Anglicanum* in the Collection is of a kind originally destined to be affixed to church vestments or vesture according to prescribed designs for each form. Such embroidered bands and panels are known as orphreys, the name deriving from *aurum* for the liberal use of gold usually found on them, and *Phrygius*, which may

211

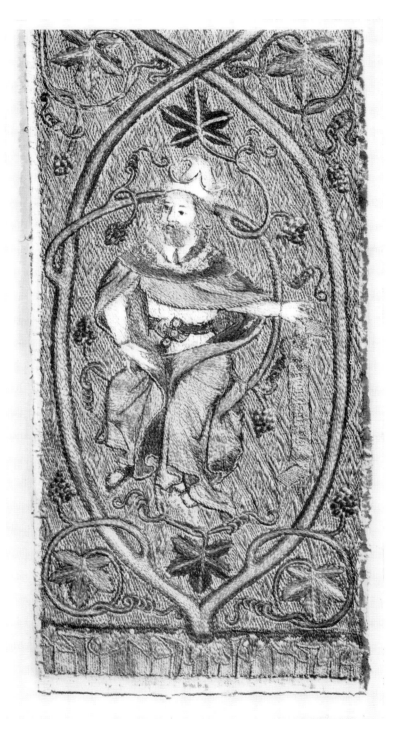

ORPHREY FRAGMENT—*Detail*

212

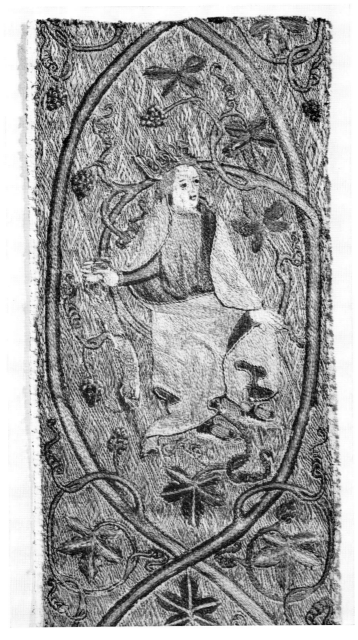

ORPHREY FRAGMENT—*Detail*

have been inspired by their exotic, luxurious appearance. There is nothing essentially remarkable in the particular kinds of stitching used in such embroidery, but what is noteworthy in *opus Anglicanum*, handsomely exemplified in this piece, is the refinement and perfection with which conventional techniques have been employed.

In the use of gold thread, so lavishly applied to the Guennol piece, may be discovered some indications of the technical virtuosity of the English embroiderers at this time. The gold is actually metallic, here silver gilt, in very fine strips wound around silk floss. The gold embroidery transforms the cloth with an effect like that of an exquisitely tooled gold ground in the more elegant manuscript miniatures. It is, in fact, formed into a delicate relief pattern of lozenges achieved by a technique conventional enough in embroidery but, here again, consummately executed. The technique, called "couching," consists of laying coarser linen threads on the surface in the desired patterns and stitching over them with the gold thread to conceal the "couch" while forming subtly wrought relief ridges. The cloth foundation for the whole is made up of two pieces of linen, the upper one finer, superimposed upon each other. Even though covered entirely by the embroidery, linen, like silk and other fine cloth, had symbolic meaning over and above its inherent quality and durability. In modern usage, too, linen has a special place as the "true liturgical material" esteemed as having "beauty of itself without adornment."[3]

Against the gold ground, the figured parts are embroidered in different values and intensities of green, blue, and rose; yellows, tan, and white are used for hair and flesh. The scrolls held by the figures are of silver thread, and the grape clusters make for scattered accents of intense reds. A few basic stitches were used in applying the silk fibers to the surface. For the larger areas of color, the needle was

drawn through the thread of the previous stitch, using a technique known as "split-stitch." This served to give continuity and fluidity of hue and value within those broad areas, and an effect akin to that by which brushwork is blended in painting. For such delicate gradations and surface finish as we see in the Guennol orphrey, the use of those techniques with minute perfection was requisite. An extremely simple succession of straight stitches (known as "stem-stitch") was used for outlining of contours and "drawing" of details, which were thereby accentuated and clarified. These are but some of the techniques[4] used in this orphrey, sufficient, however, to suggest how the refinements of *opus Anglicanum* during this period matched analogous developments in contemporary manuscript decoration and church building.

The Guennol orphrey is one of three pieces so similar in subject matter, composition, style, and technique that they must be said to have come from a single work.[5] The second of these, in the Brooklyn Museum Collection, is about forty inches long and seven inches wide. Upon it is embroidered a series of four seated figures, framed within the main stems of interlacing vines which outline almond-shaped compartments. The figures are ancestors in the genealogy of Christ: Ozias, Azor, Achaz, and Sadoch. This piece was originally somewhat longer, judging from the top compartment which is partially cut. A nearly identical orphrey in the Cleveland Museum completes the group. It is approximately the same size as that in Brooklyn but has only three compartments with ancestors, including: Achim, Ezekiel, and Eliud. The Guennol piece must have been of the same length as the others but now measures only twenty-five inches in length, having only two compartments in which are depicted Joram and Eliachim. Like the Cleveland orphrey, it would have had three when complete.

The subject matter leaves no doubt that the original work from which these sections remain must have been a large composition showing the Tree of Jesse. For Christian theology and art this theme is the exposition of the doctrine of the kingship of Christ as having descended in a direct line from Old Testament kings and patriarchs. Central to this doctrine were two texts, one in the prophecy of Isaiah, and the other at the beginning of the Gospel of Matthew. Isaiah's prophecy begins: "And there shall come forth a rod out of the stem of Jesse, and a branch shall grow out of his roots. And the spirit of the Lord shall rest upon him. . ." (Isaiah xi: 1 ff.), while Matthew declares that Christ is the messianic fulfillment of this vision, and he sets forth the lineage of Christ's descent from Abraham through three groups of fourteen generations. Among the ancestors named in Matthew, we find those which appear on the orphreys of this group.

The Tree of Jesse had become a subject for art by the eleventh century, but its real efflorescence came in the next two centuries where it is represented in great works of stained glass, stone sculpture, and illumination.[6] The Abbot Suger may be said to have launched this theme into new prominence when he prescribed a Tree of Jesse as the first in the series of new stained glass windows for his spectacular rebuilding of the Abbey Church of Saint-Denis (*c.* 1142–1144). The great Jesse window of Chartres (*c.* 1150–1155) derives directly from that inspiration. In miniatures it appears with increasing frequency from the early thirteenth century luxury psalters to the fourteenth century when it becomes the main feature of the great English psalters. The sculptured voussoirs of the great cathedrals, such as Chartres and Reims, pick up the same theme from the thirteenth century on.

A number of examples survive to show that the Tree of

216

Jesse was also shown on ecclesiastical vestments in *opus Anglicanum* of the late thirteenth and early fourteenth centuries, such as the two copes in the Victoria and Albert Museum.[7] A magnificent orphrey now in the Musée Historique des Tissus at Lyon (formerly Spitzer Collection) shows the complete central section of the Tree of Jesse, with the sleeping Jesse at the bottom and above him David, Solomon, the Virgin and Child, and the Crucifixion. A few of the ancestors are shown at the sides, the others having been placed on the lateral sections which are missing. From the curving bottom edge of this orphrey it has been deduced that this piece may have come from a chasuble. In addition to those extant vestments, inventory records tell of others. A mid-thirteenth century inventory of St. Paul's in London mentions a cope *bene breudata Iesse et stirpe*. Another in a fifteenth century inventory of the Cathedral of Lyon is described as a *cappa preciosa . . . contexta cum acu de auro, seminata in campo de virga Jesse.*[8]

Inasmuch as the form of the orphreys in our group does not seem to fit that of known types of ecclesiastical vestment, the evidence of surviving and documented pieces is both tantalizing and frustrating. The main objection to any theory that they came from a cope or chasuble is that each of the three pieces has a finished terminal which, as Elizabeth Riefstahl has pointed out, would be unlikely for such vestments.[9] The alternatives which she proposes include an altar frontal, banner, or hanging, to which these pieces might have been applied. Of these possibilities the altar frontal seems most promising.

On the assumption that the Guennol-Brooklyn-Cleveland orphreys might have come from an altar frontal, a hypothetical reconstruction of the original might be outlined. Such an altar frontal might consist of a central wide section, and two or three narrow strips (such as those we now have),

on each side. The wide central section would be necessary for the main figures requisite for the Tree of Jesse, among them: Jesse, David, Solomon, the Virgin and Child, and possibly the Crucifixion at the very top. That section might well show, among the lateral vines, those prophets associated with this theme: Isaiah, Jeremiah, Daniel, and Ezekiel. The narrow vertical strips flanking this central section would show additional ancestors, since those we now have neither exhaust the possibilities nor, more important, do they include a number of those essential even in an abbreviated genealogy. In that group may be mentioned Abraham, Isaac, Jechonias, Salathiel, and Eleazar, whom we do find in Jesse representations of the period. The dimensions of this hypothetical altar frontal would be about forty-five inches in height and, depending on the central composition and the number of side panels, some eighty or so inches in width.

The Guennol orphrey, along with the others of the group, has been dated toward the middle of the fourteenth century on the basis of costumes worn by the figures. However, from the figure style and composition, an earlier date—toward the beginning of the century—seems more likely. The comparative evidence for that conclusion comes from a number of splendid illuminated psalters datable to the last years of the thirteenth and the first years of the fourteenth centuries. In the Gorelston Psalter, the great *Beatus* leaf which opens the series has been developed into a magnificent Jesse composition.[10] The interlacing vine branches which form the main compartments are very similar in shape and development to those in these three embroideries. The figures show a similar range and variety of postures and gestures, as well as the same spirited animation. Despite the differences which go with individual styles, the general level indicated by drapery modeling and relation-

218

ship between figures and frames is essentially like that of the orphreys. In another of the great psalters made before 1308 for Sir William Howard, we find a similar Jesse with figures in vine frames on the *Beatus* page. But the points of resemblance become strikingly close when we turn to other miniatures in this psalter,[11] for we see figures whose posture and gesture, proportions, drapery lines, and modeling are among the strongest points of stylistic kinship between our embroideries and the miniatures. It might be tempting, on such grounds, to go further and say that the ateliers which produced the *opus Anglicanum* were East Anglian, the region where the manuscripts were produced.[12] But the very portability of the manuscripts, not to mention the diffusion of East Anglian style to other centers, suggests that this question must be left undecided. At any rate, it would be safe to propose that the Guennol-Brooklyn-Cleveland orphreys be dated in the first or second decade of the four-teenth century.

The actual work of embroidery may have been largely in the hands of women. A thirteenth century book of crafts by Etienne Boileau, provost of merchants, speaks of "em-broiderers and embroideresses" under the guild name of St. Clare.[13] Joan Evans notes an interesting injunction of 1314 from Yorkshire, admonishing nuns who absented themselves from church services *propter occupacionem operis de serico*.[14] But if nuns and, later, lay women were most active in the practice of embroidery, then the patterns and the designs may be credited to the monks and lay artists who illustrated the manuscripts. One such pattern book exists, containing drawings from about 1280 to the end of the fourteenth century.[15] It is as if, in *opus Anglicanum*, the de-votional arts of the monk and the nun had been wedded.

ORPHREY FRAGMENT OF OPUS ANGLICANUM

Length 25″ Width 6.9″

English, early XIV century

Ex Coll.: Marques de Cubas, Madrid.

Bibliography: E. Riefstahl, "An Embroidered Tree of Jesse," *The Brooklyn Museum Bulletin*, XI, 4, 1950, pp. 5–13, fig. 4.

Exhibited: Museum of Fine Arts, Boston, *Arts of the Middle Ages: 1000–1400*, February–March 1940, p. 35, no. 100; Brooklyn Museum, 1949; Guild Hall, East Hampton, New York, *The Tree in Art*, Summer 1957; Metropolitan Museum of Art since 1949.

NOTES

1. B. Kurth, "Genres of European Pictorial Embroidery in the Middle Ages," *Ciba Review*, 50, December 1945, pp. 1804–1805, and bibliography p. 1824.

2. A. G. I. Christie, *English Medieval Embroidery*, Oxford, 1938, pp. 2–4.

3. Dom E. A. Roulin, *Vestments and Vesture*, trans. Dom Justin McCann, Westminster, Maryland, 1950, p. 12. Note, however, this author's extreme purism, which arouses his violent criticism of the medieval orphreys whose excessive and "ugly elaboration" of decoration was a "disastrous performance" (p. 9).

4. See Christie, pp. 19–27, for discussion of materials and technique; cf. B. Kurth, "The Technique of European Pictorial Embroidery in the Middle Ages," *Ciba Review*, pp. 1798 ff.

5. See the excellent discussion of these pieces by Riefstahl.

6. A. Watson, *The Early Iconography of the Tree of Jesse*, London, 1934; cf. E. Mâle, *L'Art religieux du XIIe siècle en France*, 2nd ed., Paris, 1924, pp. 168 ff.

7. For full descriptions, bibliography, and reproductions see Christie, where six articles with the Tree of Jesse are to be found in the catalogue as follows:

 (1) no. 33, p. 68, pls. xx, xxiic. British Museum–Victoria and Albert Museum. Vestments of BishopWalter de Cantelupe (a pair of buskins). Early thirteenth century.

 (2) no. 60, pp. 112 ff., pls. lxiii–lxiv. Victoria and Albert Museum. Cope. Late thirteenth century.

 (3) no. 61, pp. 114 ff., pls. lxv–lxvi. Lyons, Musée historique des tissus (formerly Spitzer Collection). Orphrey. Late thirteenth century.

 (4) no. 62, pp. 116 ff., pls. lxvii–lxix. Barcelona, Señor Luis Plandiura (formerly Cathedral of Lérida, and Colegiata de Roda, Lérida). Orphreys of a chasuble. Late thirteenth century.

 (5) no. 63, pp. 118 ff., pls. lxx–lxxi. Victoria and Albert Museum. Orphreys of a chasuble. Late thirteenth century.

 (6) no. 64, pp. 120 ff., pls. lxxii–lxxiv. Private collection (formerly Salzburg Cathedral). Cope. Late thirteenth century.

8. For these inventory references see J. Braun, *Die liturgische Gewandung im Occident und Orient*, Freiburg im Breisgau, 1907, pp. 336, 343.

9. Riefstahl, pp. 10, 12.

10. Formerly Malvern, C. W. Dyson Perrins, no. 13, now British Museum, Add. Ms. 49622. Illustrated in E. G. Millar, *La Miniature anglaise aux XIVe et XVe siècles*, Paris–Brussels, 1928, p. 15.

220

11. British Museum, Arundel Ms. 83, pt. I (*ibid.*, pl. 7); the smaller miniatures which show the resemblance cited (e.g., David the Musician, f. 55v) are unpublished.

12. Cf. also the Ormesby Psalter (Oxford, Bodleian Library, Douce Ms. 366), Beatus page with Tree of Jesse (*ibid.*, pl. 1).

13. E. Lefébure, *Embroidery and Lace*, trans. Alan Cole, London, 1888, pp. 76, 77.

14. J. Evans, *English Art: 1307–1461*, Oxford, 1949, pp. 16, 17; cf. embroidery signed by the nun Johanna of Beverly, mentioned in *ibid.*, p. 17, note 1.

15. *Ibid.*, p. 19.

A FLEMISH LEATHER COFFER OF THE INTERNATIONAL STYLE

As material or medium for the more ambitious forms of artistic expression, leather would seem to offer little, if any, promise. Such, at least, might well be the view in this day when leather is relegated to the more prosaic crafts and the province of artisans rather than artists. Even the finer of modern works in leather are hardly to be thought of in the same class as sculpture and painting. This has not always been the case and particularly not so during the Middle Ages. Objects of leather from that period remain to show that it was regarded as suitable for fine art in the same sense as sculpture of whatever material. Their leatherwork was endowed with the same high qualities of art as works in ivory, metal, or stone. If, however, mention of leather as a vehicle for medieval art fails to evoke familiar images—as when we think of ivory, or glass—then it is because of the great paucity of surviving works. Far more than today,

221

leather was used for utilitarian objects ranging from pedestrian articles to sumptuous show pieces. Inevitable wear, in the use of works in this relatively perishable material, meant a high proportion of damage and eventual loss, hence their great rarity today. Examples of leatherwork are scarcely to be found in any but a few American collections, while only the older European museums have what might be called collections of this art.[1]

The Guennol embossed leather coffer is thus most unusual in kind, as an example of medieval leatherwork, but it is at the same time one of the finest in that medium. More than an object of curiosity, it ranks as a serious work of Gothic relief sculpture of genuine artistic merit.

The series of scenes on the sides of this remarkable box, considered together with the lions, foliate borders, and other interspersed ornament, suggests the spirit of the smaller medieval relief sculptures on the socles of church portals. It might almost appear that this coffer has the character of both the folding altarpiece and the portable altar, although it is obviously neither. Better still, it may be said to have the character of an illuminated manuscript, an analogy enhanced by the monumental inscription in formal Gothic letters which surrounds the entire piece along the rim of the lid. The inscription declares the ideological theme of the coffer's embellishment and the beginning of its narrative cycle. The perennial *Ave Maria gratia plena . . .*, hailing the central mystery of the Virgin's highest destiny, derives from the angelic salutation at the Annunciation. Completing the program in a grandiose climax is the large relief on the inside of the lid which represents the Death of the Virgin and her coronation as Queen of Heaven. Only the subject of the outer lid falls outside the narrative progression for it shows, in imperfect preservation, the Majesty of Christ. With the box in a closed position, this image expresses the

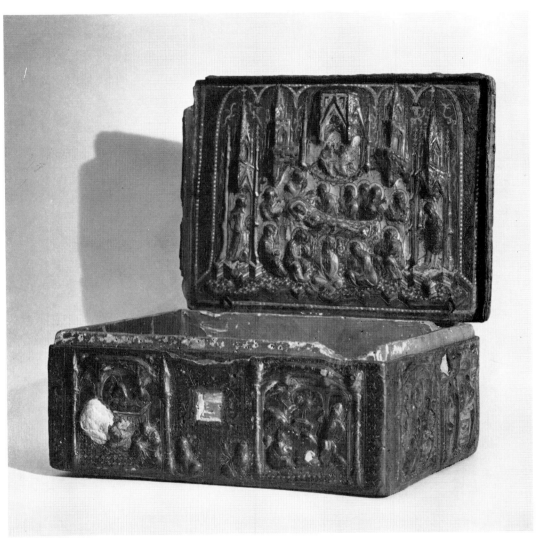

FLEMISH LEATHER COFFER

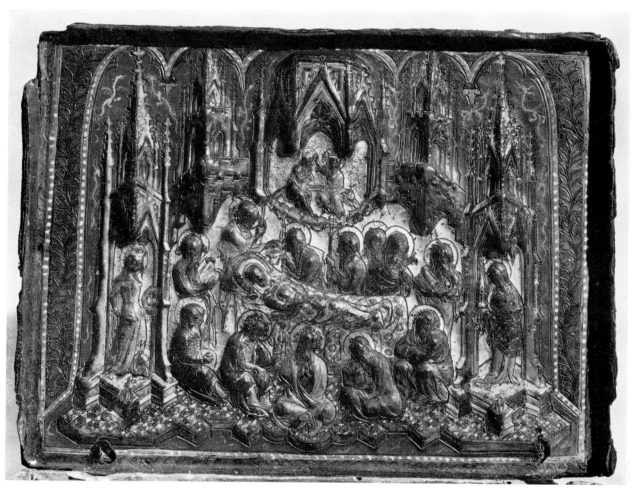

FLEMISH LEATHER COFFER—*Inside lid*

symbolic function of dogmatic reference for the historical sequence of the rest. The Majesty may be called the prelude and preparation for the mystery of the Incarnation. With the box in an open position, the true accent of the main program is revealed as that of the life of the Virgin, to which the Dormition-Coronation is the great finale.

The coffer could be said to embody, in three-dimensional form, the illuminated Hours of the Blessed Virgin. Within the Book of Hours each of the canonical hours in the offices of the Virgin is accompanied by a miniature showing an event in her life, thus for matins the Annunciation; lauds the Visitation; prime the Nativity; terce the Annunciation to the Shepherds; sext the Adoration of the Magi; none the Presentation in the Temple; vespers the Flight into Egypt or the Massacre of the Innocents; and compline the Coronation of the Virgin or the Death of the Virgin. Although there are frequent variations among the Books of Hours, the above arrangement is typical.[2] This is, in fact, exactly what appears on the coffer, whose total of nine historical scenes even includes the alternative subjects for the last two hours. In the instance of the vespers illustrations, the Massacre of the Innocents and the Flight into Egypt are both given, each in an individual panel. The subjects most frequently depicted for compline are incorporated into one representation for the inside of the lid. Since we know the *Horae Beatae Mariae Virginis* was the most widely used book of private devotions throughout the later Middle Ages, this surely must have been the source for the choice of subjects and possibly the very compositions which the leatherworkers have taken over.

For the localization and dating of the Guennol coffer, opinions have varied rather widely. Spain, Italy, France, and the Netherlands have all been suggested for place of origin, and a fourteenth or fifteenth century date for the period.[3] Of the

small number of comparable leather boxes known, the one closest to the Guennol piece yields significant clues for the dating of the group and also for localization. That coffer, in the Opera del Duomo of the Cathedral of Lucca,[4] is a very fine work with a number of analogous scenes in a style similar to the Guennol example. Since the Lucca coffer is documented as having belonged to an Italian gentleman named Alderigo Antelminelli who died in Bruges in 1401, both caskets may be dated around the turn of the century, if not slightly earlier. The circumstantial likelihood of the casket's having been purchased in Bruges opens up the possibility of its Flemish manufacture, a theory proposed by an Italian student of the Lucca piece.[5] Actually there is no cogent evidence to support any but the Flemish attribution which, thus far, rests on the documentation of its ownership. It is possible, however, to show distinct connections with Flemish art of the period on the basis of manuscript miniatures, the most abundant material available for the examination of this question.

The most essential formal characteristics of the Guennol series may be isolated by calling attention to the figure style on the one hand, and the architectural settings on the other. In depicting figures the artist shows a predilection for rather short proportions, full figures with rounded modeling, soft drapery textures, fluidity of line and movement. This character is so common to Flemish painting of the time that it is not easy to determine which of the active Flemish centers might have produced this work. It is to be seen, for example, in a Tournai manuscript of about 1390 or again, in manuscripts from Bruges of about 1400.[6] The style in the Artois, towards the end of the fourteenth century, also suggests similarities.[7] Another aspect of the reliefs which is somewhat generically Flemish is the genre interpretation of the narrative. Thus, we find

226

Joseph huddled up and dozing in the foreground of the Nativity, or carrying his walking stick with canteen and cloth, in the Flight into Egypt. Other details of homely realism, typical of pre-Eyckian Flemish painting, are to be seen here and there, one of the most touching being the crouching mother in the Massacre of the Innocents, gathering up her dead child in her arms.

Whereas the figure style and interpretation of subject matter finds numerous analogies from diverse centers of Flemish miniature painting, the distinctive architectural framing and setting presents something of a problem. Frames of approximately similar kind were widely used in many of the Flemish as well as French schools.[8] However, they are never quite the same as those on the Guennol coffer. There, each scene is set in a small building which forms a shallow room—even the outdoor subjects, such as the Flight into Egypt and the Annunciation to the Shepherds—are thus enclosed. The building is polygonal, and the three faces which appear to us are framed by flattened arches or ogee arches and opened to make the narrative visible. Two types of buildings are used in alternation: those with the ogee arches have a flattened roof and supporting columns at the sides capped by gabled pinnacles; those with flattened arches show a crenelated roof line and are framed by columns which bear little rounded or rectangular towers. All show their vaulted ceilings and lozenge-patterned floors. For all the miniatures with architectural frame and setting, only one manuscript thus far found employs a system reasonably approximating that of the coffer reliefs. That manuscript is definitely localized in Tournai and reliably datable to about 1350.[9] But it would be rash to suggest a Tournai provenance for the coffer on this basis. For one thing, the gap in time between the manuscript and the style of the coffer is too great. In the interval between the

two, such framing must have developed further and might well have been diffused to other centers.[10] For another, the figure style, which in later Tournai manuscripts does show analogies to the coffer, proved to be equally common in Bruges, among other centers.

The question as to which of the Flemish centers might have produced the Guennol and Lucca coffers may be left open to further discussion. Perhaps, some archival discovery may yet come to light which will reveal whether Bruges, Tournai, or another city was especially active in the making of leatherwork of this caliber. But the essential points remain sufficiently established, namely that these caskets must be of Flemish origin and that they may be dated about 1400 or slightly earlier.[11]

The period of the few decades just before and after 1400 is dominated by what is called the International Style in art.[12] Characteristic of this style is the material sumptuousness of the works and their great elaboration of ornament, detail, and costume. Courtly and ceremonial treatment of subject matter, as well as precious realism in recording nature, are other aspects of this art. In date and aesthetic character, the Guennol coffer belongs to the International Style. The reliefs have the lyrical character and fluent softness which are marks of this style. The courtly elegance of the Virgin in the reliefs is another indication; in the Adoration of the Magi she is even crowned. There is a great richness of ornamentation too, not only in the filling of borders and other available spaces, but in the linear multiplication of structural details of the architecture. The International Style is so called because of the wide migration and mobility of the artists during this period. Flemings are found working in Paris, Netherlanders in England, Italians in France, and so forth according to the demands of patronage and the prospects of gainful employment. Considering this

228

aspect of the period, one can better understand the variety of attributions which has been proposed for the Guennol and Lucca coffers.

There is yet another aspect of the International Style which bears directly on the example in the Collection. Throughout the Middle Ages ivory caskets had stood among the articles of highest prestige, one of the epitomes of sumptuous production. However, by the end of the fourteenth century the guilds of leatherworkers had so refined their craft as to be able to enter into this area of luxury items. In the ambitiousness of its iconographic program, sophistication of style, and wealth of decoration, this group of coffers competes successfully indeed with the finer ivory caskets. Actually it has advantages over ivory that must have brought the leatherworkers great rewards, for the leather casket is not subject to easy fracture, nor is it as heavy and complex to assemble as is the ivory casket.

From the fourteenth century on there are preserved a wide variety of decorated objects in leather. These include writing cases, purses, sheaths, goblets, gaming boxes, and, of course, trunks—not to mention the important category of book bindings.[13] Very little remains of the twelfth and thirteenth century work, but what we know of guild activities during this period attests to the important standing of this branch of the arts.[14] The most abundant material comes from the fifteenth century at which time there is even documentation for what might be called leather sculpture in the round.[15] When King Charles VII of France died in 1461, none other than the famous court painter Jean Fouquet was called upon to paint a leather effigy of the king which was to be carried in the funeral procession.[16]

Older medieval texts refer to leather worked with embossed decoration as *cuir bouilli*.[17] While this would mean

that the leather was boiled in some medium for softening in preparation for the embellishment, it is not known whether this meant boiling in oil, wax, or water or, indeed, at what temperature. Some believe that literal boiling would have deformed the leather, but that plunging into lukewarm oil or wax would make the leather supple and yielding for the embossed work. The finishing technique[18] of incision with a burin served to sharpen definition of details, to reinforce contours and drapery modeling, as well as to ornament flat surfaces. Both repoussé and tooling are exemplified with great skill and refinement in the Guennol coffer. Finally, these coffers were painted. The Guennol coffer preserves traces of the original pigment, reminders of the polychrome glory which this splendid work originally possessed.

Smaller leather caskets, such as the Guennol example, were probably destined for a secular market as opposed to reliquary chests and the like used in churches. Of the many possible uses to which they might have been put, their size and splendor suggest that jewelry and other personal treasures were to be kept thus concealed and protected.[19] They were, in fact, provided with locks, that on the Guennol coffer being no longer preserved. Such coffers might be presented to a newly married couple, or simply as a splendid gift to a lady or gentleman upon a special occasion. The subjects depicted on these coffers may be secular as well as religious and sometimes blend both. If any hint is to be read in the two female saints (Catherine and Barbara) in architectural niches which flank the Dormition of the Virgin, then one might venture to guess that the Guennol leather coffer was presented to a woman. That the program gives emphasis to the life of the Virgin would support the supposition that the coffer was meant to be used by ladies.

LEATHER COFFER

Length 19.8″ Width 8.3″

Flemish, *c.* 1400

Ex COLL.: Private collection, Spain.

BIBLIOGRAPHY: J. Lafora, in *Arte Español, Revista de la Sociedad española de amigos del arte*, VIII, 1926, pp. 80–92; *Catalogue Guide*, Madrid, May–June 1943, no. 29, pp. 45–46; J. J. Rorimer, "Acquisitions for The Cloisters," *The Metropolitan Museum of Art Bulletin*, XI, June 1953, p. 285, ill.

EXHIBITED: Madrid, Sociedad española de amigos del arte, 1940; The Cloisters of The Metropolitan Museum of Art since 1953.

NOTES

1. Among them may be noted especially the Cluny Museum in Paris and the London Museum. See E. Haraucourt, *Mediaeval Manners Illustrated at the Cluny Museum. A Guidebook to the Rooms and Collections*, Paris [1927], pp. 60–61; *London Museum Catalogues*, 7, *Medieval Catalogue*, London, 1940, pp. 185–199, figs. 59–64, pls. XL–L. For one of the larger private collections, since dispersed, see A. Darcel, "Les Cuirs," in *La Collection Spitzer*, Paris, 1891, II, pp. 191–199.

2. Cf. A. W. Pollard, ed., *Catalogue of Manuscripts and Early Printed Books from the Libraries of William Morris . . . and Other Sources, Now Forming Portion of the Library of J. Pierpont Morgan*, London, 1907, III, pp. 1–2.

3. See bibliography above. For Spanish attribution cf. Lafora; Italian, cf. Rorimer, p. 285; Flemish, cf. no. 22 in L. Bertolini and M. Bucci, eds., *Mostra d'arte sacra da secolo VI al secolo XIX*, Lucca, 1957, and cf. note 4 below.

4. See P. Campetti, "Il cofano di Balduccio degli Antelminelli nella Cattedrale di Lucca," *Dedalo*, II, 1921–1922, pp. 240–250, ill. For other caskets of this type cf. L. Venturi, "Un cofanetto francese del trecento nel Museo Civico di Torino," *Dedalo*, VI, 1925–1926, pp. 515–522, which also includes an illustration of another casket in the Cluny Museum (p. 521). For another coffer, in the Hamburg Museum, see A. Brinckmann, *Führer durch das Hamburgische Museum für Kunst und Gewerbe*, Hamburg, 1894, p. 116.

5. See Campetti, with history and documentation of the Lucca piece. Dorothy Miner of the Walters Art Gallery writes, "it has nothing to do with a Spanish attribution, but would seem to have been French or Flemish" (letter of May 20, 1959). Otto Pächt and Richard H. Randall, Jr., who have generously offered helpful information concerning the Guennol casket, are also convinced of the Flemish attribution.

6. For the best and most comprehensive study on the regional Flemish schools see E. Panofsky, *Early Netherlandish Painting*, Cambridge, Massachusetts, 1953, pp. 91 ff. The Tournai manuscript of *c.* 1390 (in Paris, Bib. Nat., Ms. lat. 1364) is reproduced in *ibid.*, figs. 145–146. As examples of the Bruges manuscripts cf. New York, Pierpont Morgan Library, Ms. 785 of about 1403 (*ibid.*, figs 135–137, and cf. figs. 139–141).

7. *Ibid.*, figs. 142–144, 147–149.

8. *Ibid.*, e.g., figs. 173, 174. Cf. similar proscenium arch in a Bruges miniature of *c.* 1370–1375 (Paris, Bib. Nat., Ms. lat. 860, f. 167v) illustrated in H. Bober, "The Cleveland 'Crucifixion,' " *Miscellanea Prof. Dr. D. Roggen*, Antwerp, 1957, p. 37, fig. 2. For comparable French examples, cf. V. Leroquais, *Les Sacramentaires et les missels manuscrits*, Paris, 1924, pl. LXXVIII.

9. Brussels, Bib. Royale, Ms. 13076–13077 (Gilles li Muisit, Antiquités de Flandres), Tournai, *c.* 1349–1352, especially f. 2r. This manuscript is described in C. Gaspar and F. Lyna, *Les Principaux Manuscrits à peintures de la Bibliothèque Royale de Belgique*, Paris, 1937, I, pp. 326–329.

10. This may be noted, for instance, in a dated Ghent manuscript of about A. D. 1366 in The Hague (Museum, Meermanno-Westreenianum, Ms. 10 A. 14), where the scene of the Adoration of the Magi (f. 27v) presents suggestive parallels. (Cf. A. W. Byvanck, *Les Principaux Manuscrits à peintures de la Bibliothèque Royale des Pays-Bas et du Musée Meermanno-Westreenianum à La Haye*, Paris, 1924, pl. XLIV. This example is interesting as it indicates a distinction between two kinds of architectural framework. While the main scene is framed by an elaborate architecture (with gabled trefoil arches, crockets, pinnacles, buttresses, and ribbed vaults), the donors are shown in subordinated flanking structures which are designed with calculated modesty—simply framed by flattened arches, with barrel-vaulted carpentry interiors. The contrast intended is that between an imposing ecclesiastical setting and a less pretentious domestic architecture. In our coffer, the scenes at the sides alternate between an "ecclesiastical" and a domestic framework, geared to symbolic or historical interpretations of their respective subjects. As a series, however, the side scenes contrast in their simplicity with the architectural splendor of the main subject, the Dormition.

11. See A.-M. Marien Dugardin, "Coffrets à Madone," *Bulletin des musées royaux d'art et d'histoire*, XXIV, 1952, pp. 101–110, for further examples from the same period, assigned to Flemish provenance.

12. See Panofsky, pp. 51 ff.

13. See *Medieval Catalogue*, pp. 185 ff., pls. XL–L, and cf. Darcel, pp. 191 ff. For medieval bindings, cf. D. Miner, *The History of Bookbinding: 525–1950 A.D.*, exhibition catalogue, Baltimore, 1957, pp. 44 ff.

14. See Darcel, pp. 192–194. This craft may well have belonged to an older tradition in Spain. See L. Williams, *The Arts and Crafts of Older Spain*, London, 1907, pp. 38 f.

15. A. Feigel, "Gotische Monumentalfiguren aus Leder," in *Festschrift für Adolph Goldschmidt zum 60. Geburtstag am 15. Januar 1923*, Leipzig, 1923, pp. 61–64, is the first to call attention to life-sized medieval sculptures in the round.

16. P. Wescher, *Jean Fouquet and His Time*, New York, 1947, p. 30.

17. The oldest mention of *cuir bouilli* may be that of 1185, in the *Chanson d'Antioche*: *son portrail lui laca qui fu de cuir bolis*. This text is cited in the *Medieval Catalogue*, p. 186. For discussion of techniques cf. *ibid.*, and Darcel, pp. 192 f.

18. For a discussion of the techniques, cf. *Medieval Catalogue*, pp. 185–188, and Darcel, pp. 192 f. The most recent technical study, extensive and with full bibliography, is that by J. W. Waterer, "Leather," in *A History of Technology*, ed. C. Singer, E. J. Holmyard, and A. R. Hall, Oxford, 1956, pp. 169–186.

19. This is the point of deception intended in *The Cid*, the great national epic of Spain believed to date *c.* 1140. In the first canto the Cid says:

> With your help I will make two coffers, which we will
> fill with sand to make them heavy and cover them with
> tooled leather, the leather red, the nails well gilded.

Translated by L. B. Simpson, *The Poem of The Cid*, Berkeley, 1957, p. 10.

A RHENISH
MADONNA STATUETTE

THOSE few centuries which separate this Gothic statue of the Virgin and Child from the Romanesque Majesty of St. Mary (p. 171) brought many profound changes in every sphere of medieval art, epitomized in the contrast between these two interpretations of the same theme. The Romanesque Virgin confronts the beholder as a timeless, ageless, impersonal being, an imposing symbol of that sanctified human vessel which bore the Christ. She is a splendid throne for Divine Wisdom incarnate through the Child, whence such a statue could also be called "The Seat of Wisdom" (*Sedes sapientiae*). The Child, a grave and lordly presence, dominates the group as the enthroned King. But Romanesque severity had already begun to yield in the springtime of Early Gothic during the later twelfth and early thirteenth centuries. By the beginning of the fifteenth century, when this little Virgin and Child of the Collection was carved, Late Gothic art was luxuriating in the warmth of full summer. The whole being of this lovely group is suffused with the tenderness of young motherhood; the Child, touchingly human, bespeaks that angelic unconcern of vulnerable infancy. The Romanesque Christ Child is presented like a ritual offering, "with the sacerdotal gravity of the priest who holds the chalice."[1] In the Gothic sculpture, He is like any little baby held by its loving mother, grasped with gentle sureness, nestled in her arm, supported against her hip. The Romanesque statue, a dogmatic mirror of Incarnation, has become, in the Gothic, a mirror of that mankind whose mortal frailty Christ had assumed.

The thirteenth century was pivotal for this shift from a

more formal theological conception to one which admitted, by stages, the gamut of ordinary human emotions and experience. The growth of cities, with their increasingly affluent merchant classes, was a contributing factor whose importance is reflected in the abundant gifts and dedications made by guilds and private patrons to the churches. Popular religious movements, developing in consonance with such changes, betray the new temper most dramatically. Franciscan Christianity, dwelling so intently upon the pathos in Christ's human history with simple and poignant appeal, spread with extraordinary rapidity, permeating religious life and art throughout Western Europe. In the Franciscan *Meditations on the Life of Christ* the new accents are strongly manifested and may be illustrated by one reference, telling how the Virgin "leaned her face against her little Son's, nursed Him, and comforted Him in every way she could, because He cried often, like all little children, to show the misery of our humanity."[2] It is not strange that the main contributions of Franciscan writing to the liturgy should include the passionate *Stabat Mater Dolorosa* and the *Dies Irae*.[3]

Understandably the Virgin assumed ever-increasing importance with such changes, for Mary was pre-eminent among the saints through whose intercession every man might hope to find solace in this life, and salvation hereafter.

> *Thine own flock commiserate thou,*
> *And our Judge's wrath abate thou,*
> *O Queen-Mother of our King!*[4]

The titular Queen of Heaven becomes truly queenly in Gothic sculpture both in the descriptive fact of her regalia and in the qualitative transformation through Gothic naturalism with its varied textures for fine cloth, rich ornament, and soft flesh. The crowned Queen, now proudly poised with sinuous elegance, is modishly coiffed and robed with in-

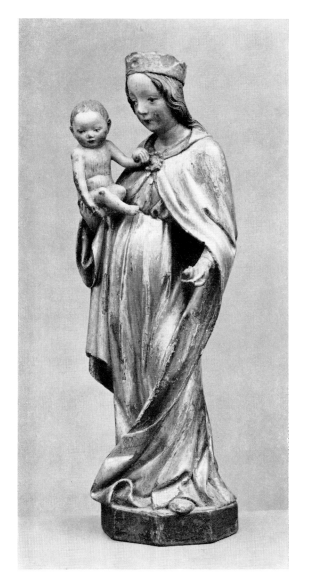

RHENISH MADONNA

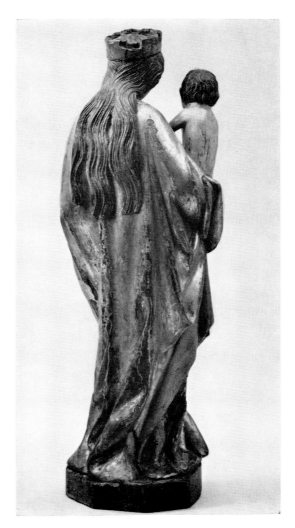

Rear view

ventive display. Bridging further the distance between Romanesque reticence and Gothic exuberance, the Virgins even smile, as in the *Vierge Dorée* of Amiens, and a new vista of emotional expression is opened. Reims, for example, fairly radiates a joyous *Gloria in excelsis Deo*, what with the infectious smiles of its angels and the beaming saints. While the smile is common in the fourteenth century, there are other moods too, such as those Virgins who seem to be filled with pride, both motherly and queenly. Then there are those expressions of mysterious sobriety, subtly clouded foreshadowings of grief which is to come. As for the Child, He may be seen holding a "ball" (as in the Guennol statue), a bunch of grapes, or a bird, or grasp the Virgin's kerchief. Sometimes He touches His mother's cheek with reassuring tenderness, at other times He nurses at her breast.[5] Through the realism of His playthings and actions, symbolic allusion to His divinity and His mission are conveyed.

As if to underscore that polarity of joy and grief, while pointing up the dialectic of their interaction, German Gothic sculptors distilled essential types out of each extreme.[6] One takes up the idea of the Virgin's beauty in a type which modern German scholarship has named the *Schönen Madonnen*.[7] The other, the *Vesperbild*,[8] as grim as the former is lovely, depicts the Virgin holding the broken body of the dead Christ on her lap. That each type is understood to be bound to the other through allusive overtones is evident from the fact that the *Vesperbild* is cast in the same compositional mold as those familiar statues of the seated Virgin holding the playful Child. The Guennol statuette is thus to be seen as a devotional image in which the very youth and beauty of the Virgin and Child are also foils against which evocations of the Passion become all the more heightened.

The group of "Beautiful Madonnas," to which the

Guennol statuette belongs, were being made around the turn of the fifteenth century, commissioned by wealthy cosmopolitan patrons of courtly taste for whose private chapels they were destined. The youthful sweetness of the Virgin is characteristic, as is the charming realism of the Child. These Madonnas were favored in a number of regions from Silesia and Bohemia to the Rhineland, all interrelated in the art of the so-called International Style.

So much do these Virgins resemble one another that it might seem a thankless task to try to determine the provenance of the Guennol sculpture, for which both Bohemian and Rhenish origins have been suggested.[9] However, certain qualities of style relate it rather to the latter region. There is, in the expression of the Guennol Virgin, a humble simplicity which contrasts with the urbane sophistication of the Bohemian Virgins.[10] More decisively different is the treatment of the drapery. The Bohemian figures are swathed in voluminous garments which fall in dense cascades across the front and side; where the drapery is bunched together under one arm, the cloth forms intricate spiral patterns, with delicately scrolled terminations.[11] The Guennol Virgin is basically different in respect to the drapery, which is rendered in long lines, with relatively few breaks and shallow relief. Moreover, there is a large and simple spatial play in the composition of its volumes, the body being distinguished from the mass of the outer robe. The Virgin's body is a slender, columnar form, delicately helical; her high-waisted dress is shaped by long, tubular ridge-folds separating broad, shallow concavities. To this interior volume the outer robe serves as a shell-like enclosure. That robe sweeps in lines of graceful simplicity to embrace the entire figure, with a virtuoso flourish as the lower part of the robe is pulled around and in front of the figure, piled in little swirls on the ground.

Similar qualities of proportion, softened modeling, simplified volumes, and delicate lyricism, are to be observed in the sculptures of the funerary monument of Archbishop Friedrich von Saarwerden (d. 1414), in Cologne Cathedral.[12] In the Cologne angel we see the same kind of drapery similarly composed to form a shell-like enclosure. The modeling of the Saarwerden Virgin, while different in detail, is stylistically of the same kind as that of the Guennol Virgin. Even the formal character and mood of the Cologne Virgin's head, and the modeling of her hands, are in closest sympathetic relationship to the Guennol statuette. This relationship is supported in comparisons with other sculptures from the same region acknowledged to constitute a closely knit stylistic group. Among the statues from the south portal of Mainz Cathedral, datable from the period of construction to about 1400, that of St. Martin shows the closest parallels to the Guennol Virgin.[13] St. Martin's cloak forms an outer shell, like that of the Virgin's robe, and his slender tubular body accentuates the underlying formal conception noted in the Guennol figure. Other Mainz works, such as the funerary effigy of Anna von Dalberg (d. 1410) at Oppenheim, and that of Gertrudis von Breydenbach (d. 1421) at Aschaffenburg,[14] confirm the Rhenish attribution beyond much doubt.

It may seem unnecessary, if not impossible, to distinguish between such closely related centers as Mainz and Cologne for further localization of our sculpture. There is, however, evidence of painted panels which allows conjecture in favor of Cologne. As in the case of sculpture, paintings of the early fifteenth century, whether of Rhenish or Bohemian origin, show close stylistic resemblances stemming from well-known artistic and cultural interchanges between those regions. Fortunately, among those many works which suggest similarities, the closest are by a known master, Hermann

Wynrich (active 1397–1413), an outstanding painter of his day in Cologne. In his paintings of about 1410, such as the Wallraf-Richartz Visitation, we find the nearest approximation of those stylistic traits noted in the Guennol statuette.[15] Other technical realms in the art of Cologne suggest that we are indeed dealing with artistic qualities which are distinctive of this center. Thus, in a series of painted glass windows by a Cologne master of about 1420–1430,[16] the familiar characteristics of the sculptures and painting are also to be seen.

The date of the Guennol statuette, considered in relationship to the comparative evidence, may be reasonably fixed in the second decade of the fifteenth century. As to the place of origin, the Rhineland is clearly indicated with the further possibility that the Guennol Virgin and Child may well have been carved in the important lower Rhenish center of Cologne.

While the statuette now stands in splendid isolation, it seems unlikely that this sculpture was originally intended to appear alone. The Virgin and Child may have been part of a group, at the center of a small altarpiece where they would have been flanked by saints, as in the Darmstädter altar of about 1420,[17] or as the focus of a composition with the Adoration of the Kings as the main subject, as in other extant altar shrines of the period.[18]

RHENISH MADONNA

Height 13.3″ Width 3.5″

German, Lower Rhenish (Cologne?), *c.* 1410–1420

Ex. Coll.: Oscar Bondi, Vienna.

Exhibited: Metropolitan Museum of Art since 1948.

NOTES

1. E. Mâle, *L'Art religieux de la fin du moyen âge en France*, 2nd ed., Paris, 1922, pp. 146–147.

2. *Ibid.*, p. 149. Translated from E. Mâle, *Religious Art from the Twelfth to the Eighteenth Century*, New York, 1949, p. 122. Compare also, two *laudes* now given to the Dominican archbishop of Ragasa, Giovanni Dominici (1356–1419), translated as "Marie, Vierge Belle," and "Dis, Douce Marie" (see P. Régamy, *Les Plus Beaux Textes de la Vièrge Marie*, rev. ed., Paris, 1946, pp. 185–188).

3. But such notes of pathetic tone represent only the darker, if dominant, register on a scale that also includes the brightness of tender human love. Nor was this trend exclusively Franciscan, for it had been anticipated in Cistercian reforms and in the works of St. Bernard. Caesarius of Heisterbach (died *c.* 1240), a Rhenish Cistercian, hails the Virgin as "matron of innocent countenance and marvelous beauty." (*The Dialogue on Miracles*, trans. H. Von E. Scott and C. C. Swinton Bland, London, 1929, I, p. 497). In the sensuous spirit of the Song of Songs, but without St. Bernard's specific allegorical interpretations, he praises Mary "whose name dispels sadness, whose odor is more fragrant than lilies, and whose lips surpass the honey-comb in sweetness . . . more full of savor than the nut, whiter than the snow, more dewy than the rose . . ." (*ibid.*, p. 454).

4. Adam of St. Victor (died 1192), De Beata Virgine XCII, lines 58–60, in D. S. Wrangham, trans., *The Liturgical Poetry of Adam of St. Victor*, London, 1881, III, p. 109.

5. Cf. M. Aubert, *Description raisonnée des sculptures du moyen âge, de la renaissance et des temps modernes*, Paris, 1950, I, pls. to nos. 199–216; and *Unsere Liebe Frau*, exhibition catalogue, Aachen, 1958, plates, *passim*.

6. Exemplifying the "Freudenmystik" and the "Leidenmystik" (W. Braunfels, in *Unsere Liebe Frau*, p. 22).

7. W. Pinder, "Zum Problem der 'Schönen Madonnen' um 1400," in *Jahrbuch der preuszichen Kunstsammlungen*, XXIV, Berlin, 1923, pp. 147–171.

8. See W. Passarge, *Das deutsche Vesperbild im Mittelaltar*, Cologne, 1924, and cf. Pinder, pp. 171 ff., figs. 144–150.

9. Exhibited at The Metropolitan Museum of Art, New York, as Rhenish or South German, first half of the fifteenth century.

10. Compare, e.g., Pinder, pp. 167–170, figs. 136–142, and F. Bucina, *Gotische Madonnen*, Prague, 1958, *passim*.

11. See V. Denkstein and F. Matous, *Gothic Art in South Bohemia*, Prague, 1955, figs. 59–68.

12. Pinder, p. 136, fig. 99.

13. All the sculptures of this portal are consistent in style and attributed to a single artist, the Master of the Memorial Portal. In addition to St. Martin, the statues of St. Margaret and St. Stephen show pointed similarities to the Guennol Virgin. See R. Kautzsch, *Der mainzer Dom und seine Denkmäler*, Frankfort on Main, 1925, I, pls. 70, 71, and cf. pp. 21–22.

14. *Ibid.*, p. 203, fig. 179, and p. 204, fig. 181.

15. Illustrated in F. Burger and H. Schmitz, *Die deutsche Malerei vom ausgehenden Mittelalter bis zum Ende der Renaissance*, Berlin, 1917, I, pt. 2, p. 379, fig. 460, and cf. fig. 459.

16. *Ibid.*, p. 390, fig. 473, and cf. pp. 383 f.

17. Cf. Pinder, p. 189, fig. 166.

18. E.g., altarshrine from Alpkapelle Leiggern ob Ausserberg (Kt. Wallis), *c.* 1400, reproduced in D.W. H. Schwarz, *Das schweizerische Landesmuseum: 1898–1948*, Zurich, 1948, pl. 64.

EMBROIDERED SCENES FROM THE LIFE OF ST. MARTIN

Toward the end of the Middle Ages, when the Late Gothic artist was depicting bright vistas of realism in paint and stone, the embroiderer proved to be no less alert to the new pictorial ideas. The panels in the Collection are eloquently representative of the attainment of the fifteenth century needleworker, both on technical and aesthetic levels. It is actually from the parallel evidence of the other high arts that the provenance and date of these embroideries must be studied. No less interesting than their art and craft, however, is the subject matter of these examples. Their theme, events from the life of St. Martin, deserves attention on account of the particular significance of this saint for the Middle Ages, but also because of the unique subject on one of the panels. Moreover, these panels prove to be but a small part of a remarkably extensive cycle on the life of St. Martin, the other panels of which are still preserved.[1]

To the well-established early medieval tradition of embroidery in the monasteries and the great noble houses, the thirteenth century introduced the considerable production of secular ateliers located in the rapidly growing cities. For the arts in general, the urban economy meant increasing specialization and organization to meet demands of production and marketing. Like the other artisans, needleworkers formed guilds, those of the embroiderers being known under such telling names as the Confraternity of Needle-Painters *(confraternitas acupictorum)*, indicative of their acknowledged kinship with painters of the brush. On the technical side the embroiderer's repertoire of materials, dyes, and stitches was of such virtuosity as to parallel the miniaturists' pictorial range.

ST. MARTIN AND REPENTANT HORSEMEN

ST. MARTIN AND THE EMPEROR JULIAN (?)

In our rectangular panel, for example, the embroiderer achieved effective contrast between figures and ground not only through color and value, but through the use of tightly concentrated stitching in regular rows for the figures, and loose, cross-hatched stitches for the landscape. The scene is set against a gold background which, in the roundel, is worked in a geometrical relief pattern resembling an embossed gold-leaf surface in the background of a panel painting. The effect of this technical means is that of a needle-worked equivalent to the opaque painting of figure-subjects against the thinner brushwork of the landscape elements in paintings. Considering that these basic techniques had been long established and in general use by the Gothic period, this aspect of our panels becomes less significant in itself than in its bearing upon the art which has thus been achieved. Whether produced in a monastic or urban workshop, the series of St. Martin panels shows every mark of accomplished "modernity" which might be expected in the most advanced miniature or panel paintings of this time.

Interestingly enough, there exists a silverpoint drawing which is virtually identical in subject and composition to our embroidery of the kneeling St. Martin. The drawing was published as a Netherlandish work of about 1440 and thought to be a copy after a painting; the embroidery was unknown to the student of the drawing.[2] It must be noted that they are almost the same size, the differences accountable by the arched top, and the slight damage at the sides of the embroidery. Were it not for revealing marks of style and technique which are peculiar to copies, it might be tempting to argue that the drawing provided the pattern for the embroiderer. Instead, however, it may be suggested that the drawing depends either on our embroidery or on a preparatory drawing for our embroidery. Since there are no fundamental stylistic differences between these two works,

they both must be assigned to the same period and region.

The provenance and date of the Guennol needle-paintings may be fairly well approximated on the basis of similarities to still another drawing as well as manuscript miniatures. In a British Museum drawing attributed to the Master of the Exhumation of St. Hubert, resemblances in the proportions of figures, design of drapery, facial types, and costume bring us reasonably close to the stylistic locus of our embroideries.[3] To be noted especially is the costume of the kneeling man at the center of the Guennol panel. Certain peculiarities of his costume are to be found in the same form in one of the figures in the left half of the British Museum drawing, namely: collar rolled at neck and falling in long rectangular "lappets" over chest and shoulders, billowing sleeves becoming tight and narrow at the wrist. The drawing is not dated but the anonymous master's main work is safely placed around 1440, and his style in general associated with the early period of Roger van der Weyden.

In manuscript illumination, the somewhat stocky figure proportions, soft modeling, and simplified volumes of our needle-paintings will be found to resemble the style of the so-called Master of the Roman de la Rose, a Flemish or North French painter of about 1420–1430.[4] In the Vienna manuscript from which this master is named we may also observe similarities of costume, such as the heavy cloth hat worn by St. Martin in the roundel, and the tightly belted tunics of the men kneeling in the rectangular panel. Such indications as these, taken together with the evidence of still other manuscripts,[5] suggest a date of about 1440 for our embroideries and the possibility that they originated in the Hainaut, perhaps at Tournai.

Working from the silverpoint drawing, Campbell Dodgson was at first "completely puzzled" by its subject but finally decided that it must show an incident from the life of

St. Raynald of Nocera (thirteenth century), and "certainly most uncommon in Northern art." There can be little doubt, however, that the incident is from the life of the fourth century bishop saint of Tours, St. Martin. The incident depicted is one reported in the earliest account of St. Martin, which was written by Sulpicius Severus about A. D. 400.[6] It is repeated in the thirteenth century *Golden Legend* of Jacobus de Voragine, a book widely read throughout the later Middle Ages.[7] The story tells of a procession of officials on horseback being disrupted when their horses shied at a little donkey which Martin was riding along the same road. The enraged riders set upon Martin and beat him mercilessly, but the saint accepted this abuse in silence. "When they remounted their horses, however, the beasts stood fixed to the ground as though they were made of stone, and however much the soldiers lashed them, they would not move, until the men went back to Martin and confessed the sin which they had unwittingly committed. Then the saint gave the animals leave, and they trotted off at a lively gait." All the essential elements of this narrative are present in our scene. The interrupted procession and the beating of St. Martin occupy the background; the immobilized horses and the repentant men before St. Martin are placed in the foreground.

The only suggestion as to the subject of the roundel would have it that this shows St. Martin taking leave from his parents.[8] Nothing in the textual sources would support this interpretation of the embroidered scene. It seems inherently dubious that the humble Martin would be depicted as taking leave from his own parents from this proud perch on horseback. As for the handclasp, as the last farewell, such formality between father and son seems hardly plausible. The subject may rather be that of St. Martin and the Emperor Julian, an incident bearing on St.

Martin's surrender of military life to become a soldier of Christ. The Emperor Julian had accused Martin of cowardice in the face of an impending battle which the saint had refused to join. To prove his faith, Martin offered to face the enemy unarmed. "But on the morrow, the enemy sent legates, and surrendered themselves and their goods. Hence there is no doubt that the bloodless victory was gained by the merits of the saint."[9] The scene would thus represent St. Martin, unarmed, receiving the legates of the surrendered enemy, while the Emperor Julian stands before the gates to witness this miracle. With that event, Martin abandoned the military life and his service to Caesar to enter into the service of Christ as an acolyte at Poitiers, under the sainted Bishop Hilary.

"Where Christ is known, there Martin is honored," so wrote a great poet of the late sixth century.[10] Indeed, the place of St. Martin in Europe is one of special importance and wide veneration. Certainly in France, his feast day is one of joyous celebration, and it seems one of the last miracles of the saint that his feast day should be the same as that which ended the First World War on November 11. "St. Martin was, during many centuries, the great saint of France, the national saint, a saint venerated by all, by kings as by artisans or peasants, and even more loved than venerated. His memory has been kept everywhere, in monuments as in customs and proverbs, in the names of men as in those of streets, of fountains, of rocks, of villages and towns."[11] His reputation, his legend, and his cult rested on many things: his faith, his miracles, his goodness, his victories over paganism, and above all, his patience and his charity. While the theme of St. Martin's faith underlies both of our embroidered panels, the subject of the repentant horsemen has been interpreted mainly with reference to the remarkable patience of the saint.

248

Medieval legend and art singles out the virtue of charity as pre-eminent among those which St. Martin exemplified. The most common image of St. Martin in art shows him dividing his cloak to clothe a beggar, the theme taken from an incident in his youth which epitomized his virtue. It was at the gate of Amiens that Martin saw a vision in which Christ appeared, wearing that part of the cloak which the saint had given to the beggar, saying: "Martin, while yet a catechumen, has clothed Me with this garment!"[12] In sharing his cloak, St. Martin had truly followed the example of Christ who said: "Inasmuch as ye have done it unto one of the least of these my brethren, ye have done it unto me" (Matthew xxv:40). The cloak, as the main symbol of St. Martin's charity, is celebrated throughout medieval art and letters. As early as the sixth century, the poet Fortunatus gave to this marvelous cloth a prominent place in his *Life of St. Martin*. The poet laments that the coat he has made for the saint is not sufficiently worthy, that it should have been of silk and gold, adorned with flowers and precious stones.[13]

What was the nature of the vestment or cloth which our panels originally decorated? Some thirty additional embroidered panels, mostly roundels and of the same series, stylistically and thematically, are known today. They are scattered over a number of different collections: in the textile museum at Lyons, in the Thyssen Collection at Lugano, the Walters Art Gallery of Baltimore, the Metropolitan Museum, and other collections.[14] Assuming that these were part of a single work, it might be difficult to imagine what that work might have been. Fortunately there are a number of copes in existence that are decorated with as many as thirty-nine roundels, to suggest a likely possibility. Some of these copes show scenes from the life of Christ in these medallions, others the lives of saints.[15] The

roundels to which our example belongs might have been part of a similar series designed to cover the great semicircular field of the cope. As for the rectangular panel, this might have been part of the orphrey to the same cope.

In general composition, the original cope from which these *membra disiecta* remain may possibly have resembled such later thirteenth century copes as those at Uppsala and Anagni.[16] The former shows thirty-nine roundels in regular rows across the semicircular field; the latter has thirty roundels, similarly disposed. The medallions of the Uppsala and Anagni copes are much larger than the Guennol medallion, the first being $12\frac{1}{2}$ inches and the second 18 inches in diameter. There is no doubt that the larger medallion size was in favor during the fourteenth century. Lacking precise measurements for the fifteenth century copes it is impossible to document the suggestion that the smaller size could have been perfectly possible in later copes.

Along the straight edge of the cope, there would have been a narrow orphrey which, when the cope was worn, would fall as two vertical bands of embroidery at the front. The orphrey of the Uppsala cope, measuring about $5\frac{1}{2}$ inches in width, tells us that the relatively small size of the Guennol rectangular panel (6 inches), conforms with acceptable possibility if we suggest that it might have served as part of the orphrey of a lost cope of St. Martin. This panel lacks its original architectural frame, but from the frequent practice in the design of such orphreys we may imagine two vertical series of smaller scenes, framed in architectural niches, to which our panel might originally have belonged. Presumably the entire series would have been dominated by a panel showing the important scene of St. Martin at the gate of Amiens, dividing his cloak. That hypothetical main panel would have been centrally placed and, perhaps, larger or of different shape, than the rest.

Only one other medieval embroidery even approaches this series in giving such importance to St. Martin. It is an embroidered antependium of the later fourteenth century from the church of St. Martin in Liège, now in the Brussels Museum.[17] There we find nineteen scenes, arranged as a continuous horizontal series. The existence of such an elaborate antependium given to the life of St. Martin invites speculation as to whether our magnificent cope of St. Martin might not be considered as part of a group of related pieces of liturgical cloth. Surely the church for which our cope would have been destined would have had a particular interest in this saint. If not actually dedicated to St. Martin, that unknown church might have had an important altar consecrated to his honor. We may imagine that the bishop who wore the cope of St. Martin officiated at an altar whose frontal or *praetexta* was decorated with scenes from the life and works of the saint, and that matching chasubles were also used.

ST. MARTIN EMBROIDERIES

Diameter of roundel 6.5″
Rectangular panel: Height 7.6″ Width 6″

Flemish (Hainaut?), *c.* 1440

Ex COLL.: Joseph Brummer; Joseph Brummer Sale, Parke-Bernet Galleries, New York, April 21, 1949, no. 511.

BIBLIOGRAPHY: *Exposition de la collection Lehman de New York*, Paris, 1957, cited under no. 293.

EXHIBITED: The Cloisters of The Metropolitan Museum of Art since 1950.

NOTES

1. The entire series has been published by M. B. Freeman, *The Saint Martin Embroideries*, New York, 1968, to whom I owe thanks for a number of helpful suggestions concerning the Guennol embroideries.

2. The drawing, in the University Library at Uppsala, was published by C. Dodgson, "Unknown Netherlandish Artist (*c.* 1440)," in *Old Master Drawings*, IX, September 1934, pp. 32–33, pl. XXIII. The drawing measures 18.9 x 16.2 cm.

3. Reproduced in A. E. Popham, *Drawings of the Early Flemish School*, New York, 1926, pp. 23-24, pl. 15 ("A Religious Procession").

4. See F. Winkler, *Die flämische Buchmalerei des XV. und XVI. Jahrhunderts*, Leipzig, 1925, pp. 32–33.

5. E.g., Brussels, Bib. Royale, Ms. 9005–9006, and Vienna, Nat. Bibl. Ms. 2583, attributed to the Master of Gilbert of Metz (see Winkler, pp. 28–29).

6. For translation of the accounts by Sulpicius Severus, see P. Monceaux, *Saint Martin: Récits de Sulpice Sévère*, Paris, 1926. The incident in question is to be found in the *Dialogues*, chap. III, pp. 195–197.

7. See *The Golden Legend of Jacobus de Voragine*, trans. G. Ryan and H. Ripperger, London–New York, 1941, II, pp. 663–674, for life of St. Martin. The incident described is to be found on pp. 668–669.

8. From an unsigned typescript report to A. B. Martin.

9. From *The Golden Legend*, p. 664. Again, this is taken from the *Life of St. Martin*, by Sulpicius Severus, chap. IV (Monceaux, pp. 79 ff.).

10. Venantius Fortunatus, *Life of St. Martin*, IV, 712, quoted by Monceaux, p. 49.

11. *Ibid.*, p. 7.

12. *The Golden Legend*, p. 664.

13. The poet metaphorically likens his long work to a coat (or cape) which he has woven to cloak the saint, choosing this image from the most popular theme in the life of Martin—that of his clothing the beggar at the Amiens gate. The ambitious length and style of the poem belie his modesty in calling his effort a "poor rough weave." But the silver and gold woven and jeweled mantel that it should have been sounds more like a sumptuous liturgical cope than a secular cape. See F. Leo, ed., *Venanti Honori Clementiani Fortunati Presbyteri Italici*, Monumenta Germaniae Historica Scriptores, Berlin, 1881, pp. 367–368, for the text of this passage, which occurs at the beginning of a long epilogue to the last book (IV, 1–6). It is briefly paraphrased by H. Waddell in *The Wandering Scholars*, 6th ed., Garden City, New York, 1955, p. 27.

14. The series intermingles roundels with scenes from the life of St. Catherine with others of St. Martin, all essentially of the same style and workmanship. They were reported to have been part of an altar frontal, dismembered in the seventeenth century and reused for chasubles and orphreys. For this history, see M. B. Freeman, "The Legend of Saint Catherine Told in Embroidery," *The Metropolitan Museum of Art Bulletin*, XIII, June 1955, p. 293. One of the Metropolitan Museum roundels of St. Martin is reproduced by Freeman, cover; that belonging to Robert Lehman is illustrated in *Exposition de la collection Lehman de New York*, pl. CIV. In addition, see H. d'Hennezel, *Musée historique des tissus: Catalogue des principales pièces exposées*, Lyon, 1929, no. 236 (two orphreys and 2 chasuble crosses, with 24 roundels). These are reproduced in *idem*, *Pour Comprendre les tissus d'art*, Paris, 1930, figs. 280–283.

15. Cf. A. G. I. Christie, *English Medieval Embroidery*, Oxford, 1938, e.g., nos. 45, 46, 50, 54; no. 55 is a chasuble with twelve scenes from the life of St. Nicholas in roundels. A *pluviale*, imperfectly preserved but still having seventeen roundels with scenes from the lives of Sts. Vincent and Blasius, is reproduced in M. Dreger, *Künstlerische Entwicklung der Weberei und Stickerei*, Vienna, 1904, pl. 167.

16. Christie, nos. 45, 54, cf. figs. 80, 91.

17. See M. Calberg, "L'Antependium de l'église Saint-Martin à Liège," *Bulletin des musées royaux d'art et d'histoire*, XIX, 1945, pp. 22–43.

18. Contemporary inventories show that there were dozens, even scores, of copes in the church treasures with various embroidered subjects, allowing, we assume, choice to suit the different feast days. Among the numerous inventories, cf. C. Dehaisnes, *Documents et extraits divers concernant l'histoire de l'art dans la Flandre, l'Artois, & le Hainaut avant le XVe siècle*, Lille, 1886, pp. 812–814.

FAR EASTERN OBJECTS

George J. Lee

FAR EASTERN ART

Mᴏʀᴇ than a thousand years before Marco Polo's travels to Cathay (1271–1295), the people of the Roman world imported and enjoyed rare products from China and the Indies. So great indeed was the demand for Chinese silk that one Emperor suspended its import lest Rome be drained of gold resources. The trade was primarily in the hands of middle men who passed the objects along the overland route by caravan, or carried them by ship in a series of short voyages. The decline of two great empires, Rome in the West and Han China in the East, reduced the trade to an irregular trickle.

By the end of the first millennium A.D. geographical information and material knowledge about the Orient had been for the most part forgotten in Europe. Contacts with the Near East were re-established by the Crusaders, but not until the Mongol Khans had pacified Central Asia was there a real revival of ancient associations with the Orient. This was the era of the Polos, of religious envoys to the Great Khan, and of relatively peaceful journeys across Asia.

After the fourteenth century there were variable periods

255

of commercial relations. Improved transportation facilities made the trips safer and quicker, and stimulated the market for exotic objects. Eventually another important commodity appeared: art objects took their place beside the silks and spices with which the Orient had long provided the West.

Western collecting of Far Eastern antiquities began seriously in the seventeenth century, and for a long time involved primarily Oriental ceramics. This was, in the main, a royal or aristocratic pastime, and culminated in famous porcelain collections such as that of Augustus the Strong at Dresden. In Europe there continued to be interest in these ceramics, relatively late examples of Far Eastern art, and by the turn of the last century two important collections of this type also had been formed in the United States, those of W. T. Walters in Baltimore and of J. Pierpont Morgan in New York.

American collectors were among the first to realize the importance of Oriental art objects other than porcelain and its customary escorts of jade, ivory, and contorted carvings in a variety of media. In the beginning a coterie of Boston collectors led the way. They were a diverse and interesting group and they assembled monumental collections within such specialized areas as Japanese pottery, prints, and early Chinese and Japanese paintings. Today the Boston Museum is unsurpassed outside the home islands in its superlative collection of Japanese art.

Activity was by no means limited to Boston. Perhaps, the most important American collection formed during the first two decades of our century was that of Charles Freer of Detroit. It covered most fields of Oriental art, but was especially strong in Chinese and Japanese painting. During the last twenty-five years an outstanding collector was Grenville Winthrop of New York. His collection of early Chinese jade may never be equaled, and no serious study of early Chinese

256

bronze culture or of early Buddhist sculpture can be initiated without reference to Winthrop objects. These and other more recently formed collections in the United States continue the artistic intercourse between the Occident and the Orient.

AN-YANG MARBLE "ELEPHANT"

DURING the past thirty years the soil of China has yielded a wealth of ancient objects. Primarily these have been years of contention and warfare in China, and often these ancient pieces of art have been sent to the Western world for protection, if not for more pragmatic reasons. Chaos in China weakened the position of those who were interested in excavating scientifically and strengthened an already well-established system of nocturnal tomb robbery. The inevitable result has been a plenitude of objects but a scarcity of information about the Bronze Age in China.

Unquestionably the most important documented evidence on this early bronze culture was collected by the Academia Sinica in a series of excavations near the town of An-yang in Honan Province. North of the site of Hsiao-t'un excavators found in the fall of 1929 the stone torso of a squatting human figure.[1] This piece by its documented association with inscribed oracle bones, which provided a basis for dating, became the first scientifically excavated example of Shang Dynasty sculpture in the round. The date assigned to

this figure was a thousand years earlier than that of any other Chinese figure then known, as it was attributed to the period between 1300 and 1000 B. C. Subsequent excavations in 1934 and 1935 at Hou-chia-chuang, in the An-yang district north of the Huan River, unearthed additional sculptures in white marble as well as objects in bronze, jade, and ivory, and what seemed to be the remnants of painting. These early finds, including the 1929 statue, were published in a preliminary report, but the material of the 1934 and the 1935 campaigns has been described only scantily.[2]

Informal digging followed the official excavations at An-yang. It was reported that this admirable marble sculpture was found at that site in 1943.[3] It passed into the collection of the Marquis Inoue in Japan and came from there to the United States in 1950.

The genus of the animal represented remains open to further investigation. Umehara published the piece as an elephant.[4] This description does not appear to be conclusive as the object displays some characteristics of the pig family. The elephant was known at An-yang during the Shang period, but it may have been a tribute beast and rather rare. The pig, on the other hand, was domesticated in China even before the Bronze Age.

Among the Academia Sinica finds at Hou-chia-chuang was a pair of marble tortoises providing direct comparative material for the Guennol animal.[5] Shang sculptors seemed to have maintained a block-like quality in their images by limiting naturalistic details to the head and feet of the figures. Few pieces of Chinese art show such obvious similarities to Western concepts of primitive art as this "elephant." The body is defined only by a slight modeling of the back while the legs are indicated by simple perpendicular sections. A few features are in relief and the remaining details are incised, a combination of techniques paralleling

258

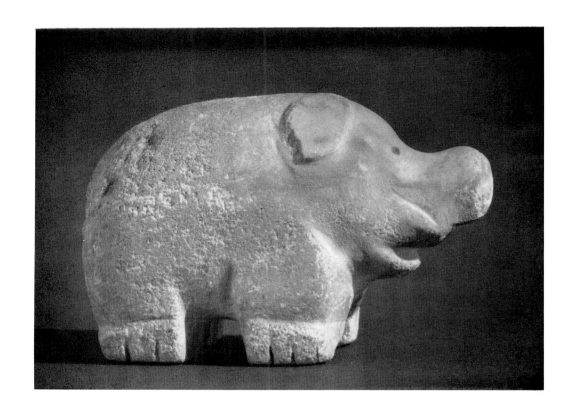

AN-YANG MARBLE "ELEPHANT"

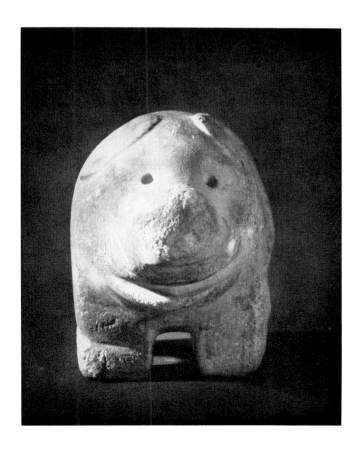

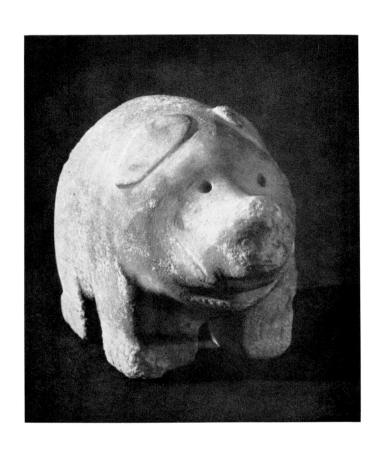

AN-YANG MARBLE "ELEPHANT"

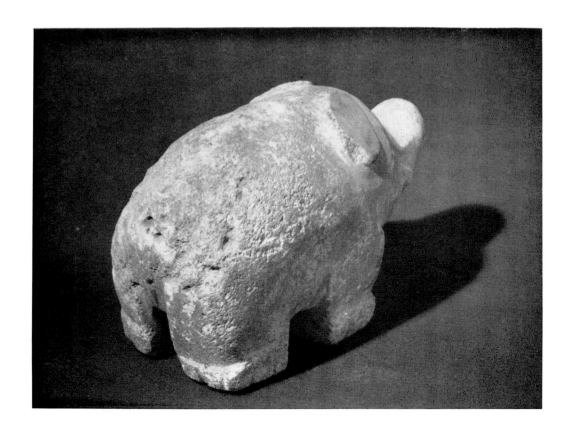

those of the Academia Sinica tortoises. In effect, the Shang craftsman combined qualities inherent in his material with enough naturalistic detail to create this sculptured animal whose small scale is belied by the vigor and monumentality with which the artist has endowed it.

AN-YANG MARBLE "ELEPHANT"

Height 3″ Length 4.5″ Width 2.3″

Shang, XIV–XI century B. C.

PROVENANCE: Reported to have been found in the Shang tombs outside of An-yang (Chang-tê Fu) in Honan Province.

EX COLL.: Inoue, Tokyo.

BIBLIOGRAPHY: S. Mizuno, *Chinese Stone Sculpture*, Tokyo, 1950, pl. 1; S. Umehara, "Antiquities Exhumed from the Yin Tombs Outside Chang Tê Fu in Honan Province," *Artibus Asiae*, XIII, 3, 1950, pp. 150–151; *Sekai Bijutsu Zenshu* [The Complete Work of World Fine Arts] II-Kodai Shoki [The First Stage of Ancient Times], Tokyo, 1951, pl. 70; R. Grousset, *La Chine et son art*, Paris, 1951, pp. 15–16; G. J. Lee, "The Earliest Known Chinese Sculpture," *The Brooklyn Museum Bulletin*, XIII, 2, 1952, pp. 16–20.

EXHIBITED: China Institute of America, New York, *Small Sculpture—Shang through Sung Dynasties*, February–April 1954, no. 4; Brooklyn Museum since 1950.

NOTES

1. Li Chi et al., eds., *Anyang fa-chüeh pao-kao* (Preliminary Report on Excavations at An-yang), Peking, 1929, parts 1–4, cf. pl. x opposite p. 250 in pt. 2.

2. Perhaps the most useful popular article was written by H. J. Timperley in *The Illustrated London News*, April 4, 1936, pp. 587–589.

3. Umehara, pp. 150–151.

4. *Ibid.* Schuyler Cammann of the University Museum, Philadelphia, has suggested that it represents a bear.

5. P. Pelliot, "The Royal Tombs of An-yang," in *Studies in Chinese Art and Some Indian Influences*, London [1938], pl. 7. fig. 16.

TWO CHIN-TS'UN JADES

ALTHOUGH jade was cherished in the Late Chou period, as it seems to have been at all times in Chinese history, much of the symbolism inherent in the objects was ignored. Thus a jade *pi*, which represented the concept of heaven, also could serve as a bribe to march an army unmolested through a neighboring state.[1] A dragon pendant, once symbolic of the benign forces which brought life-giving rain, probably from the time of its making was used only as a decorative piece.

In Late Chou it was a common practice to cut many thin slices from a jade boulder in order to provide material for a number of pieces. Both Guennol jades were originally "slices." The outline of each piece was then cut with a blade, sand, and water. The brown markings on the edge contrasting with the pale green interior of the Guennol *pi* suggest the craftsman's interest in utilizing fully the beauties of the stone. He did the interior cutting by abrading a hole with a pointed tool and sand, and then sliding through a thin blade or wire and sand-sawing along the desired line. This reticulation, enhanced by a beveling and rounding to suggest modeling, helped to create the two lively animals which adorn the Guennol *pi*. All this work was done by abrasion, and the tools in the craftsman's hands were never actually cutting the stone.

Surface designs were created by using relief and incising techniques. The relief method, actually a reserving in relief with the unwanted material being abraded away, is well illustrated by the series of comma-shaped spirals on the *pi*. The flat surfaces of the dragon ornament show an ingenious use of incising technique. Here especially the stone restricts the design, for the lines generally must be straight except

for the arc of circles in which the human hand or fingers serve as a fulcrum. These designs were then enhanced by a lustrous polished surface, characteristic of the best Late Chou work. The Guennol jades are nephrite, basically a silicate of calcium and magnesium, with small fibers irregularly bundled together into larger units. One may speculate that in some way — probably due to finer materials or the greater skill of the craftsman — in Late Chou it became possible to get a refraction of light from each nephrite strand. This in turn meant greater diffusion of light and a lustrousness approximating translucency on the jade surface.

The Guennol *pi* can be associated with a small group of special jade pieces, most of which are in the Winthrop Collection at the Fogg Museum, ascribed by undocumented evidence to the site of Chin-ts'un.[2] Jades of this group are characterized by fine although not homogeneous material, vigorous design, and extremely skillful cutting. But the overriding characteristic which is apparent on all these pieces is a high polish which gives an almost translucent quality to the surface. That alone indicates that the Guennol *pi* belongs to a group of objects representing the finest jade craftsmanship of the Late Chou period. And one may hope that the increasing archaeological work on the China mainland will eventually add to the knowledge of jade and of those other art objects now ascribed to the site of Chin-ts'un.

TWO CHIN-TS'UN JADES

Pi–Length 4″ Diameter (of ring) 3″

Dragon Ornament–Height 1.9″ Length 4.1″

Late Chou, V–III century B. C.

PROVENANCE: The *pi* is presumed to have been found at Chin-ts'un near Loyang in Honan Province.

Ex COLL.: Chang, New York.

EXHIBITED: *Pi*–University Museum, Philadelphia, *Archaic Chinese Jades*, February 1940, no. 30, pl. 1; Norton Gallery and School of Art, West Palm Beach,

CHIN-TS'UN JADE *PI*

CHIN-TS'UN JADE DRAGON ORNAMENT

Chinese Archaic Jades, January–March 1950, no. 3, pl. 47; Chinese Art Society of America, New York, *Art of Late Eastern Chou*, March–May 1952, fig. 4; Brooklyn Museum since 1950. **Dragon**–Norton Gallery and School of Art, West Palm Beach, *Chinese Archaic Jades*, January–March 1950, no. 8, pl. 50; Brooklyn Museum since 1950.

<div align="center">NOTES</div>

1. According to the *Tso Chuan* (V, 11–667 B. C., 3), Tsin marched through Yu for a team of horses and a jade *pi*. See J. Legge, *The Chinese Classics*, Hong Kong–London, 1872, V, pt. 1, p. 136.

2. Both W. C. White, *Tombs of Old Lo-yang*, Shanghai, 1934, and S. Umehara, *Rakuyō Kinson Kobo Shūei* [Collection of the Best Specimens from the Ancient Tombs of Lo-yang], Kyoto, 1937, ascribe these superior jades of the Late Chou period to Chin-ts'un.

ALBUM OF
JAPANESE TEXTILES

Few nations have so zealously preserved their cultural artifacts as the Japanese. Despite a building construction depredated by fire and earthquake, many examples of their early arts have survived, but for years a strictly enforced Cultural Properties Act has discouraged their export. The result is that many types of Japanese art are known to the West mainly through publications. In the field of early textiles, for example, Western scholars have had to rely until recently on book illustrations or modern copies. In 1951, however, official permission was granted for the export to the United States of two albums of early textile fragments. One of these rare books came into the Collection and the other went to the Cleveland Museum of Art.[1] Both books cover the same period of time, from the sixth to the twelfth century A. D., and were probably formed in the same way. As the original pieces and bolts of cloth in the reposi-

266

tories were found to be developing minute flaws, small samples were cut from them. Perhaps a few swatches were actually snipped off for study purposes. It was probably in the nineteenth century that these fragments were gathered into small, accordion-like albums, and it was two of these which traveled to the United States.

The Guennol textile album contains forty swatches, and is especially important for the variety of techniques represented. A light-brown fragment illustrates the batik process with a floral pattern wax-reserved in the natural color of this eighth century material. A textile of a slightly later date is decorated with lotus petals drawn in ink and then painted in flat washes of blue, red, and yellow. Another example from the Heian period displays a peony design, handsomely brocaded in blue, yellow, white, and brown on a green background.

Perhaps the most controversial fragment in this album is a swatch of silk brocade believed to have come from a narrow textile strip once in the collection of Hōryūji Temple, Nara.[2] The original brocade has been considered by Japanese scholars as traditionally belonging to Princess Kashiwade, wife of the famed Prince Shōtōku Taishi (A. D. 572–621), and is thought to be of native manufacture.[3] The Guennol fragment is a warp-weave brocaded silk, a technique in which the entire pattern is made by the warp threads. Brocades of this technique have been found with first century A.D. Chinese lacquers in Mongolia, with third century Chinese records in Turkestan, and perhaps as far west on the silk route as Palmyra in the Syrian Desert.[4] The fragment in the Collection is a red ground silk divided into rectangles by bands crossing at right angles. In the center of each rectangle is a roundel of petals and pearls as well as spandrels of a palmette design. Green, yellow, blue, and white are used in making the design, which seems to bear some Sasanian influence.

267

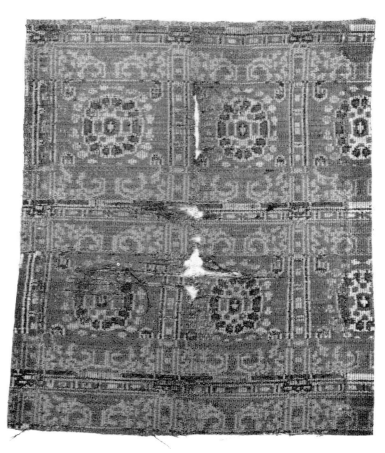

WARP-PATTERN SILK BROCADE
FROM ALBUM OF JAPANESE TEXTILES
Fragment No. 3

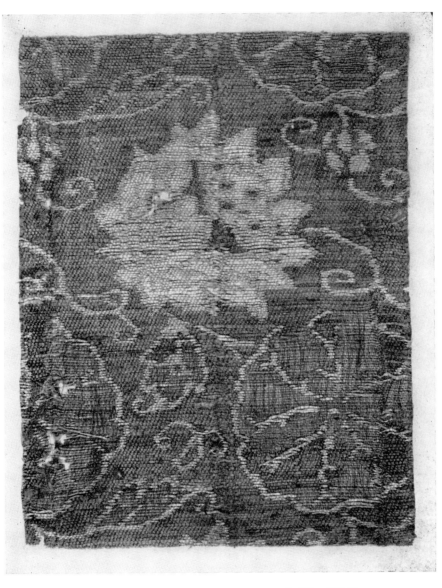

PEONY DESIGN ON BROCADED SILK
FROM ALBUM OF JAPANESE TEXTILES

Fragment No. 20

FLORAL PATTERN PONGEE
FROM ALBUM OF JAPANESE TEXTILES
Fragment No. 7

LOTUS PATTERN PONGEE
FROM ALBUM OF JAPANESE TEXTILES
Fragment No. 31

270

In his 1913 explorations A. von Le Coq found in a seventh century monastery in Turkestan a fragment of silk brocade with precisely the same design as this Guennol piece.[5] The Le Coq fragment has obviously faded, and it is now possible to see only the browns and the yellows on a red ground. Aurel Stein cites a variant of the Guennol textile design which is to be found in Turkestan on a fragment from the seventh century cemetery at Astana.[6] In view of these Asiatic mainland finds, at least one Japanese scholar accepts a Chinese origin for the Hōryūji strip and by extension for the Guennol fragment.[7] Thus it would be difficult to find a Far Eastern textile pattern more widely traveled or better documented than this silk brocade in the Collection.

ALBUM OF JAPANESE TEXTILES

Album Height 6.5″ Width 12″ Folded thickness approx. 2.5″

Forty varying sized fragments of different textiles which were placed, probably in the nineteenth century, in an accordion-like folding album.

Asuka, Nara, and Heian, VI–XII century A. D.

Ex Coll.: Mayuyama, Tokyo.

Exhibited: Brooklyn Museum since 1952.

Fragment no. 3.
 Swatch of warp-pattern silk, brocade design in green, yellow, blue, and white on red; presumed to have come from a larger strip originally preserved at Hōryūji Temple, Nara.

Length approx. 5.1″ Width approx. 6″

Probably the work of Chinese craftsmen, VII century A. D.

Fragment no. 7.
 Swatch of floral pattern pongee, design reserved in natural by batik process on brown dyed cloth; presumed to have come from a larger piece preserved in the Shōsōin, the Imperial Treasure House, at Nara.

Length approx. 4.1″ Width approx. 4.4″

Nara, VIII century A. D.

Fragment no. 20.

Swatch of brocaded silk, peony design woven in blue, yellow, white, and brown on a green background.

Length approx. 6″　Width approx. 4.5″

Heian, IX–XII century A. D.

Fragment no. 31.

Swatch of lotus pattern pongee, design outlined in ink on natural background and then painted in flat washes of blue, red, and yellow.

Length approx. 2.4″　Width approx. 2.4″

Heian, IX–XII century A. D.

Besides the above fragments, which we reproduce, we are listing the remainder of the contents of the textile album. When the place is not named, it is not known.

1.	Shōsōin	Nara	Period	23.	—	—	—
2.	Shōsōin	Nara	"	24.	—	—	—
4.	Hōryūji	Asuka	"	25.	—	—	—
5.	Shōsōin	Nara	"	26.	—	Heian Period	
6.	—	Nara	"	27.	—	Heian	"
8.	—	Heian	"	28.	—	—	
9.	Shōsōin	Nara	"	29.	—	Heian	"
10.	Shōsōin	Nara	"	30.	—	Heian	"
11.	Shōsōin	Nara	"	32.	—	Heian	"
12.	—	Nara	"	33.	—	Heian	"
13.	—	Nara	"	34.	—	Heian	"
14.	Hōryūji	Asuka	"	35.	—	Heian	"
15.	—	Nara	"	36.	—	Heian	"
16.	Shōsōin	Nara	"	37.	—	—	
17.	—	Heian	"	38.	—	Nara	"
18.	—	Nara	"	39.	—	Nara	"
19.	—	Heian	"	40.	Offering at Hachiman		
21.	—	Heian	"		Shrine	Nara Period	
22.	—	—	—				

NOTES

1. D. G. Shepherd, "An Album of Textiles from the Shōsōin and Hōryūji, *The Bulletin of the Cleveland Museum of Art*, XLII, 6, 1955, pt. 1, pp. 124–127.

2. Then transferred to the Imperial Household Museum, which is now the National Museum.

3. *Gomotsu Jōdai Senshokumon* [Textile Fabrics of the Sixth, Seventh, and Eighth Centuries A. D. in the Imperial Household Collection], Tokyo, 1929, pl. 16.

4. For a discussion of whether some of the Palmyra textiles are of Chinese manufacture see P. Simmons, *Chinese Patterned Silks*, New York, 1948, pp. 8–9.

5. A. von Le Coq, *Chotscho*, Berlin, 1913, pl. 51a.

6. A. Stein, *Innermost Asia*, Oxford, 1928, II, p. 706, Ast. ix. 2.022.

7. E. Ota, "The Age of Brocade Patterns Found in the Hōrūyji Murals," in *Report of the National Institute of Art Research*, Tokyo, 1953, English summary, pp. 3–4.

—

JAPANESE SHINTO STATUE

A TRULY difficult thing for the Western mind to grasp is the particular kind of tolerance which exists in some Oriental religions. It is a tolerance which sometimes accepts one god without rejecting all others, and which often condones borrowing from other religions to a degree beyond that customarily indulged in by Western faiths. This Oriental tolerance can be seen quite as clearly in the religious icons as it can be understood in the basic tenets of faith. A Japanese wood sculpture in the Collection admirably serves as an illustration of this point since it is considered to be a Shintō statue rendered in a Buddhist style.

The Guennol piece is one of fifteen sculptures[1] believed to have stood in a Shintō shrine in Idzumo prefecture on the west coast of the main island of Japan. These statues are said to have represented Prince Shōtōku Taishi (A. D. 572–621),

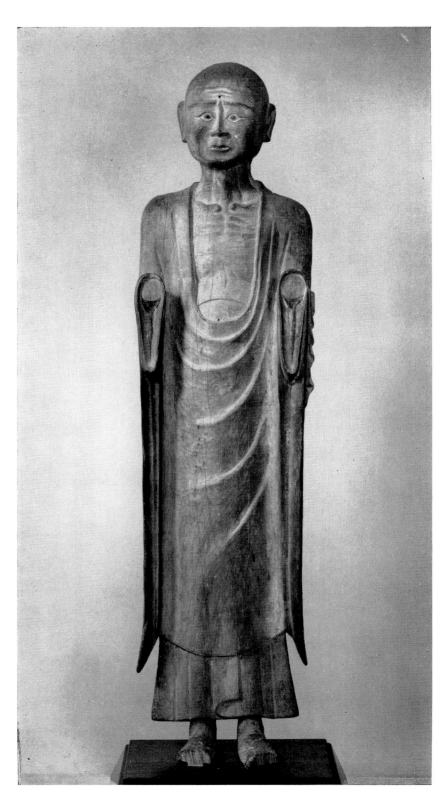

JAPANESE SHINTO STATUE

his family, and attendants. The Guennol statue is believed to represent a Korean monk named Eji who was spiritual adviser to the prince. Ancient records, which are nearly contemporary with Eji, supply considerable information about him.[2] He came from the district of Koma[3] in Korea, migrated to Japan, and lived at the Temple of Hōkōji after its completion in 596,[4] and made at least one trip back to his native land.[5] There can be little doubt that Eji was one of the ranking Buddhist monks of seventh century Japan but the historical importance of Shōtōku Taishi has permitted the Shintōists to make Eji into a minor deity. It is, of course, the national heroes of history and legend, bound in with a kind of primitive and local animism, who serve as the main core of the Shintō religion.

In addition to the historical personage Eji, the Shintōists seem to have borrowed the Buddhist manner of representing him as a priest. Tradition alone makes the Guennol piece an example of Shintō sculpture, although the simple conception of the figure and the intentional roughness of the wood surface could substantiate a Shintō attribution. Traces of gesso and paint, adhering to the wood, indicate that the figure was painted black, white, and possibly red. There is no identifying inscription. A few characters of an uncertain date, written in ink on a projection below the right foot of the statue, appear to be merely the traces of a workman's size notation.

As for the sculpture itself, it is an idealized portrait, for the artist could not have had any knowledge of Eji's appearance but knew only of his activities. The craftsman has preserved an awareness of the half log from which the statue was created, especially when one considers the object from the back. The front offers a dramatic contrast between the tense realism of the head and neck and the formalized rendering of the drapery and the body beneath. The realistic

275

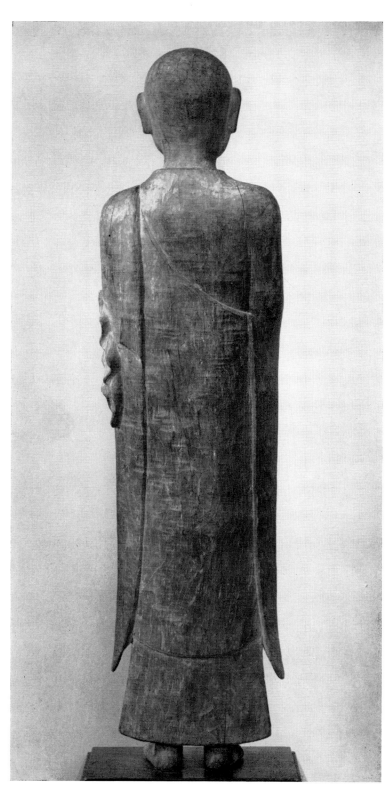

JAPANESE SHINTO STATUE—*Rear view*

276

276

concept of the head has prompted Western scholars to date the statue around the twelfth century, but Japanese specialists have suggested the earlier date of the tenth century.

Whatever the date of the Guennol piece, it is undoubtedly an early and fine example of Japanese portrait sculpture, and future research will bring more documentation as to its place and period of origin. Until then, the will and determination depicted in this statue can suggest the monk Eji, who, when he heard of his patron's death, decided to die at the appropriate hour so that he might enter with him into paradise. Small wonder then that, as the ancient text records, when Eji died on the specified day, "all the people of the time said. . . . 'Prince-Ear-Quick-Wise-Virtue was not alone in being a wise man; Eji was one also.'"[6]

JAPANESE SHINTO STATUE
Height 37.8″ Width 9″ Diameter 4.8″

XII century A. D., or earlier

PROVENANCE: Reported to have stood in a Shinto shrine in Idzumo prefecture.

EX COLL.: Tanikawa, Tokyo.

EXHIBITED: Brooklyn Museum since 1953.

NOTES

1. Of the other fourteen pieces in the group, ten are currently owned by R. Umehara, a well-known painter. Two others, belonging to K. Maeyama, were registered as Important Art Objects in 1940. Another piece from this group was purchased by the Cleveland Museum of Art.

2. These events in the life of Eji are recorded in the *Nihongi*, completed in A. D. 720. A translation of the *Nihongi* by W. T. Ashton appeared in Supplement I, *Transactions and Proceedings of the Japan Society*, London, 1896. P. Wheeler has translated material from the *Nihongi* in *The Sacred Sculptures of the Japanese*, New York, 1952.

3. Ashton, p. 122; Wheeler, p. 348.

4. Ashton, p. 124; Wheeler, p. 349.

5. Ashton, p. 146.

6. Wheeler, p. 358.

TOBA SOJO SCROLL

THE use of pictures to help tell a story goes back far into Japanese cultural history. At first, as in the Inga-kyō scrolls of the eighth century, the painting had no real separation from the written text. In Inga-kyō, a continuing picture in bright colors illustrated scenes from the life of the Buddha, while the text was written below in vertical columns of ink characters. About three hundred years later, individual chapters of the religious texts were prefaced with illuminated designs or representations of the Buddhist hierarchy. Later still, in the twelfth century, some sutras began with pictures in color of Japanese life instead of religious symbols. Also dated to the twelfth century are the illustrated scrolls of the *Genji Monogatari*, a novel of Japanese court life. In *Genji* the pictorial scenes of splendid color and design are interspersed with sections of the text. From Inga-kyō to *Genji* is not a single, straight line development, but the intermingling of painting and text as well as the relative importance of color to the picture are constituent principles.

Drawing in line, as opposed to painting in color, seems also to have existed in Japan as early as the eighth century.[1] An excellent example of this live and characterizing line is the ink Bodhisattva on hemp preserved in the Shōsōin. Some forty years ago sketches were found on the bases of Buddhist sculptures at the eighth century temple of Tōshōdai-ji. These consist of lively depictions of figures, landscapes, animals, all drawn in fluid line. More recently drawings and notations have been discovered on the ceiling of the main hall at Hōryūji.[2] These parallel in technique and freedom the sketches at Tōshōdaiji, but are restricted mainly to human figures and practice characters. Further investigation may reveal that additional examples of expressive line

278

drawings have survived from the art of early Japan.

Sometime during the twelfth century, a cross pollination between painted illustration and drawing in line took place. The result produced a series of narrative scrolls in twelfth and thirteenth century Japan which any other civilization would be hard pressed to match. Many of the scrolls have washes of color subsidiary to their ink line, but plain ink drawings also exist. Of these black and white pictures perhaps the most famous are four (originally five) scrolls of animals and men preserved at Kōzanji. The Kōzanji scrolls are usually ascribed by tradition to a Buddhist official named Toba Sōjō of the Fujiwara Period (twelfth century), and they are generally reckoned among the popular masterpieces of Japanese art.

Standing apart from the late dated copies made in Momoyama and Tokugawa times, three separate fragments bear rough association with the Kōzanji scrolls. One is to be found in the Tokyo National Museum, a second is in the possession of Baron Masuda, and the third has become part of the Collection. To understand what is happening in the Guennol fragment, one has to turn to a series of scroll copies made for the Sumiyoshi family in 1598.[3] A race has been arranged between the animals with a rabbit riding the fox and the monkey on the deer. As they race before the animal spectators, the monkey is knocked off his mount by the overhanging tree limb whose tip is visible at the right edge of the Guennol fragment. Two of the animal spectators help the rider monkey to his feet, and, at the left, he chases after his mount.

At present much scholarly work remains to be done on the scrolls at Kōzanji. More investigation is required on their proper sequence, and on the painters and dates involved. Until such information is available, conclusions on the Guennol fragment must be limited in scope. It is obviously

279

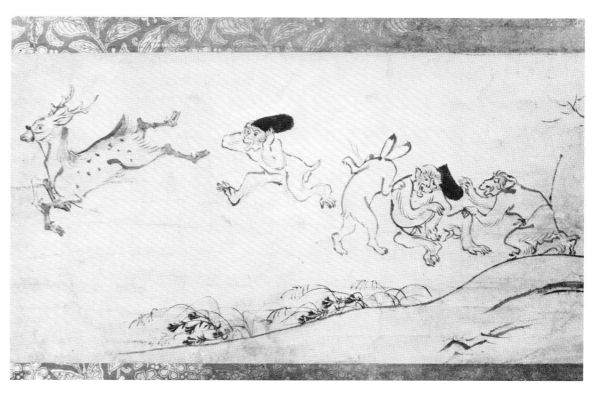

TOBA SOJO SCROLL

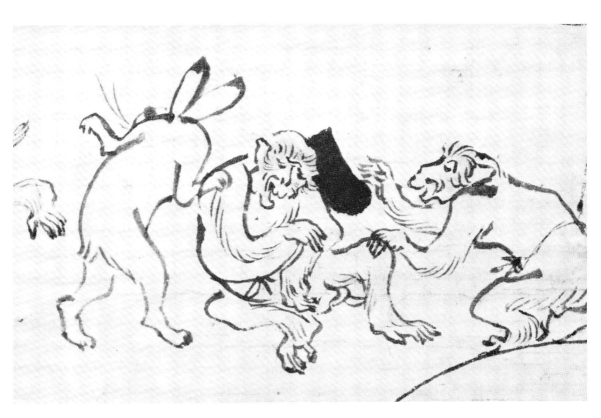

TOBA SOJO SCROLL—*Detail*

an old fragment cut from a handscroll.[4] Some of the drawing, such as the back of the rabbit, stands comparison in the use of vital and characterizing line with the Kōzanji scrolls. Other sections of the Guennol drawing, notably the flowers and grasses, take the comparison less well. One may hope that the future will provide increased knowledge, such as being able to determine scientifically the character of the paper, which will aid in dating the paintings of the entire school. But whatever the ultimate conclusions on the Kōzanji scrolls, it is fair to call the Guennol fragment the most distinguished example outside Japan of that school of painting.

TOBA SOJO SCROLL

Height 11.3″ Length 21.1″

Fujiwara or Kamakura, XII–XIV century A. D.

Ex Coll.: Yamamoto, Tokyo, until 1921; Takamatsu, Aichi, until 1938.

Bibliography: K. Tanaka, "On a Newly Found copy of the *Kozanji* Cartoon, Handed Down in the Sumiyoshi Family," *The Bijutsu Kenkyu*, 116, 1941, pl. 5; J. Mayuyama, ed., *Japanese Art in the West*, Tokyo, 1966, pl. 117.

Exhibited: Ohio State Museum, Columbus, *Art of the Far East*, June–August 1955, no. 43; Brooklyn Museum since 1955.

NOTES

1. This distinction is indicated in the later *Genji Monogatari*, which uses *sumigaki* for drawing in ink and *tsukuri-e* for painting in color. See K. Toda, *Japanese Scroll Painting*, Chicago, 1935, pp. 52–53.

2. T. Kuno, "Notes on the Drawings and Scribblings Discovered on the Ceiling of the Main Hall, Hōryūji Monastery," *The Bijutsu Kenkyu*, 140, 1947, pp. 32–42, pls. 10–15.

3. See Tanaka, pp. 235–247, for a discussion of the Sumiyoshi scrolls and an analysis of the problems of the Toba Sōjō paintings.

4. Thus it seems probable that there are other fragments hidden away in Japanese collections. One hopes that the future will reveal additional evidence and permit a more precise attribution for the Guennol piece.

KAMAKURA WOODEN HEAD

SOMETIMES an art object appears which is so basically convincing and so well documented that fundamental research on it can be done in a relatively short time. Such is the case with this Oriental object in the Collection. It is a triple-life-sized head, originally part of a Japanese Buddhist guardian-king statue. The head has been carved with dextrous realism out of two blocks of wood and has an inserted top-knot carved from a third. The dramatic quality of the sculpture is heightened by the use of crystal insets for the eyes, by a metal crown, and by the remains of old polychrome. These stylistic elements point to the Kamakura period (A. D. 1185–1336), and it is known that the head was, until recently, preserved in the Kōfukuji Temple. It is, indeed, illustrated among the art treasures of Kōfukuji in the survey, *The Ten Great Temples of Nara*, published some years ago in Japan.[1]

What then remains to be said of this piece, so obviously acceptable to the top scholars in the field? One can add only a brief speculation based on circumstantial evidence. It is known that Kōfukuji, the family temple of the Fujiwara clan, was severely damaged during the struggle for power at the end of the Fujiwara regency, and especially in the Chisho era (A. D. 1177–1180). Yoritomo, founder of the next regency, treated the Imperial Court at Kyoto and its surroundings in Nara and elsewhere with respect, while he established temporal power in the north at Kamakura. It is known that Yoritomo contributed large sums of money and generally encouraged the restoration of shrines and temples throughout Japan.[2] Thus, one would expect considerable activity at Kōfukuji during the early decades of the Kamakura reign, and the inscribed temple objects seem to bear

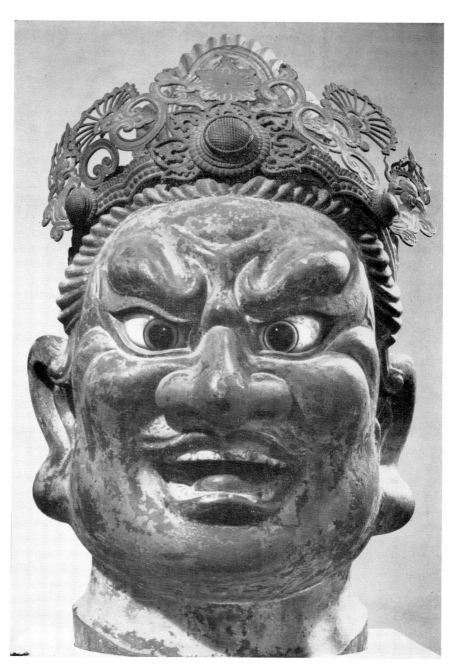

KAMAKURA WOODEN HEAD

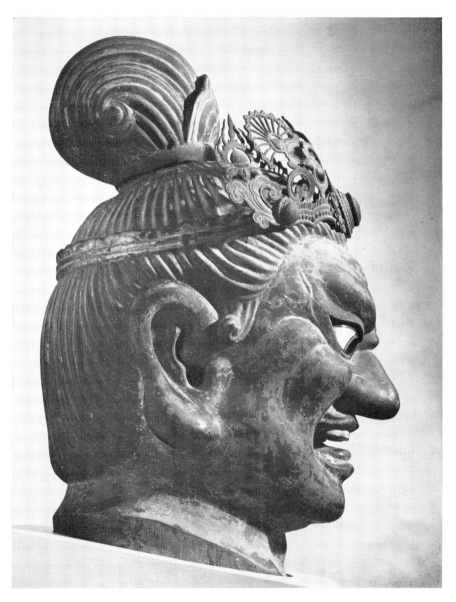

KAMAKURA WOODEN HEAD

out this supposition. Examples of this activity include a set of small *Shitennō* (four guardian-kings), which were carved by Kōkei for Kōfukuji around A.D. 1189. There are painted images of guardian-kings on the remaining doors of a shrine believed to date from approximately A.D. 1194, which are stylistically very close to the Guennol head.[3] Two large Bodhisattvas, made in A.D. 1202 as restorations for images in the Saikondō (West Golden Hall) are especially interesting.[4] These figures carved in a formula appropriate to the higher gods, but rendered realistically and with crystal inset eyes, may possibly provide a clue to the original provenance of the Guennol head. As attendant deities, these two wooden sculptures stand nearly twelve feet high and thus indicate a shrine scale approaching that suggested by the Guennol head. Probably from the same hall is a tremendous wooden head of Buddha, some three and a half feet high, which bears the inscription "Saikondō" in India ink.[5] The Saikondō Hall has long been destroyed, and its treasures, some of them dating back to the eighth century A.D., are scattered throughout the other buildings at Kōfukuji. One must also keep in mind that even the existent buildings at Kōfukuji have been destroyed a number of times, and that any connection between the pieces originally in the Saikondō and the Guennol head remains in the realm of speculation.

Temple history and comparative objects do suggest that the Guennol head from Kōfukuji dates from early Kamakura times. One is tempted by the preceding evidence to date the piece to the close of the twelfth century. But to be properly discreet, at least until the temple records are again searched, one should consider an early Kamakura attribution sufficiently precise for this admirable head.

Height (overall) 27.5″ Width 13.8″ Diameter 15″

Kamakura, late XII–XIII century A. D.

EX COLL.: Kōfukuji Temple, Nara.

BIBLIOGRAPHY: *Catalogue of Art Treasures of Ten Great Temples of Nara*, XV [The Kōfukuji Temple, part II], Tokyo, 1933, pl. 78; J. Mayuyama, ed., *Japanese Art in the West*, Tokyo, 1966, pl. 63.

EXHIBITED: Brooklyn Museum since 1954.

NOTES

1. *Catalogue of Art Treasures*, pl. 78.
2. G. B. Sansom, *Japan: A Short Cultural History*, New York, 1936, p. 333.
3. *Catalogue of Art Treasures*, XV, pls. 90–91.
4. *Ibid.*, XIV, pls. 15–16.
5. *Ibid.*, XV, pl. 77.

CHINESE
BLUE-AND-WHITE PLATE

THE handsome Chinese blue-and-white porcelain is a recent addition to the Far Eastern section of the Collection, being added a decade and more after the other pieces. This essay is, in turn, written some ten years after all the other essays.

Despite the above passage of time, and the scholarly work done on three continents, we still know little of the beginnings of Chinese blue-and-white. Early attributions are based on relationships with a pair of vases in the collection of the Percival David Foundation, London, which are dated in accordance with A. D. 1351. John Alexander Pope has well summarized the additional archaeological evidence from Hamā, Syria, and from Kharakhoto, on the desert to the

287

west of China, in his work on the Chinese porcelains at the Ardebil Shrine.[1] We must avoid over-exercising our stylistic horses, however, for pieces of early stylistic character are appearing in Ming Dynasty (1368–1644) tombs.[2]

One finds considerable scholarly harmony on early fifteenth century porcelains, the period into which the Guennol plate fits. True, we cannot always differentiate between the unmarked pieces of Yung-lo (1403–1424) and Hsüan-tê (1426–1435), and even some marked Hsüan-tê objects may in fact be made a little after the close of the period. But one finds general agreement that a fairly unified group of large plates belongs to the early fifteenth century, and that these pieces must be considered among the finest quality of Chinese blue-and-white, if not, indeed, of all Chinese porcelain.

The Guennol plate is made of porcelain clay with the decoration in underglaze cobalt blue. The central design contains three grape clusters with vine, leaves, and tendrils indicated. A wave design covers the foliate, flattened rim, while in the twelve sections of the cavetto, six representations of fungi alternate with other floral sprays. Two close parallels to this plate are currently known to the writer. By "close" be it understood that the design elements are the same in concept and location, there being only minute variation in the drawing. Shape, including rim type and cavetto, and size, are also the same. One such plate remains at Ardebil,[3] and the other is in the Cleveland Museum.[4]

The Guennol plate bears the drilled mark of Shāh Abbās of the Persian Safavid dynasty,[5] who donated some 1100 pieces of porcelain to the Ardebil Shrine in 1611. An inscription on the foot rim of the plate shows it also belonged to Shāh Jehan.[6] This piece seems to symbolize the cultural interrelations between the Near and Far East. The Chinese imported cobalt blue from Persia (or perhaps, more cor-

288

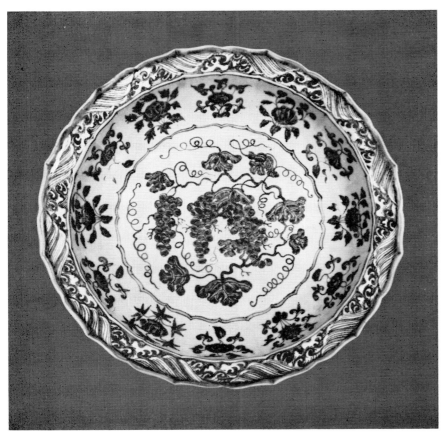

CHINESE BLUE-AND-WHITE PLATE

View of bottom

rectly, from northern India), and used it to decorate low fired pottery at least as early as the eighth century. The grape was also a cultural export to China, and perhaps its first citation in Chinese records is its inclusion among the western products which adorned the imperial garden of the Han Emperor Wu-ti (r. 140–87 B.C.). In turn, many of the finest early Chinese blue-and-whites have been discovered and preserved in the Near East. It is appropriate that this distinguished plate, of Chinese origin, and Near Eastern associations, should bear further cultural interchange, this time in the Western world.

CHINESE BLUE-AND-WHITE PLATE

Diameter 17″

Chinese, early XV century A. D.

Ex Coll.: Shah Abbas (1557–1629), Persia; Shah Jehan (1599–1666), Persia.

Exhibited: Metropolitan Museum of Art, New York, *Art Treasures of Turkey*, January–March 1968; Metropolitan Museum of Art since 1968.

Notes

1. J. A. Pope, *Chinese Porcelains from the Ardebil Shrine*, Washington, D. C., 1956, pp. 69–77.

2. For example, an early bowl, which would be called by some scholars Yüan (before 1368), has been found in a Ming tomb datable to 1418. This is surprising, although the archaeological evidence is completely valid only in the other time direction. For details of the aforementioned excavation, see "Excavations of the Ming Tombs Outside of the Chung Hua Men Gate, Nanking," *Kaogu* (Archaeology), 9, 1962, pp. 470–478.

3. Pope, pl. 37.

4. Cleveland Museum of Art, 53.127. Published by S. E. Lee, "Early Ming Blue and White Porcelain," *The Bulletin of the Cleveland Museum of Art*, XLII, 1955, pp. 27–31. Reproduced in *Sekai Toji Zenshu: Ceramic Art of the World*, XI, Tokyo, 1954, pl. 56, and in the 1966 anniversary publication of the Cleveland Museum of Art.

5. The inscription has been read by Don Aanavi, Assistant Curator of Islamic Art, Metropolitan Museum of Art, New York, who has written us that only three lines of the stamp on the Guennol plate are decipherable at this point. They read:

Waqf (religious donation)

Abbas

Safavi

The known seals of Shah Abbas on Chinese porcelains are reproduced in Pope, pl. 6.

PRE-COLUMBIAN OBJECTS

Samuel K. Lothrop

Gordon F. Ekholm

ABORIGINAL AMERICAN ART

WHEN Columbus returned from his first voyage to the New World, he brought back samples of the products and household articles he had seen on the various islands. Today these objects would be of extraordinary interest, but only one has been preserved, a sword (of a broadbill swordfish) which to the European of Columbus' day must have symbolized the surrender of the newly discovered lands.

Thirty years later, when the treasure of Cortes reached Europe, the craftsmanship and beauty of individual objects aroused great enthusiasm. "I do not marvel at gold and precious stones," wrote the royal historian, "but am in a manner astonished to see the workmanship excel the substance." Cortes brought back a large and varied collection of Aztec material. An inventory of this treasure exists today, as well as a list of his gifts to thirteen monasteries or churches and to twenty-two officials. The King of Spain also must have received a similar collection and he, in turn, sent gifts, principally to Austria and Italy. With several exceptions, all the gold and silver objects were melted

down, but a few dozen artifacts of wood, stone, mosaic overlays, and featherwork have been preserved in Europe.

Later Spanish conquests in South America obtained more gold and silver objects than did those in Mexico, but these lacked the novelty of those procured earlier and very few (of any kind) were preserved. The phenomenally dry climate of the Chilean and Peruvian coastal areas, however, has allowed the preservation of vast numbers of textiles and other perishable objects, so that excavations there provide a much fuller view of aboriginal craftsmanship than they do in other portions of America.

The formation of collections of aboriginal American objects, previously regarded as curiosities, began at the end of the eighteenth century. Perhaps the first was the *Cabinete de Historia Natural*, maintained by the Spanish Crown, where Maya sculptures were exhibited as early as 1787.

The first public acceptance of New World articles as art must be attributed to the Burlington Fine Arts Club in London which held an *Exhibition of Objects of Indigenous American Art* in 1920. However, a prefatory note in the catalogue cautiously states that: "delicately nurtured dilettanti . . . may say that, while it may be indigenous, it is not art."

Today, at least in the United States, the picture is very different. Individual collectors vie with each other to secure rare objects. Art museums, especially in the Middle West, are dedicating more and more space to New World material. The older and more conservative natural history and university museums in the East, pioneers in the collecting of "Indian relics," are revamping their exhibits to show more effectively what are now considered to be objects not only of historical importance but also of real aesthetic significance.

294

EFFIGY PIPE FROM INDIANA

Although the Indians of North America are not usually regarded as sculptors, they did fashion many objects of stone, the finest of which are of high artistic merit. These carvings are usually on a small scale, there being no monumental sculpture comparable to what is found in Mexico, Central and South America. The possibility of stylistic influence from the south has repeatedly been discussed, but has never been established.

Carved effigy pipes of stone occupy the top rank in North American Indian sculpture. Tobacco of some forty-odd species was grown by the Indians in most of the regions where it could flourish, and from there it was traded to other areas. Today, we smoke for pleasure, but in pre-Columbian times, smoking was also considered to have ceremonial significance and medicinal value. Cigars, sometimes of gigantic proportions for community enjoyment, and cigarettes were manufactured in many areas. The pipe was known from the Algonquin tribes of southern Canada to the Araucanian Indians of Chile. Owing to its ceremonial importance, the pipe often appeared in elaborate forms.

This black steatite effigy pipe from Indiana has a long history and has been published several times. It has been termed "one of the finest examples of pre-Columbian art found in the eastern part of the United States." When discovered, the right front leg was missing but fifteen years later this was recovered during the cultivation of a garden and forwarded to the owner of the pipe. The left ear and right eye are slightly damaged.

The pipe represents a crouching feline, probably a puma, with the tail curved along the sides of its body. The bowl of the pipe is in the center of the animal's back and is connected

by a drilled hole to a flat mouthpiece behind the rump. The sculptor, while conventionalizing his subject, has brought out the muscular tension and ferocity of the animal. At the same time, he has incorporated such details as the dew claws and pads on the feet.

There are roughly drilled round and oval holes or slots on the back, haunches, cheeks, and neck. The eyes and mouth are similarly fashioned. Presumably these were inlaid with some perishable materials of contrasting color, a trait and technique occasionally used in the United States and well known from Mexico southward.

This pipe was found in Indiana and has been attributed to the Hopewell culture, which centers in the Ohio valley. It has also been stated that feline animals with added serpent and bird elements (dragons) are characteristic of the Middle Mississippi area. Pipes representing crouching animals are found in that region, but they normally are of clay rather than stone and were fashioned in such a way that they required a wooden stem. The Hopewell culture was formerly "guess-dated" as c. A.D. 900–1300, but more recent work and radio-carbon dates place it as having been in existence by the time of Christ.

EFFIGY PIPE FROM INDIANA

Length (maximum) 6.4″ Height 2.3″

Hopewell culture

PROVENANCE: Said to have been found at the Mann Site, Posey County, Indiana.

Ex COLL.: Henry Mann, Mount Vernon, Indiana; Joseph J. Geringer, Indianapolis, Indiana; G. I. Groves, Chicago, Illinois; Judge Claude U. Stone, Peoria, Illinois; Byron W. Knoblock, Quincy, Illinois.

BIBLIOGRAPHY: *Journal of the Illinois State Archeological Society*, V, 4, April 1948, p. 6; *Brooklyn Museum Annual Report 1948–1949*, 1949, p. 19; W. R. Adams, *Archaeological Notes on Posey County, Indiana*, Indianapolis, 1949, pp. 54 ff., pls. I, II; B. W. Knoblock, "Superb Sculptured Art of the Eastern United States," *Journal of the Illinois State Archaeological Society*, II, 1, July 1951, p. 24,

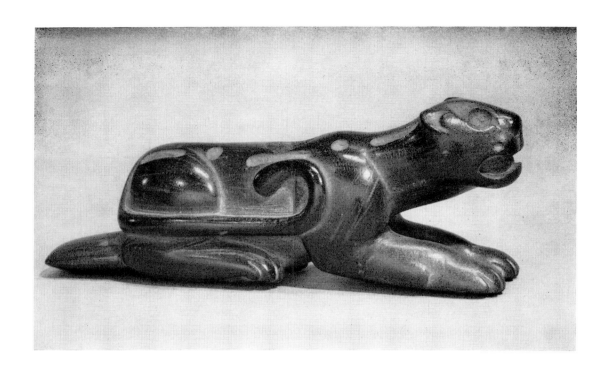

EFFIGY PIPE FROM INDIANA

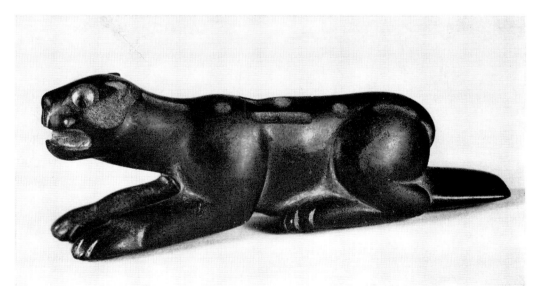

fig. 17; M. Covarrubias, *The Eagle, the Jaguar, and the Serpent*, New York, 1954, pl. XXXIX; H. C. Wachtel, "The Panther Pipe," *Ohio Archaeologist*, V, 2, April 1955, p. 60, ill.

EXHIBITED: Brooklyn Museum, New York, *Ancient Art of the Americas*, Winter 1959; Brooklyn Museum since 1949.

———

PLATFORM PIPE FROM ILLINOIS

THIS curved-base platform pipe, made of green Ohio pipe-stone, was discovered by accident in a large, carefully shaped oval mound situated on the right bank of the Illinois River near Naples. This find occurred shortly after the year 1840 when some local residents were engaged in digging a fresh grave at that site. Their spades struck a buried stone bowl in which they found this pipe, another bird pipe, a frog pipe, and a copper implement. Within a five mile radius of Naples there are at least fifty such mounds of various sizes.

From the earliest days of United States history, Indian remains have attracted quite a bit of attention. In 1801 empirical observations regarding burial mounds in Virginia were published by Thomas Jefferson. It was he who first correctly associated these tumuli with the Indians who once had inhabited that region.

The complex of earthworks at Naples, Illinois, had been visited and partially ransacked before 1879, but in that year a thorough, scientific investigation of this Indian site was undertaken by the Smithsonian Institution, and since that time much research has been devoted to the field of Indian archaeology in the United States.

In discussing this pipe in 1882 an important early authority stated that: "It is certainly the finest mound pipe thus far known . . . and is as perfect as on the day when it was

298

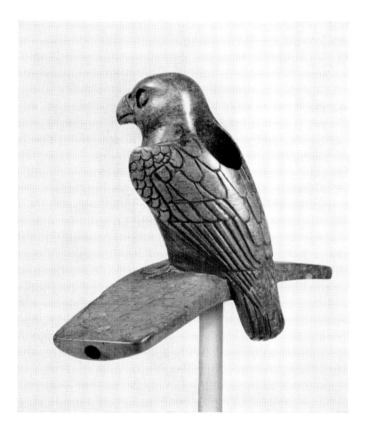

PLATFORM PIPE FROM ILLINOIS

made." It has had many owners, and several not very accurate drawings have been published.

The pipe represents a bird of prey, probably an eagle, perched crosswise on a thin, curving platform. The bowl of the pipe is in the bird's back, and the stem is at one end of the platform. Wing and tail feathers are rendered in realistic detail, but the rest of the body, feet, and head are worked with minimum embellishment. The whole surface of the soft, compact, conglomerate stone has been smoothly polished. The tail of the bird has been broken off and mended. On it are scratches which may once have been meaningful.

The eagle was a bird of supreme importance to the North American Indians in their religion, mythology, and social organization. Not only was an eagle god worshiped, but most tribes with clan organizations had an eagle clan. Eagles either were killed for their feathers, a difficult feat with a bow, or were trapped, and the young were secured from their eyrie and kept in captivity. Eagle feathers were highly prized as symbols of valor in war and for use in religious ceremonies. In the Plains area, during the days when war bonnets were common, the twelve tail feathers of an eagle were worth the price of a horse. Eagle bones served as flutes or as sucking tubes for medicine men.

Platform pipes of stone with either straight or curved bases surmounted by carved figures are typical of the Hopewell culture. This culture centered in the Ohio drainage, but extended for considerable distance in all directions.

PLATFORM PIPE FROM ILLINOIS

Height (of pipe) 3.3″ Length (of platform) 4.3″

Hopewell culture

PROVENANCE: Said to have been found with other items in a mound located on the right bank of the Illinois River about 300 yards below Griggsville Landing, near Naples, Illinois, in about 1832.

Ex Coll.: Daniel Burns, Valley City, Illinois; Daniel Burns, Jr., Detroit, Michigan; Mrs. Mattie Burns Hall, Detroit, Michigan; Mrs. Elma C. Bickerdike, Griggsville, Illinois; Byron W. Knoblock, Quincy, Illinois.

Bibliography: J. Shaw, "The Mound-Builders in the Rock River Valley, Illinois," *Annual Report . . . of the Smithsonian Institution . . . for the Year 1877*, 1878, p. 256, publishes the cast in the United States National Museum (cat. no. 31478), but there is a cast in the British Museum as well; J. G. Henderson, "Aboriginal Remains near Naples, Ill.," *Annual Report . . . of the Smithsonian Institution . . . for the Year 1882*, 1884, pp. 691 ff., describes and illustrates the pipe; C. Thomas, "Burial Mounds of the Northern Sections of the United States," *Fifth Annual Report of the Bureau of Ethnology to the Secretary of the Smithsonian Institution, 1883–1884*, 1887, pp. 38 ff., figs. 14, 15; J. D. McGuire, "Pipes and Smoking Customs of the American Aborigines, Based on Material in the U. S. National Museum," *Annual Report . . . of the Smithsonian Institution . . . for the Year Ending June 30, 1897. Report of the U. S. National Museum. Part I*, 1899, pp. 521 ff., fig. 135, publishes their cast of this pipe; *The Brooklyn Museum Annual Report 1948–1949*, 1949, p. 19; *Central States Archeological Journal*, II, 1, July 1955, p. 5.

Exhibited: Brooklyn Museum, New York, *Ancient Art of the Americas*, Winter 1959, p. 11, ill.; Brooklyn Museum since 1949.

—————

TWO MICHIGAN "BIRD STONES"

COLLECTORS of Indian artifacts in the eastern United States have been aware for a long time of a number of special types of small, finely finished, oddly shaped, stone objects. Usually made of slate, but sometimes of a much harder or more highly colored stone, these objects have been given the somewhat fanciful names of banner stones, butterfly stones, boat stones, or bird stones. Since they are classifiable into well-defined types, a functional purpose for them was to be assumed. The more cautious were inclined to consider them merely as "problematical" or "ceremonial." More recently, however, some of these objects have been definitely identified as weights for spear-throwers. It has not been proven conclusively that bird stones were used in

this way, but they were obviously made to be bound to some shaft-like object, and therefore it appears most probable that they formed parts of these weapons.

The spear-thrower, also called throwing stick, *atlatl*, or *estolica*, is a device for increasing the leverage of the arm when casting a lance or light spear, just as a racquet gives added speed when stroking a ball. In use since Palaeolithic times in Europe, it has been employed all over the world, especially in wooded areas, but it was ultimately replaced by the bow. Nevertheless, many tribes in the New World were still using spear-throwers when they were first encountered by Europeans.

The spear-thrower consists of a wooden rod or slab which is about two feet in length. It is held at one end and may have finger holes or a hand guard to insure a proper grip. The base of the spear is placed against the other end, contact being maintained either by a slot in the throwing stick or by a peg which rests in a depression on the butt of the spear. In the New World, spear-throwers were known from the Arctic region to the Pampas of Argentina and there were many local variations of the basic form. Aztec atlatls are noted for their carved bas-reliefs. Some examples from western South America were sheathed in gold or silver.

In weapons of this kind which are made for personal use, it is quite natural that there should be individual adjustments in order to obtain better balance for greater momentum. Some time ago it was noted that spear-throwers preserved in dry caves in Arizona had small stone weights lashed to their staffs. More recently, in eastern grave sites, it was discovered that pegs from spear-throwers and banner stones were found in alignment. It was therefore reasonable to presume that at one time they had been connected by a wooden shaft that long since had decayed. Furthermore, it

302

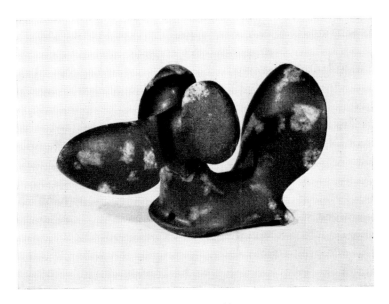

MICHIGAN "BIRD STONE B"

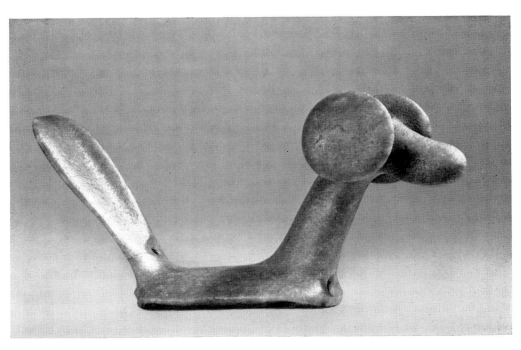

MICHIGAN "BIRD STONE A"

seems plausible that bird stones were also parts of spear-throwers.

The name "bird stones" is given to a group of objects some of which remotely resemble a bird. The body is small and without any definite character, but there is a big broad tail, a long neck, and a head with a large bill or snout. The most unusual features are great button-like eyes which project from the head on slender stems. The base is either flat or slightly concave.

Bird stones are associated with the Hopewell culture and are found chiefly in the Ohio basin. They are known to occur northward to the Great Lakes and eastward to New York. Boat stones, however, seem to have greater distribution to the south, southeast, and west.

Two specimens are illustrated here. Bird stone "A" is of brownish red quartz spotted with shades of tan, and "B" is of black and white porphyry. The latter is remarkable for its very small body and huge eyes, snout, and tail. The neck of this bird stone has been broken and mended. On the other one the tail has been mended, while at each end of the base underneath the body is a perforated crossing ridge, the rear ridge being broken out. The surface of both bird stones is smooth, but without a high polish.

BIRD STONES

"A" Length 5.3″ "B" Length 3.3″

Hopewell culture

PROVENANCE: Bird stone A said to have been found near Benton Harbor, Michigan; bird stone B said to have been found on the banks of the Kalamazoo River between Kalamazoo and Galesburg, Kalamazoo County, Michigan.

EX COLL.: Sprague W. Chambers, Kalamazoo, Michigan; Byron W. Knoblock, Quincy, Illinois.

BIBLIOGRAPHY: *Brooklyn Museum Annual Report 1948–1949,* 1949, p. 19; B. W. Knoblock, "Superb Sculptured Art of the Eastern United States," *Journal of the Illinois State Archaeological Society,* II, 1, July 1951, pp. 25 ff., figs. 18–19; L. Johnston, "Birdstones and Their Distribution Pattern in Ohio," *Ohio Archae-*

ologist, IV, *3*, July 1954, p. 19; *Central States Archaeological Journal*, I, *2*, October 1954, p. 62; M. Covarrubias, *The Eagle, the Jaguar, and the Serpent*, New York, 1954, pl. XXXVI (bird stone B).

EXHIBITED: Brooklyn Museum, New York, *Ancient Art of the Americas*, Winter 1959, both shown; Brooklyn Museum since 1949.

———

TWO OLMEC JADES

OVER sixty years ago, large, peculiarly stylized, and beautifully carved jades from Mexico began to appear in various collections. It was not until 1929, however, that the late Marshall H. Saville grouped these jades together, linking them with monumental sculpture discovered in southeastern Mexico by Frans Blom and Oliver La Farge, and proposed that all these carvings be assigned to the Olmec culture. Since then many more examples of this art have come to light, but the larger and finer jades are still of the utmost rarity.

Olmec was not an entirely appropriate name to apply to these carvings. It was the name of a people living in the Gulf Coast region of southern Vera Cruz at the time of the Spanish conquest of Mexico in the sixteenth century. Objects in the "Olmec Style" have been found in that locality in the greatest numbers, but there was no certainty that these objects had any connection with the Olmec people. This became apparent when further investigations indicated that the archaeological remains associated with the "Olmec Style" were as old and in part older than the early portion of the Mesoamerican Classic Period, and now have recently been placed much further back in time—to the period of approximately 1400–400 B.C. This excludes any necessary connection between the objects in question and the

305

later Olmec people. With the intention of avoiding possible confusion it was decided at one time to refer to the entire archaeological complex as La Venta, the name of an important site, but the term Olmec was too well established and continues to be used.

While objects in the Olmec style are at home primarily in the Gulf Coast region, they have been found as widely separated as Western Mexico and Panama. This distribution is partially due to the fact that individual objects were traded, but it is also a result of the dispersal of the Olmec technique and styles to various peoples. Many fine Olmec carvings have been discovered in central Mexico and particularly in the states of Morelos and Guerrero. What this distribution means in regard to the place of origin of the Olmec style or to the Olmec culture's contribution to the rise of Middle American civilization are complex and important problems still to be solved by future research.

The nature and origin of the jade from which our two pieces are carved are of special interest, of course, to the student of Olmec art. In the Orient, the term "jade" is applied to two types of stones: nephrite and jadeite, the former being the more common. In the New World objects made of nephrite have been found in Alaska, Puerto Rico, Venezuela, Colombia, and Brazil, while jadeite objects have come only from Mexico and Central America.

The name "jade" has also been applied to other minerals which are more or less green in color and as hard or harder than steel. For instance, the "jade" from Swiss lake dwellings is in fact saussurite. Some of the harder serpentines, especially the hard compact varieties grouped under the name bowenite, can be mistaken for jade. Green jasper also has been described as jade.

It was once thought that American jadeite objects were carved of stones imported from China or Burma, but chem-

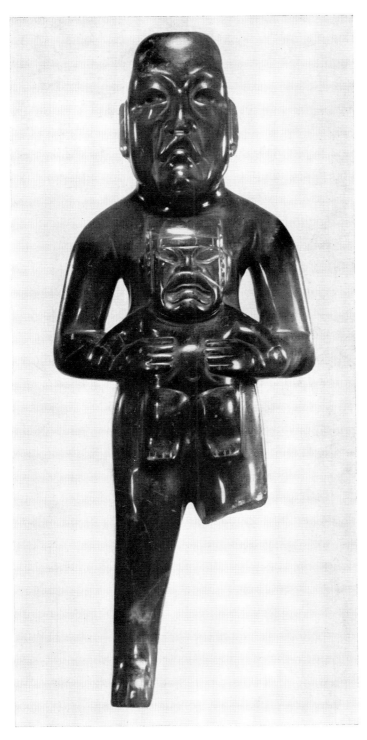

OLMEC JADE FIGURE WITH "BABY"

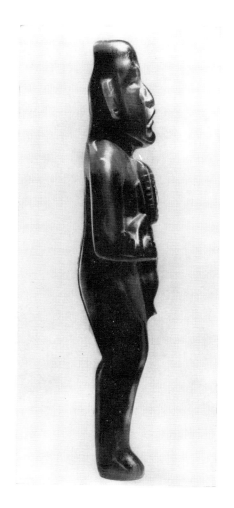

OLMEC JADE FIGURE
WITH "BABY"

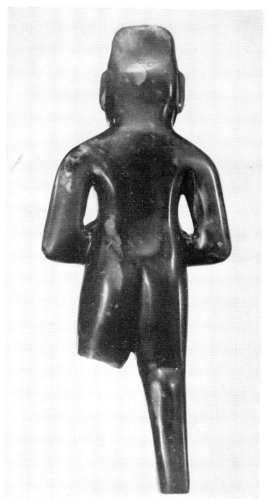

308

ical analyses have shown that the "pure" jadeite of Oriental countries is rare in the New World. The American stone contains increasing amounts of lime and magnesia and diminution in silica and soda. A new name obviously is needed to describe this stone. *Tuxtlite* and *maya-ite* have been suggested, but have not been accepted. *Diopside-jadeite* is now employed in technical literature, but the term jade is fully justified in popular terminology for as far as their use in art is concerned, all these minerals have much the same properties.

Throughout Mexico and Central America there is great variety in the quality and color of jade. Jades may be almost white or various shades of gray, pea-green, grass-green, emerald-green, or blue-green. They also may be mottled or translucent. Surfaces may be highly polished or dull. These characteristics have not been fully analyzed and appraised, but it is generally recognized that Olmec jade often is of a characteristic dark blue-green and its quality is unsurpassed in the New World.

The ancient sources of Mesoamerican jade are unknown and it is suspected that the natives secured their supply from water-worn boulders in stream beds. In many artifacts, only one side was carved while the back retains its original surface. Large jade boulders were cut into pieces by sawing. Jade does not flake like flint or obsidian, but must be shaped by abrading and grinding. These are tedious and painfully slow tasks. This explains why aboriginal artisans often modified the original shape of the stone as little as possible, taking advantage of natural forms to express their purpose.

Olmec jades, in contrast to those of other peoples and periods in Middle America, are almost always completely finished on all sides. Rough surfaces or marks of manufacture have been obliterated. This represents a command of material and a striving for perfection which is not often

found in other jade carving centers such as Oaxaca, Guatemala, Honduras, or Costa Rica.

We can say little about the manufacture of Olmec jades beyond what is apparent to the eye. They are larger and heavier than most Mesoamerican jades, and a great deal of the outer surface must have been removed by rubbing or sawing with stone tools or by using abrasives with string or wooden tools. The very delicate incised lines are thought to have been made with a cactus spine and an abrasive. A drill was extensively used in Olmec jade carving, as can be seen in the hollows in the eyes, nose, and mouth of both Guennol pieces. The hollow or tubular drill, greatly favored in Maya and Oaxaca styles of jade carving, appears never to have been used by the Olmecs.

Olmec sculptures range in size from small jades to great basalt heads up to nine feet in height. Some of the large stone sculptures in the form of stelae and altars exhibit flamboyant details somewhat similar to those of the Maya. In general, however, figures carved in the round as well as those shown in relief are naked, sexless, and fleshy.

The faces are usually characterized by a peculiar type of mouth, thick-lipped and with the corners drawn down, which has earned them the name of "baby faces." In many other examples this mouth has become clearly the mouth of a jaguar, and we have what may be regarded as anthropomorphic jaguar-gods. Covarrubias has pointed out that in most of Mesoamerica the dominant animal symbolism is based on the serpent, feathered serpent (dragon), or the eagle, but in Olmec carving the jaguar is of paramount importance.

The two objects under consideration here are extremely fine and notable examples of Olmec jade carvings. Their places of origin are unknown, but being carved from varieties of jade characteristic of the coastal area it is most likely

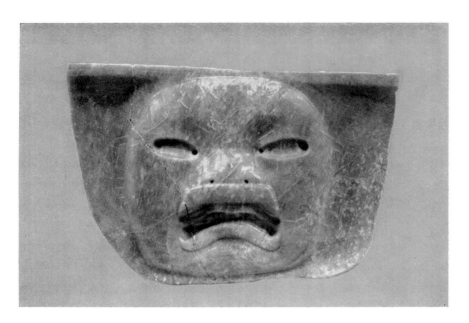

OLMEC JADE PLAQUE

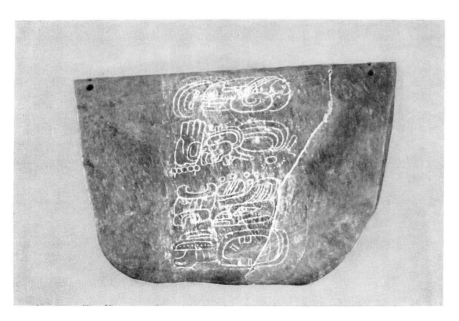

OLMEC JADE PLAQUE—*Rear view with powder bringing out the
incised glyphs*

311

that they were made somewhere in that region.

The standing figure with "baby" is unusual among Olmec jades for its large size and is unique in having a smaller individual in its arms. This feature can be seen in some of the large basalt sculptures, such as Altar 5 at La Venta which has five similar pairs. It is of interest that the face of the main figure is done in a markedly different style from that of the "baby" which is held. The former is entirely human in appearance while that of the "baby" has the exaggerated jaguar-like muzzle common to many Olmec figures. The jade is of extremely fine quality, dark blue-green in color, and very highly polished. It is in perfect condition except for one missing leg which may be due to accidental breakage, but it is also possible that the piece was ceremonially "killed," a practice suggested by other Olmec objects showing such purposeful mutilation as an arm neatly sawed off.

Our second piece, which is a flat plaque, is another unusually large and fine example of Olmec carving in a lighter bluish green jade. The upper corners are pierced, and it probably was worn as a chest ornament suspended from the neck. The round face with its fleshy lips, broad nose, and slanting eyes is typical of Olmec art. The eye sockets have not been polished and probably contained an inlay. The ears are indicated by delicate incising, the combination of bold modeling and incising being a feature of many Olmec jades.

The object has been subjected to purposeful mutilation of the kind mentioned above, the two ends having been rather crudely sawed off and only partially smoothed. One can only guess at its original form, but judging from related Olmec pieces it would appear to have been one of a class of long, oval, dish-shaped objects which in some cases appear to be representations of clam shells. The back of this plaque has a

very delicately inscribed text in a column of Maya-like hieroglyphs.

It is of interest that another jade pectoral in the British Museum[1] is nearly identical to our piece in form and the manner in which it has been cut down from a larger dish-shaped original. These and a large pendant now in the Dumbarton Oaks collection are the only Olmec pieces known which have definitely Maya style glyphs inscribed upon them.

The style of the glyphic writing on our plaque is unlike any of those few known examples which can properly be classified as Olmec, but it resembles very closely that of the glyphs on the Leyden Plaque in arrangement and cursive quality. This is a well-known incised jade object, found in the lowlands of eastern Guatemala, which bears the second oldest decipherable Maya date yet known, A. D. 320, according to the Goodman-Thompson correlation. The stylistic similarity of these two inscriptions suggests that they are of approximately the same period even though ours has no apparent calendrical significance and cannot be deciphered in any way at the present time. Nevertheless, this pectoral is an object of great interest, for it clearly indicates that fully developed Olmec carving was in existence at the time of the earliest known style of Maya glyphic writing. One cannot immediately assume, of course, that the Olmec sculptors knew Maya hieroglyphic writing. It is most probable that this piece passed from Olmec to Maya hands and that the inscription was added at a later date by people who used a form of writing that was seldom on durable objects and thus has remained largely unknown to us. This may be true of many phases of the history of writing in Middle America. Or, it might mean that there was a much closer relationship between the Olmec and Maya cultures than we have any indication of in our still meager knowledge of these Middle American civilizations.

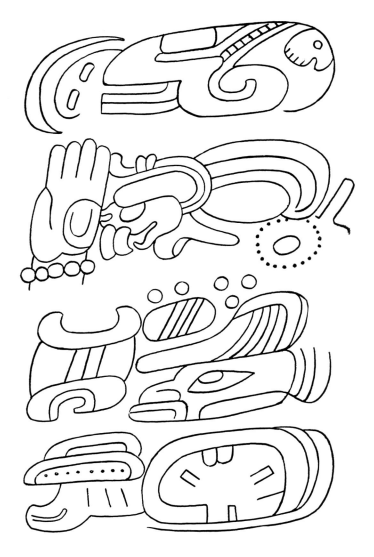

OLMEC JADE PLAQUE
Drawing of inscription on rear

OLMEC JADE FIGURE WITH "BABY"
Height (of main figure) 8.5″

PROVENANCE: Believed to have been at some time in the Chasseloup Loubat Collection, France, probably having been taken from Mexico during the French intervention in the mid-nineteenth century.

BIBLIOGRAPHY: Prior to its being in the Collection, this figure was known through plaster casts illustrated in: M. Sommerville, *Engraved Gems: Their History and Place in Art*, Philadelphia, 1889, p. 89 and appendix, "Catalogue Raisonné of the Sommerville Collection," no. 1399, pl. 58; *idem, Engraved Gems*, Philadelphia–London, 1901, p. 128; J. Pijoan, *Arte precolombiano, mexicano y maya*, Summa artis: Historia general del arte, ed. M. B. Cossío, X, Madrid-Bilbao, 1946, p. 250, fig. 405. A cast is in the collection of the University Museum of the University of Pennsylvania; H. J. Spinden, "An Olmec Jewel," *The Brooklyn Museum Bulletin*, IX, 1, 1947, pp. 1–12, publishes the actual object, along with its entire history, illustrations, and a full description; H. Comstock, "The Connoisseur in America," *The Connoisseur*, CXXVII, April 1951, p.41, ill.; D. F. Rubín de la Borbolla, *México:˙Monumentos históricos y arqueológicos*, Mexico, 1953, p. 277, fig. 229; S. Linné, *Treasures of Mexican Art*, trans. A. Read, Stockholm, 1956, pp. 50, 51, ill.; H. J. Spinden, *Maya Art and Civilization*, Indian Hills, Colorado, 1957, pt. 2, pl. LVIC; W. Spratling, *Escultura precolumbina de Guerrero*, Spanish text by D. F. Rubín de la Borbolla, Mexico, 1964, fig. 54; A. M. Zenil, "La Escultura de las Limas," *Instituto Nacional de Antropología e Historia*, 21, September 1965, p. 8; M. D. Coe, "The Olmec Style and Its Distribution," *Handbook of Middle American Indians*, ed. R. Wauchope, Austin, Texas, 1965, III, pt. 2, p. 743, fig. 7; E. Dávalos Hurtado, *Temas de antropologia física*, Anales. Instituto Nacional de Antropología e Historia, Mexico City, 1965, pl. VI.

EXHIBITED: Taft Museum, Cincinnati, *Ancient American Gold and Jade*, October–November 1950, no. 8; Musée d'Art Moderne, Paris, Liljevalchs Konsthall, Stockholm, Tate Gallery, London, *Mexican Art from Pre-Columbian Times to the Present Day*, 1952–1953, no. 118; Brooklyn Museum, New York, *Ancient Art of the Americas*, Winter 1959, p. 32, ill.; Brooklyn Museum since 1947.

OLMEC JADE PLAQUE
Height 3.3″ Width 4.8″

BIBLIOGRAPHY: M. Covarrubias, *Indian Art of Mexico and Central America*, New York, 1957, p. 214, fig. 94, drawing of inscription on rear; M. D. Coe, "The Olmec Style and Its Distribution," *Handbook of Middle American Indians*, ed. Robert Wauchope, Austin, Texas, 1965, III, pt. 2, p. 749, fig. 21.

EXHIBITED: Taft Museum, Cincinnati, *Ancient American Gold and Jade*, October–November 1950, no. 10; Society of the Four Arts, Palm Beach, Florida, *Pre-Columbian Art*, January–February 1953, no. 5; Brooklyn Museum, New York, *Ancient Art of The Americas*, Winter 1959, ill. p. 6; Brooklyn Museum since 1948.

NOTE

1. P. Kelemen, *Medieval American Art*, New York, 1943, II, pl. 246A.

OLMEC HAND-VESSEL

A LESS awkward label would be more fitting for this magnificent jade, but considering its unique form and unknown function a merely descriptive term seems most appropriate. We can only vaguely speculate on what meaning it must have had for its Olmec owner.

Looking at its hollowed-out side we see that it is very similar to the largest piece found by Stirling in the great jade cache of Cerro de las Mesas in central Vera Cruz.[1] This other object was described as a miniature "canoe," for it has projecting platforms at both ends and resembles in form the dugout canoes commonly used at the present time in many parts of this coastal area of Mexico. It is approximately the same size as the Guennol piece and has incised representations of the Olmec jaguar-monster on the two platforms. Several other green stone "canoes," undecorated and of smaller size, have been seen in private American collections.

If the Guennol jade is to be thought of as a miniature "canoe," it becomes most extraordinary when we turn it over and find that from this side it is an elongated, delicate human hand. Could there be any meaningful association of a hand with a canoe? Searching for an answer one wonders if this object could be a representation of some mythological concept of a deity holding the canoe above the primordial waters for the safety of man. The origin of man from the depths of the sea is a widespread myth in the New and the Old World.

There is some reason to think, however, that we may be completely wrong in identifying these rectangular hollowed-out objects as "canoes." Perhaps, they are specialized ceremonial vessels or dishes (like other types mentioned on

316

page 313) that only by chance resemble dugout canoes. Unlike hands, furthermore, canoes are not represented in other Mexican cultures. The hand must have had some special meaning throughout Mesoamerica. It is prominent in Maya hieroglyphs where it has the meaning of "completion" and death, and it appears to have similar meanings in Aztec art. Hands carved in jade are known from the Mayan area and others in shell are known from several parts of Mexico.

Another factor to be considered in attempting to interpret the "canoe" vessel and hand association is that the object may originally have been only a "canoe," and the hand was carved later. It appears probable that the "canoe" had at one time a platform at both ends, like the Cerro de las Mesas example, and that one of these was cut off to better form the wrist of the hand. Such alteration or mutilation of Olmec jades, done undoubtedly by the Olmecs themselves, is not uncommon, another example being the Olmec jade plaque in the Collection.

The Guennol piece is in almost perfect condition, having only a small chip, probably no more than an eighth of an inch in thickness, broken from the end of its thumb. It is cut from the fine quality light blue-green jadeite that is typical for the Olmec. The stone is translucent, slightly veined and with white or lighter patches within it. All the surfaces are smooth and highly polished. Slight traces of red paint remain in the suspension holes and in the grooves between the fingers of the hand.

The suspension holes are curiously placed and difficult to interpret. There are two oppositely placed holes on the wrist end that would seem to indicate that the object was suspended vertically as a pendant, but there is another hole on the thumb side matching one of those just mentioned which would also allow a horizontal suspension. On the

317

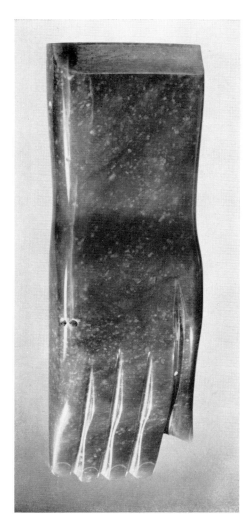

OLMEC HAND-VESSEL—*View of hand*

OLMEC HAND-VESSEL—*View of "canoe"*

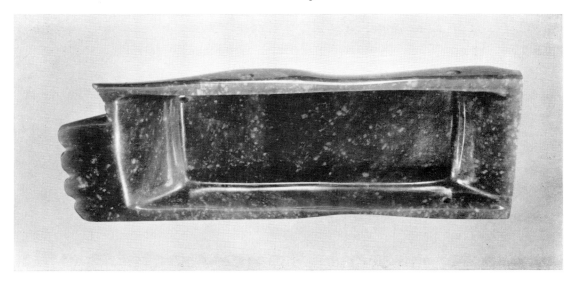

hand side there are two biconical holes forming a loop at the base of the little finger and there are similar unfinished perforations near the wrist. These could have been made for dangling ornaments if the object were suspended horizontally from the perforations on the other side. One other hole, completely unexplainable in the same terms, is in the corner of the bottom of the "canoe" and goes through the groove between the thumb and the first finger of the hand.

Because of its simplicity and cleanness of line, one's first reaction to this jade is that it is completely modern in concept and could not belong to an early Mexican culture. With further study, however, and with some knowledge of the quality and range of Olmec stone carving, one realizes that it has all the features that are characteristic of that remarkable art. The subtlety of line, the superb polish, the precise incising of the fingernails, and the complete cutting of this whole block of stone are certain indications of its Olmec origin. It can only come from the great period of Olmec art dating in the neighborhood of 500 B.C.

OLMEC HAND-VESSEL
Length 8″

PROVENANCE: Unknown; probably from southern Vera Cruz.

BIBLIOGRAPHY: A. Emmerich, *Art before Columbus*, New York, 1963, p. 67.

EXHIBITED: Brooklyn Museum, New York, *Ancient Art of the Americas*, Winter 1959; Brooklyn Museum since 1959.

NOTE

1. Reproduced in P. Drucker, "The Cerro de la Mesas Offering of Jade and Other Materials," *Smithsonian Institution. Bureau of American Ethnology. Bulletin 157, Anthropological Papers*, 44, 1955, pp. 47–48, pl. 38.

TWO OLMEC WINGED DEITIES

O<small>NE</small> must naturally expect the extraordinary skills of the Olmec jade carvers to have been as much admired in ancient times as they are today. Consequently, we cannot be too surprised when we find typically Olmec objects appearing as far distant from the centers of Olmec culture as Costa Rica. The two winged deities to be described here were found at different times and places in that country, and another jade object of Olmec origin has been discovered as far south as Panama.[1] They raise interesting questions as to whether they were imports from Mexico or whether they were the result of strong Olmec influence on the jade carvers of these regions.

The first of the two winged deities was found on the western slopes of the Guanacaste Mountains in Costa Rica. It is cut from a fine blue-green jade and in most ways is typically Olmec. The head is greatly elongated, and the face shows the flatness, the large lips depressed at the sides, and the toothless mouth characteristic of the style. In addition, we note as Olmec features the simple treatment of the body and the incised decoration around the lower edge of what is a cloak or mantle. The simple element in the center, similar to a belt buckle, is one of the most common Olmec symbols, but its significance is entirely unknown to us.

The symmetrical wings projecting from the body are of especial interest for they are a feature not found in other Olmec carvings from Mexico. Because of their scalloped outer edges, one suspects that they are the wings of a bat and that the figure as a whole represents some concept of an anthropomorphic bat—or bat demon or deity—in much the same manner as we find in the Mixtec bone handle and reliquary see p. (339). It is of interest that there is a hole drilled

320

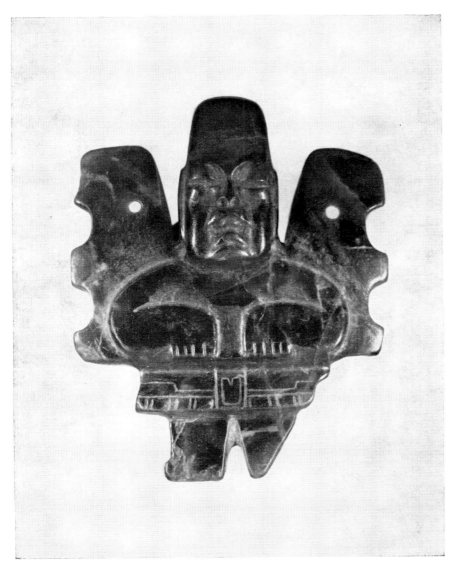

BLUE OLMEC WINGED DEITY—*Enlarged*

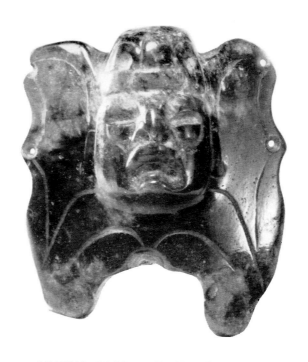

GREEN OLMEC WINGED DEITY

near the center of each of the wings, since in several Maya representations of bats there is a half moon or some other design in that same position. These holes may have had some symbolic significance or they may have served to attach something to the surface of the jade. Other holes drilled in the back of the figure were used for suspending it as a pendant.

The second winged deity is similar in style and in what it portrays, but it is cut from a dark green stone with areas of bright emerald green color previously unknown in Costa Rica and also quite typical of Olmec jade. The object was found at Union de Guapilas in the "Old Line" region of eastern Costa Rica, a considerable distance from the find spot of the other carving.

Rather than a complete figure, we see here only the head, shoulders, and arms of a human being, but the hands are disposed in much the same manner as they are in the other jade. There are wings also that rise from the sides of the body and have the same general "mariposa" shape, including the twice-scalloped outer edges. The design of the carving differs in that the wings are not separated from the head and that they are traced both by incised lines and by the borders of the object.

Our speculation that the first winged deity probably represents a combination of a human and a bat is reinforced here by the design of what is worn like a cap on the head of the figure in this carving. It is an animal face with round eyes and a central upright element that would seem to be the nose of a leaf-nosed bat. It is of special interest that the two Olmec jades known to have been found in Costa Rica are so notably alike and that each can be identified as probably representing a bat deity.

The archaeological implications of the finding of these two winged deities in Costa Rica are far from clear, but interest

in them is heightened by the aesthetic and technical qualities of the objects themselves. They are masterful examples of Olmec jade carving and attest further to the importance and strength of the Olmec tradition in Middle America.

BLUE OLMEC WINGED DEITY

Height (total) 2.4″ Thickness (maximum) .5″

PROVENANCE: Western slope of the Guanacaste Mountains, Costa Rica.

BIBLIOGRAPHY: J. A. Lines, "Dos nuevas Gemas en la arqueologia de Costa Rica," *Proceedings of the Eighth American Scientific Congress: Anthropological Sciences*, II 1942, pp. 117–122, publishes a drawing and a description; M. Covarrubias, "El Arte 'Olmeca' o de La Venta," *Cuadernos americanos*, 4, July–August 1946, pp. 153–179, note on p. 155, fig. 19; *idem, Mexico South*, New York, 1946, p. 83, note 9; C. Balser, "La Influencia olmeca en algunos motivos de la arqueologia de Costa Rica," *Informe Semestral: Instituto Geográfico de Costa Rica*, San José, October 1961, pp. 63–75, fig. 2, p. 67; A. Emmerich, *Art before Columbus*, New York, 1963, p. 64; J. A. Lines, *Costa Rica: Land of Exciting Archaeology*, San José, 1964, p. 22, ill.; M. D. Coe, "The Olmec Style and Its Distribution," *Handbook of Middle American Indians*, ed. R. Wauchope, Austin, Texas, 1965, III, pt. 2, pp. 753, 766, 767, 747, fig. 16; W. J. Moreno, "Mesoamerica before the Toltecs," in *Ancient Oaxaca: Discoveries in Mexican Archeology and History*, ed. J. Paddock, Stanford, California, 1966, p. 20, fig. 16.

EXHIBITED: Brooklyn Museum, New York, *Ancient Art of the Americas*, Winter 1959, p. i, ill.; Brooklyn Museum since 1949.

NOTE

1. S. K. Lothrop, "Archaeology of Southern Veraguas, Panama," *Memoirs of the Peabody Museum of Archaeology and Ethnology*, Harvard University, IX, 3, Cambridge, Massachusetts, 1950, p. 87.

GREEN OLMEC WINGED DEITY

Height 1.7″ Width 1.5″

PROVENANCE: A site known as Costa Rica, near Union de Guapilas, Costa Rica.

BIBLIOGRAPHY: C. Balser, "Los 'Baby Faces' olmecas de Costa Rica," *Actas del XXXIII Congreso Internacional de Americanistas*, San José, 1959, II, pp. 280–285, publishes description and photograph, fig. B; *idem*, "Some Costa Rican Jade Motifs," in S. K. Lothrop et al., *Essays in Pre-Columbian Art and Archaeology*, Cambridge, Massachusetts, 1961, pp. 210–217, publishes a photograph, fig. 2e; *idem*, "La Influencia olmeca en algunos motivos de la arqueologia de Costa Rica," *Informe Semestral: Instituto Geográfico de Costa Rica*, San José, October 1961, pp. 63–75, fig. 1, p. 67; M. D. Coe, "The Olmec Style and Its Distribution," *Handbook of Middle American Indians*, ed. Robert Wauchope, Austin, Texas, 1965, III, pt. 2, pp. 753, 766, 767.

EXHIBITED: Brooklyn Museum since 1965.

OLMEC STATUETTE

Aᴺᴼᵀᴴᴱᴿ small but remarkably "monumental" Olmec sculpture is a partial figure carved in black compacted serpentine. Only the upper portion remains of what was apparently a complete human figure, but even in this fragmentary state it is an extraordinarily handsome and interesting variant of the Olmec style.

The figure is basically that of a human being, but the face has the projecting muzzle and the large canines of the jaguar in a manner that is common to a number of Olmec sculptures. It is primarily the upper lip that shows the feline features, the lower lip being human in form as is the small chin beard. This latter feature, the beard, is seen in several other Olmec-style carvings and is generally more common in Mesoamerican art than one might expect, considering the relatively slight facial hair occurring on the basically Mongoloid American Indian peoples.

It is a characteristic of the Olmec style to be imaginative about the shape of the human skull, but one can only wonder if the strangely bulging and projecting forehead of this piece represents a human head or a headdress. The indications are conflicting: there is no line marking the edge of any headdress, if such is meant, and hair is indicated very clearly in the back. On the other hand, there are incised and partly modeled spirals on the sides of the head that might represent some portion of ornamental headgear, and in at least two other Olmec sculptures we have noted similar bulging foreheads where one can see clearly that a headdress is meant. We can go only so far in such an analysis, of course, for here we are obviously dealing with a sculptural presentation in which the effect of the work as a whole was uppermost in the artist's mind, and all unnecessary details

325

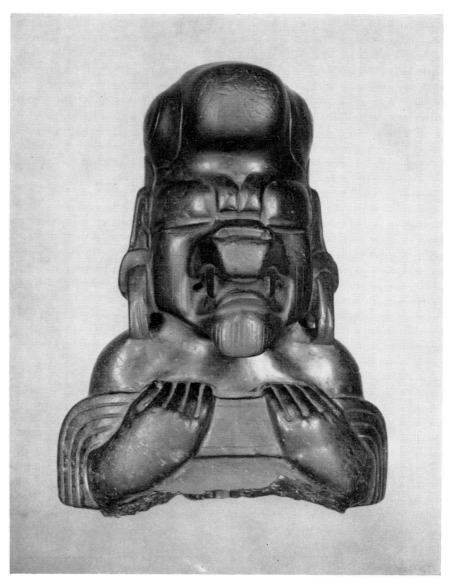

OLMEC STATUETTE

of realistic portrayal were either subordinated to this or eliminated.

This figure is of especial importance to our slowly growing knowledge of Olmec art in that it exhibits several elements not found in any other Olmec pieces. Notable among these is the precise and formal arrangement of the hair in horizontal bands, a feature unduplicated anywhere in Mesoamerica as far as we know. Scrolls such as those on the side of the head are a completely unexpected element in an Olmec object, but scrolls of varying kinds are abundant in Maya and Tajín-style carving. The looped ear ornament seen here is probably a unique occurrence in Olmec art, as is the limp-appearing object held across the chest in somewhat the same way as the ceremonial bar is held by figures in Maya stelae. When detailed analyses of the distribution of these elements are made, we will certainly learn more of the relationship of the Olmec style to other major Mesoamerican sculptural traditions.

Other features worthy of note in this sculpture are the indications of clothing in the two grooves and the lightly incised scallops across the shoulders and back, and the vertical incised lines above a deeper groove lower down along which the sculpture has broken. Lightly incised motifs symmetrical in form and placement are seen on the two cheeks. The one from the right cheek is reproduced here. Barely visible in the side and back view photographs are two drill holes about one quarter inch deep at the top of the head. They do not connect and their purpose is unclear. It might be suggested, however, that they were meant to receive some kind of ornament which would project from the head.

One naturally wonders what the entire figure may have been like, whether it was seated or standing, but there can be no certainty from an examination of the fragment we have.

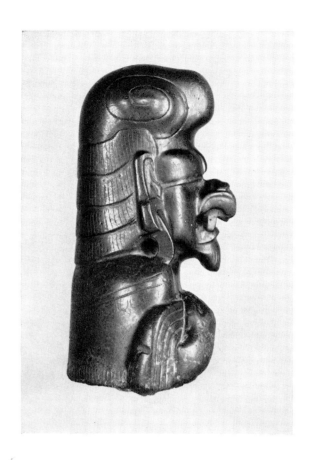

OLMEC STATUETTE

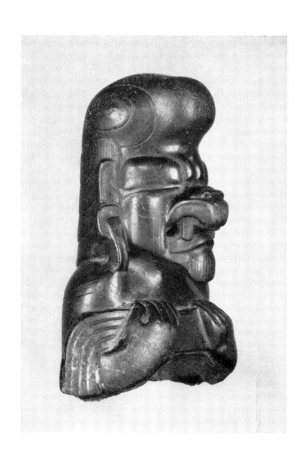

328

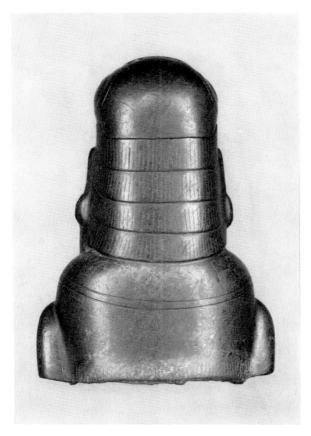

OLMEC STATUETTE—*Rear view*

There are some indications that it was a seated figure. The broken portion seems to show a certain forward extension of the stone below the arms, as if it were projecting outward at that point to form the legs. Also the rounded shoulders and back would appear to be more characteristic of the form of seated Olmec figures than of standing examples. Perhaps, by a lucky chance, some day we will locate the missing portion and the figure can then be completed.

Too little is known as yet of the Olmec sculptural tradition to allow us to place this figure on stylistic grounds in any particular chronological or stylistic category. One's first impression is that it might be a relatively late example of Olmec art, when the style may have been affected more by foreign elements than it was earlier. The occurrence of scrolls on the head, the patterned hair arrangement, an object held across the chest in a manner somewhat like the Maya ceremonial bar, are suggestive in this direction, but they are not very definite indications of lateness. The placement of this figure will have to await further knowledge of the whole Olmec tradition, but at the moment one can only say that it probably belongs within the period of Olmec florescence dating somewhere between 1200 and 400 B. C.

OLMEC STATUETTE

Height (maximum) 5.1"

La Venta Period A. D. 600

PROVENANCE: See *Introduction* for account of its previous owner.

BIBLIOGRAPHY: M. Covarrubias, *Indian Art of Mexico and Central America*, New York, 1957, pl. xi; G. F. Ekholm, "Art in Archaeology," in R. Redfield et al., *Aspects of Primitive Art*, New York, 1959, pl. 10; M. D. Coe, "The Olmec Style and Its Distribution," *Handbook of Middle American Indians*, ed. R. Wauchope, Austin, Texas, 1965, III, pt. 2, pp. 752, 753, 756, ill. p. 745, fig. 14, and p. 764, fig. 53; A. Warman and C. S. de Bonfil, *Olmecas, Zapotecas, Mixtecos*, Mexico City, 1967, p. 12, ill.

EXHIBITED: Society of the Four Arts, Palm Beach, Florida, *Pre-Columbian Art*, January–February 1953, no. 6, ill.; American Museum of Natural History since 1952.

CLASSIC MAYA JADE PLAQUE

THIS jade plaque represents a personage of high rank seated cross-legged. The legs, body, and arms are seen from the front, but the head is in profile looking over the left shoulder. One hand rests on a knee, while the other forearm passes horizontally across the body.

Comparable human figures appear on monumental stone carvings, bone, shell, painted and incised pottery, and in frescoes. These diverse objects are distributed from Copan in Honduras, across the highlands of Guatemala and the Usumacintla Valley, to southern Mexico. A related example in jade has been found near Teotihuacan in central Mexico. No period or center for the dispersion of this particular motif is known. The half dozen or so recorded Maya jades depicting this subject cannot be assigned to a single school of art. It thus seems that this motif had been widespread in various media.

Just what the significance was of the varying representations of seated figures is by no means evident. At Copan such figures are shown on Altars Q and T in groups of four, sometimes all facing in one direction, other times in pairs opposing each other as if in conversation. On Maya painted pottery two isolated individuals are usually seen on opposite sides of a vessel. In some cases a solitary individual appears to be looking at a glyphic inscription. Two of the jade specimens show a major personage looking down towards either a child or dwarf. In these, as in the Guennol standing figure with "baby," two facial types are recorded. Other known Maya jades show single figures.

The Maya jades related to this one are alike in that the human figure is in high relief with the details indicated by incised lines. In all cases the decorated surface has been

CLASSIC MAYA JADE PLAQUE—*Enlarged*

burnished, but the back is often left unpolished, as in the Guennol example. All have a horizontal perforation, drilled cross-wise at about the level of the head for a suspending cord. Judging from the way ornaments are worn by the figures on the Maya stelae, the small holes that sometimes occur on the edges of the jades were probably for attaching secondary ornaments.

These cross-legged human figures are usually thought to belong to the Late Classic Maya Period (*c.* A. D. 600–900). It is possible, however, that this specimen may be of a somewhat earlier date. We note that the ears, hands, wristlets, and the bar pendant are rendered with minimum detail. The need for carving the feet has been evaded by placing a loincloth with a diagonal pattern in the space where the feet should appear. This loincloth is attached to a crudely carved belt. Another feature suggesting an early date is the fact that there are no signs indicating the use of a tubular drill. This versatile tool, which bores a circle when used vertically or a semicircle when held diagonally, must have been invented in Late Classic times. It immediately became popular for cutting all kinds of small objects. This jade plaque clearly has had the background removed in part with a solid drill. There are drill holes in front of the nose, on the chin, above both forearms, over the belt, and in the front of the head-dress. The resulting sharp edges have been smoothed and polished until they are not unduly noticeable, but they definitely record the technique of manufacture which is one not found on most other jades of this type.

CLASSIC MAYA JADE PLAQUE

Length 2.1″ Width 1.5″

EXHIBITED: Taft Museum, Cincinnati, *American Gold and Jade*, October–November 1950, p. 17, no. 27; Brooklyn Museum since 1950.

CLASSIC VERA CRUZ STYLE
STONE YOKE

Until recently stone "yokes" have ranked as problematic objects, for while many theories concerning their use were formulated, none of them won general acceptance. These objects came to be known as yokes because of their resemblance in size and shape to ox yokes. They were labeled Totonac because the finest examples were found in the state of Vera Cruz on the Gulf Coast of Mexico where the Totonac Indians lived in the sixteenth century. It is now recognized, however, that these stone yokes are many centuries older and are in fact coeval with the Classic Maya and Teotihuacan periods. The style complex to which they pertain is referred to both as Classic Vera Cruz and as Tajín, the latter being an archaeological site where many fine examples of this style are seen.

Yokes are made of various kinds of stone, most of them very hard and capable of receiving a high polish. They have been found as far south as Honduras and El Salvador, and northward to the Mexican state of San Luis Potosí. Often they are devoid of ornament. In the Vera Cruz region, however, they usually are covered with intricate carvings. In some cases a human or animal head appears on the arch of the yoke, and the body and limbs are carved on the straight sections. At times two or more individuals are represented. There also are yokes like this example which are covered with highly conventionalized designs which still defy analysis.

The first clue as to the use of yokes came from an effigy vessel representing a man wearing one around his waist. It was ascertained that the opening between the two straight

parts of actual specimens varied little in width, that the yokes balanced themselves on hips of normal size, and that one could move with surprising freedom while wearing a yoke.

In the course of time, other avenues of research led to the identification of various accoutrements of Maya and Mexican ball players. Lately a number of clay figurines have been published which show individuals wearing not only the distinctive paraphernalia of ball players, but yokes as well. Their game, known in various forms from Arizona to Paraguay as well as in the West Indies, was played with a massive ball of solid rubber. In Mexico and northern Central America this game assumed a religious significance and was played in great masonry courts erected in the ceremonial centers of the cities.

The Spaniards were not interested in these Indian ball games and left no very detailed description of them. We do know that the cardinal rule of the game was that the ball must be struck with the head, body, or thighs. Different types of gloves, pads, and aprons have been identified on figurines as protective gear for the players, who not only had to propel the ball by striking it with their persons, but often had to fling themselves against the solid walls or floor in order to do so.

It must be accepted then that the stone yokes had at least some connection with the ritual aspect of the game. Perhaps they were worn only in ceremonial processions, but their curious form presumably was copied from prototypes in actual use, which were made of other materials such as wood, basketry, or leather. On the other hand, although we know little about the game and its objectives, we are told that the solid rubber balls were heavy enough to cause severe injuries, or even death, in spite of the protection worn. It seems possible then, that the stone yokes may have been more than ceremonial replicas. The strategy of the game

335

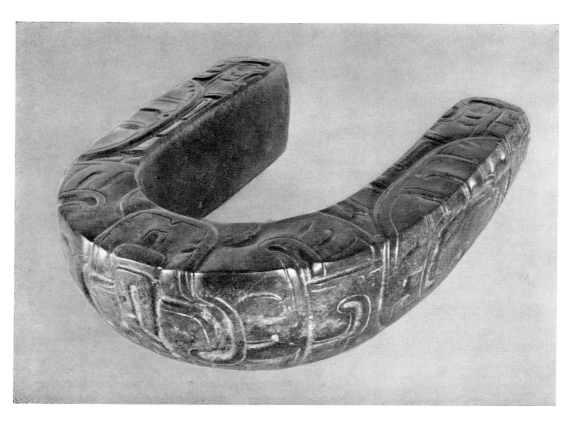

CLASSIC VERA CRUZ STYLE STONE YOKE

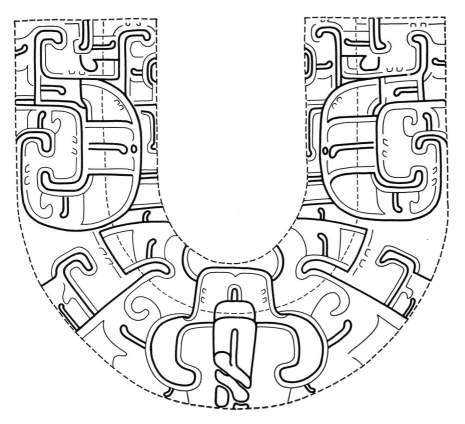

EXTENDED DESIGN ON STONE YOKE

337

may have called for a player to sacrifice mobility by carrying forty to sixty pounds around his waist in order to gain greater hitting power.

This particular yoke is noted for its exceptionally fine finish. The surfaces of the hard dark-green granular stone are polished except on the inside and the bottom edge. In the hollows of the design there are traces of red coloring. The Guennol yoke, in perfect condition, bears an excellent example of the abstract ornamental design of the Classic Vera Cruz style. This is characterized by interlocking hooks or scrolls in squared form but with rounded corners, and by what might be called a double outline—a fine line running parallel to the major relief of the carving. Sometimes these abstract patterns merge into recognizable human or animal forms, but the only element in this case that might be identified is the bell-shaped form in the curve of the yoke which could be the muzzle of a tiger as seen from the front. It has often been pointed out that these interlaced motifs have a remarkable resemblance to those on the Late Chou Dynasty Chinese bronzes. We can speculate about possible historical relationships between these two widely separated areas, but it must remain an open question until we know much more about the origins and development of American Indian art.

CLASSIC VERA CRUZ STYLE STONE YOKE

Length 16.8″ Width 14.5″

PROVENANCE: Unknown, but the form of the yoke and the style of design suggest Vera Cruz, Mexico.

BIBLIOGRAPHY: Not previously published. For speculation on the use of stone yokes see G. F. Ekholm, "The Probable Use of Mexican Stone Yokes," *American Anthropologist*, XLVIII, 4, October–December 1946, pp. 593–606.

EXHIBITED: Brooklyn Museum since 1951.

MIXTEC BONE HANDLE
AND RELIQUARY

Measuring only three and one half inches in length and with complex carving on all its surfaces, this unique and superb example of sculpture in bone must be seen and handled to be fully appreciated. Because it cannot be very successfully illustrated in either drawings or photographs and due to its rather special aesthetic and archeological interest, we shall describe it and attempt to analyze its meaning in considerable detail.

The object appears to have been used as a handle for some implement, there being a sharply rectangular hole about five thirty-seconds of an inch by three eighths of an inch in size and with a depth of seven eighths of an inch in the small, or foot, end. The rectangular shape of this hole suggests that it held a metal implement, but there is no sign of copper staining or any other indication of what material it might have been. A copper knife or chisel blade of some kind seems most probable, but if that were the case, it must have been separated from the handle before the latter was buried. Further indications of the object's having served as a handle are seen in its being of proper size for a hand grip, without any sharp protuberances, as well as the fact that the highly smoothed and worn surfaces on its raised portions seem to be the result of much use. Also, the only missing part of the piece is a tripart loop extending outward from the tongue and from the two sides of the head of the carved figure, a loop which could have been meant for the attachment of a wrist thong.

In addition to being a handle, the object is a box or container, and it thus seems proper to call it a reliquary, as was

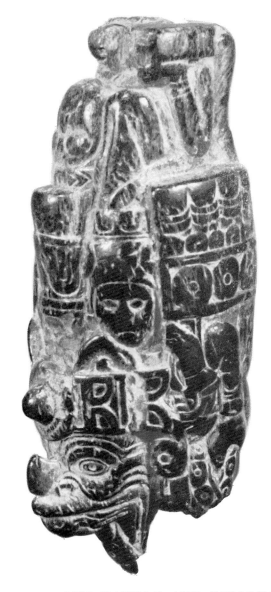

MIXTEC BONE HANDLE AND RELIQUARY

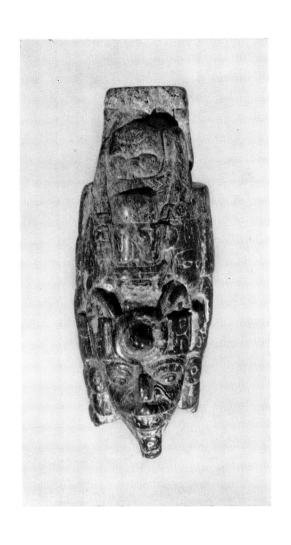

MIXTEC BONE HANDLE
AND RELIQUARY

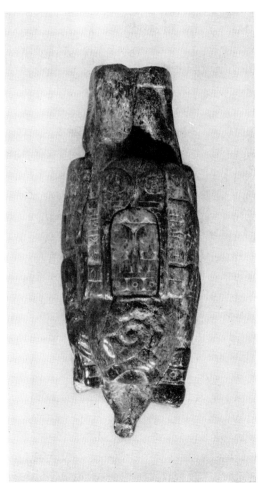

done when it was first exhibited in the Brooklyn Museum. A well-fitting cover, continuing the design, closes the opening to a surprisingly large rounded chamber, one inch long by three quarters of an inch in each of its other dimensions. Three tiny copper bells, one of which is illustrated, accompanied the object when it was acquired. They were reputedly found within the chamber, and this is confirmed by a green copper-oxide stain on the inside of the chamber and on the lid. We conclude, then, that the object was used as a handle for some kind of important ceremonial implement and also as a container for what, we might guess, was some revered relic or substance. No other artifacts showing this same combination of functions have previously been reported from Middle America. There are the well-known Aztec sacrificial knives with mosaic-decorated handles in human or animal form, but none of these are also containers.

The piece is said to have been found in Yucatan within a pottery jar which was also acquired with the copper bells. This alleged provenance is to be doubted, however, for, as will be indicated in the description of the carving, its style can be attributed to a late period of the Mixtec culture of northwestern Oaxaca in southern Mexico. The style and symbolism of the reliquary are completely outside of the Maya tradition, although the jar in which it was reputedly found is Maya. The jar has been definitively identified by the late G. W. Brainerd, an outstanding authority on Yucatan pottery, as an example of a type he knows as Florescent Medium Slateware, dating, to the best of his knowledge, between A. D. 775–900, and a product of the Puuc area of Yucatan. This places the jar entirely too early to coincide with our judgment of a much later date, based on stylistic data, for the bone handle. It is of course very possible that a small object made in northern Oaxaca could have been traded

into Yucatan, but because of the discrepancy in dating and because the objects and the "information" arrived through the hands of commercially interested persons, this data on provenance or association cannot be accepted with any degree of certainty.

Our interpretation of the carving of the bone is that it represents a combination bat and human figure which we can properly call a bat god. It also is equipped with several symbols commonly associated with the god Quetzalcoatl in a manner similar to depictions in three Mixtec codices. These picture books are the finest of the pre-Conquest codices of Mexico and are attributed to the Mixtec peoples of northern Oaxaca. Their representations of bat gods have been discussed in detail by Seler in his commentary on the Codex Vaticanus.[1] Another important source of information concerning representations of the bat god in the Oaxaca area is the study of Oaxacan urns by Caso and Bernal.[2]

The entire design of the carving and its detail can be best understood by reference to the "unrolled" drawing we reproduce. In this there is, of course, considerable distortion and therefore the illustrations must be used for seeing the proper relationships of the different parts of the piece. The pose of the figure is one in which the head is bent backwards to the extent of 180° making it upside down in relation to the rest of the body. In the illustration we have oriented the drawing so that the head can be seen clearly at the bottom, which results in the body extending upwards behind the head. In unrolling the figure to make the drawing, the division was made along one side of the chest area with its scallop and scroll design and the breech-clout in which the door into the hollowed-out interior of the bone is cut, seen at the far right of the drawing.

It is only in the face that the distinguishing characteristics

of the bat are indicated. The mouth is wide open showing sharp canine teeth, but these are laid down sideways instead of projecting—apparently to conform to the rounded nature of the carving as a whole. The tongue is narrow and projecting and its upper surface is decorated with dotted circles. The upper lip is drawn back showing considerable areas of the gum line in a manner common to other representations of bat gods. The nose is large, protruding, and upturned, and the face is lined in a manner to represent the grimace of a bat with its mouth open. A decorative band with a large high central boss crosses the forehead with two pointed, convoluted, and distinctively bat-like ears projecting up behind it. The face as a whole, then, is almost entirely the representation of a real bat face. We note, however, that there are ear ornaments at the side of the head in a human manner, each composed of a large circular element with a squared hook pendant below it. The "hooked" ear plug is common to representations of Quetzalcoatl in many late Mexican sculptures and drawings.

The column rising directly above the head is probably part of a headdress, but its nature is not entirely clear. This feature ends with the plain section at the top and does not include the inverted face which is actually a different portion of the sculpture as a whole. The drawing does not show it clearly, but this face is at a different level, as can be seen in the illustration. This columnar part of the headdress probably represents the peaked hat of Quetzalcoatl. Just below it, between the bat's ears, is an area where there had been a piece that is now broken away. It is curious that a break should have occurred here, in a relatively low area between the two slightly projecting bat's ears, and this suggests a larger projecting element which caused the break to occur. This appears plausible, for in other representations of bat gods—seen especially in some of the Oaxacan urns illus-

344

trated by Caso and Bernal—projecting medial crests are often depicted. In a drawing of Quetzalcoatl as a bat god in the Codex Borgia, a bird's head is shown projecting outward from this part of the peaked hat.

One hand of the bat god is seen to the right of the face, it being the larger of the two hands shown here. (Designations of right and left are from the point of view of the observer.) This hand grasps what appears to be the sharply curved body of a serpent whose upper surface is marked throughout its length with a series of dotted circles. A row of squared elements, which appear to be the under-body scales of the snake, is seen in the portion actually grasped by the hand. The thumb of the hand has a band about it, supposedly a ring, and there is a broad bracelet on the wrist, the markings of which are very vague. Held under the arm by a loop handle is a large decorative square purse that covers a good part of the space on this side of the bone. Decorated purses or bags are often seen in the hands of gods depicted in the Mixtec codices. Known as *copalxiquepilli* in Nahuatl, they were apparently meant to carry, or were symbolic of, the copal resin to be burnt as an offering to the gods. Usually these purses are more complex in form than the one shown here.

Another portion of the bat god that is shown in this complexly designed carving is his right leg (near the top at the far left of our drawing). The leg is pulled up and there is a decorated band around the ankle. Above this leg (below it in the drawing) is an elaborately ornamented area apparently representing his cloak. Neither the leg nor the cloak are to be seen on the other side, as the space where they would be is occupied by the large purse.

We might discuss next the two faces above the bat god's head on each side of the central columnar portion of the headdress. These probably can be interpreted as the heads

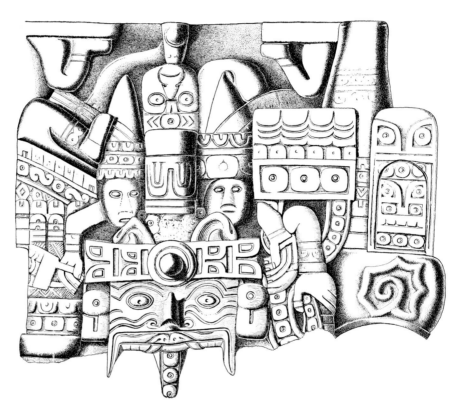

"UNROLLED" DRAWING OF MIXTEC RELIQUARY

of sacrificial victims perhaps tied to the belt or hanging over the back of the bat god. Both have conical headdresses with decorative bands, and accompanying each of these heads is a single arm. That on the left has his right arm and hand and is holding a smaller version of the copal bag carried by the main figure. The head on the right has a left hand in which he is holding some unknown object which fits around the back of the fingers.

Looking at the lower part of the drawing, we see at the far right the chest with its relatively simple design. This is the *ecailacatzcotzcatl* or "wind jewel" which is one of the most frequent symbols of Quetzalcoatl. Hanging from the belt (upwards in the drawing) is the breech-clout decorated with approximately the same design seen on the headband of the figure. Just to the left of the breech-clout there is apparently a small portion of the cloak similar to that found on the other side. However, the meaning of the column which extends up from this to the foot end of the piece is uncertain.

We would be inclined to think of the entire figure of the bat god as representing a being descending from the sky—considering the manner in which the head is thrown backwards and the legs are drawn upwards—if it were not for the small crouched human figure, at the narrow end of the bone, which appears to be supporting on its head the entire figure of the bat god. This figure is dismembered in the rolled-out drawing, due to the small size of this end of the bone, and it must be seen by referring to the photographs. The possible symbolic meaning of the small figure in relation to the bat god is unknown to us.

The entire conception of this bone carving obviously stems from the complex religious symbolism of the late so-called Mixteca-Puebla cultures of Oaxaca and Central Mexico. Involved in this symbolism are the concepts of the

bat—most likely the vampire bat associated with blood as a sacrificial substance. The heads probably represent sacrificed victims. The dominant cloak motif on the copal bags and on the snake is the glyph for jade which, by extension, means also a "precious substance." The glyph is present, too, on the tongue of the bat—the vampire bat taking blood from its victims by the licking of its long tongue.

We must think of this bone object, then, as representing a bat god and Quetzalcoatl figure covered with symbols of blood as the precious substance of sacrifice. If we are correct, as we think we are, in interpreting the form of the object as the handle of some implement, it is most likely that it was used in blood sacrifices for drawing blood from portions of the body as we know the Aztecs and the peoples of related cultures often did. The symbols on this reliquary bear a close correspondence to the iconography of the Mixtec codices, and there can be little doubt that it is of Mixtec origin and was probably carved by the Mixtecs within the last two or three centuries before the Spanish Conquest in 1520. Another, if less precise indication of origin, is the overall excellence of the carving, for the Mixtec are noted as having been the foremost craftsmen of Ancient Mexico.

MIXTEC BONE HANDLE AND RELIQUARY

Length (overall) 3.5″ Rectangular hole .2″ by .4″ and .9″ deep

Chamber length 1″ by .8″ in all other dimensions

Mexico, A. D. 1200–1300

PROVENANCE. Said to have been found in Yucatan, Mexico, within a pottery jar with three tiny copper bells inside the reliquary's chamber.

EXHIBITED: Brooklyn Museum, New York, *Ancient Art of the Americas*, Winter 1959; Brooklyn Museum since 1950.

NOTES

1. G. E. Seler, *Codex Vaticanus No. 3773 (Codex Vaticanus B)*, Berlin–London, 1902–1903.

2. A. Caso and I. Bernal, *Urnas de Oaxaca*, Mexico, 1952.

CHAVIN-STYLE SHELL
TRUMPET

The term "Chavín" is used in Peruvian archaeology to identify an early culture and a widespread art style whose type site is Chavín de Huántar in the central Andes. Chavín is of especial importance, not only due to the high quality of its art, but because it includes the first major developments in such arts as weaving, stone carving, stone architecture, and metallurgy. The regions it influenced include most of the coast and the northern highlands of Peru as well as parts of Ecuador. Radio-carbon dating and various estimates place the fully developed Chavín culture in the period of approximately 1200–400 B.C.

This shell trumpet bears a fine and typical example of Chavín-style ornamentation. It was found in January 1947, while enlarging the airport at Chiclayo, in a field situated on slightly elevated land above the irrigation level of the Lambayeque Valley. More Chavín objects have been found in these coastal regions than in the highlands, both because the dry climate makes for better preservation and because more digging has been carried on there.

The shell is a large conch known as *Strombus galeatus*. In a manner that is widespread in the New World, the apex has been broken off thus converting the shell into a trumpet. There is a wee hole, near the edge of the shell at the open end, which was probably for a suspension cord. This specimen is one of two known Chavín examples. In addition to these actual trumpets, there is also a Chavín gold figurine representing a man blowing a tiny silver conch shell. Later, during the Mochica period, several centuries after Chavín, a kind of dragon who lived in a conch shell was apparently worshiped, for it was

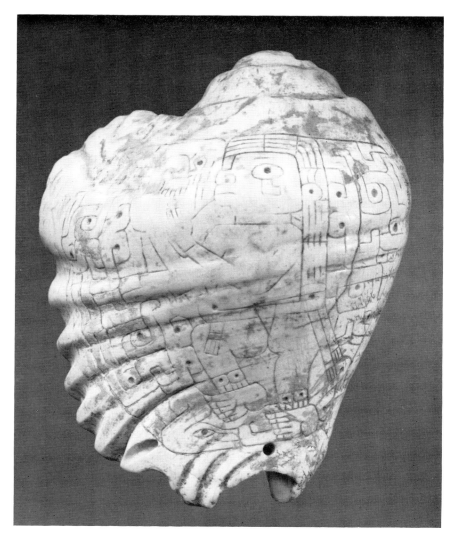

CHAVIN-STYLE SHELL TRUMPET

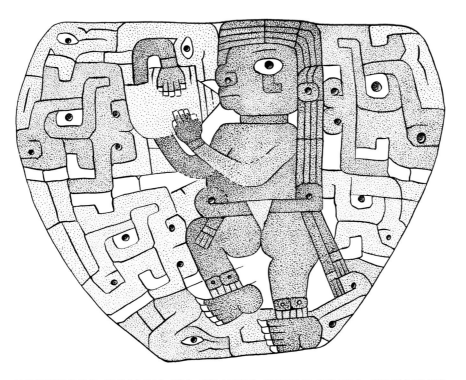

EXTENDED DESIGN ON CHAVIN-STYLE SHELL TRUMPET

often depicted on pottery, both in modeled form and in paint.

The conch shell trumpet is of great antiquity in Peru. It has been in use continuously from a very early date, through the time of the Spanish Conquest until the present day. It is still favored in Indian communities near Cuzco in Peru.

The chronicler Cabello de Balboa (1576–86) has described the mythical invasion from the North of the great king Naymlap with his queen and concubines. His household officials are listed by name, presumably in the order of their importance. The first is his "blower of the trumpet or sea shell," who outranked the keeper of his bed and throne, his cupbearer, his maker of shell powder, cook, beautician, and tailor. The reference to powdered shell perhaps relates to religious offerings, such as the Zuñi Indians of New Mexico still make today.

Sixteenth century drawings depict the Incas' messenger on the road blowing a trumpet as a warning for all to clear the way. Another shows the Inca Huascár, captive of his brother Atahualpa, led barefooted in bonds, his degradation proclaimed by a conch trumpet. To the Spanish *conquistadores*, the sound of the conch shell was a signal to prepare. All over the Caribbean, in Mexico, Central America, and much of South America, the sounding of the conch indicated an attack, no less than did the blare of the Spaniards' trumpets.

The Guennol trumpet is adorned with an incised panel, in the center of which is an individual who is, appropriately enough, depicted playing a shell trumpet. Through comparison with other Chavín carvings, he may be identified as an anthropomorphic jaguar god. On either side of his body are loops and scrolls representing serpent bodies. In front of his face and his raised foot are two serpent heads whose square snouts and mouths formed in a double curve are in the classic Chavín tradition. The eye, with its curious ap-

352

pendage underneath, is of the type known as the "weeping eye," possibly a symbol of rain. This is one of two known examples of this element in the Chavín style, and probably the earliest occurrence of this common Peruvian motif.

The jaguar god is unusual in a number of ways, among which is the absence of the usual feline features, such as claws, and enlarged canine teeth. Also, the raised leg and foot seem definitely to imply motion. Although these characteristics are common in the art of later Peruvian periods, at present the carving on this shell is the only example of these features that can be attributed to the Chavín style.

The attempt at perspective, with the jaguar god figure shown from several points of view, is still another feature heretofore unknown in Chavín art, except for one other carving in stone. It will be observed that on this shell the waist of the figure is presented frontally while the feet are in profile. One corner of the mouth is shown in addition to only one nostril and one wing of the nose, while the bridge of the nose is carried up to the hairline *inside* of the outline of the face. The eye is pictured in full-face. The shoulders are arranged diagonally, while the left arm and hand supporting the shell are in what we would consider proper perspective. More difficulty was encountered with the right arm. It is well done to the point where it suggestively passes behind the shell, but instead of having the hand hidden, the unknown Chavín artist stretched the arm like a rubber tube until it circled the shell so that he could indicate both hands. Comparable distortions and a groping for perspective are found in the art of later periods as well, for the Peruvians never fully mastered the principles of low relief sculpture or fresco painting. They learned to avoid certain pitfalls, but never achieved the comparative freedom that we find, for instance, in the paintings of Bonampak or in the more refined sculpture of the Classic Maya.

CHAVIN-STYLE SHELL TRUMPET

Height 9″ Width 7″

Peru, *c.* 900–500 B. C.

PROVENANCE: Chiclayo, Peru.

EX COLL.: Abraham Pickman, Lima.

BIBLIOGRAPHY: J. C. Tello, *El Strombus en el arte chavin*, Lima, 1937; R. L. Hoyle, *Los Cupisniques*, Lima, 1941, p. 88, fig. 174; J. C. Tello, "Discovery of the Chavín Culture in Peru," *American Antiquity*, IX, 1, 1943, p. 135, provides further descriptions and illustrations; F. Cossío del Pomar, *Arte del Peru pre-colombino*, Mexico, 1949, p. 49, drawing p. 40; A. J. Borja, "Instrumentos musicales peruanos," *Revista del Museo Nacional*, XIX–XX, 1950–1951, p. 170, ill.; J. H. Rowe, *Chavin Art*, New York, 1962, p. 5, figs. 40, 40a.

EXHIBITED: Society of the Four Arts, Palm Beach, *Pre-Columbian Art*, January–February 1953, no. 70; Museum of Modern Art, New York, *Ancient Arts of the Andes*, February–March 1954, fig. 24; Brooklyn Museum, New York, *Ancient Art of the Americas*, Winter 1959, p. 66, ill.; Museum of Primitive Art, New York, *God With Fangs–The Chavin Civilization of Peru*, February–May 1962, no. 36, ill.; Brooklyn Museum since 1952.